THE PRAYER BOOK OF CHARLES THE BOLD

THE PRAYER BOOK OF CHARLES THE BOLD

A STUDY OF A FLEMISH MASTERPIECE FROM THE BURGUNDIAN COURT

ANTOINE DE SCHRYVER

ENGLISH TRANSLATION BY JESSICA BERENBEIM

THE J. PAUL GETTY MUSEUM
LOS ANGELES

Getty Museum Monographs on Illuminated Manuscripts
Thomas Kren, *General Editor*

© 2007, © 2008 Faksimile Verlag Luzern, in association with
The J. Paul Getty Museum, Los Angeles

Translation © 2008 Faksimile Verlag Luzern

Original French text © 2006 J. Paul Getty Trust

First published in the United States of America in 2008 by
The J. Paul Getty Museum

Getty Publications
1200 Getty Center Drive, Suite 500
Los Angeles, California 90049-1682
www.getty.edu

Gregory M. Britton, *Publisher*
Mark Greenberg, *Editor in Chief*

Ann Lucke, *Managing Editor*
Mollie Holtman, *Editor*
Elizabeth Morrison, *Translation Editor*
Kristen Collins, *Translation Editor*

Design and typesetting by Vollnhals Fotosatz, Mühlhausen, Germany
Printed in Germany by Erhardi Druck GmbH, Regensburg

ISBN 978-0-89236-943-0
Library of Congress Control Number 2008924691

In 2007 Faksimile Verlag Luzern published a facsimile of *The Prayer Book of Charles The Bold* (Ms. 37, J. Paul Getty
Museum) along with this commentary volume by Antoine de Schryver. ISBN 978-3-85672-110-7.

The color reproductions are 142% larger than the original illuminations.

Table of Contents

PREFACE

The story of the creation of this publication is an extraordinary one that extends across the full career of the late Antoine de Schryver, the remarkable scholar of southern Netherlandish manuscript illumination and highly regarded professor of art history at the University of Ghent. During the early 1950s, while conducting research for his dissertation in the archives of the Burgundian dukes in Brussels, De Schryver discovered documents of payments to the scribe, illuminator, and a silversmith (who contributed to the decoration of the binding) for a small prayer book ordered by Charles the Bold (r. 1467–77). Before too long, De Schryver also managed to identify the prayer book itself, the glorious manuscript that was reproduced in facsimile by Faksimile Verlag Luzern in 2007. The book was then in a private collection in France, and in 1957 De Schryver mentioned his discovery in a short publication on the book's illuminator, Liévin van Lathem, but he did not publish the documents themselves there. (De Schryver's unpublished dissertation, on the illuminators in the service of Charles the Bold, was completed in 1957 for the University of Ghent.) In 1969, in an article on Nicolas Spierinc, who was the prayer book's scribe, De Schryver published the pertinent document concerning Spierinc. While De Schryver's plans to publish the remaining documents did not immediately reach fruition, his identification of the book's illuminator as Liévin van Lathem, one of the great Flemish book painters of the 1460s and 1470s, nonetheless became widely accepted in the literature, starting with L.M.J. Delaissé's landmark exhibition of 1959, *La Miniature Flamande: Le Mécénat de Philippe le Bon.*

As Professor De Schryver related the story to me nearly twenty years ago, he had hoped to persuade the owner of the ducal prayer book to permit the publication of a facsimile, which he further envisioned as the appropriate vehicle for reproducing all of the documents related to the manuscript. In the intervening years, as he awaited this opportunity, De Schryver developed a reputation for writing and publishing works that detailed the activities of major scribes, such as the aforementioned Nicolas Spierinc, and illuminators, such as Loyset Liédet and Philippe de Mazerolles; and, in conjunction with his discoveries concerning Spierinc and Van Lathem, an ambitious study of the Vienna Hours of Mary of Burgundy. When the J. Paul Getty Museum had the good fortune to purchase the prayer book of Charles the Bold in 1989, we agreed that Professor De Schryver would have the opportunity to publish a full study of it, an undertaking that would include a detailed discussion of the documents. He set about to do this upon his retirement from the University of Ghent, also in 1989. However, due to health issues within his family, coup-

led with increased family responsibilities and, eventually, health issues of his own, it was not until 1997 that De Schryver first delivered a complete draft of his text. He completed the revised, final text in 2004, less than a year before his death in March 2005. Thus, this volume truly embodies a life's work, representing the culmination of a study lasting more than fifty years, and one that Professor De Schryver rightly considered to be an important component of his scholarly legacy.

In this connection the reader will note that the bibliography listed here takes into account relatively little scholarship since the completion of the first draft in 1997, a choice made by the author, though we understand this also to result in part from his declining health. When the final revisions were submitted, given the importance of the contents, the decision was made to see this long-awaited study put to print as quickly as possible, and as a result no fur-

ther revisions to the final text have been undertaken.

Regrettably, Professor De Schryver died without being able to thank the many scholars who had aided him over the years in his research on the prayer book of Charles the Bold. At Getty Publications, Editor in Chief Mark Greenberg has been involved with the book from its inception. I feel confident that Professor De Schryver would also want to thank the anonymous readers who provided a careful review of the first complete draft. Also due sincere thanks are Urs Düggelin, Manfred Kramer, Gunter Tampe, Clarissa Rothacker and the dedicated staff at Faksimile Verlag Luzern for their high standards and strong commitment to this extraordinary project.

Thomas Kren
Curator of Manuscripts
The J. Paul Getty Museum

INTRODUCTION

The small and precious prayer book that is the subject of the present work remained in private hands until its acquisition by the J. Paul Getty Museum. It was still completely unknown when Count Paul Durrieu discovered it and was able to acquire it in about 1900. Durrieu commented on some of its iconographic particularities in 1910.[1] In 1916, he published the first study to reveal the interest of the manuscript and underline the exceptional qualities of its execution. He believed he could attribute the illumination to Philippe de Mazerolles, official illuminator to Charles the Bold.[2] The hypotheses and assertions that Durrieu and Friedrich Winkler, independently of one another, advanced and developed at the beginning of the last century with regard to de Mazerolles are no longer current today. I have demonstrated that they were ill-founded and have established that the work that they attribute to de Mazerolles was in fact that of Lieven van Lathem.[3] The prayer book that is the subject of the present work was a centerpiece of the corpus erroneously attributed to Mazerolles. It has now been established that Nicolas Spierinc and Lieven van Lathem were two of its principal creators.

As he had often done before, Charles the Bold left for a sojourn in Holland during the summer of 1469. In August, as the Count of Holland he resided at The Hague's seigneurial residence, which Albert of Bavaria had so remarkably enlarged and en-

hanced in the previous century.[4] It is there that the prayer book commissioned by the duke was presented to him. The illuminators Nicolas Spierinc and Lieven van Lathem were both sent to The Hague, and the prayer book was submitted for the duke's approval, which was necessary before the finishing touches could be added. Spierinc had also come to deliver a collection of eight Ordinances which he had also been commissioned to make for the duke.

The attribution to Lieven van Lathem of an important and well-defined portion of the prayer book's illumination is fully documented. This devotional book therefore contains the central work around which we may gather the production of one of the most admired and most brilliant painters and illuminators of the fifteenth century. On the basis of data that I have previously published or communicated, the attribution to van Lathem of the work previously believed attributable to de Mazerolles has over the years found general acceptance.[5] Moreover, it has already been several years since Eva Wolf presented a very useful contribution to the study of the work of van Lathem.[6]

The perfect correspondence between precise details supplied by the documents, and the identification of different elements of a portion of the manuscript's illumination, could not have been established without a preliminary analysis of the small volume's structure, and without taking into

account the divergences in style that can be observed in its borders and miniatures. At the same time, combining the archival data, the resources of codicology, and observations of formal characteristics, also allows the reconstitution of this precious book's successive stages of creation, until the later addition of the Hours of the Cross.

Lieven van Lathem and Nicolas Spierinc were figures of the very first rank of illuminated manuscript production in Flanders and Brabant during the second half of the fifteenth century. Their biographies, considerably enriched by new data presented here for the first time, better permit us to situate them in their artistic environment as well as their social and familial context. The qualities and the originality of their work demonstrate that they must have played an influential role in a crucial phase in the evolution of manuscript painting. I have sometimes abandoned, revised, or corrected propositions or positions previously adopted, which explains the contradictions that the present work sometimes seems to have in comparison with positions or propositions I previously advanced.

The analyses and syntheses here proposed clarify the fruitful exchanges among artists in centers of illuminated book production in the Southern and Northern Low Countries. They also reveal that van Lathem or his entourage must have had contacts with the milieu of illuminators who worked in Provence for King René of Anjou, the milieu to which among others, Barthélémy d'Eyck (also known as the Master of the Aix Annunciation), originally from the Mosan region, belonged.

The Prayer Book of Charles the Bold occupies a crucial position in the history of Flemish illumination. This incontestable masterpiece opened the path to the brilliant production of succeeding decades, profoundly effected by several exceptional artists, among whom the enigmatic figure of the Master of Mary of Burgundy figures as one of the most influential and innovative. Research now tends to consider the many books that were long attributed to him as, instead, products of the activity of several connected masters, more or less close to the leader around whom they gravitated, in what was apparently a non–hierarchical context. Nicolas Spierinc, who belonged to this group, seems to have occupied an eminent and respected position in it. Even if the commissions that he obtained from Duke Charles led him to carry out his work temporarily in both Antwerp and Brussels, everything indeed appears to indicate that he held a major role in the milieu where the most beautiful works of Ghent illumination were painted, marked by the flourishing of Hugo van der Goes and by the development of new conceptions of border decoration and mise-en-page.

This prayer book is therefore of great importance for the history of manuscript painting in the Low Countries. Even if it did not have the rare advantage of also being so well documented, its outstanding qualities alone would have sufficed to justify its being the object of an intensive study. To all these reasons must certainly be added its illustrious provenance. Executed for the last of the great Dukes of Burgundy of the Valois line, this marvelous book represents a mag-

nificent testimony of the assured taste with which Charles the Bold chose the artisans who executed the works or objects intended for his personal use. The jewel that is Getty Ms. 37 had been commissioned some time after the prestigious marriage celebrations at Bruges of Charles the Bold and Margaret of York, in July of 1468. Its patron could have used it from September of 1469. As much on account of taste as love of ostentation, the duke intended that the personal objects with which he wanted to surround himself respond to the highest demands and thus reflected the dignity and eminence of his rank and authority.

On the fifth of January 1477, the disaster at Nancy tragically put an end to the reign of Charles the Bold, less than ten years after the death of his father in June 1467. We might wonder whether the prayer book could have been lost at the time of the defeats suffered against the Swiss in 1476 at Grandson and Morat, or at the time of the fatal disaster at Nancy, at which the manuscript could have fallen into other hands. There is no specific indication or explicit reference that permits us to affirm this. No mention of the precious manuscript appears after the documents relating to its creation by Spierinc and Van Lathem in 1469. No inventory was drawn up which could have made mention of the personal manuscripts left by the duke after his disappearance. It is, however, established that in 1482 or the beginning of 1483, his book of prayers was in the hands of Mary of Luxembourg, the daughter of Peter II of Luxembourg, Count of Saint–Pol, Conversano, and Brienne. Appendix 5 at the end of this book gives an account of research concerning Mary of Luxembourg and sets out the circumstances that allow us to conjecture how the prayer book could have come to her. Finally, Appendix 5 also gives evidence relating to the eighteenth and nineteenth centuries, on the basis of which we may recount the later history of the manuscript.

Endnotes

1 'Les préfigures de la Passion dans l'ornementation d'un manuscrit du XVe siècle', *Revue de l'art chrétien* (March–April 1910), pp. 67–69.

2 P. Durrieu, 'Livre de prières peint pour Charles le Téméraire par son enlumineur en titre Philippe de Mazerolles', *Monuments et Mémoires publiés par l'Académie des Inscriptions et Belles-Lettres (Fondation Eugène Piot)* 22 (1916), fasc. 1, pp. 71–130. Durrieu had underlined in passing the importance of the manuscript and had already proposed in 1913 the attribution to de Mazerolles: 'Les miniaturistes franco–flamands des XIVe et XVe siècles', *Annales du XXIIIe Congrès (Gand 1913) de la Fédération archéologique et historique de Belgique* (Ghent 1914), tome 3, pp. 235–238, Pl. XXXIII (first reproduction of the miniature of Saint Martin, fol. 34v).

3 De Schryver, 1969/1, pp. 23–45.

4 F.P. van Oostrom, *Het woord van eer: Literatuur aan het Hollandse hof omstreeks 1400* (Amsterdam, 1987), pp. 14–16.

5 On the subject of de Mazerolles, see: A. de Schryver, 'Philippe de Mazerolles: le livre d'heures noir et les manuscrits d'Ordonnances militaires de Charles le Téméraire' *Revue de l'Art*, n°126 (1999–4), pp. 50–67.

6 Eva Wolf, *Das Bild in der spätmittelalterlichen Buchmalerei: Das Sachsenheim–Gebetbuch im Werk Lievin van Lathems* (Hildesheim, Zürich, New York 1996). Wolf did not have the opportunity to examine Getty Ms. 37, and anticipating the appearance of the present study, did not include this manuscript in the carefully elaborated catalogue with which she concludes her book. The indications that she gives on pp. 15–16 take their inspiration from some information that I gave her in a conversation that I had with her during the 'Congress on Medieval Manuscript Illumination in the Northern Netherlands' in Utrecht in 1989. This information appears not to have been completely understood. It will be corrected in light of Chapter 2 of the present work.

MS. GETTY 37: A PRAYER BOOK CREATED FOR CHARLES THE BOLD

1.1 CHARLES THE BOLD, THE MANUSCRIPT'S PATRON

Folios 1v and 2r, each provided with a large miniature and a border, resemble a diptych illustrating the worship of Christ's Holy Face; the text of the prayer, *Salve sancta facies*, begins below the miniature on fol. 2r. This diptych offers a very precise set of data, permitting us to establish that the manuscript was indeed executed for Charles the Bold.

The right-hand leaf of the diptych, fol. 2r, depicts Saint Veronica, standing and holding before her the cloth on which the Holy Face is imprinted. Fol. 1v, the left-hand leaf of the diptych, depicts a nobleman in prayer. The book's patron is under the protection of Saint George, who stands behind him in a suit of armor. To the left, behind Saint George, an angel carries a helmet in his hands. The upright pole, with a banner visible above the angel, rests against his shoulder.

In contrast to the other paintings in the volume, which are generally in very good condition, this first miniature appears to have suffered some damage. One easily notices that it has been modified: originally, the helmet held by the angel obviously sat on top of a shield. Representing a helmet without this shield, as we see it here, was inconceivable in an era when heraldry played such an important role. It is clear that a new owner of the manuscript wanted to erase the first recipient's most obvious marks of ownership. Removing the shield created a void in the composition, at the place where this shield originally concealed the pavement. So that this void would not be too noticeable, the artist responsible for the alteration was obliged to complete the line of the pavement below the helmet, between the angel and Saint George. Although this was done in quite a skilful manner, a slight error in perspective is noticeable: the diagonals in the added portion incline less to the right than those of the original portion. The slightly stronger color of this portion of the pavement further emphasizes the repainting. Despite the disappearance of the shield properly speaking, the helmet and crest remain unchanged, and say enough about the manuscript's first owner. The fleur-de-lis that surmounts the helmet could only have been worn by a prince of the Valois line. The red and blue *tortil*, or twisted fold, that surrounds the helmet is in the colors of Burgundy. On the blue and white banner that the angel holds, we can

distinguish a Saint Andrew's Cross and the letters *ie*. Saint Andrew is the patron of Burgundy, and the *ie* or *je* is none other than the first word of the duke's motto: *Je l'ay emprins*. Originally, the pole of the banner was partially hidden by the shield; the artist did not notice this while reworking the miniature, as this pole would have had to be extended downwards.

It is well known that from a young age Charles the Bold had chosen Saint George as a favorite protector.[1] He had already had himself represented under the protection of Saint George is 1457 in an important piece of plate that the Brussels goldsmith Henri de Backer executed according to a pattern executed by Jean Hennequart, painter and *valet de chambre* of the future Duke Charles. This piece was offered by the duke to Our Lady of 's Gravesande in Holland, on the occasion of the birth of his daughter, Mary of Burgundy.[2] Now, the opening diptych of the manuscript, as well as the two others that will be discussed below, each demonstrate this devotion to Saint George. In addition, the first diptych bears witness to a special veneration of the Holy Face, a devotion which, since Philippe le Hardi, was especially honored among the dukes of Burgundy.[3]

A second devotional diptych on fols. 5v–6r illustrates the prayer to the Virgin, *Excellentissima et gloriosissima atque sanctissima Virgo …* In the miniature on fols. 5v–6r, the Virgin and Child are represented surrounded by angel musicians; Charles the Bold, kneeling under the protection of Saint George, is depicted in a smaller miniature

on fol. 6r. With a gesture of his hand, Saint George presents the duke to the Virgin, whom the saint salutes by uncovering his head with his other hand.

The duke is represented in a third devotional diptych on fols. 67v–68r, and this time it is Saint George himself whom the duke invokes. The full-page miniature on fol. 67v shows Saint George battling the dragon, and the facing miniature shows the duke at prayer within a church, under the protection of an angel. In the border next to duke's portrait, we observe two branches arranged in a Saint Andrew's Cross, clearly alluding to the patron saint of Burgundy. Just above stands a quite conspicuous marguerite plant with abundant flowers, very likely an allusion to the duke's wife, Margaret of York. One must assume that the two scrolls in the border originally contained inscriptions that could have been effaced, as was the heraldry in the first miniature. The white layer, opaque and rather thick, which covers these scrolls could have been added to conceal the original inscriptions. One can scarcely imagine that, in a border framing the duke's portrait, it would originally have been satisfactory to have a scroll bearing only the illegible marks now visible, traced rather carelessly, on the scroll in the lower border. The inscription on the scroll at the right, near the Saint Andrew's cross, can be read as *O marti(r) dei*. It alludes to Saint Andrew or Saint George, but could have been added as an alteration. One wonders whether at least one of the scrolls originally bore the duke's motto, *Je l'ay emprins*; one can well imagine the motto in this

border alongside the emblems of the marguerite and the Saint Andrew's cross.

Finally, the text of the prayer to Saint Christopher (fols. 26v–27r) also confirms that the volume was originally intended for Duke Charles. The recipient of the little book asks to be protected from the attacks of his enemies and their conspiracies, and he is named: *michi famulo tuo Karolo peccatori sis in adiutorio*. When the calligraphy was done, the special enhancement of the duke's name had been deliberately planned: it was written in the beautiful blue color also used for the rubrics and for certain line fillers.

Just as Durrieu had already remarked in 1916, it is well known that the figure of Saint George on fol. 6r is repeated from Jan van Eyck's *The Madonna of Canon Van der Paele*, as was also the Saint George in the Liège reliquary (Cathedral of Saint Paul), created for Charles the Bold by his goldsmith Gérard Loyet.[4] Although he reversed the figure, who therefore now salutes with his left hand, van Lathem stayed very close to his model, but accentuated Saint George's movement, who appears to move forward more in order to present his protégé (Fig. 1).

He painted the Saint George in the first diptych using the same model, but modified the gesture of his hand, which, instead of saluting, this time holds the pole of his standard. It seems as though the red cross on a white field that Saint George's banner usually bears has here been effaced. The artist who was put in charge of removing the duke's coats of arms, originally depicted behind Saint George on the removed shield, probably believed it necessary to take care of the saint's attribute as well.

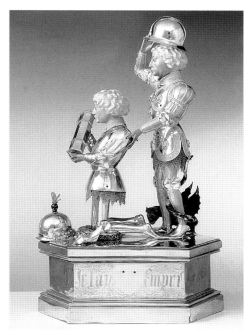

Fig. 1: Gérard Loyet, *Charles the Bold kneeling under the protection of Saint George.* Reliquary. Liège, Saint Paul's Cathedral, Treasury.

1.2 THE DUKE'S PORTRAITS

The very reduced dimensions of the figures' faces in this book's miniatures preclude the portraits of the duke from attaining any great resemblance. In the three diptychs, the illuminator inevitably had to content himself with depicting the major facial features of his patron.

All the same it is striking to notice that, in each of the three diptychs, Saint George's facial features are also those of the duke. Gérard Loyet had done the same in the Liège reliquary. The intention is clear: stimulating and flattering at the same time, these mirror-portraits, as one might call them, allowed the duke to see himself as a *miles*

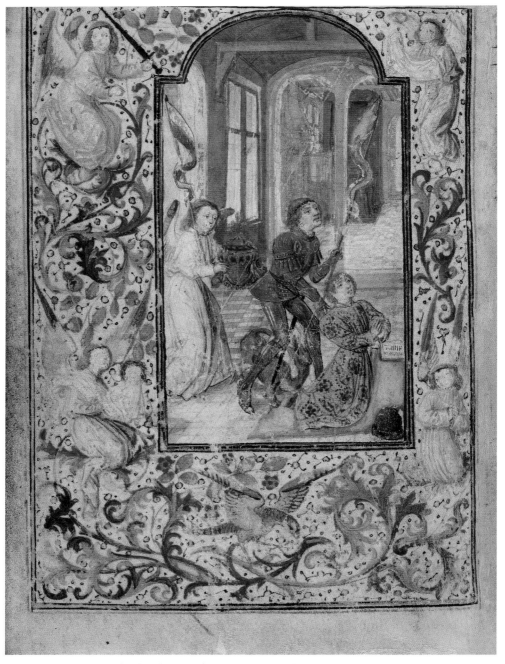

The manuscript was trimmed in the 17th century during re-binding, which resulted in a different positioning of the miniatures on each page.

PLATE I | 19

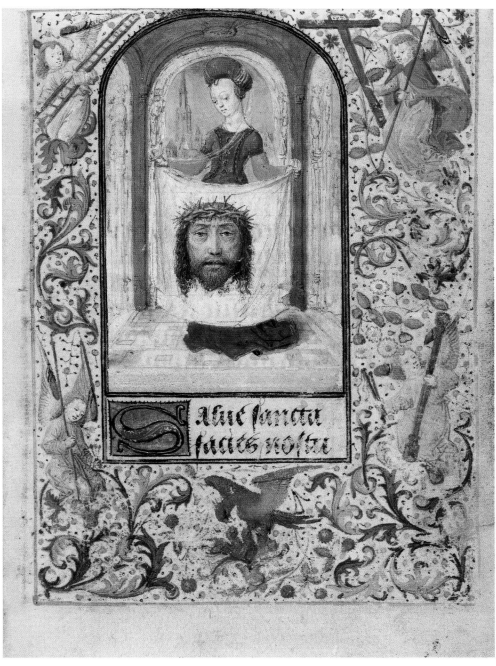

Fol. 1v–2r: The diptych of the Holy Face. Left-hand leaf: Charles the Bold in prayer presented by Saint George; an angel carries a helmet in his hands, a banner rests against his shoulder. Right-hand leaf: Saint Veronica displays the imprint of the Holy Face.

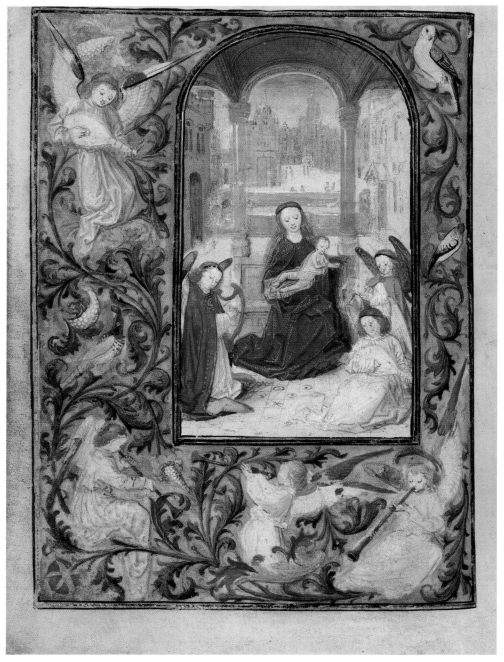

Fol. 5v–6r: The diptych of the Virgin and Child surrounded by angel musicians in the borders. Right-hand leaf: Charles the Bold kneeling under the protection of Saint George.

PLATE II | 21

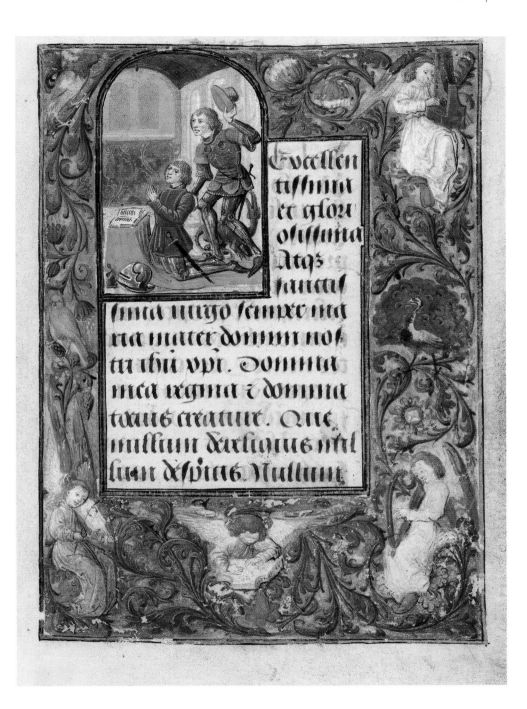

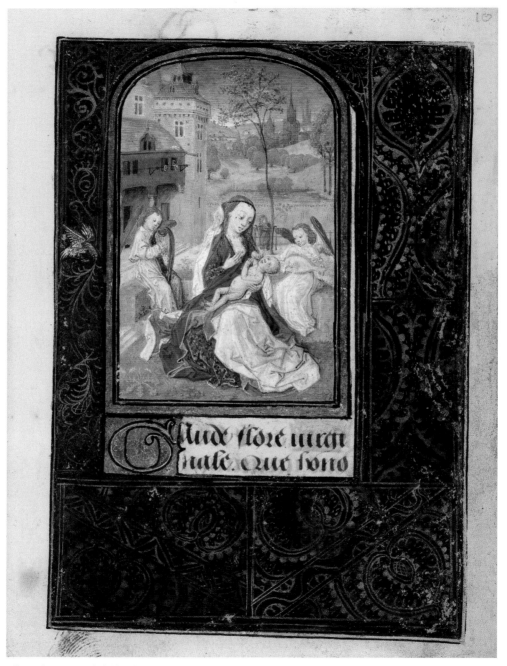

Fol. 10r: The Virgin and Child in the Garden.

PLATE IV | 23

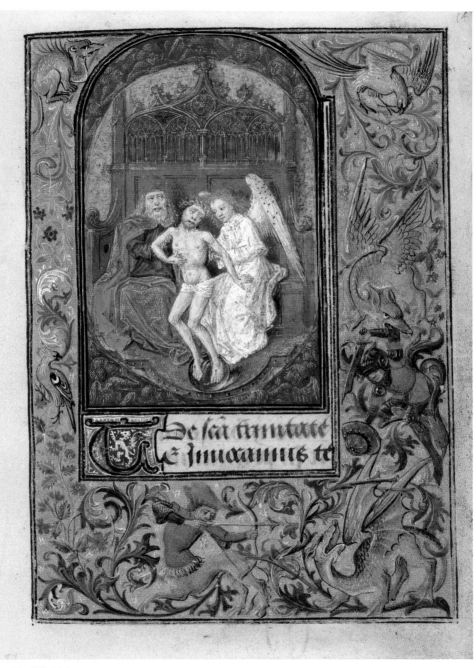

Fol. 14r: The Holy Trinity.

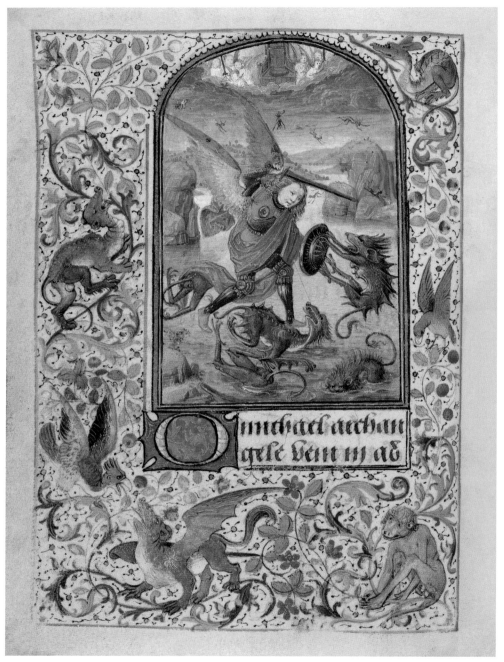

Fol. 15v: Saint Michael Fighting the demons.

PLATE VI | 25

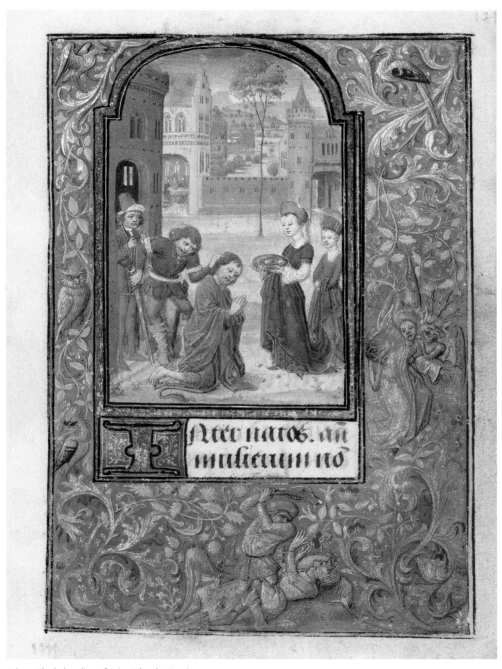

Fol. 17r: The beheading of Saint John the Baptist.

Christi and to identify himself with the chivalric ideal that, in his eyes, his valiant protector incarnated. Moreover, the case is far from being unique, and we do not only come across it in the old Low Countries.[5] Maximilian I had himself ostentatiously represented as Saint George in an engraving by Daniel Hopfer. A woodcut of Saint George, made by Hans Burgkmair as a pendant to an equestrian portrait Maximilian, bears the inscription *Divus Georgius christianorum militum propugnator*, which clarifies perfectly the intention of such representations.[6]

Philip the Fair had also been represented as Saint George on horseback slaying the dragon. A great wood sculpture from the end of the fifteenth century depicts the saint, adopting the features of the young Philip, wearing the chain of the Order of the Golden Fleece above his cuirass decorated with the briquets of Burgundy and the cross of Saint Andrew.[7]

The mirror-portraits of the prayer book could have been responses to an explicit wish of the duke. It could, however, be Van Lathem who took the initiative.[8] The brocaded robe in which the duke is dressed in the miniature on fol. 1v completes to some extent the attributes of his sovereignty. The richness and splendor of the clothing accorded with his rank, and it went without saying that the artist took this into account. In the miniature of Saint Hubert (fol. 39v) the patron saint of hunters is similarly clothed in a brocade doublet, in which we can also see the shimmer of gold and silk. It was necessary for sumptuous clothing to reflect the figure's nobility, most especially as one is here, once again, in the presence of a mirror-portrait and of a saint particularly venerated by the duke. This attention to the nature and quality of a figure's clothing demonstrates well the importance accorded in that era to costume as an element of social differentiation. Particularly on certain special occasions, the court of Burgundy used it to reflect degrees of the hierarchy of dignity or position.[9]

1.3 THE CONTENT OF AN EXCEPTIONAL DEVOTIONAL BOOK

Of a rather unusual composition, this devotional book principally contains spiritual exercises in Latin, each corresponding to a particular devotion. One finds neither a calendar, nor the pericopes of the Evangelists, nor the Hours of the Virgin, nor the *Obsecro te* or the *O Intemerata*, nor any of the other essential or usual elements of a book of hours. It is therefore obviously in error that it is sometimes referred to as such. The presence of the Hours of the Cross at the end of the volume could have caused the confusion. However, this justifies the label even less, since it proves not to have been part of the manuscript's original contents, as the following chapter demonstrates.

The prayer book testifies to some of Charles the Bold's own predilections; it also reflects the popularity of a number of very widespread devotions, of which the duke could not avoid also being aware.

The prayers to the Holy Face and to the Virgin, illustrated by the diptychs described above, are followed, after a second minia-

ture of the Virgin (fol. 10r), by the hymn *Gaude flore virginale*,[10] followed by a versicle, responsory, and the prayer *Dulcissime domine Jesu Christe, qui beatissimam genetricem tuam*…. The antiphon, versicle, responsory, and prayer that follow the miniature of the Trinity (fol. 14r), are borrowed from the Office of the Holy Trinity.[11] The rest of the small book is somewhat like the Suffrages in a book of hours. The texts each comprise an antiphon, versicle, and responsory, and one or two prayers. These texts are often borrowed from the office or the mass of the feast of the saint invoked, and therefore can be found in a number or breviaries or missals. Without having systematically searched for them, one will notice that this is the case, for example, in the prayers to Saint Andrew, Saint James, Saint Stephen, and Saint Lawrence. For the prayers to the apostles, the chosen antiphon, *Vos amici mei estis* (fol. 23v), is borrowed from the Common of one Apostle out of Eastertide.

The selected devotions follow, according to a certain hierarchy, the example most often found in the Suffrages of books of hours. After the Holy Face, the Virgin, and the Trinity follow the prayers addressed to saints. Saint Michael appears in the lead. He is followed by the Precourser, Saint John the Baptist; then by the principal apostles, Saints John, Peter and Paul, Andrew, and James the Greater. The other apostles, represented by the miniature of the Last Supper, are invoked as a group, and without being named. Then come Saint Stephen, Saint Eutropius, and All Saints; and finally Saints Anne, Mary Magdalen, Catherine, Margaret, and Apollonia. Therefore, the

majority of saints whose cults were widespread, like their images, have been retained. In this selection, however, the presence of Saint Gatianus and Saint Eutropius appears more unexpected.[12]

Saint Gatianus was the first bishop of Tours. At the end of the fourth century, his relics had been transferred to the cathedral of Tours by Saint Martin, who was one of his successors. In the fourteenth century, the cathedral was placed under the patronage of Saint Gatianus.[13] In many liturgical manuscripts and books of hours for Tours use—but also in others of Paris use—calendars, litanies, and suffrages testify to the cult devoted to Saints Gatianus and Martin.[14] The popularity of Saint Martin appears to have relegated that of Gatianus to the second rank. The *Guide du Pèlerin de Saint-Jacques de Compostelle* urged pilgrims to Santiago who took the Tours route to visit the holy body of Saint Martin there, but says not a word about Saint Gatianus.[15] In contrast to the many representations of Saint Martin, those of Saint Gatianus remain rather rare, and are only found in a few breviaries, missals, or books of hours connected to Tours.[16]

The reasons why Gatianus and Eutropius appear in Charles the Bold's small personal book still remain enigmatic. If one cannot see the reason for Gatianus, one might tentatively and not without reservation suggest one for Eutropius. The cult of Saint Eutropius was widespread in France. A chapel was dedicated to him at the Abbey Church of Cluny, and the Cluniacs promulgated his cult in Burgundy.[17] The city of Saintes, of which Eutropius was the first bishop, was one of the pilgrimage sites that extended

along the *via Turonensis*, the road to Santiago that pilgrims coming from Flanders used.[18] Saint Eutropius owed his celebrity to the *Codex Calixtinus*, written in the twelfth century with the intention of encouraging pilgrimage and the cult of Saint James. The *Guide du Pèlerin de Saint-Jacques*, which constitutes the last part, contains in effect the *Passion de saint Eutrope*, recounting his incredible history.[19] In the duke's prayer book, the antiphon for Saint Eutropius refers to his royal ancestry and his arrival in Jerusalem to see and hear Jesus Christ.[20] These details are taken from this *Passion*. The prayer that follows alludes to his healing of people suffering from dropsy, attributed to him by a childish play on his name [translator's note: i.e., *hydropique*, someone with dropsy, and *Eutrope*, Eutropius]. Van Lathem, however, preferred to show the healing of the maimed, which better lends itself to imagery, and moreover agrees with the text of the *Passion de saint Eutrope*, which does not speak about dropsy. Representations of Saint Eutropius are not very numerous. Jacobus de Voragine does not speak of him, but the additions included in certain manuscripts of the *Legenda aurea* mention and sometimes depict him.[21] He is also represented in several French breviaries.[22] Some miniatures of the martyrdom of Saint Eutropius have been remarked upon in fifteenth-century books of hours.[23] The feast of Eutropius was solemnly celebrated on the 30th of April in the diocese of Tournai,[24] and he was especially venerated at Heule, near Courtrai.[25] However, nothing allows us to presume that the duke had a special reverence for him. Following Perdrizet, Réau recalls that *Eutropos* in Greek means, 'he who turns to good'.[26] Could it be that this sense of *Eutropos* was a parallel to the phrase *bien en advienne*, which responds to *Je l'ai emprins* in Duke Charles's motto? Perhaps it was thought that invoking Saint Eutropius would be favorable for the duke's enterprises? The hypothesis seems precarious. However, in a time and a milieu that loved this type of wordplay and readily took on all kinds of superstitions, it is not completely impossible.

After the section of the prayer book containing the invocations of the saints, some texts of another kind follow (fol. 52r to 66v). These are: fols. 52r–57v, the Creed of Saint Athanasius (*Quicumque*);[27] fols. 59v–61v, the seven versicles of Saint Bernard (*Illumina oculos meos…*); and finally fols. 62r–65v, a rather long prayer to Christ, imploring his protection against the ruses and attacks of his enemies: *Iuste Iuge Jhesu Christ, Roy des roys, et Seigneur des seigneurs qui tousiours regnes…* This prayer is the only one in the little book that is in French.[28] No miniatures accompany these texts, each of which is followed by several prayers and invocations.

The prayer to Saint George follows on fols. 68r–70r, and is prefaced by one of the diptych illustrations, fols. 67v–70r, described above. The Hours of the Cross, which make up the last section of the book, occupy fols. 71r to 125r.

Endnotes

1 See H. Beaune and J. d'Arbaumont (ed.), *Mémoires d'Olivier de La Marche, maître d'hôtel et capitaine des gardes de Charles le Téméraire.* (Paris 1883), vol. 2, p. 226.

2 ADN, CDC, n° B. 3661, fols. 68r and 73v. L. de Laborde, *Les ducs de Bourgogne. Etude sur les lettres et les arts et l'industrie pendant le 15ᵉ siècle, et plus particulièrement dans les Pays-Bas et le Duché de Bourgogne*, vol. 1 (Paris 1849–52), pp. 466–68; A.M. Bonenfant-Feytmans, 'L'Orfèvrerie Bruxelloise au XVᵉ siècle', *Bruxelles au XVᵉ siècle* (Brussels 1953), p. 62. In a window of the church of Saint John in Ghent, painted c.1458, Philip the Good was represented under the protection of Saint Andrew, and his son Charles under that of Saint George. On this subject, see E. Dhanens, 'Vorstelijke Glasramen van circa 1458 te Gent', *Relations artistiques entre les Pays-Bas et l'Italie à la Renaissance. Etudes dédiées à Suzanne Sulzberger* (Brussels, Rome, 1980), pp. 123–126.

3 F. Lyna, 'Un livre de prières inconnu de Philippe le Hardi (Bruxelles, Ms. 11035–37)', *Mélanges Hulin de Loo* (Brussels, Paris, 1931) pp. 251–54; M. Meiss, *French Painting in the Time of Jean de Berry: The Late Fourteenth Century and the Patronage of the Duke* (London 1967), pp. 201–202, 321; P.M. de Winter, *La bibliothèque de Philippe le Hardi, duc de Bourgogne (1364–1404)* (Paris 1985), pp. 192–193; M. Smeyers, B. Cardon, et al., *Naer Natueren Ghelike. Vlaamse Miniaturen voor Van Eyck* (Leuven, 1993), p. 99; *Vlaamse Miniaturen voor Van Eyck, (ca. 1380 – ca. 1420)*, exh. cat. (Leuven, Cultureel Centrum Romaanse Poort, 1993), Corpus of Illuminated Manuscripts, Vol. 6, M. Smeyers ed., p. 7. Other witnesses to the cult of the Holy Face, linked to devotion to Saint Veronica: Prayer Book of Philip the Good (Paris, BnF, Ms. n.a. fr. 16428, fol. 92v), Hours of Philip the Good (The Hague, Koninklijke Bibliotheek, Ms. 76 F 2, fol. 246v) and the Hours of Mary of Burgundy and Maximilian (Berlin, Staatliche Museen zu Berlin, Kupferstichkabinett, Ms. 78 B 12, fol. 302r). See G.I. Lieftinck, *Boekverluchters uit de omgeving van Maria van Bourgondië, c. 1475–c. 1485* (Brussels 1969), ills. 212 and 214.

4 Durrieu 1916, pp. 121–122.

5 S. Braunfels, 'Georg', *Lexikon der Christlichen Ikonographie*, edited by E. Kirschbaum, W. Braunfels (Rome-Fribourg 1968–76), vol. 6, col. 385–387.

6 *Maximilian I. 1459–1519*, exh. cat. Vienna 1959 (Österr. Nationalbibliothek, Graphische Sammlung Albertina, Kunsthistorisches Museum), pp. 125–126, nr. 404–405, 407.

7 M.J. Onghena, *De Iconografie van Philips de Schone* (Académie royale de Belgique. Classe des Beaux-Arts. Mémoires in-8°, Tome X, Fascicule 5), Brussels 1959, p. 282, Pl. 43a; *Het Gulden Vlies. Vijf eeuwen Kunst en Geschiedenis*, Bruges 1962 (Stedelijk Museum voor Schone Kunsten, Groeningemuseum), exh. cat., p. 147, n° 70; W. Prevenier, W. Blockmans, *De Bourgondische Nederlanden*, Antwerp 1983, Fig. 213; M.P.J. Martens, *Lodewijk van Gruuthuse, mecenas en Europees diplomaat ca. 1427–1492*, Bruges 1992, pp. 76 and 78.

8 The idea of giving the duke's features to a character who could appear as a model with whom he could identify himself had already been put to good use in a *Girart de Roussillon* made for Philip the Good (Vienna, ÖNB, Cod. 2549). The legendary Burgundian figure Girart appears to be represented twice (on fols. 9v and 97r) with the features of Philip the Good. See A. De Schryver, 'Pour une meilleure orientation des recherches à propos du Maître du Girart de Roussillon', *Rogier van der Weyden en zijn tijd. Internationaal Colloquium, 11–12 Juni 1964* (Brussels 1974), p. 53; O. Pächt, U. Jenni, D. Thoss, *Die Illuminierten Handschriften und Inkunabeln der Österreichischen Nationalbibliothek. Flämische Schule I* (Vienna 1983), I, p. 52.

9 The details of a distribution of textiles to dress the members of the duke's retinue when he met with Frederick III in Trier in 1473 demonstrates this. The decreasing rank of the different categories of members of that retinue corresponds to the decreasing price of the fabrics that were delivered to them. See A.D.N., B. 2098/67326. R. Vaughan, *Philip the Good* (London 1973), pp. 140–144. The duke's retinue comprised about a thousand people, and not about 430 as I had stated in error: 'Notes pour servir à l'histoire du costume au XVe siècle dans les anciens Pays–Bas et en Bourgogne', *Annales de Bourgogne* (29, 1957) p. 34.

10 U. Chevalier, *Repertorium hymnologicum. Catalogue des chants, hymnes, proses…* (Louvain 1892), n° 6810.

11 The antiphon *Te invocamus, te adoramus, te laudamus…* is that of Psalm 46 on the second nocturne. The prayer *Omnipotens sempiterne deus qui dedisti famulis tuis in confessione vere fide….* is the collect for the mass of the Feast of the Trinity, and the first prayer of Lauds for the daily office.

12 As Durrieu had already noticed,: 1916, pp. 101 and 113.

13 R. Aubert, 'Gatianus', *Dictionnaire d'Histoire et de Géographie ecclésiastique*, vol. 20, col. 1.

14 V. Leroquais, *Les Bréviaires manuscrits des bibliothèques publiques de France* (Paris 1934), vol. 2, pp. 168, 383; vol. 3, p. 18, vol. 4, pp. 194, 197, 198; Idem, *Les livres d'heures manuscrits de la Bibliothèque nationale* (Paris 1927), passim (see Index for numerous examples); J. Plummer, *The Last Flowering. French Painting in Manuscripts 1420–1530* (New York 1982), n° 53, 58, 60, 61, 110, 112, 115.

15 Ed. by J. Vieilliard, *Le Guide du pèlerin de Saint–Jacques de Compostelle* (Mâcon 1938), pp. 60–61.

16 Paris, BnF, lat. 1032, fol. 260r (V. Leroquais 1932–34, III, p. 21); New York, PML, M.380, fol. 102r; M.388, fol. 153v; M.495, fol. 115v (New York 1982, n° 110, 112 and 115).

17 L. Réau, *Iconographie de l'art chrétien* (Paris 1955–59), III–1, pp. 473–475.

18 R. de La Coste–Messelière, 'Des Chemins de Saint–Jacques et de quelques itinéraires jacobites', *Santiago de Compostela. 1000 ans de Pèlerinage Européen*, exh. cat. (Ghent, Centrum voor Kunst en Cultuur, Abbaye Saint–Pierre, 1985), pp. 108–111.

19 J. Vieilliard, *Le Guide du Pélerin de Saint–Jacques de Compostelle* (Mâcon 1938), pp. 66–79; B. de Gaiffier, 'Les Sources de la Passion de S. Eutrope de Saintes dans le « Liber Sancti Iacobi »', *Analecta Bollandiana*, LXIX (1951), pp. 57–66; *The Pilgrim's Guide to Santiago de Compostela*, ed. Paula Gerson et al., (London 1998), vol. 2, pp. 54–65.

20 'Eutropius de genere regali trahens originem venit Iehrosolimam in templum adorare, meruit dominum nostrum Ihesum Cristum videre et sancta sua allocucione informari', fols. 51v–52r.

21 For example in a *Légende dorée* (the French version of Jean de Vignay) that once belonged to Philippe of Clèves with a supplement of new feasts, among them that of Saint Eutropius. The miniature represents Eutropius on horseback, taking leave of his father (Brussels, KBR, Ms. 9282–5, fol. 336v). See F. Lyna, *Les principaux manuscrits à peintures de la Bibliothèque royale de Belgique*, vol. 3, ed. C. Pantens (Brussels 1989) pp. 232 and 451.

22 Paris Breviary, 13th cent., BnF, Ms. lat. 13233, fol. 655r; Breviary of Charles V, BnF, ms. lat. 1052, fol. 366v, a miniature of Saint Eutropius' martyrdom. See Leroquais 1932–34, vol. 3, pp. 55 and 239.

23 V. Leroquais 1927, vol. 1, pp. LX, 33, 79, 112, 178. Among the latter is a Tournai Book of Hours: Paris, BnF, Ms. lat. 1364, fol. 223v.

24 And therefore in an important part of the duke's territories. H. Grotefend, 'Heiligen–Verzeichniss', *Zeitrechnung des Deutschen Mittelalters und der Neuzeit*, vol. 2 (Hannover 1892), p. 97; E. Strubbe and L. Voet, *De Chronologie van de Middeleeuwen en de Moderne Tijden in de Nederlanden* (Antwerp, Amsterdam, 1960), pp. 168–169 and 468. Eutropius appears on the 24th of April in the calendar of Bruges books of hours; see J. Plummer '"Use' and 'Beyond Use'", in R.S. Wieck, *Time Sanctified: The Book of Hours in Medieval Art and Life* (New York 1988), p. 154.

25 Where he was invoked against the broadest range of maladies, including those affecting livestock: See *Acta Sanctorum*, April III, Antwerp 1680, pp. 735–736.

26 P. Perdrizet, *Le Calendrier parisien à la fin du moyen âge d'après le bréviaire et les livres d'heures* (Paris 1933) (Publications de la Faculté des lettres de l'Université de Strasbourg, fasc. 63), pp. 125–126; Réau 1955–59, 3, p. 474. Perdrizet indicates that Louis XI and Duke Philip the Good 'montrèrent à saint Eutrope beaucoup de révérence'. He was apparently in error in the case of Philip, and moreover he provides no reference for him in order to back up this assertion. He appears to have confused 'Philippe le Bon' and 'Philippe le Bel'. Indeed, Philip the Fair and Queen Jeanne had a great devotion to Saint Eutropius, and it was at their command that the cult of Saint Eutropius was established in Paris in 1296. This breviary has no Office for Saint Eutropius. V. Leroquais, *Le bréviaire de Philippe le Bon* (Brussels 1929), pp. 76 and 135.

27 The *Quicumque* was in fact penned by Saint Fulgentius of Ruspe (d. 533): see J. Stilgmayr, 'Athanase (Le prétendu symbole d')', *Dictionnaire d'histoire et de géographie ecclésiastiques*, vol. 4 (Paris 1930), cols. 1341–48.

28 This prayer is translated from the Latin: J. Sonnet, *Répertoire d'incipit de prières en ancien français* (Geneva 1956) no. 1001; U. Chevalier 1892, p. 599, no. 9910. It also appears in the Hours of Philip the Good in Munich (BSB, Ms. Gall. 40) and was added for him to the Prayer Book of Philip the Bold (Brussels, KBR, Ms. 11035–37). The same prayer is in the Hours of Pauwels van Overtvelt (Brussels, KBR, Ms. IV 95). See C. Lemaire, 'De bibliotheek van Lodewijk van Gruuthuse', *Vlaamse Kunst op perkament. Handschriften en miniaturen te Brugge van de 12de tot de 16de eeuw*, exh. cat. (Bruges 1981), p. 273; C. Lemaire and M. Henry, *Isabelle de Portugal, duchesse de Bourgogne. 1397–1471*, exh. cat. (Brussels 1991), n° 27.

THE FOUR PHASES OF THE PRAYER BOOK'S PRODUCTION

Documents relating to the prayer book's production allow the identification of two of its main creators: Nicolas Spierinc and Lieven van Lathem.[1] By combining the details provided by archival references with the manuscript's codicological and stylistic particularities, four phases of production can be distinguished.[2]

This chapter is devoted to explaining the data on which the attribution to Spierinc and van Lathem is based, as well as the elements supporting a conclusion that the prayer book of Charles the Bold was created in four phases. The two subsequent chapters recount the biographies of van Lathem and Spierinc, and attempt to outline their roles and status in the Flemish artistic circle of the second half of the fifteenth century. A study of the illustration and the exceptional decoration of the duke's book of private devotion will be the subject of the rest of this book. This study will seek to better demonstrate the importance of the illuminators of this key work of Netherlandish manuscript painting, and to clarify some aspects of the fruitful relationships that van Lathem and Spierinc had with other important figures in illuminated manuscript production of the period.

2.1 NICOLAS SPIERINC, THE CALLIGRAPHER

The script of Charles the Bold's book is of an exceptional quality. We recognize in it the hand that wrote the beautiful manuscript of the *Ordonnance du premier écuyer d'écuyerie* in Vienna (ÖNB, Cod. s.n. 2616; Fig. 2–4). This manuscript, the execution of which is fully documented, constitutes the fundamental work for our knowledge of Nicolas Spierinc's art.[3] The prayer book's beautiful calligraphy incorporates numerous cadels and is adorned with many graphical fantasies, in which the flexible lines sometimes terminate in a dragon's head, a leaf, a flower, or a simple arabesque. These ornaments, like the writing they accompany, are of a style identical to that which characterizes the Vienna *Ordonnance* manuscript. Therefore there remains no doubt about their attribution, which is further confirmed by the reference of a payment to Spierinc in January of 1469 in the amount of 12 lb. 10 s., *pour ses painne et sallaire d'avoir escript… aucuns oroisons pour mondit segneur* (ap. 1, doc.1).

It was during or after his participation in creating the prayer book that Nicolas was entrusted with the execution of a new

commission for the duke: the book of *Ordonnances de l'hôtel* of which the Vienna *Ordonnance du premier écuyer d'écuyerie* was a part.[4] The documents relating to the production of the *Ordonnances* contain some details of great interest for our purposes.

On the first of January in 1469, the duke enacted new palace Ordinances. In addition to one general ordinance, eight special ordinances regulated the functions of eight different offices in the duke's palace. Spierinc was asked to complete a collection intended for the duke's personal use, containing each of these eight ordinances (ap. 1, doc. 5). He also had to make eight books, each separately containing one of the eight ordinances, probably intended to be sent to the heads of the different offices concerned (ap. 1, doc. 4). Of these eight special ordinances, the *Ordonnance du premier écuyer* cited above is the only one to survive. The duke's collection containing all eight ordinances is also lost.

When he had finished the calligraphy and illumination of this collection, Spierinc set out to present it to the duke. Apparently he had worked on or completed these *Ordonnance* manuscripts in Brussels, as he was paid for *avoir porté ledit livre de Bruxelles à La Haye* (ap. 1, doc. 3), where the duke had been staying since 12 August.[5] Doubtless it is not by chance that Lieven van Lathem was also paid for going to The Hague during that same month of August, where he came to present the duke with the little prayer book that he had been asked to illuminate (ap. 1, doc. 6).

2.2 THE DOCUMENTED CORE, ILLUMINATED BY LIEVEN VAN LATHEM

The account items that mention below Spierinc's payment for the *Ordonnances* are followed by those in which the treasurer registered the payment to Lieven van Lathem *pour autres parties d'istoires, vignettes, lettres dorées et autres par luy faictes en ung petit livret de mondit seigneur contenant pluseurs oroisons fais a sa dévocion, ainsi qu'il ensuit...* (ap. 1, doc. 6).[6] The document goes on to enumerate in detail the work for which van Lathem is being compensated: twenty-five miniatures (*istoires*) and as many borders (*vignettes*), eighty-eight smaller borders (*moindres vignettes nommez bastons*), and 200 initials with gold or colored backgrounds (*lettres de champaignes*).[7]

Our book, however, contains many more miniatures, large and small borders, and initials, than are indicated by the document.[8] A first glance, it might seem futile to attempt to establish a connection between the manuscript and the reference to van Lathem's payment. Three observations nevertheless remain particularly troubling:

1. As we have seen, the attribution of the little volume's calligraphy to Spierinc has been established. Eight months passed between the payment to Spierinc and the one to van Lathem. It appears likely that the two documents relate to the same manuscript, and van Lathem could have begun to work on the illumination before Spierinc had finished the calligraphy.

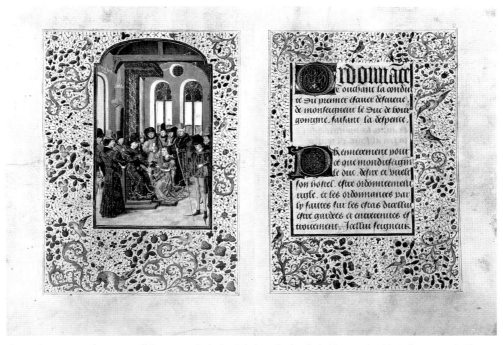

Fig. 2: Lieven van Lathem or a collaborator and Nicolas Spierinc, *Charles the bold presenting his Ordinance to the First Squire, and the illuminated beginning of the text of that Ordinance*, in *Ordonnance du premier écuyer d'écuyerie*, Vienna, ÖNB, Cod. s.n. 2616, fols. 1v–2r.

2. The little manuscript appears to have responded perfectly to the terms employed by the document: a *petit livret de mondit seigneur, contenant pluseurs oroisons fais à sa dévocion*.

3. If one had to date the manuscript in the absence of any documentation, its style suggests approximately the period of the payment to van Lathem.

The presumptions behind these observations are not idle. Codicological analysis of the manuscript and various stylistic and iconographic observations allow us to conclude that the illumination of the little book must have been executed in several distinct phases. We can easily prove that the illumination of a well-defined portion of the prayer book corresponds to one of these phases, and that this portion is exactly the one that van Lathem was paid to illuminate. By taking into account data concerning the book's material structure, we can also explain why the illumination of this portion of the book could be the object of a separate payment. The latter can be verified with the help of a diagram showing the structure of quires and the placement of miniatures (Appendix 2.7)

The first quire, fols. 1–8, contains the prayer to the Holy Face and that to the Virgin, each illustrated by one of the devotional diptychs (see section 1.1).

The second quire, fols. 9–13, is made up of two bifolia, preceded by fol. 9, which is a

single leaf left blank on both recto and verso. On fol. 10r is the miniature of the Virgin in a garden, beneath which begins the text that ends on the recto of fol. 13, which also has a blank verso.

The following six quires, fols. 14 to 63, are all composed of four bifolia. Only the fifth quire (signature e, fols. 30–39) also includes two single leaves. We shall see that this irregularity originally corresponded to a specific intention, explained below in Chapter 10.

The ninth quire (signature j, fols. 64–69) is a ternion, in which the French prayer, begun in the previous quire, is completed. It is followed until fol. 66v by the antiphons, versicles, and responsories that complete this section of the text, which occupies exactly the first half of the quire. Fol. 67r remained blank.

Thus, the portion of the manuscript that extends from the beginning of the second until the middle of the ninth quire (signatures b to j), makes up a whole that is perfectly complete with regard to its contents. Its material structure permits us to separate it from that which precedes it, since it begins with fol. 9, the single leaf, blank and unruled, at the beginning of the second quire. The portion of the manuscript that interests us therefore follows the opening quire with its two prayers illustrated by diptychs, and concludes on fol. 66v before a recto that is left blank and followed by the prayer to Saint George, also illustrated with a diptych. The illumination of this portion of the

Fig. 3: Nicolas Spierinc, *Graphic and partially painted decoration in the margins of a text folio.* In : *Ordonnance du premier écuyer d'écuyerie*, Vienna, ÖNB, Cod. s.n. 2616, fols. 4v–5r.

book, fols. 10r–66v, could have been fully executed without taking into account what the first quire, or the second half of the ninth, would contain, or could have already contained. And it is clear that if we take into account the different elements of the illumination of this core of the manuscript, we notice that it corresponds in each detail to the work for which van Lathem was paid, such as it is recorded in the account item registered by the duke's treasurer in the month of August 1469 (ap. 1, doc. 6).

We find exactly the twenty-five miniatures and the twenty-five full borders of which the document speaks. Moreover, we also find exactly eighty-eight smaller borders decorating the text pages. These *moindres vignettes nommez bastons* were carefully enumerated; for example, it is taken into account that fol. 25, exceptionally, does not have one.

The enumeration of the decorated initials is somewhat more complicated to verify and interpret. It is necessary to take into account the manner in which illuminators very often calculated the price of small decorative elements. For this they often used the *point* as a unit of measurement for the completed work. The origin of the use of the *point* in the language of book artisans is clearly linked to the traditional method of ruling sheets of parchment or paper intended for the fabrication of a manuscript. One connected the prickings made at regular distances with each other to obtain, within the width of the chosen justification, a ruling that ensured regular lines.[9] For the illuminator, a *point* was equivalent in height to one line, that is to say, to the distance be-

tween two consecutive prickings used for the ruling. I have demonstrated that for initials, paragraph signs (*paraphes*), and line fillers (*intervalles*) the *point* did constitute the basic unit for calculating the price of more modest elements of the illuminator's work, at least during the period and in the milieu that concerns us.[10] Even though the word *point* does not appear in the text of van Lathem's calculation, an examination of the case of Charles the Bold's little prayer book will confirm the use of this method for calculating for the price of initials.

The documented core of the manuscript includes sixty-one two-point initials, that is to say initials of two lines in height, and sixty one-point initials, or initials of one line in height. For calculating the price of their work, the line endings and the paragraph signs belonged, in the illuminators' eyes, to the same category of small decorative elements as did the initials.[11] One must therefore include line fillers in the calculation.

One finds two different types of line fillers in the book. Many are baguettes of alternating colors, of an execution analogous to that of the initials. Other line fillers are lighter and more open in form, and executed in the beautiful blue color also used for the rubrics. Some of these blue line fillers are further augmented with gold. They were probably added at the same time and by the same hand as the one that wrote the rubrics.[12] The other line fillers, eleven in number and of the same technique as the initials, would therefore have been included by van Lathem in his calculation of the price.[13]

In total, one therefore has 61 + 60 initials and 11 line fillers, equivalent to 130 units. This number of 130 initials does not correspond to that of 200 *lettres de champaigne* in the calculation of the illuminator because the initials were counted by the *point*, and the initials of two lines in height, and therefore of two *points*, counted double. One therefore has $(61 \times 2) + 60 + 11 = 193$. It could be that some line fillers occupying a space of half or perhaps three-quarters of the length of a line of text counted for more than a *point* (see fols. 16v, 42v, and 55v). It matters little whether or not van Lathem counted them for more than a *point*; what matters is that we arrive at a total approaching the number 200 that was brought to account.

Indeed, illuminators often did not care about a few *points*, give or take. Often they rounded their number to the hundred or fifty because the price of these small initials and line filler equivalents was calculated by the hundred. In calculating the number of *points* that he would bring to account for the initials, van Lathem would have obtained a number approaching 200, and would have rounded it to 200. In many cases, breaking the price of the hundred into fractions was avoided, except sometimes for fifties. The statements that the accounts provide concerning the details of the manuscript's illumination are very significant in this regard.[14] It cannot be by chance that the number of small initials they cite is so often a round figure of a hundred or fifty. The round number of 200 in our document is itself an echo of this common practice.

The enumeration of the prayer book's initials therefore allows us to confirm that the agreement between details provided by the document and those provided by analysis of the core of the manuscript is complete, even if this agreement appeared, at first glance, impossible or uncertain. Lieven van Lathem was therefore indeed commissioned to illuminate this core of the manuscript. The work was carried out at his workshop in Antwerp, and doubtless was completed toward the end of July or the beginning of August 1469. The documented core of the prayer book therefore constitutes the fundamental work on which our knowledge of the style and ability of Lieven van Lathem is based.

However, it is important here to take into account the relative value of so well established an attribution, and to remain attentive to the fact that certain aspects of reality or of the course of things can be masked by apparently indisputable proofs, based on incredibly precise documents. In the case of the prayer book in question, as is moreover often the case with illuminated manuscripts, it goes without saying that it is not out of the question for the work's master to have secured assistance in its execution.

While this possibility will be considered and examined in the rest of this work, there is no need to see a contradiction here. The very nature of the enterprise that the fabrication and illumination of an illuminated manuscript constituted, and the possibilities for the division of labor that it offered, must be kept in mind. Moreover, the mention of payment for the eight ordinances of the palace government provides an eloquent example, since it specifies that Spier-

inc was paid for the script and the illumination of these books, including their miniatures, which he did not execute. One will remember that he had them fetched to Antwerp from Brussels, where he was then working (ap. 1, doc. 4).

2.3 THE ILLUMINATION OF THE PRAYERS ILLUSTRATED WITH DEVOTIONAL DIPTYCHS

The core illuminated by van Lathem is located exactly between the first quire, where the two first devotional diptychs appear, and the middle of the ninth quire, the second half of which contains the third devotional diptych. The placement of this core allows us to assume that the execution of these diptychs and of the illumination of the prayers that they illustrate had been intentionally saved for later, and that the conception of the diptychs still had to be subject to discussion or approval before they could begin to be realized.

It seems to be precisely on account of the special character of these diptychs that their execution was reserved for a distinct phase of the manuscript's creation. To determine the way in which the duke would be represented on three occasions, and the way in which his coats of arms or other marks of ownership would be presented in these diptychs, doubtless constituted a decision and a choice of sufficient importance in the duke's eyes for him to have wanted a discussion with the artist before their execution, or for him perhaps to have wanted drafts submitted for his approval.

Fig. 4: Nicolas Spierinc, *Graphic and partially painted decoration in the margins of a text folio.* In : *Ordonnance du premier écuyer d'écuyerie*, Vienna, ÖNB, Cod. s.n. 2616, fol. 10v.

The style of the miniatures in the three devotional diptychs permits us to consider them as having been conceived by van Lathem and, at least in part, painted by him. It seems that Lieven would have had to execute them in haste at The Hague. Indeed, the archives inform us that the prayer book as well as the collection of ordinances delivered by Spierinc were both bound at The Hague in September of 1469 (ap. 1, docs. 8 and 9). The mention of payment for the binding designates the prayer book as containing *pluseurs oroisons à la dévocion de mondit seigneur*. One will notice that the terms are almost identical to those employed when the payment to van Lathem was registered. Therefore, the two docu-

ments concern the same book. The fact that the mention of payment associates the two works that Spierinc and van Lathem came to deliver toward mid-August tends to confirm this.

The binding of the prayer book was then provided with a gold clasp delivered by *Ernoul de Duvel, orfèvre demourant à La Haye en Hollande* (ap. 1, doc. 8). The goldsmith was paid at the same time for having also provided another of the duke's devotional books with a gold clasp.[15]

These details of the binding permit us to fix the chronology of events. Van Lathem could not have given his work to the duke before the 12, August, the date of the latter's arrival at The Hague.[16] Less than seven weeks later, the book was in the duke's hands, completed, bound, and provided with its golden clasp.[17] At this point it included only the first nine quires, for starting from the tenth quire the Hours of the Cross begins, which were added to the manuscript later (see section 2.4, below).

Therefore it is clear that Lieven van Lathem, and the other artisans who participated in the completion of the book at The Hague, only had a few weeks to execute the miniatures and borders of the first quire and those of the prayer to Saint George in the second half of the ninth.

The technical and stylistic details of the six folios of diptychs, as well as an examination of the thirteen partial borders decorating the text pages of the prayers that these diptychs introduce, confirm that these folios were illuminated under different conditions of execution from those that had allowed van Lathem to create the documented core. Numerous disparities between these folios and those of the documented core testify to this. The architecture visible in the background on both sides of Saint Veronica displaying the imprint of the Holy Face, fol. 2r, was left at the state of a sketch. The very diluted tones of the cityscape behind the Virgin on fol. 5v, and the distant hills in the miniature of Saint George on fol. 67v, appear to have been applied in more rapid a manner that was generally the case in the landscapes of the miniatures in the documented core. The hasty execution, lighter and perhaps more spontaneous, of the background of these two small paintings does not affect their quality, but seems to confirm that they were not realized under the same circumstances as those that prevailed during the meticulous completion of the illumination of the book's core. The angels and the border figures of the six diptych miniatures, and the angels who, in the miniature on fol. 5v, surround the Virgin, also convey a certain degree of incompleteness, particularly in their faces and in some of their draperies.

The acanthus rinceaux and the flowers of the borders surrounding the Virgin's diptych are of a type that does not appear in any of the borders of the documented core but is to be found around the diptych of Saint George. These details betray the intervention of an assistant who must have been put to work at The Hague in order to complete the work within the required time. Other observations concerning the illumination of the first quire and of the prayer to Saint George are worthy of note.

On the text pages of the book's first quire, the decoration of the partial borders seeks to imitate that of the partial borders of the documented core, but one hesitates to recognize the same hand here. In addition, the line framing the partial borders is sometimes lacking, which does not occur on fols. 9 to 66. In the documented core, most of the full borders with plain backgrounds are framed by rose-colored lines. On the left section of the first diptych, fol. 1v, the border is the only one in the manuscript where this rose line is traced on the exterior of a border of a thin gold *baguette* between two black lines. Perhaps this was intended to mark the importance of this frontispiece, where the arms of the patron and owner of the precious volume were displayed.

Almost all of the borders in the book with gold or colored backgrounds are framed by a thin gold *baguette* between two black lines.[18] The borders of Saint George's diptych are the only ones in the manuscript that are bordered by two black lines without the intermediary gold *baguette*. The partial borders of fols. 68v–69v that follow this diptych are of a different technique than that of the partial borders of the documented core. They are moreover the only ones in the book to be framed this time by double rose lines.

All of these details, anomalies, omissions, or differences observed in the illumination of the first quire, which precedes the documented core, and in that of the prayer to Saint George, which follows it, confirm that the painting of the diptychs and the illumination of these text pages could not have been executed in the course of the same phase of work as that of the execution of the core.

It remains rather surprising that these diptychs, to which the artist and patron unquestionably attached a special importance, could be delivered when certain elements of the architecture or landscape in the miniatures were practically left at the state of a sketch, without the meticulous completion that van Lathem had insured in the documented core. With regard to the folios that were to highlight the manuscript's patron and represent him accompanied by the emblems of his rank, one would have expected an execution completed with more care. One can hardly imagine that such a demanding patron as Charles the Bold would have put up with it, unless it would be explained by his impatience to possess the precious jewel. With the arrival of van Lathem, he would have discovered the splendor and originality of the illuminations already completed. Taking into account some of his character traits, and perhaps also his poor state of health during that time,[19] such impatience on his part would not have been at all astonishing.

We cannot be sure that we have here the true explanation of the first quire's unexpected aspects. The arrangements to be approved or made for the book's completion no doubt constitute a more than sufficient reason for having wanted van Lathem to come to The Hague to deliver his work. Could it not be, however, that this first reason was coupled with a second that completely escapes us, and that led to van Lathem's being suddenly unavailable for the completion of the diptychs? Perhaps it was

the duke himself who wanted van Lathem to dedicate himself without delay to another project, which could have forced the master to delegate a portion of the diptychs' illumination in order to discharge his new obligations at once.

If that is what really happened, it is also possible that the arrival of Spierinc at The Hague was also motivated in part by the duke's intention, or that of his entourage, to entrust him, perhaps at the same time as van Lathem, with a new commission or assignment. The idea that Spierinc and van Lathem, or one of the two, could have been put to work at The Hague on a new commission of course remains only a conjecture. It could nevertheless explain the disconcerting aspects of the diptychs' execution.

2.4 THE LITTLE HOURS OF THE CROSS: A LATER ADDITION TO THE ORIGINAL MANUSCRIPT

An examination of the Little Hours of the Cross reveals a number of traits in the borders and miniatures of this portion of the manuscript which clearly distinguish themselves from those of the documented core.[20] It was certainly still Spierinc who copied the text of the Hours. He did so by logically adopting the same mise-en-page. The script, however, is tighter and its verticality more accentuated than in the preceding portion of the manuscript. The common features of the Hours' calligraphy and cadels with those of the preceding portions of the manuscript, however, appear sufficiently obvious for us to forego seeing the inter-

vention of another hand there. We find, for example, treated in an identical manner, the little head of a dragon that we often find in Spierinc's work, which could be taken as a personal sign. The same remark can also apply to other motifs, such as, for example, the curious flower whose petals wind and curl as his acanthus leaves do elsewhere. It appears earlier on fols. 37r, 41r, and 48v in the documented core and reappears on fol. 74r in the Hours of the Cross.

In the whole of the manuscript, the partial borders are decorated with blue and gold acanthus branches,[21] and with very thin black lines, forming spirals and imitating stems or foliage bearing flowers, fruit, and leaves, as well as small gold discs encircled with a black line and often provided with small black *antennes*. Among theses decorations, a bird or two sometimes appears. These are simple sparrows, whose plumage has been endowed with a bit more color than nature usually provides. The acanthus branches, like the birds, are absent from some of the borders, but the freshness of color, the glitter of the small gold discs, and the lightness and delicacy of the whole design are never lacking.

There exists quite a significant similarity between the partial borders of the Hours of the Cross and those of the documented core. However, a number of signs reveal that those of the Hours were painted in the course of a later phase of execution. They are usually decorated in a slightly less dense manner that those of the documented core. One finds there the same thread-like foliage traced by the pen, bearing little gold discs

or spots with short black curled *antennes* attached, but most of these discs are generally of a slightly larger scale. The sweetness and the lightness of the birds' plumage in the partial borders of the Hours of the Cross are rendered by small touches of the brush, in a more suggestive manner than in the documented core. Their contours are also less prominent. One sees many there whose postures or movements are not found in any of the birds in the borders of the documented core.

A large number of partial borders in the Hours of the Cross do not contain a single acanthus leaf, an occurrence which is far less frequent in the original portion of the book. One counts 84 partial borders in the documented core,[22] of which 13 do not include acanthus leaves. There are 102 in the Hours of the Cross, of which 44 do not include acanthus leaves. That is, in terms of percentage, 15.29% of cases on one hand, rising to 43.13% of cases on the other. This difference in frequency of a typical motif in this type of border could betray the intervention of another hand than that responsible for the partial borders in the documented core.

The difference between the two series of partial borders is also marked by the presence, in those from the Hours of the Cross, of certain motifs that do not appear elsewhere, such as the strange flower or fruit that decorates several borders (see fols. 73v, 74r, 76r, 78r, and 81r). One also notices that several partial borders in the Hours partially or completely lack the plain rose line that usually frames them,[23] and which is never missing in the partial borders of the

documented core. Finally, the text pages of the Hours of the Cross sometimes also display the remarkable motif of birds painted in the margin outside the border.

The regular alternation in the core between borders with plain backgrounds and borders with colored backgrounds in the folios with miniatures is no longer the case in the Hours. The eight miniatures of the Hours of the Cross and their borders are not in the same style as that of the folios with miniatures from the documented core. These observations, combined with those made above regarding the script and the partial borders, are all indications that the Hours do not belong to the same phase of the book's execution as the sections of the manuscript that precede it.[24]

The Hours were thus the result of a new commission, later than that of the initial manuscript. Probably, the duke used his prayer book for awhile in its original state after having been bound at The Hague in 1469. He would have wanted to add the Hours of the Cross to it later.[25] It was not rare in those days for princes to have the contents of their personal devotional books altered or supplemented. The unbinding and the creation of a new binding that this would have entailed was not a problem in their eyes.[26]

In order to have this complement to his prayer book made and appended, Charles the Bold would naturally have gone to the person who had so competently provided the initial phase of the manuscript's realization. In carrying out this new task, Spierinc would have paid attention to the homogeneity of the manuscript and have tried to

assure in the remainder a level of quality equal to that of the original book. In order to avoid all risk of error or confusion in the manufacture of the new binding, he continued in the new quires the sequence of signatures from the old quires and marked them in the same way. To finish this new binding, the gold clasp made by Ernoul de Douvel in 1469 would have had to be adapted, or even redone.

In contrast to the case of the documented core, no archival reference survives concerning the creation of the Hours of the Cross, or the new binding work that was necessary. The payments rendered for these tasks could have been recorded in accounts now lost: for the period from the beginning of 1471 until the end of the reign of Charles the Bold, only several fragments of the accounts of the duke's treasurer are preserved. A reference to payment for the Hours of the Cross could therefore have been recorded after 1470, without our being able to know about it. One must also take into account the unexplained fact that many expenditures relating to manuscripts were not deducted from the funds that the Receiver and the Treasurer had to account for. There is no need to be surprised, then, that payment for the illumination of the prayers illustrated by diptychs, completed after van Lathem's arrival at The Hague, have left no trace in the surviving archives.

Endnotes

1 For the complete transcription of the documents cited in this chapter see Appendix 1.

2 The part of the book that begins on fol. 126 was added for a new owner and is therefore later than these four stages. This addition is described and examined separately in Appendix 3.

3 A. De Schryver 1969/2, pp. 434–458, pls. 124–128.

4 The information that follows concerning these manuscripts of the Ordinances of 1469 are based on the study that I had previously devoted to them: De Schryver 1969/2.

5 Van der Linden 1936, p. 19.

6 The steward speaks here of ***autres*** *parties d'istoires ...* etc. (ap. 1, doc. 6), because this payment is noted immediately after the payments to Spierinc that also include compensation for the *parties d'istoires, vignettes ...* etc.: see ap. 1, docs. 4 and 5. Where he writes, *À Liévin de Lattem **aussi** enlumineur,...,* 'aussi' alludes to Spierinc, named in the preceding account item.

7 The word *champaigne*, like the word *champié*, which one finds in other texts relating to manuscript production, alludes to the *champ*, the base against which the initial stands out. The analogy with the heraldic term *champ* is noticeable; that it is indeed the base on which the letter stands can be verified, for example, by the document concerning the payment to Paul Fruit for the execution in 1468 of the initials of volume 3 of *Charles Martel* (Brussels, KBR, ms. 8). It mentions the *lettres de trois poins ouvrées **à champaigne d'or**,* as well as *lettres de deux poins **champiées d'or*** and the *lettres d'un point **champiées d'or** parmi paraphes et intervalles* that one can find in the manuscript.. AGR, CDC, n° 1923, fols 171v–173v; Pinchart 1865, pp. 476–477. In the *Cité des dames*, Christine de Pisan proclaims the talent of a woman called Anastaise, an expert in making *vigneteures d'enlumineure en livres et **champaignes d'ystoires***. H. Martin, *Les Miniaturistes Français* (Paris 1906), p. 164, had believed the word *champagne* could be associated with that of *campagne*, and believed that it alluded to the landscapes of the miniatures. This was obviously an error. Christine de Pisan wrote in an era when miniatures most often still had decorative backgrounds like those that one sees in the majority of manuscripts of the fourteenth and beginning of the fifteenth century, and, of course, these are the backgrounds that are designated by *champaignes d'ystoires*.

8 This reckoning obviously has not taken into account the portion of the manuscript that follows fol. 125. Fol. 125 is the last of the manuscript, such as it was created for Charles the Bold. The 34 folios that follow are an addition, executed after the duke's death for another owner.

9 *Punctum* is the Latin word for a 'pricking'.

10 De Schryver 1979, pp. 469–79.

11 Idem, pp. 471–73 and note 23. See also the citation of a document of 1468 provided at note 40, in which are cited *lettres d'un point champiées d'or **parmi***

paraphes et intervalles. This well demonstrates that the *paraphes et intervalles* are included in the count of letters of one *point.*

12 These blue line fillers appear on fols. 11r, 32v, 54r, 54v, 55v, 56r, 56v, 57r, 57v, 59v, 62r. There are 2 on fols. 56r and 59v. Therefore, there are 13 in all.

13 Fols. 11r, 16v, 42v, 49r, 53v, 54v, 55r, 55v, 57v. Fols. 53v and 54v include 2. That makes 11 in total.

14 The numbers of small initials brought to account by Liédet for each of the manuscripts he illuminated are as follows: 3750 for a *Bible Moralisée* lost today (Pinchart 1865, p. 476), 4150 for volumes 3 and 4 of *Charles Martel* (The major part today Brussels, KBR, Mss. 6–9; ADN, B. 2085/66161. Dehaisnes 1881, p. 237), 2750 for volume 2 of the *Songe du viel Pélerin* (Paris, BnF, Ms. fr. 9200–9201). For vol. 1 of this manuscript, Liédet noted 2326 letters of one *point.* He set the price by counting 23 hundreds at 3s., plus 1s. extra for the 26 letters, rounding their number to one–third of a hundred (De Schryver 1979, pp. 472 and 478), 1700 for the *Faits et Gestes d'Alexandre* (Paris, BnF, fr. 22547). The illuminator's account survives on fol. 269v of the manuscript, constituting a proof of this method of reckoning by the hundred. He had noted 1762 *petites lettres* but only charged for 1700 (De Schryver 1979, p. 472–473). One will notice that van Lathem charged 20s. for his 200 *lettres de champaignes.* It therefore comes to 10s. per hundred, a price clearly much higher than that of 3s. per hundred charged by Liédet and others for the *lettres d'un point.* The reference in January of 1470 to a payment to Marmion for the execution of the duke's breviary mentions 2500 *lettres de deux poins faiz oudit bréviaire au pris de 6 s. le cent, font 7 lb. 10 s.* (Pinchart 1860–81, vol. 2, pp. 202–203; Dehaisnes 1892, pp. 140–141; Hénault 1907, pp. 419; Hindman 1992, p. 230). Curiously, the number of one–point letters, provided by the same document, was not rounded. It is 5859. The price calculation for this number of letters, costing 4s. per 100, would ultimately yield 11lb. 4s. 4d. and about a third. This amount was rounded to 11lb. 14s. 6d. Illuminators continued for a long time to round the amounts: in January of 1521, Gerard Horenbaut was paid by Margaret of Austria for the illuminations that he added for her to the Hours of Bona Sforza (London, BL, Add. Ms. 34294), including among other things 700 gold letters at the price of 12s. per cent: Pinchart 1860–81, pp. 17–18.

15 The binding of the collection of ordinances was provided with two gold clasps in November. Made by the goldsmith Jean van Aken, who remained in Brussels, they were delivered during the duke's stay in that city after his return from Holland. De Schryver 1969/2, pp. 453 and 458.

16 Van der Linden, p. 19.

17 After the duke's return to Brussels, through the efforts of Charles de Visen, a *certain livret où sont escriptes pluseurs oroisons pour mondit seigneur* was provided with a cover of black velvet (ap. 1, doc. 10). It is possible that they wished to protect the little prayer book and its fittings of goldsmith work with a black velvet case. However, it is not out of the question that this document relates to one of the duke's other devotional books.

18 Several are framed by a simple black line: fols. 29r, 33r and 46v.

19 Several references in the treasurer's account allude to the poor state of the duke's health before and during his sojourn at The Hague. In addition to the doctors and surgeon's who were a daily part of the palace's staff, he also summoned those who were not in service at that time (the palace ordinances anticipated that three of the six doctors would only serve alternately for periods of four months, and that two of the five surgeons would only serve for periods of six months: Oxford, Bodleian Library, Ms. Hatton 13, fol. 8r). In addition, a *Maistre Jehan de Reynsberghe, cirurgien demourant à Anvers* was called, who was not a part of the official medical staff, and who remained at the duke's disposal from 1, August to 10, September: AGR, CDC, n° 1924, fol. 90v, 205r, 215r, 220v–221v. This information concerning the duke's health can be added to those provided by Vaughan 1973, p. 157–158.

20 On fol. 124v, an instruction to the rubricator for the rubic *loco fidelium* is discretely traced crosswise along the fold of the bifolio. It is the only instruction for the rubricator found in the manuscript. Other instructions for the rubricator affixed in this way could have been carefully scraped or sanded off before the volume went to the binder.

21 On fol. 29v, the acanthus leaves are, exceptionally, green and lilac in color.

22 Not including the four folios decorated with drolleries in the margin instead of with a partial border.

23 For example, on fols. 83r, 116r, 116v, the border is not framed. On fol. 83v, there is no line closing the frame at the bottom of the border, while the framing line is coupled with a black line on the text side.

24 Yet another indication: in the Hours of the Cross, one of the artisans used initials decorated with small pink vine foliage against a gold ground (for example, at the beginning of Matins, Terce, and Vespers fols. 71r, 90r, 111v). This type of initials is not found anywhere in the book's core.

25 Philippe Siron, first chaplain of the duke's domestic chapel, was paid in April of 1470 *pour avoir fait escripre deux passions en vellin pour mondit seigneur, comprins l'estoffe, 4 lb. 10 s.* (AGR, CDC, n° 1925, fol. 504r). Easter fell on April, 22 that year, and no

doubt it was in anticipation of the Offices of Holy Week, in the course of which the liturgy anticipated the Passion readings, that the duke wished to have these texts at his disposal. This tells us nothing specific about the prayer book, but testifies to the duke's pious tendencies. The latter can, at a certain point, and eventually at the suggestion of his confessior, of the first chaplain, or of another cleric from his retinue, have aroused the intention of having the Hours of the Cross added to his prayer book.

26 The documents and the manuscripts themselves testify to this. We have one example thereof in ap. 1, doc. 7. The duke's *ancien livret*, to which he had added a complementary text, was rebound.

LIEVEN VAN LATHEM'S BIOGRAPHY

The van Lathem family owes its name to its native village. Although there are many Lathems in Flanders, it was believed that theirs was the Lathem located on the Lys a few miles from Ghent,[1] later called Sint-Martens-Lathem to avoid confusion. However, Lieven's family was from Sint-Maria-Lathem. Indeed, Lieven's brother, Simon van Lathem, was registered as a native of Sint-Maria-Lathem when he acquired the *droit de bourgeoisie* in Ghent on November 4, 1477.[2]

Lieven van Lathem was born c. 1438, for he affirmed on February 28, 1492 that he was then fifty-four years of age.[3] He could therefore have been only sixteen or seventeen when he was admitted as a master of the guild of painters of Ghent on October 30, 1454. In 1491 and 1492, documents mention him in Antwerp as *meester Loeni-zone wilen* (son of Master Louis).[4] The Antwerp documents refer to Lieven's father as a master while in Ghent, at the time of Lieven's admission to the *maîtrise*, he is noted simply as *filius Lonis*,[5] without designating Lonis 'master'. This could be an indication that Louis was less well known in Ghent than in Antwerp where he perhaps practiced his profession. However, the data remain insufficient and Master Louis's occupation as well as the place where he practiced are still to be established.

In 1456, less that two years after he had obtained the *maîtrise*, Lieven van Lathem worked for Duke Philip the Good. He profited from this situation, stating his occupation at court as the basis for assuming the right to suspend the settlement of annuities that he was committed to paying at the time that he acquired the *franchise du métier*. Of six annuities of 2 lb., payable at the feast of Saint John (December 27), only the first two had been paid, in 1454 and 1455. The guild evidently did not allow van Lathem to claim exemption from payment of the contracted debt. The resulting litigation was brought before the jurisdiction of the aldermen. The dean and jurors of the guild were hardly inclined to satisfy van Lathem's claims. The privilege of which he sought to avail himself was indeed generally accorded only to an artist who had been nominated by the duke in due form.[6] This was not the case for Lieven van Lathem at that time, but this did not prevent him from seeking to profit from the protection of Philip the Good in the matter. The latter intervened on two occasions by writing in favor of Lieven to the dean and jurors of the guild. Their determination to reject van Lathem's claims was not shaken by a first letter. The duke intervened once more, and this time proposed not only to exempt van Lathem

from the four payments that remained due, but also to return to him the amount of the two payments that had been made. The dean and jurors of the guild were finally compelled to concede to the duke's entreaties. However, they did so only 'ten versoucke ende lyefde vande voorseiden minen gheduchten heere' (in view of the duke's demand, and for love of their redoubted lord), but with severe clauses straining to preserve respect for the demands of guild regulations. Indeed, the aldermen's sentence, pronounced on January 31, 1459,[7] leaves it clearly apparent that concessions with regard to the financial arrangement would only be accorded under certain conditions. The latter required van Lathem's complete renunciation of the rights that he held by virtue of his attaining the franchise du métier, and the prohibition that he as well as his descendents affiliate with the guild of Ghent again in the future.

As Jozef Duverger has suggested, this litigation must be situated in the historical context of the years that followed Ghent's defeat in the war that pitted them against their prince. One must take account of the climate of tension and repression that still reigned in Ghent during these years, which the milieu of painters apparently did not escape.[8] The duke's protection, of which van Lathem did not hesitate to avail himself, could have revived the resentment of some of his colleagues at the heart of the guild, who perhaps hardly appreciated that van Lathem allied himself with the duke.[9]

Van Lathem did not wait for the pronouncement of the sentence that would settle the litigation, and left Ghent around the beginning of 1459. On December 31, 1458 he granted power of attorney to the calligrapher Gerard van Crombrugghe to represent him in his dispute with the guild.[10] From this one wonders whether Lieven had not pushed his demands against the guild so far because he had the intention of leaving Ghent definitively in any event. This would explain why the painter did not hesitate to oppose the dean and jurors of his guild overtly, and to take advantage of the duke's good will toward him to obtain a financially advantageous ruling. He did not hesitate to compromise his relationship with the guild of Ghent, probably because he calculated that, from then on, he would be able to do without it.

Van Lathem's service for Philip the Good in 1456 coincides with the production of the famous Chroniques de Jérusalem abrégées, commissioned by the duke and made according to a minute completed in December of 1455 (Vienna, ÖNB, Cod. 2533).[11] It is, by consequence, quite possible that Lieven would have participated in the illumination of this sumptuous manuscript.[12] The Master of Girart de Roussillon, considered the principal creator of this masterpiece, is probably none other than Dreux Jehan, named valet de chambre and the duke's illuminator on October 21, 1449.[13] No document specifies the nature of the task at which Lieven was working for the duke in 1456. The sentence of the Ghent aldermen says no more than that 'hij vrochte int hof van minen geduchten heere' (he worked at the court of my redoubted lord), which could very well have been said if Lieven were at work with the official illumi-

nator in one of the duke's residences.[14] The duke's repeated intervention in the conflict between Lieven and the guild of Ghent could be an indication of the interest that Philip the Good had in the work in progress. It surely demonstrates in any event that the artist had succeeded in entering the duke's good graces and in making himself appreciated.

At present, we have no written source relating to the occupation or possible wanderings of van Lathem during the period between his departure from Ghent and the moment when he joined the Guild of Saint Luke in Antwerp in 1462. Boon has shown that the decoration of a manuscript of very beautiful quality, illuminated by the Master of Catherine of Cleves and dating to around 1460, was completed by van Lathem, who could therefore have been in Utrecht for a while at about this time.[15] We will see in Chapter 8 (under section 8.3) that the contribution of van Lathem to the illumination of this manuscript could however be more recent than that of the Master of Cleves. The manuscript could have been left unfinished, with van Lathem completing the illumination a few years later. This does not exclude the possibility that Lieven, who appears to have seen Albert van Ouwater's *Raising of Lazarus* in Haarlem,[16] could have passed through Utrecht between 1459 and 1462.

Lieven was admitted as a master to the Guild of Saint Luke of Antwerp in 1462.[17] The fifteenth of October of that same year, Lieven is mentioned for the first time as the spouse of Antoinette Meyster, daughter of Jacques Meyster,[18] a native of Amsterdam but long established in Antwerp. Before

October 14, 1452, Meyster already lived there in a house that belonged to him on the *Predikherenstraat* (street of the Friars Preachers). He was admitted as a master of the Guild of Saint Luke of Antwerp in 1457. He was registered as *Meester Jacob*, which leads us to believe that he already enjoyed a certain fame, because this was an unusual form for the inscription of a new master.[19] Other sources also identify him as *Meester Jacob* and describe him as a *boekverkoorper* (bookseller).[20] It was therefore professional connections that led van Lathem to meet his future spouse, for Meyster was very probably also a book artisan. Lieven's decision to leave Ghent could have been motivated, then, by a convergence of professional and family considerations. The contacts that Jacques Meyster would no doubt have maintained, as a merchant or as an artisan, with the book artisans of the northern Low Countries may also have been beneficial for van Lathem. One wonders whether the relationships and experience of the father-in-law joined with the talent of the son-in-law perhaps even gave rise to fruitful collaborations.

Lieven's marriage probably took place in 1462. The document of October 15, 1462, registered an arrangement concerning the estate of Gertrude, daughter of Godevaert Gheerijt de Bergeyk,[21] mother of Antoinette and spouse of Jacques Meyster. She had died a decade before, when her daughter was still a minor. Arrangements preserving the rights of the child in the estate of her mother had been stopped on October 15, 1452. Two close relatives of the deceased then intervened as guardians.[22] It does

appear that the marriage of Antoinette was the occasion of the settlement executed on October 15, 1462 regarding the payment of this inheritance, Antionette being this time assisted by her husband.

Shortly after his arrival in Antwerp, Lieven participated with Dreux Jehan in the illustration of a prayer book for Philip the Good (Paris, BnF, Ms. n.a.fr. 16428).[23] It was probably at about this same time that he contributed to the production of several very fine books of hours, in which one recognizes his hand or at the very least that of illuminators in a style very close to his.[24] In c. 1465 he was at work on the illustration of a romance, *Gillion de Trazegnies* (Chatsworth, Collection of the Duke of Devonshire, Ms. 7535), for Louis de Gruuthuse. His last work for Philip the Good was perhaps *L'histoire du bon roi Alexandre* (Paris, musée du Petit Palais, coll. Dutuit, Ms. 456), the abundant illustration of which was executed principally by Willem Vrelant, but Lieven executed the series of nine miniatures illustrating the *Voeux du paon*.[25] Later he illustrated and decorated, again for Louis de Gruuthuse, *L'histoire de Jason ou de la Conquête de la Toison d'or* and *Le livre des secrets d'Aristote* (Paris, BnF, Ms. fr. 331 and fr. 562). Anthony of Burgundy, called the *grand bâtard*, also appears to have appreciated van Lathem's talent. It was for him that van Lathem illuminated about 1458–1460 a *Gillion de Trazegnies* (Dülmen, Collection of the Duke of Croy, Ms. 50) and, c. 1470, the largest part of a superb example in four volumes of the *Chroniques de Froissart* (Berlin, Staatsbibliothek, Stiftung Presussischer Kulturbesitz, Breslau Deposit, Ms. I, 1–4). The work that

Lieven accomplished in the course of the 1460s and 1470s is considerable. Certain manuscripts, however, display inequalities or variations in style, revealing that their illumination would not have been completed without recourse to associates or assistants.

A little after the first of April in 1468, Lieven left Antwerp and only returned after the following July 11. He was one of a number of artists then recruited to contribute to realizing the program of decoration and works of art that had been devised to heighten the brilliance of the Chapter of the Order of the Golden Fleece in May, and the wedding celebration of Charles the Bold and Margaret of York, which would take place in July. Work on the illuminations that he was then in the process of producing at his workshop would probably have been interrupted.

The majority of the hundred and sixty-six artists or artisans recruited to participate in these festivities at Bruges, drew a salary of 8 to 10 s. a day, but van Lathem was paid 18 s. a day. Philippot Truffin of Tournai drew the same salary as he. Three well-known masters, older then Lieven, were the only ones to draw a higher salary. Jacques Daret and Vrancke van der Stockt received 24 s. a day, and Daniel de Rijcke received 20 s.[26] Lieven was therefore considered a member of a small group of the most renowned masters.

It was the duke's two painters and *valets de chambre*, Jean Hennecart and Pierre Coustain, who recruited the artists and artisans for this work at Bruges. The Antwerp masters were recruited by Coustain. He assembled them, lodged them, and main-

tained them for three days *en son hostel en la ville de Brouxelles*, where they carried out certain tasks before departing for Bruges. This explains why the account of works done in Bruges mentions that Lieven and other Antwerp masters, such as, for example, the sculptor Bertelemeus van Raphorst, were also paid for their journey from Brussels.[27] In ignorance of this, it has sometimes erroneously been believed that these masters were from Brussels, or were established in Brussels for some time.

Perhaps it was in the course of the works at Bruges in 1468 that the duke contemplated having a new prayer book made for himself and entrusting the illumination to van Lathem. The commission would have been made later, some time after the Bruges festivities. Nicolas Spierinc must necessarily also have been notified, since he would consult with van Lathem for the refinement of the project. Moreover, we shall see in the next chapter that Spierinc probably stayed for a while in Antwerp for the production of the prayer book, with Lieven or in his circle. The small jewel that the two colleagues would create is situated at the heart of the most productive years of van Lathem's career. The close collaboration with Spierinc worked wonders. It was to repeat itself a few years later, for the production of the book of hours called the Vienna Hours of Mary of Burgundy (Vienna, ÖNB, Cod. 1857), perhaps commissioned by or for Margaret of York.[28]

With the approach of the feast of Easter in 1474, which fell on April 10 of that year, Lieven van Lathem was made responsible for writing and illuminating the *tabella*

paschalis for the church of Our Lady in Antwerp.[29] This concerned a painting or sign, provided with a text for calculating the date of Easter for many years, and other chronological details relating to the new year. It was to be suspended or fixed to the paschal candle during the ceremony of the candle's benediction on Holy Saturday.[30] The ancient use of the *tabella paschalis* was here in keeping with that of the form of Easter. The *tabella* furnished by Lieven was to be a quite important and richly decorated work; the price that he obtained for it surpassed that of two folios with miniatures and borders of the manuscript illuminated for the duke.[31]

His many activities and his success assured van Lathem of a favorable social position and a pleasant prosperity. We find him mentioned in many documents as having negotiated a variety of transactions that we will not describe here. He appears to have been well integrated in the Antwerp milieu and to have established good contacts with some of his colleagues in the Guild of Saint Luke, of which he became one of the jurors in 1479.[32] The documents almost always identify him as *Meester Lieven* ('Master Lieven'),[33] where his colleagues are usually mentioned only by their names, and sometimes also an indication of their profession.

In 1490 we find a reference, in the archives of the Chamber of Accounts, of *maistre Liévan van Lathem, varlet de chambre et painctre du Roy*. Lieven was therefore the *valet de chambre* and painter to Maximilian. We have not yet been able to specify at what moment this appointment was

made, but in any case it dated back several years. In fact, the daily wage statements of the court staff mention him in the service of the young King of the Romans, at Bruges on the April 21, 1487, and once more on January 13 and February 21, 1488.[34]

He was therefore to be found in the service of Maximilian at Bruges in 1488 under very peculiar circumstances. Following the death of Mary of Burgundy in 1482, the exercise of power and of the regency had been the object of an interminable conflict between Maximilian and the 'Membres' of Flanders. In 1488, events took a dramatic turn. Maximilian would be held prisoner by the citizens of Bruges on February 5, 1488, and remain so for nearly three and a half months.[35] Lieven found himself therefore in the service of the sovereign during the course of this enforced stay, the same as Pierre Coustain, who had then been painter and *valet de chambre* for nearly thirty-five years.

Van Lathem would have been well known to the painters Pierre Coustain and Jean Hennecart, who had directed the works at Bruges in 1468. Over the years, he had seen them at work as painters and *valets de chambre*, and could well have nourished the hope of one day holding the same position, and enjoying the same privileges.[36] The death of Hennecart shortly before May 18, 1479,[37] could have permitted Lieven to be promoted to the post left vacant. We are, however, unaware of when Lieven's appointment was made. The connection between the latter and the death of Hennecart remains to be confirmed, but appears probable.

Even if it implied an obligation to follow the court frequently in its movements, belonging to the staff of the prince's *hôtel* carried numerous advantages. Among the latter, one must count the payment of regular wages, to which the painter could add remunerations for the works that were commissioned from him. The amounts that were paid to Lieven in 1490 were high.[38] Lieven was therefore not only active as an illuminator, but must have also distinguished himself in other areas. In 1485, moreover, we find him mentioned as *Lieven de schildere* ('Lieven the painter'), which confirms that he was not known only as an illuminator.[39] His appointment as court painter probably explains why we do not know of manuscripts illuminated in his hand after the end of the 1470s. Jozef Duverger suggested that he could be the artist of the portrait of Louis de Gruuthuse preserved in the Bruges museum.[40] The inherent difficulty in comparing the style of a painting with that of miniatures leaves us hesitant on this point, but the hypothesis deserves attention. An official painter was also often given responsibility for decorative and heraldic work. Certainly nothing excludes the possibility that van Lathem was still entrusted with illumination work. We know, however, that that the painter and *valet de chambre* could also be asked to execute portraits or other panels, mural paintings, designs for stained glass, etc. In contrast to what we know of his sons (see below), we have for Lieven no specific references relating to these jobs.

Toward the end of his life, Lieven built himself a new house on *Predikherenstraat*.

On two occasions, October 20, 1491 and June 26, 1492, he sold an annuity against his house.[41] It is tempting to think that the new residence was perhaps erected on the site of Jacques Meyster's, which his wife and he had no doubt inherited. This hypothesis, however, does not seem tenable.[42] In giving their house the name *De Pennen* ('The Quills'), they made a point of evoking the world of script. The master lived there at *De Pennen* until the end of his life. He died between February 14 and March 14, 1493.[43] The arrangements that Lieven made in anticipation of his death or that of his wife leave us to assume he must have sensed that his strength was declining. He had an agreement established that stipulated that the survivor of the two would retain ownership of the house for life, and thus the freedom to be able to make use of it, as well as the land and the outbuildings that the property included. He had taken the precaution of having this agreement ratified by his two sons in a deed passed before the aldermen on February 14, 1493.[44] One month later, on March 14, Antoinette Meyster is cited for the first time as the widow of Master Lieven van Lathem.[45]

A debt of 129 lb. 8 s. that the city of Bruges had contracted toward Lieven was still unpaid at the time of his death. The master's widow and two sons did not delay in trying to recover it, and agents were appointed and charged with recovering this considerable sum.[46] The van Lathems nevertheless had to wait patiently in order to see the business settled. Indeed, Bruges, confronted with serious financial difficulties, obtained letters of extension from Maximilian and from Philip the Fair dated December 11, 1494. The city would thus be able to spread out the payment of a whole series of important debts over a period of seven years. The amount due to van Lathem's heirs was among this number.[47]

Perhaps it was during the period that van Lathem was part of Maximilian's retinue in Bruges that this debt was contracted. However, the documents do not allow us to confirm this, and no indication could be found of the assignments or services that could be the source of this debt, or of the dates when it arose.

Lieven van Lathem trained some apprentices, two of whom are mentioned in the registers of the Guild of Saint Luke: *Hanneken van Brugge* in 1474, and a certain *Tuenken* (a diminutive of Anthony) in 1490.[48] Lieven's two sons, Jacques and Lieven the Younger, were probably trained by their father and probably remained his collaborators until he died. As long as they worked in their father's atelier, they could avoid acquiring the *franchise du métier*. That they both were registered as *franc-maîtres* just after their father's death[49] confirms the assumption of a prolonged collaboration and association with their father.[50]

Jacques van Lathem and Lieven the Younger would profit from the lessons and the experience of their father. The good relations that the latter had entertained with the court, and the way in which he seems to have been appreciated there, must have contributed to the favorable course of the two sons' careers. They both became *valets de chambre* to Philip the Fair, and accompa-

nied him to Spain in 1501: Jacques as paint-er, Lieven as goldsmith and engraver.[51] Before this, they among others had been given responsibility for various tasks in the decoration of the tomb of Mary of Burgundy. Lieven the Younger also provided drafts of seals.[52] Around 1510, Jacques had been given the responsibility for making *croquis* of birds and other animals, the models of which Master Jan Borman was to sculpt in wood to be cast in bronze. These figures of animals were intended to be posed on the pillars of a stone balustrade, erected to border the esplanade in front of the entrance to the palace of the Dukes of Brabant on the Coudenberg in Brussels. The pillars with animals alternate with other, higher ones, on which statues would be erected of the old Dukes of Brabant. It was Margaret of Austria, governor of the Low Countries in the name of her father Maximilien I, who commissioned these works in 1509–1515.[53] The painter Jan van Roome, alias van Brussels, had been assigned to make preliminary *cartons* of the statues that were to be placed on the high pillars.

It is not difficult to imagine the reason for choosing Jacques van Lathem to create *cartons* of the animal sculptures. Jacques would have acquired and cultivated in his father's workshop the talents of an excellent animal portraitist that Lieven brilliantly displayed in the borders of his manuscripts. That he was specially solicited for these *cartons* appears to confirm that he remained for a long time associated with his father.

Finally, we must remember that the reputation of Lieven van Lathem outlived him. It is thus that he is found named by Jean

Lemaire de Belges in his *Couronne Margaritique*, composed between September 1504 and March 1505:

> *Encore y fut Jacques Lombard, de Mons*
> *Accompaigné du bon Liévin d'Anvers*[54]
> *Trestous lesquelz autant nous estimons*
> *Que les anciens iadis par longs sermons*
> *Firent Parrhase et maints autres divers*

As Pinchart already noted, this *bon Liévin d'Anvers* can only be Lieven van Lathem, whose name thus appears thus in a text that we know names only the most renowned masters of the fifteenth century.[55]

Endnotes

1 This was perhaps also the belief, in 1498–99, of the person who mentioned Lieven's son as *Meester Jacop van Lathem by Gendt* (Master James of Lathem near Ghent). J. Duverger, *Brussel als kunstcentrum in de XIVe en de XVe eeuw* (Antwerp 1935), p. 88.

2 J. Decavele, *Poorters en buitenpoorters van Gent: 1477–1492/1542–1796* (Ghent 1986), p. 33, n° 277.

3 In a declaration made in Antwerp on this date, he stated the conditions under which a certain number of people had been recruited in Antwerp to go to work in Portugal in the service of Emmanuel, son of the Portuguese king. Among these were the painters Jan Casens; Willem de Hollandere; and Jacques van Lathem, Lieven's son. SAA, Certificatieboeken, n° 2, fol. 103v. I would like to thank Jan van der Stock for having alerted me to the existence of this document, which has since been published by E. Duverger, who meanwhile had also discovered it: 'Une déclaration faite par Lieven van Lathem au sujet de peintres flamands au Portugal en 1490', *Gentse Bijdragen tot de Kunstgeschiedenis en Oudheidkunde* 31 (1996), pp. 291–295. I only discovered later that this document was already mentioned in R. Doehaerd, *Études anversoises: Documents sur le commerce international à Anvers* (Paris 1962), vol. 2, p. 84, n° 562.

4 SAA, *Schepenregisters*, n° 99, fol. 167r and n° 102, fol. 70v.

5 SAG, *Keure 1454–1455*, series 301, n° 43, fol. 35v. Van der Haeghen 1899, p. 55; De Schryver 1969/1, pp. 42–45; J. Duverger 1969, pp. 97–98.

6 See the sentence settling the dispute that pitted Pierre Coustain, the duke's official painter, and his assistant Jean de Hervy against the Guild of Bruges. One will note that the suit was not tried by the aldermen, who were not accustomed to judging complaints against member's of the duke's palace staff. J. Weale, 'Inventaire des chartes et documents… de la corporation de St. Luc et St. Eloi à Bruges', *Le Beffroi*, 1 (1863), pp. 204–206. See also: Duverger 1982, pp. 76–78.

7 SAG, series 301, n°45, *Keure 1458–1459*, fol. 54v. De Schryver 1969/1, p. 43. All details relating to the suit between van Lathem and the Guild authorities are drawn from this important document, published in full by J. Duverger 1969, pp. 97–98, note.

8 Some people were even executed in the month of August 1460 for having incited sedition. Among them was the messenger of the Guild of Painters. *Memorieboek der stad Gent* (Ghent 1852), vol. 1, pp. 255–256; J. Duverger 1969, p. 98. Concerning the situation in Ghent during this period, see: W. Prevenier and M. Boone, 'De « stadsstaat »–droom' in: *Gent. Apologie van een rebelse stad* (Antwerp, 1989), ed. J. Decavele, pp. 99–103.

9 Lieven's work leads us to believe that he could have started out in the circle of the Master of Girart de Roussillon. From then on, his apprenticeship would not have been done in Ghent. He would not have lived in the city during the period when Ghent was at war with the duke. Later, at the time of the *Chroniques de Jérusalem* commission, whoever was his master could have wished, and proposed, that his disciple be recruited to assist and participate in the work's realisation. (See below.)

10 SAG, series 301, n° 45, *Keure 1458–1459*, fol. 44v. When van Lathem had acquired the *franchise du métier*, van Crombrugghe guaranteed the first two of the six annuities that Lieven committed to paying.

11 Information concerning the draft of the manuscript, previously ignored, was taken into account for the first time by Pächt/Jenni/Thoss 1983, pp. 62, 74–75.

12 De Schryver 1964, pp. 74–75.

13 AGR, Chartes du sceau de l'audience, n° 409. De Schryver 1964, p. 62.

14 If such were indeed the case, taking into account what we know about the biography of Dreux Jehan, it is likely that this was in Brussels or Bruges. This hypothesis seems to me to prevail against that envisaged by J. Duverger 1969, p. 98, who thought that van Lathem could have been assigned to work at one of the duke's Ghent residences.

15 The Hague, Rijksmuseum Meermanno–Westreenianum, Ms. 10 F 50. K.G. Boon, 'Nieuwe gegevens over de Meester van Katharina van Kleef en zijn atelier', *Bulletin van de Koninklijke Nederlandsche Oudheidkundige Bond* 17 (1964), cols. 241–254.

16 A. de Schryver, 'Relations et parentés entre l'oeuvre de Liévin van Lathem et celle de Dirk Bouts et d'Albert van Ouwater', *Bouts Studies: Proceedings of the International Colloquium (Leuven, 26–28 November 1998)*, B. Cardon, e.a., (Leuven-Paris-Sterling, Virginia 2001), pp. 209–222.

17 Rombouts/Van Lerius, *Liggeren*, p. 14.

18 SAA, *Schepenregisters*, n° 61, fol. 249r.

19 Perhaps he had already obtained the *maîtrise* in another city. Lieven van Lathem, who was in the same situation, was not designated as *meester* at the time of his registration in Antwerp, but when an apprentice is registered with him in 1490 he his mentioned as *Meester Lieven*. Rombouts/Van Lerius, *Liggeren*, p. 42.

20 Rombouts/Van Lerius, *Liggeren*, p. 11. One must be attentive to the variants with which the noun 'Meyster' can be cited in the archives. He is sometimes also referred to as *Jacop de Meester*: SAA, *Schepenregisters*, n° 61, fol. 249.

21 *Gheertruyden, Godevaert Gheerijts'dochter van Bercheycke*, SAA, *Schepenregisters*, n° 45, fol. 199v. Bergeyk is a village located in the northwest of Brabant, to the southwest of Eindhoven.

22 SAA, *Schepenregisters*, n° 45, fol. 199v.

23 This manuscript had remained completely unknown until its acquisition by the BnF in Paris in 1972: Ms. n.a. fr. 16428. It was displayed there for the first time in the *Le Livre* exhibition (p. 208, n° 648, Pl. VI of the catalogue). See Thomas 1976, p. 85; Paris 1993, p. 88.

24 For example: Paris, BnF, Ms. n.a. lat. 215; Rouen, Bibliothèque Municipale, Ms. Martainville 192. Others are discussed in Chapter 8.

25 De Schryver 1969, p. 137 and note 229.

26 AGR, CDC, n° 1795, fol. 82r–82v, 94r–95r and *passim*. Laborde vol. 2, pp. 332–337. After April 17th, the salaries of all artisans were reduced by about a third or sometimes even by a half, …*considéré que l'ouvraige dure plus longuement qu'on entendoit*. … Van Lathem's did not reach more than 12 s.

27 AGR, CDC, n° 1795, fols. 165v–166r; Laborde, vol. 2, p. 339.

28 The feast of Thomas Becket, emphasised in the manuscript's calendar, and a text mentioning the appearance of the Virgin to Thomas of Canterbury, justify the hypothesis that the book would originally have been intended for Margaret of York rather than Mary of Burgundy. Pächt/Thoss 1990, pp. 69–70; A. Hagopian van Buren, review of Pächt/Thoss 1990, in: *Speculum*, vol. 68 (1993) pp. 1189–1190. As M. Steffens had already suggested to me in a letter of September 30, 1985, the presence of the Rose of York in the manuscript's graphic decoration seems to confirm this idea. However, one will see in Chapter 5 below that there are grounds for remaining cautious with regard to the significance of the Rose of York.

29 *Item, meester Lieven heeft verdient vande tafelen te maken daer Incarnacien in staet met scriven ende floreren tsamen: 2 lb. 15 s.* Accounts of the building of the Church of Our Lady (Christmas 1473 – Christmas 1474), n° 8, fol. 18r. I warmly thank Jan van der Stock, who very kindly passed on this reference to me.

30 A. de Boüard, *Manuel de Diplomatique Française et Pontificale* (Paris 1929), p. 304, note 1; E. Strubbe and L. Voet, *De Chronologie van de Middeleeuwen en de Moderne Tijden in de Nederlanden* (Antwerp, Amsterdam, 1960), p. 55.

31 His high price of 2 lb. 15 s. included the script and the illumination. This price, equal to 55 s., approaches that of the half of the script and illumination by Spierinc in the Vienna *Ordonnance du premier écuyer*. It is lower by only 1 s. 3 d. (calculation made on the basis of details of doc. 4 of Appendix 1).

32 He acted in this capacity with his colleagues in an Act of October 25, 1479. SAA, *Schepenregisters*, n° 95, fol. 191. Mentioned by A. Wauters, 'Sur quelques peintres de la fin du 15ᵉ siècle' *Bulletin de l'Académie royale des sciences, des lettres et des beaux–arts de Belgique* 51, 3ʳᵈ series, tome 4 (1882), p. 109; J. Duverger 1969, p. 99.

33 For example in 1474: Rombouts/Van Lerius, Liggeren, pp. 25 and 42, and on several occasions in the subsequent Acts.

34 J. Duverger 1969, pp. 99–100.

35 R. Wellens, 'La révolte brugeoise de 1488', *Handelingen van het genootschap 'Société d'Émulation de Bruges'* 102 (1965), pp. 13–26; W.P. Blockmans, 'Autocratie ou polyarchie? La lutte pour le pouvoir politique en Flandre de 1482 à 1492, d'après des documents inédits', *Bulletin de la Commission royale d'Histoire* 140 (1974), pp. 295–298.

36 All three had begun their careers in the fifties. Coustain was named painter and *valet de chambre* to Philip the Good in January of 1454. He remained so under his successors. A. de Schryver, s.v. 'Coustain', *Le Dictionnaire des Peintres Belges du XIVe siècle à nos jours*, Brussels 1995, pp. 215–216. The earliest known reference to Hennecart dates to 1454. In 1457, we already find him mentioned as painter and *valet de chambre* to Charles, still the count of Charolais. ADN, B. 3661, fol. 68r. Laborde, vol. 1, pp. 424–425 and 466.

37 An injunction of May 18ᵗʰ, 1479 ordered the payment of 194 lb. 6 d., *À Ysabeau de Vernembourg, vesve de feu Jehan Hennecart.* ADN, B. 2118, fol. 378r–378v. It related to a sum still owed to the *valet de chambre* and painter for work executed on behalf of the late Duke Charles.

38 J. Duverger 1969, p. 100.

39 J. Duverger 1969, p. 99, note 9.

40 J. Duverger 1969, pp. 100–103. Dirk de Vos remarked that the technique of this portrait was not exactly the same as that of the other portraits of the Master of the Portraits of Princes, to whom this painting was attributed: *Catalogus schilderijen 15de en 16de eeuw: Stedelijke Musea Brugge* (Bruges 1979), pp. 156–157.

41 SAA, *Schepenregisters*, n° 99, fol. 167r and n° 102, fol. 70v. These documents certainly specify that this concerns a new house.

42 None of the new house's neighbors bear the same name as the neighbors of Meyster's neighbors in 1466.

43 It is in error that Erik Duverger believed van Lathem was no longer alive on June 26, 1492. E. Duverger 1996, p. 291, refers to one of the documents indicated in notes 63 and 100. It names *Meester Lievyn van Lathem, meester Loenis'sone wilen*. The word *wilen* (late, deceased) relates to Loenis or Louis, father of Lieven van Lathem, and not, as E. Duverger believed, to Lieven himself. In specifying the first name of Lieven's father, one avoided a possible confusion with his son, Lieven the Younger.

44 SAA, *Schepenregisters*, n° 101, fol. 248r.

45 SAA, *Schepenregisters*, n° 102, fol. 261v.

46 Document of March, 14 1493 cited in the preceding note. Jacques's name is omitted after his brother's at the beginning of the text (scribal absent-mindedness!). The contract speaks later of the Lieven's widow and of 'his two legitimate sons' (*huerer beyder wittige sone*). It is therefore in error that Wauters 1891, col. 423, believed that Lieven the Younger and his mother would have acted without Jacques.

47 Bruges, Archives de la ville, n° 1251. L. Gilliodts-Van Severen, *Inventaire des archives de la ville de Bruges* vol. 6 (Bruges 1876), p. 389.

48 Rombouts/Van Lerius, *Liggeren*, pp. 25 and 42. One must however take account of the fact that far from all of the apprentices are mentioned in the *Liggeren*. J. van der Stock, 'De organisatie van het beeldsnijders—en schildersatelier te Antwerpen. Documenten 1480–1530', *Antwerpse retabels, 15de–16de eeuw*, (Antwerp 1993), ed. H. Nieuwdorp, exh. cat. (Kathedraal van Antwerpen), 2, pp. 48–49.

49 Rombouts/Van Lerius, *Liggeren*, vol. 1, p. 46. The situation could be compared to that of Jan and Cornelis Massys who were also registered as *franc-maîtres* in 1531 after their father's death.

50 This familial association appears to have been maintained between the two brothers. At the time of the payments in 1495 and 1498, for work that they produced for the tomb of Mary of Burgundy, they sometimes issued a joint invoice. Duverger 1995, pp. 57 and 61.

51 The fact that Lieven the Younger worked as a goldsmith does not contradict his likely beginnings and

his activity in the paternal workshop. It was proba-
bly his marriage that led him to turn toward the
trade of goldsmith and engraver. He married Elisa-
beth Staes, daughter of the goldsmith Adriaen Staes,
whose workshop he no doubt revived. SAA, *Schepen-
registers*, n°131, fol. 92r, contract of July 10, 1507.
Originally, the goldsmiths of Antwerp were part of
the Guild of Saint Luke. They established themselves
in an autonomous guild and trade in 1456, were rec-
ognized as such, and obtained the ratification of
their statutes. Certain goldsmiths, however, pre-
ferred to affiliate with the Guild of Saint Luke as
well, perhaps to avoid any protest during the real-
ization of their projects. Projects involving plate or
seals were often commissioned from painters. *Zilver
uit de Gouden Eeuw van Antwerpen.* exh. cat. (Ant-
werp, Rockoxhuis, 10 Nov. 1988 – 15 Jan. 1989),
pp. 21–23.

52 A. Pinchart, 'Liévin van Lathem (cited 1493, died in
1515)', *Revue de la Numismatique belge*, série 2, t. 5
(1855), pp. 369–378; Pinchart 1881, pp. 195–197; A.
Wauters, 1891, col. 424–425; J. Finot, *Inventaire som-
maire des archives départementales antérieures à 1790*,
vol. 7, (Lille 1892) p. 231; J. Duverger 1982, p. 82,
note 117; E. Duverger, 1995, pp. 39, 57, 59, 61–62.

53 E. Dhanens, 'Jan van Roome alias van Brussel, schil-
der', *Gentse Bijdragen tot de Kunstgeschiedenis* 11
(1945–1948), pp. 54 and 133–135; A. Smolar-Meyn-
aert, 'Des Origines à Charles Quint' in: *Le Palais de
Bruxelles. Huit siècles d'Art et d'Histoire* (Brussels
1991), pp. 46–53. Drawings, paintings, and tapes-
tries have represented the esplanade with its bailles,
or have been inspired by it. The February tapestry
from the *Hunts of Maximilian* series (Paris, Musée
du Louvre) represents it very well. Reproduced in
Smolar, pp. 36–37.

54 The author must have known that Jacques Lombart
de Mons was active in Antwerp, where he had been
permanently established in 1478. (Rombouts/Van
Lerius, Liggeren, p. 29). It is surely unnecessary to
search for another reason for the fact that he de-
scribes him as *acompaigné du bon Liévin d'Anvers*.

55 Pinchart 1862–1863, p. CCXXII; E. Duverger and
D. Duverger-Van de Velde, 'Jean Lemaire de Belges
en de Schilderkunst. Een bijdrage', *Jaarboek van het
Koninklijk Museum voor Schone Kunsten Antwerpen*,
1967, pp. 62–63 and 66. The last three verses of our
quotation and a portion of the rest of the poem ap-
ply to the group of thirteen artists that the author
cited in the preceding verses.

PLATE VII | 57

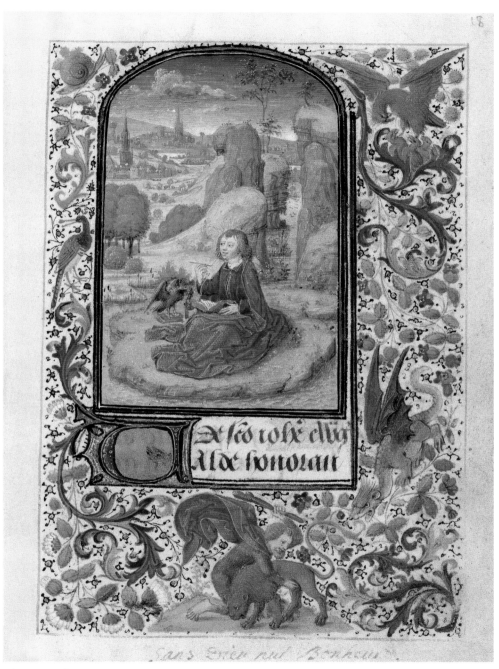

Fol. 18r: Saint John on Patmos.

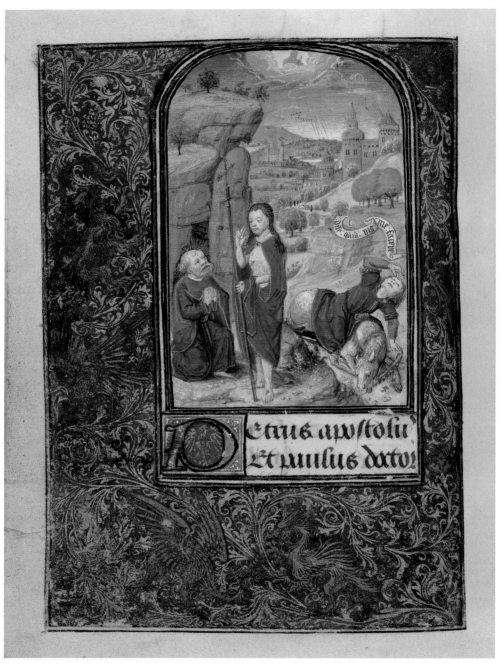

Fol. 19v: Saint Peter and Saint Paul.

PLATE IX | 59

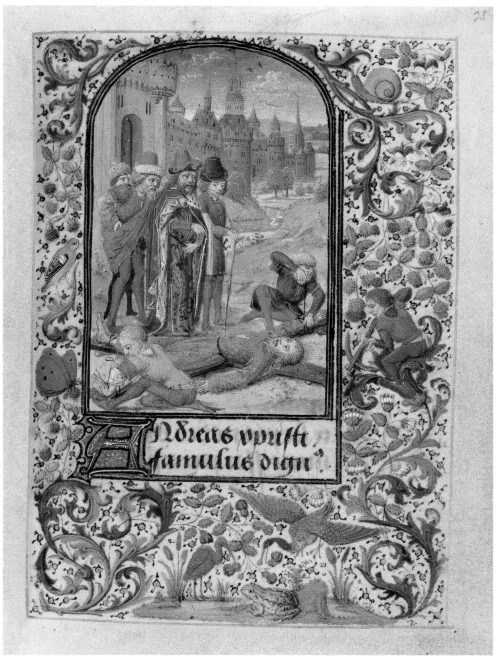

Fol. 21r: The Crucifixion of Saint Andrew.

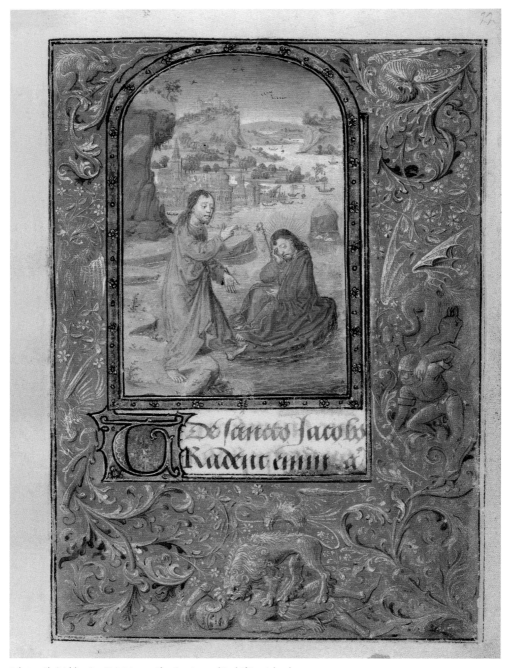

Fol. 22r: Christ blessing Saint James the Greater on his drifting island.

PLATE XI | 61

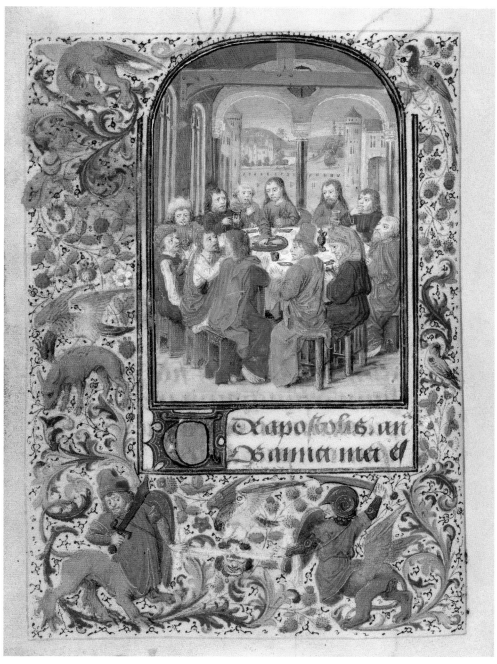

Fol. 23v: The Last Supper.

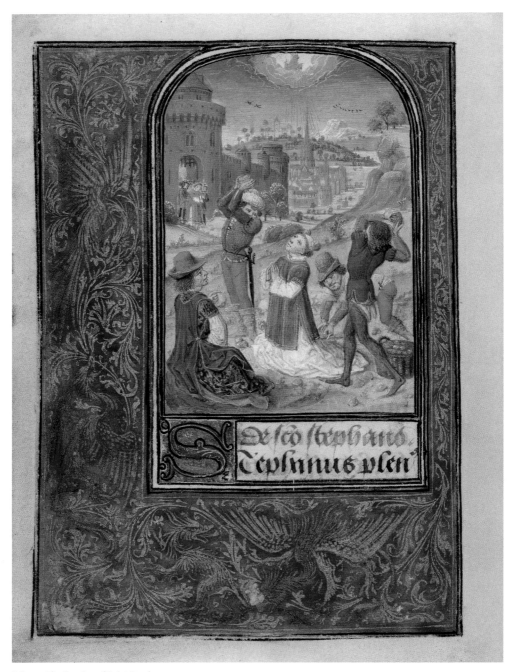

Fol. 24v: The Stoning of Saint Stephen.

PLATE XIII | 63

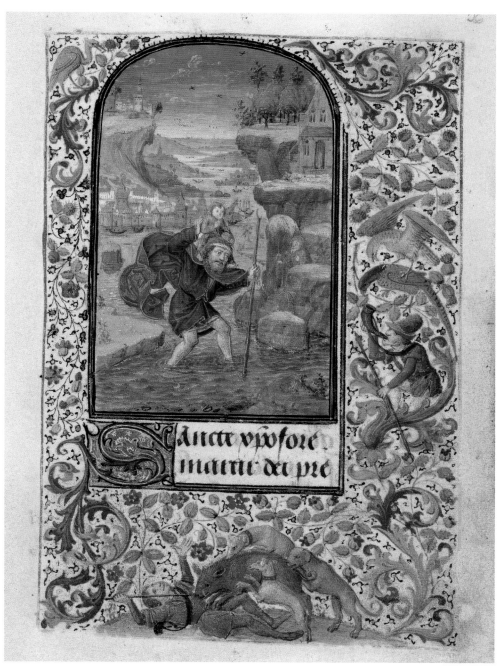

Fol. 26r: Saint Christopher

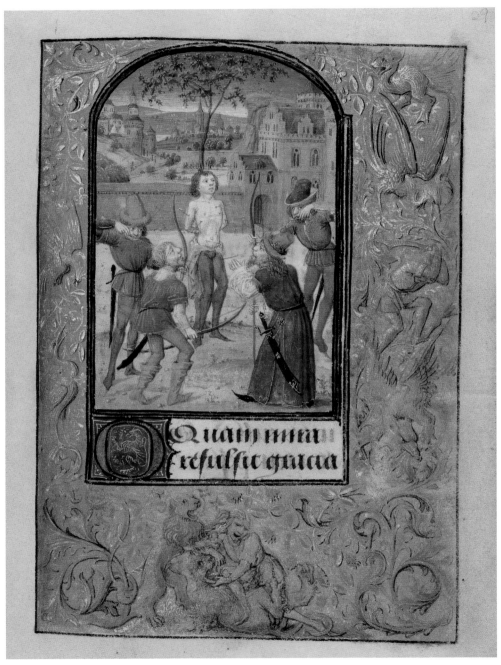

Fol. 29r: The Martyrdom of Saint Sebastian.

NICOLAS SPIERINC'S BIOGRAPHY

Nicolas Spierinc's family was from Zwijndrecht, a village located a few miles from Antwerp on the left bank of the river Scheldt, to the east of the Waasland.[1] The names the Spierinc family members appear in many Waasland revenue books, at least since 1376 and throughout the fifteenth century.[2] Nicolas probably always maintained contacts with his place of origin. He and his sons Nicolas the Younger and Thomas owned property in Zwijndrecht or elsewhere in the Waasland, while two others among his five children, Jan and Clémence, had marital ties with other native families of the region, Brijssinc and Metter Evenen.[3]

If Nicolas had been born and had grown up in Zwijndrecht, whence a ferry allowed him to reach Antwerp on the other bank of the Scheldt, he could have been attracted by that city while still very young. The economic and social interests of Waasland families led them to seek, multiply, and develop their connections with Ghent in particular.[4] It is in Ghent that in December of 1453 we find *meester Clais Spierinc* mentioned for the first time in connection with a *cens dû* due on a house that he owned on Saint Catherine's Street, in the parish of Saint James.[5]

From this first reference he is thus favored with the title of 'Master' and, in the many documents that mention him throughout the second half of the fifteenth century, it is exceptional for his name not to be accompanied by this title. Taking into account the fact that, somewhat later, we find him enrolled in the Faculty of Medicine at Leuven, we can surely conclude that Nicolas had obtained a Master of Arts in or before 1453.[6] He had therefore had the opportunity to acquire a good intellectual training. Perhaps he had also already done an apprenticeship.[7]

We cannot avoid noticing that the first references to Nicolas Spierinc in Ghent, much like those for van Lathem, are found in the wake of the war between Ghent and Philip the Good. After the defeat of Ghent's militias, the city saw itself subjected to the stringencies and the humiliations of the Peace of Gavere, on July 28, 1453.[8] Perhaps Spierinc had left Ghent before or during the troubled period that began there in about 1450. He could have left for an apprenticeship, or for studies elsewhere.

When he registered in the Faculty of Medicine at the University of Leuven on January 31, 1455,[9] he must in fact have stayed at another university center previously, for one did not reach the Faculty of Medicine without having acquired the Master of Arts.

At the time when Nicolas registered at Leuven, one Jean Spierinc, who could well have been Nicolas's uncle or relative, was for some time a professor at the Faculty of Medicine. Jean Spierinc was rector of the university three times.[10] He was physician and councilor to Philip the Good[11] and Charles the Bold[12] and remained esteemed at court, since he was still physician for Maximilian[13] and Philip the Fair.[14]

This *Maistre Jehan Spierinc, conseiller et phisicien de mondit seigneur* received in 1470 a gift of 32 lb. from the duke, *quant nagaires il luy a présenté ung alminac sur l'année courant et pour aucuns aggréables services qu'il lui a faiz.*[15] Although Nicolas's talent can have been more than sufficient to provoke comment, it could nevertheless be the case that the doctor recommended the calligrapher and illuminator to the duke.

Family ties between the professor of medicine and the artist could also have supported the latter's direction toward the study of medicine. However, this family connection, which seems quite probable, has not yet been able to be established.

We may wonder whether Spierinc really intended to pursue a university education.[16] He could have registered with the intention of being admitted as a member of the university. Those who were asked or admitted to fill a university position, or who practiced an occupation in which the university could be interested, were obliged to have themselves registered. This was the case for the first printers who were active at Leuven, after 1473.[17] One could imagine that Spierinc had no intention in registering other than to work as a copyist and calligrapher

in the university city, and in that case it seemed convenient and favorable to him to enroll. This could be the reason why his position as *scriptor* was noted at the time he registered on January 31, 1455. Whatever the reason he enrolled, his interest in the Faculty of Medicine should be noted. One might suppose that he did so opportunistically, perhaps seeking to ensure the support of Professor Jean Spierinc, an influential personage on that faculty.[18] Whether or not such considerations played a role, the choice leads us to believe that Nicolas had a real interest in medical science.

He certainly followed a course of study in medicine, as can be inferred form the fact that he gave the name *cybauries* to cadels, *jeux de plume*, and other graphical fantasies with which his calligraphy is generously provided (see Appendices 1.4 and 1.5). In calling them this, he had apparently remembered a passage from Dioscorides *De materia medica*, which he would have studied in the course of his medical education. On the subject of water–lilies, alluding to the stems of the *ciboria*, flowers of an Egyptian plant, Dioscorides noted: *(h)asta eius lenis, et non grossa et nigra, similis civorio*. These terms perfectly evoke the character of the sinuosities and graphical caprices that Spierinc drew in the margins of his manuscripts, and they would have given the calligrapher the idea for the neologism *cybauries* to designate them.[19]

Dioscorides' *De materia medica* remained for a long time one of the fundamental works for the study of medicine.[20] The use of this neologism reveals the approach of a spirit molded by study and

proud enough to let it show. It is obviously not impossible that he could have known the *De materia medica* because he had to copy it as a scribe, but in that case one might doubt that he would have remembered it and used it in this way. If his registration was simply that of a medical student, the fact that his capacity as *scriptor* was noted appears to indicate either that he made a point of having himself known as such, or that his qualities as a calligrapher had already been recognized and perhaps had even procured him the beginnings of fame.

Around three and a half years after his registration at Leuven, in June of 1458, Spierinc reappears in the Ghent documents. If he was pursuing studies in medicine, we may wonder if they could already have come to an end. In both Paris and Leuven, the statutes of the Faculty of Medicine prescribed six years of study for obtaining a license or doctorate in medicine.[21] However, since he must have passed through another university before arriving in Leuven in 1455, it is not impossible that he had already started his medical studies elsewhere, in addition to obtaining his Master of Arts, which could have shortened his time of study at Leuven.[22] Although there is no evidence that allows us to be certain, Nicolas could well have completed the university curriculum. His son Thomas practiced medicine (see below), but nothing at present permits us to assume that this was also the case for Nicolas.

On June 22, 1458, Nicolas, who had probably just left Leuven, bought a house in Ghent.[23] It was a stone house located not far from the Hôtel de Ville, opposite the Saint-

Georges square in the Hoogpoort, a street inhabited especially by the privileged echelons of society.[24]

Less than two and a half years later, on November 20, 1460, we see Spierinc already re-selling this house.[25] The buyer was the calligrapher and illuminator Émeric van Bueren.[26] The document explicitly made an inventory of the woodwork and furniture that 'maître Clays' had had made in the dining room, and it specifies that they were included in the sale. The quick re-sale of this house, which Spierinc had nonetheless gone to some expense to furnish, cannot but intrigue us. The site and price of the property seem to reflect a relatively comfortable social situation.[27] The terms of payment for the house's purchase in June of 1458 suggest that Spierinc had sufficient means at his disposal.[28] At the time when he sold the house, one year had passed since he had paid the last installment for his acquisition. If he found himself confronted with financial problems, one would have expected that the property he owned at St Catherine's Street would have allowed him to get out of trouble without having to sacrifice the residence that he had fitted out.

The sale contract he entered into with van Bueren included a clause that accorded Nicolas Spierinc, as well as his wife, the right to occupy a room behind the house at no cost for one more year.[29] If Nicolas wanted this arrangement to give him time to find another place to live, he would have to admit that he had effectively been forced to sell his house in order to extract himself from an awkward situation. It is not at all certain that this was the case. Unforeseen

circumstances could have persuaded him to leave the city. In that case, the possibility of guaranteed lodging for one more year could be intended to allow him to still stay in Ghent from time to time, to organize his professional affairs or matters relating to his inheritance.

Although no document proves this, it appears likely that Spierinc did not normally reside in Ghent during this period. Even if this could be confirmed by a document, it by no means suggests that Nicolas severed or interrupted all of his contacts with Ghent. If he was established in another city, matters relating to his inherited property and perhaps also his family ties will no doubt have led him to arrange to pass through Ghent from time to time. His presence there may have been necessary on more than one occasion. This was the case, for example, at the beginning of November 1464. Émeric van Bueren foresaw then that he would not be in a position to pay the 6 lb. 5 s. on Christmas Eve, the amount of the final annuity due for the purchase of the house. To get van Bueren out of trouble, Spierinc agreed to buy a 20 s. bond against van Bueren's house.[30] The first payment of this bond would only be made one year later, on November 1, 1465, which allowed van Bueren some respite. The bond was payable for life to Nicolas, to his wife Barbara Colfs, or to their son Jan. The latter was still young, since he is designated by the diminutive *Hannekin*. Taking into account this modification of van Bueren's obligations to Spierinc, the November 20, 1460 deed of purchase for the house was struck from the aldermen's register and provided

with a rider that recorded Spierinc's consent to the annulment of the final payment outlined by the deed.[31]

Nicolas's departure from Ghent could be explained by an advantageous offer or a favorable opportunity that he made a point of seizing, but which entailed a fairly long period of absence. At present, we have no indication at our disposal regarding the activity or movements of Spierinc during the period after the sale of his house in November of 1460. On the basis of subsequent events, might one imagine that the abandonment of his house in Ghent related to an intention to be closer to van Lathem, with a view toward the realization of a common project or important commission of which we are unaware. These are still only pure conjectures. But, after the duke's marriage festivities in 1468, the commission of the prayer book surely led the two illuminators to form a partnership, and, according to what the documents suggest, to meet in Antwerp.

Indeed, the mise-en-page and the illumination program of the prayer book could not have been developed without Nicolas and Lieven agreeing and consulting one another on the matter. The very careful manner in which this program was developed, as well as certain details of the prayer book's material composition and the execution of its illumination (see Chapter 10), can only be explained by a close collaboration between these two artists. It is certainly possible that Nicolas worked and stayed with Lieven during the execution of the prayer book. It could be there that the commission for the ordinance books was conveyed to him.

The two illuminators' concern to better assure the close collaboration that the prayer book's realization would demand could be the reason that Spierinc came to Antwerp. As mentioned above, however, it could be that the latter had already settled in Antwerp beforehand. In this case, their arrangement and collaboration could have been settled all the more easily, as much for the prayer book as for the execution of the *histoires* of the eight ordinance books that must have been executed by van Lathem or in his circle, judging from the style of the miniature in the Vienna *Ordonnance du premier écuyer d'écuyerie* (ÖNB, Cod. s. n. 2616, Fig. 2).[32]

In August of 1469, in Brussels, Spierinc had completed the calligraphy and illumination of the Ordinance manuscripts. One will recall that this commission included, on the one hand, the eight small books, each containing one of the *Ordonnances de plusieurs estas de chevaliers, escuiers et autres de son hostel*;[33] and, on the other, the compilation intended for the duke's personal use, containing the eight different ordinances in a single volume.[34] It was probably for this commission that Spierinc had to go to Brussels. It is by no means certain that he was ever actually established there.[35] He was paid for having had the *histoires*, which would serve as frontispieces for the eight books, brought from Brussels to Antwerp.[36] He had therefore made arrangements in Antwerp, before going to Brussels, and struck an agreement that he would be in charge of painting these miniatures. It is likely that he will also have given instructions regarding the manner in which the

subject was to be treated, perhaps by drawing a sketch or designing a model.[37]

The manuscript of the *Ordonnance du premier écuyer* allows us to judge the care with which Spierinc made sure to provide a perfect harmony and equilibrium between the frontispiece folio and the first text page facing it (Fig. 2). The mise-en-page of the eight small books, and that of the folios serving as frontispiece miniatures, would have been prepared before his departure for Brussels. Indeed, the *histoires* could only be executed on folios prepared such that the lines delimiting the space intended for the miniature and border correspond to those of the justification and border of the first text page, which faces the frontispiece. The collection of the eight Ordinances intended for the duke would have been executed with the same care, and it was probably with some degree of pride that Spierinc made his way to deliver the collection to the duke at The Hague.

To reach The Hague from Brussels, his itinerary would logically have led him to pass through Antwerp. Taking into account preceding events and the good relations linking the two artists, we have several reasons to think that Spierinc could have joined van Lathem in Antwerp and would have arranged to go with him to The Hague, where van Lathem was also expected—in order to give the duke the prayer book that was moreover largely their joint effort.

We have not yet been able to establish when Spierinc returned to Ghent after his journey to The Hague in the summer of 1469. We know that he left from Brussels, but we do not know where he settled upon

his return. He could have lingered in Antwerp or Brussels again, but he could also have returned immediately to Ghent, where we find him mentioned several years later, established in a grand house that he perhaps occupied for some time. On March 29, 1476, he burdened his property with new annuities, invested for the benefit of the Beguine convent of Notre-Dame Ter Hooie.[38] In this document, it emerges that Nicolas was the proprietor of several adjacent houses, located on Gelukstraat in the Parish of Saint James. They were: a bakery, two smaller houses, and *'t grote huus daer naest daer de selve Claeis inne woont, met allen den lochtinghen, plaetsen ende aysementen diere toebehoren ende ancleven van voren toot achter* ('the large neighboring house inhabited by Nicolas, with its gardens, its outbuildings, and everything that is part of it, from the front to the back'). This residence was very close to the house on Saint Catherine's Street that he already owned in December of 1453, and also close to the corner that this street forms with the Gelukstraat.[39] He remained settled in this large house for years. It could be there that the request reached him to retrieve the prayer book from the duke, so that the Hours of the Cross could be added. It could also be there that its illumination was divided up with collaborators (which will be discussed in Chapter 9), and it was certainly also there that he strengthened promising contacts with the Master of Mary of Burgundy.

The properties of 'Maître Claeys' seem to have been situated in the Parish of Saint James, in the neighborhood north of the church, within the loop made by the Lys; it

was not far from the Marché du Vendredi where two of his sons, Jan and Thomas, had their house (see below). Some properties were located in other parishes,[40] as well as in Zwijndrecht.[41]

On April 1, 1480, he sold three houses to the Convent of Chartreux.[42] These houses were located on the Struivelstraat, a little street leading to the Marché du Vendredi. The deed recording this sale alludes to the estate of his wife, Barbara Colfs, deceased shortly before that date. It shows up in a later document relating to this estate that three of Nicolas's five children, *Maeskin, Clemencie ende Joorinekin*, (diminutives for Thomas, Clémence and Georgette), were still minors at the time of their mother's death.[43] On August 23, 1481, Nicolas, their guardian, sold one of his houses on Saint Catherine's Street. It was the *brasserie* called *d'Wielkin* ('The Little Wheel'), which was a joint possession shared among his minor children and himself. From this we can deduce that his property came to him, at least in part, from his wife. On May 10, 1482, Nicolas sold an annuity to his son Jan. This annuity was fixed to two houses on the Gelukstraat, and one house on Saint Catherine's Street.[44]

The annuity that, as we have seen, he owed to the Beguine convent of Ter Hooie since 1476, was allocated to other property on March 31, 1483, and the 1476 contract was invalidated. The document provides an inventory of a house that he owned, still in the same neighborhood, but this time on Baudeloo Street.[45] On January 19, 1485, he bought another house from a grocer, located on the rampart at the height of the

boundary of Baudeloo Street and the Gelukstraat.[46]

An act of September 7, 1486, records Nicolas's sale of an annuity to his son Jan, for a sum of 10 lb. This annuity of 12 s. 6 d. was fixed on a property he owned in Zwijndrecht, and on the recently purchased house located on the rampart at the end of Baudeloo Street. The document specifies that he lived in this house.[47] Nicolas therefore left his large house on Gelukstraat in about 1485–1486.

This move preceded or followed a lamentable episode in the Spierincs' history, which occurred in 1485. In the course of a violent dispute that degenerated into battery, the Spierincs injured Pieter van den Doorne, son of Heyndric. The victim was the son of a person of consequence, judging by the financial means at his disposal.[48] It turned out that Nicolas and his two sons, Jan and Thomas, were very much guilty in this sad affair. The house where Heyndric van den Doorne, the victim's father, lived was next to the house called *De Croene* ('The Crown'), which was the property of Thomas Spierinc. These houses were situated south of the Marché du Vendredi, near the Church of Saint James.[49] We do not know the details of the dispute's circumstances or motives. The fact that Jan Spierinc and the van den Doornes were furriers, as well as the information at our disposal concerning the rest of this story (see below), lead us to presume that it was a professional conflict. At the time, Nicolas and Thomas would naturally have sided with Jan.[50]

Thanks to the good offices and mediation of the prior of an Augustinian convent,

another priest from the same convent, a member of the Furriers Guild, and a member of the Wardrobers Guild, the conflict was able to be settled in reconciliation.[51] The terms of the agreement in which the parties were joined were recorded by the aldermen of the *Keure* on January 23, 1486.[52] The Spierincs could count themselves lucky that the opposing party agreed to compromise. Indeed, the severity of the demands to which they were held, and which they agreed to follow, aptly demonstrate the gravity of the situation they got themselves into.

The three Spierincs first had to commit to covering all the charges of the victim's doctor and surgeon, and all other expenses that could follow therefrom.[53] They had to express their regrets and beg the victim's pardon, as well as that of his father and family, and to reconcile with them. In the six weeks following, they each had to embark upon a pilgrimage in honor of the victim's father and all of his friends and family. When a guilty party was condemned to take a pilgrimage, he was frequently allowed simply to discharge this obligation through reparations.[54] However, the Spierincs were expressly forbidden recourse to reparations. Their temporary removal must have been judged desirable. They were obliged to make their pilgrimages in person and to present on their return the certificate proving that they had completed it. Nicolas was supposed to go to Rome (*tsente Pieters ende Pauwels te hoghen Rome*) and the two sons each to go on a pilgrimage to Santiago de Compostela. In the course of 1486, Nicolas Spierinc and his sons Jan and Thomas

would each have had to undertake a long journey of several months.

We may wonder in what state of mind a fifteenth-century man embarked upon an imposed pilgrimage like the one that Nicolas Spierinc had to make. Without being able to imagine what this journey could have represented for him, we can assume that as an artist and book artisan, perhaps he would not have neglected the opportunity this Roman pilgrimage offered to try to meet Italian colleagues, or at least to discover or become more familiar with the important production of illuminated manuscripts in the Italian peninsula.

Besides his pilgrimage to Santiago de Compostela, Thomas had still another heavy penalty imposed upon him. Henceforth, he was forbidden to occupy his house *De Croene* at the Marché du Vendredi, unless the victim, Pieter van den Doorne, or his father, Heyndric, who occupied the neighboring house, gave their consent. This prohibition was probably actually applied. We do not know if it was maintained permanently, but it is quite curious to discover that in 1499–1500 *De Croene* house became the victim's property![55] It has not yet been possible to establish under what circumstances, at what moment, or for what price the property changed hands.

Much like his father, Thomas took an interest in medicine. He studied it somewhere other than Leuven, for he does not appear on the rolls of that university. In contrast to his father, he practiced the physician's profession and is noted as such.[56] Perhaps this did not provide sufficient revenue, for we also see him dealing with purchases of wool

and sheep in February and March of 1485.[57] It is not certain that he still lived in Ghent; perhaps the prohibition from occupying his house at the Marché du Vendredi led him to leave the city in 1486. He seems then to have more connections with Zwijndrecht where his family and his wife's family came from. He is located there by certain acts that were established by the aldermen there, relating to debts contracted toward him—for lavish care in his capacity as a doctor, among other things. In 1490, he sold a house used as an inn that he owned on the bank of the Scheldt, near the ferry that provided the river crossing to Antwerp.[58] Although nothing proves this absolutely, it seems quite possible that he had returned to live in Zwijndrecht after this incident, all the while maintaining contact with his father and his brother Jan in Ghent.[59]

References to Nicolas in the archives continue to allude now and then to transactions concerning his financial situation. He even sold an annuity to Jan one last time, on April 18, 1488.[60] On May 19, 1490, it is to Jan's widow, Lievine Brijssincx, that he sells an annuity, to support Betkin, Jan's minor daughter.[61] An acknowledgement of debt by a certain Pieter Pieters, declaring that he owed 2 lb. 9 s. to Clays Spierinc, was recorded on June 14, 1497.[62]

The final archival reference noted in Nicolas's lifetime dates to June 26, 1499. It is an acknowledgement of a debt of 22 s. 2 d., which he still owed for the purchase of a pelisse.[63] His death must have taken place between August 15, 1500, and August 15, 1501. The city accounts for that year record inheritance taxes collected for the estate of

meester Claeys Spierinc. These duties were levied on inheritances that passed, in full or in part, into the hands of heirs not established in Ghent. It appears in the wording of the account article that four of the five portions of the estate were going to heirs who did not reside, or no longer resided, in Ghent.[64] The portion reverting to an heir settled in Ghent was no doubt for Betkin, Jan's daughter and Nicolas's granddaughter.

Two of Nicolas Spierinc's sons, Jan and Nicolas the Younger or Nicolas II, took an interest in the crafts of the book. Jan is the one who left more extensive traces in the Ghent archives. He was still a child in November of 1464.[65] He affiliated as an illuminator with the guild in Ghent on July 14, 1477, after having perhaps practiced illumination for a while under his father's guidance.[66] His guarantors were his father and his aunt, Elisabeth Spierinc.[67] Shortly thereafter, Jan became a member of the *Chambre de Rhétorique Marien Theeren*, which had its seat in the Chapel of Our Lady at the Church of Saint James. He is mentioned there as *verlichtere* (illuminator).[68] If he is definitely the one whom we find listed in 1478 as a *beildemakere* (maker of images) at the Bruges booksellers' confraternity, no doubt he joined this confraternity in a temporary fashion to avoid all risk of conflict with the Bruges booksellers at a time when he had business in Bruges. He is mentioned only once in the accounts of the Bruges confraternity,[69] and therefore did not continue to pay a fee from year to year, as did both local artisans and local booksellers.

We know of no work that can be attributed to Jan. Byvanck and Hoogewerff had attributed some manuscripts to Nicolas Spierinc in which certain illuminated folios were signed with the name *Spierinck* (sometimes in an abbreviated form, and accompanied several times with the year).[70] These books are northern Netherlandish products of medium quality. I have already indicated that this attribution is not acceptable, and that Destrée, Durrieu, and Hulin de Loo were therefore perfectly correct in refusing to admit it.[71] I then added that *On ne peut toutefois envisager non plus, comme le firent deux de ces auteurs* [notably Durrieu and Hulin de Loo] *que ces oeuvres signées pourraient être des oeuvres de Jean Spierinc, fils de Nicolas, qui fut également enlumineur. Non seulement Jean Spierinc n'a pu s'établir pour un temps suffisamment long en Hollande, mais, dans trois des cinq manuscrits cités* [this concerns manuscripts bearing the *Spierinck* signature and a date] *la signature est accompagnée de dates ultérieures à son décès car il n'était plus en vie le 18 mai 1490. Il s'agit donc d'un simple cas d'homonymie.*[72] It is therefore quite clear that the Dutch illuminator Spierinck[73] has nothing to do with his homonyms Nicolas and Jan, established in Ghent. In the same publication, I made known the year of Jan Spierinc's death, unknown until then. One may be surprised that from then on, Pächt and Jenni attributed to me an opinion absolutely opposed to the one I had formulated, furthermore insinuating that I neglected to take the date of Jan's death into account, a date that they themselves could only have known from the above passage in my article.[74]

The single reference to Jan's name in the accounts of the booksellers' confraternity of

Bruges seems to suggest that he was not very active in Bruges. In any case, he never had the intention of leaving Ghent for long, and everything leads us to believe that he abandoned his activities as an illuminator early on to take an interest in the businesses managed by his father-in-law, unquestionably more profitable than the practice of illumination. His marriage to Lievine, the daughter of Felix Brijssincx, a wealthy furrier with a presence at the Marché du Vendredi, seems to have changed the course of things.

Jan then affiliated with the guild of furriers (*lammerwerckers*) on March 5, 1481, and with the wardrobers (*oude-cleercoopers*) on January 23, 1482, his father-in-law then being the Dean of this guild.[75] On Easter in 1484 (that is, April 18), he was also admitted into the guild of curriers (*grauwwerkers*).[76] The intentions that we would assume based on these affiliations are confirmed by the contract that Jan had previously executed with his father-in-law. With this contract, signed March 2, 1481, Jan had bought the house at the Marché du Vendredi called *De Pollepele* ('The Ladle'), where Brijssincx was living. This house was located on the south of the market square, toward the corner farthest from the Church of Saint James.[77] The property's importance is clear from the very high price of 217 lb. of groats. The agreement furthermore included Jan's takeover of a stock of garments with a value of 40 lb. of groats. Therefore, it was actually a family arrangement that would allow Jan to take up and continue his father-in-law's business. One clause of the contract moreover reserves the latter's right, and that of his wife, to live in a portion of the property's back buildings at no expense for life, and also to use half of the garden.[78] Jan paid 27 lb. at closing, and it was agreed that payment of the balance of the 257 lb. to which the whole transaction amounted could be settled at a rate of 10 lb. per year. The payment of the remaining 230 lb. still due would thus be spread out over twenty-three years.

Jan was not able to complete this payment. He died when still relatively young, in his house at the Marché du Vendredi, before May 18, 1490. He left a minor daughter, *Betkin* (Elisabeth).[79] Jan's only daughter had the first name of her aunt, Nicolas's sister, already mentioned above.

Jan possessed quite an important estate. Over the course of the 1480s, we find him cited frequently in documents concerning the management of his property. We also see him constantly building up new revenues through the purchase of annuities.[80] His marriage and his businesses certainly seem to have made Jan the wealthiest member of his family, which could explain why his father turned to him in 1482, 1486, and 1488 to sell him annuities.

Among Nicolas Spierinc's children, Nicolas the Younger or Nicolas II is the one who left the fewest traces in the archives of Ghent. On April 19, 1482, he established an annuity at the profit of his brother Jan and the latter's wife, Lievine Brijssincx, and committed to return the capital of 10 lb. within three years, or, in default of restitution, to see that this annuity was then fixed to sufficient property located in Ghent or in the Waasland.[81] Once more, the documents reveal the family's Waasland origins.

It could well have been Nicolas the Younger whom we find later on, working as a bookbinder in Cambridge. The binder is quite well known, and a number of bindings made by him and bearing his mark are preserved.[82] We know nothing of the circumstances or timing of his departure for England.[83] He was in Cambridge at least from 1514–1515, and very likely from 1505–1506.[84] Erasmus seems to have known him, and mentions him among several old friends and booksellers to whom he sends his complements, in a Christmas letter of 1525 addressed to Dr Robert Aldrich of King's College. He lived in Saint Mary's Parish, where he was elected churchwarden on several occasions, like his colleague Garret Godfrey, himself also a native of the Low Countries. In 1534, along with Garret Godfrey and Segar Nicholson, he was officially named University 'stationer' and printer. His will, dated August 20, 1545, has been preserved. His wife was named Agnes. He had a son, William, who in turn had a son named Nicolas.[85] When he died toward the end of 1545 or the beginning of 1546, Nicolas II must have reached an advanced age.

The sum of the information at our disposal regarding Nicolas Spierinc senior's financial situation, and the property that he possessed, acquired, or gave up, gives the impression that he was perhaps not particularly apt at managing an estate and using the money that passed through his hands in a reasonable and thoughtful way. He seems to have too often needed to resort to the sale of annuities to have liquid assets at his disposal, always burdening more of the property constituting his inheritance. However, if this impression corresponds with reality, it still does not allow us to conclude that he ended his days in a precarious financial situation. Refined illuminator and brilliant calligrapher that he was, he would probably have been assured of regular income. He may have known some difficulty when he had to face the consequences of the tragic dispute with Pieter van den Doorne. We have no indication of the amount of the damages that the Spierincs would have had to pay the victim, but the financial repercussions of the offence could have been severe. We must also take into account the expenses of the voyage and the loss in earnings as a result of the long absence on pilgrimage. But these circumstances do not seem to have been really liable to hamper him. Indeed, a fiscal document of 1493 relating to his inheritance of property in the neighborhood of Saint James Parish permits us to establish that *Meester Claeys Spierinc* belonged to the category of its most well-off inhabitants.[86]

The moderate amount of 6 sols 6 deniers for the inheritance tax seems to confirm that the figure this charge amounts to was not necessarily proportionate to the part of the inheritance to which it relates. As Victor Fris and Georges Hulin de Loo saw it, concerning the inheritance tax paid on the estate of Hubert van Eyck,[87] it seems that one must imagine with regard to this tax that certain estates in effect profited from preferential treatment. A detailed analysis of all the data concerning the property transactions and setting up of annuities, and of complementary research attempting to establish the source of the property that

Nicolas possessed, could contribute a clearer view of the fluctuations of his financial situation and the history and genealogy of the Spierinc family.

It would be fortunate if these investigations could also clarify more for us with regard to his activity as an illuminator and the relationships that he maintained in Ghent's artistic circle. The only indications that have come down to us through the local archives on these matters are the agreements reached with his colleague, Émeric van Bueren, during the purchase of the house at Hoogpoort in 1460, and the new agreement reached between them at the time of the latter's financial problems in 1464. Spierinc's first contacts with van Lathem could go back to the first years of their practice in Ghent, and could predate van Lathem's dispute with the Guild or his departure from the city toward the end of 1458 or the beginning of 1459.

Although we have no explicit reference to it, Nicolas was undoubtedly a member of the painters' guild. As van Lathem had done, new masters often enlisted in Ghent in order to pay the rather high fee for the *maîtrise* in annuities. Affiliates of the Guild of Saint Luke in Ghent are known to us only through the recording of new masters' debt acknowledgements at the time they acquired the *maîtrise*, and not—as in Bruges or Antwerp, for example—through the guild's register. The names of masters with sufficient means at their disposal to pay their *maîtrise* debt at once therefore do not appear in the aldermen's registers where these acknowledgements of debt are recorded. The same thing could also happen

when an artisan was admitted directly after having done his apprenticeship or when he acquired his *maîtrise* in another city. It is therefore important to take into account the definite gaps in the list of affiliates for the Ghent painters' guild.[88] At the beginning of his career, Nicolas Spierinc apparently had rather significant means at his disposal. It would therefore hardly be surprising that he could have acquired the *franchise du métier* without having to contract any debt.

His talent and his success doubtless assured Spierinc the respect of his fellow book artisans. It could be that, among the members of the Ghent corporation, some people did not appreciate his good relations with van Lathem. The latter's falling-out with their guild could have left some enduring animosity.

Although he was equally an illuminator, his reputation as a calligrapher no doubt earned him commissions limited exclusively to the writing of a manuscript's text. This could explain the case of the book of hours at the Biblioteca Nacional de Madrid, Vit. 24-10, which is written by Spierinc. The illumination of this manuscript does not approach the level of quality of the other manuscripts that he wrote. Among the artisans who contributed to the execution of these Hours is the 'Master of the Feathery Clouds', a Dutch illuminator of rather middling talent who sometimes worked in Ghent, where he illuminated manuscripts, notably for the Abbey of Saint Peter.[89] The illuminator of the calendar for this book of hours seems to be the same as the one who illuminated a calendar written against a

black background, preserved in Budapest (Orzàgos Széchényi Könyvtär, Nat. Bibliothek, Ms. lat. medii aevi 396). In its numerous cadels and other graphical caprices, but not at all in its illumination, this manuscript in Madrid is close to the Vienna Hours of Mary of Burgundy (Vienna, ÖNB, Cod. 1857). Its rubrics are in French, but we do not know for whom it could have been intended.

The duke's prayer book and the manuscript of the *Ordonnance du premier écuyer* (Vienna, ÖNB, Cod. s. n. 2616) are the only surviving manuscripts for which the attribution to Spierinc has been documented. The quality of these works and of the other services that Nicolas provided for the duke must have contributed to creating new commissions from members of the duke's family or the court circle. Spierinc's calligraphy can be found, among other places, in three highly luxurious books of hours: that of Mary of Burgundy (Vienna, ÖNB, Cod. 1857), perhaps even originally commissioned for or by Margaret of York ;[90] the Hours executed for Engelbert of Nassau (Oxford, Bodleian Library, Ms. Douce 219–220) and later passed on to Philip the Fair after having been adapted ; and, finally, still another book of hours, with several borders decorated by the inscription 'Voustre demeure' (Madrid, Biblioteca Nacional, Vit. 25-5). A collection preserved in Berlin (Kupferstichkabinett der Staatlichen Museen, Ms. 78 B 13) contains some twenty miniatures that were removed from this manuscript in the eighteenth century.

These three manuscripts testify to Spierinc's importance at the heart of Ghent's art-istic circle. They contain, in effect, the masterpieces of the production attributed to the Master of Mary of Burgundy, the circle's most brilliant illuminator. The identity of this anonymous artist remains one of the most nagging enigmas of the history of art in Ghent. Undoubtedly I went too far when, in 1969, I thought he could be identified with Spierinc.[91] We must not, however, disregard the fact that Spierinc played a major role in the realization and organization of these three manuscripts' production, which we can agree in recognizing as exceptional masterpieces. The Master of Mary of Burgundy and Spierinc therefore certainly seem to have been very close to one another. As Nicolas was also active in his capacity as illuminator, we may question whether Nicolas's participation in the realization of these masterpieces was limited to the calligraphy and the *jeux de plume* embellishing their pages. The anagram of Nicolas Spierinc appearing in the border of the miniature of the Way to Calvary on fol. 94v of the Vienna Hours of Mary of Burgundy confirms that he also worked with a paintbrush, which moreover emerges clearly from the references to payments relating to the Ordinance books (ap. 1, doc. 4 and 5). In contrast to the frontispiece miniatures that he had brought back from Antwerp for the eight separate small books, the more expensive one that appeared at the beginning of the collection of Ordinances intended for the duke could have been painted by Nicolas. It could be that Nicolas had this miniature brought from Antwerp at the same time as those of the eight separate small books. But he could also have reserved for himself the

execution of the miniature that was to serve as a frontispiece to the collection intended for the duke's personal use. It cost 18 s., and not 16 s. like the others (ap. 1, doc. 4 and 5). The higher price paid for this miniature proves that it was different from those in the series of eight intended for the eight separate Ordinance books, but does not allow us to settle the question of its authorship. We must therefore admit that many questions still remain unanswered with regard to the works that Spierinc could have executed in his capacity as illuminator.

Endnotes

1 The large amount of new information set out in this chapter supplements and profoundly alters what I had formerly published on the history of the Spierinc family: De Schryver 1969/1, pp. 45–50 and 1969/2, pp. 436–437. I would very much like to thank Daniel Lievois for the generosity and the enthusiasm with which he has helped me in verifying certain archival references and in passing on several that were unknown to me. His comments, and the discussions that I was able to have with him, have been most useful to me.

2 AGR, CDC, *Livres de rentes du pays de Waas*: n° 45227, fol. 23v; n° 45228, fol. 183v, 187, 189v, 197, 203v, 213r and v, 214v, 220v, 223r and v: n° 45230, *passim* (all these references under the rubric 'Zwijndrecht' in these registers). Other references to Spierinc in Zwijndrecht in: C. Serrure, 'De weerbare mannen van het Land van Waas in 1480, 1552 en 1558' *Maetschappij der Vlaemsche Bibliophilen*, 3rd series, n° 6 (Ghent 1861) p. 12 and 18–19; de Schoutheete de Tervarent, *Livre des feudataires des comtes de Flandre au Pays de Waes, au XIVe, XVe et XVIe siècles*, (1872) p. 95 and 521. L. de Burbure, 'Familles du Pays de Waes affranchies en 1243. Généalogies de leurs descendants aux XIVe et XVe siècles (1350 à 1511)', *Annalen van den Oudheidkundige Kring van het Land van Waas* 7 (1877–1879), p. 294—the name appears in these *livres de rentes* in the form *Spierinc*, and sometimes also in the variants *Spirinc, Spierinx, Spierijnc, Spierijncs, Spierins*, etc. In the Ghent archives, the form *Spierinc* almost always ends with a *c*. Regrettably, authors have not always paid attention, leading to confusion with the Holland illuminator

Spierinck (see notes 187 and 188, below). Most often, Nicolas's first name is given in one of the shortened forms, *Claeys, Clais, Clay, Claes*. Also, rarely, *Nicholaus* or *Niclaus*.

3 SAG, series 301, n° 55, vol. 2, Keure 1479–1480, fol. 99v; idem, n° 56, fol. 151v; idem, n° 61, fol. 98v; SAG, series 152, *Terriers des cens de la ville*: n° 7, fol. 18 and n° 8, fol. 29.

4 The documents cited in the two prior notes, and a number of others, allow us to confirm this.

5 SAG, series 152, Terriers des cens de la ville, n° 7, fol. 18r.

6 It could not be as a calligrapher that Spierinc was designated 'Master' in Ghent. Other known calligraphers were not qualified there as masters.

7 For example, in the writing of books, analogous to the one followed by Joos Stervinc, filius Jans, who was admitted as an apprentice on August 30, 1452, by Pieter Jooris.
He promised *te leerne boucken scriven* (to learn to write books) as a new apprentice. The apprenticeship lasted four years, during which time the master committed to feeding the apprentice and providing his shoes. SAG, *Keure 1452–1453*, series 301, n° 42, fol. 24v. If Spierinc had already done such an apprenticeship, which could go together with that of an illuminator, it is not certain that he did so in Ghent.

8 On the history of Ghent and the city's conflict with Philip the Good, see: Prevenier and Boone 1989..

9 J. Wils, *Matricule de l'Université de Louvain*, vol. 2 (Brussles 1946), p.16. It is error in error that Wils believed this inscription could have concerned a provost of Herenthals, mentioned in 1482 and also named Nicolas Spierinc. The registration also indicates that Spierinc came from the diocese of Tournai, which is the case for our calligrapher and illuminator. De Schryver, 1969/1, p. 46; Idem, 1969/2, p. 436.

10 E. Reussens, 'Documents relatifs à l'histoire de l'Université de Louvain (1425–1797)', *Analectes pour servir à l'histoire ecclésiastique de la Belgique* 27 (1899), pp. 304–307; De Schryver 1969/1, p. 46; De Schryver 1969/2, pp. 436–437.

11 Laborde 1849–1852, pp. 478 and 481 (references in the accounts of 1461–1462 and 1463–1464).

12 Regularly mentioned in this capacity in the documents of the ducal *Chambre des Comptes*. For example, in November of 1468 and November of 1469: AGR, CDC, n° 1923, fol. 306r and n° 1924, fol. 220v.

13 For example in 1481: ADN, CDC, B. 2126/68799.

14 Still cited as such in 1499, the year of his death: for example, Finot, *Inventaire sommaire des archives départementales antérieures à 1790*, vol. 8 (Lille 1906) p. 84, n° B. 3457. He died in Leuven on October 7, 1499: C. Van Bambeke, 'Spierinck (Jean)', *Biographie Nationale de Belgique*, t. 23, col. 341–342. This ducal

physician was a clerk, and obtained a canon's prebend from the Church of Saint Peter in Leuven.

15 AGR, CDC, n° 1925, fol. 374r. De Schryver 1969/1, p. 46. During this period, doctors were obliged to be astrologers as well. They often composed almanacs and prognostications. This literary genre was sometimes used for propagandistic ends: A. Abel and M. Martens, 'Le rôle de Jean de Vésale, médecin de la ville de Bruxelles, dans la propagande de Charles le Téméraire' *Cahiers Bruxellois*, 1, 1956, pp. 41–86. A fragment of an almanac printed by Jean Spierinc for the year 1484 has been preserved. It is probably a test sheet or an apprentice's exercise. The fragment was discovered in an antique binding. *De vijfhonderdste verjaring van de boekdrukkunst in de Nederlanden*, exh. cat. (Koninklijke Bibliotheek Albert I, Brussels 1973), pp. 387–389, entry by E. Cockx–Indestege, with previous bibliography. French edition: *Le cinquième centenaire de l'imprimerie dans les anciens Pays-Bas*, pp. 386–388. In this last edition, the year of Doctor Jean Spierinc's death was omitted by mistake, and the context could lead one to believe that he died in 1479. His death properly dates to October 7, 1499.

16 A member of the university was removed from the aldermen's authority and jurisdiction, and enjoyed certain privileges. Sometimes people only enrolled at university as a strategy to enable them to practice their crafts without having to affiliate with the local guild, or to take advantage of other privileges. It has been thought that perhaps this was the reason that Martin Schongauer and a painter called Nikolaus Eisenberg enrolled at the University of Leipzig in 1465. Panofsky 1953, pp. 157 and 421, note 2 (with an error regarding Schongauer's age ; Panofsky still places his birth around 1430 instead of about 1450). A. Châtelet, 'Schongauer, documents biographiques' (Colmar 1991), pp. 38–39. A certain Jacques Roberti, who began to pursue studies at the University of Leuven at the end of 1450, was registered since 1449 *pour goyr des previleges*. J. Wils, 'Les dépenses d'un étudiant à l'Université de Louvain (1448–1453)' *Analectes pour servir à l'histoire ecclésiastique de la Belgique*, 3rd series, tome 2 (32, 1906), pp. 494 and 498.

17 M. Smeyers, 'Het Leuvens Boekbedrijf (tot ca. 1550)', *Erasmus en Leuven*, exh. cat. (Stedelijk Museum, Leuven, 1969), p. 158. Later, booksellers also had to register and submit to certain rules. The decisions that were made on the matter, on December 27th, 1523, are evidently tied to the diffusion of Reformation ideas. See *Erasmus en Leuven*, op. cit., pp. 170–171, n° 148.

18 If he were not really a student, he doubtless would not have lacked this support had he registered at another faculty.

19 'Dioscorides Longobardus (Cod. lat. Monacensis 337). Aus T.M. Aurachers Nachlass herausgegeben und ergänzt von Hermann Stadler', *Romanische Forschungen* X (1899), pp. 214 and 435. De Schryver 1969/2, pp. 441–443. One cannot doubt that it was surely Spierinc who invented the term *cybauries*. The terminology that the account-keepers use is the one employed by the artist or artisan in the statement detailing his work, according to which the account article is drawn up.

20 De Schryver 1969/2, p. 442 and note 39.

21 J. Le Goff, *Les intellectuels au moyen âge* (Paris 1957), p. 85; P. De Ram, 'Anciens Statuts de la Faculté de Médecine de Louvain', *Compte-rendu des séances de la Commission royale d'histoire ou recueil de ses bulletins*, 3rd series, tome 5, Brussels 1863, pp. 395–396.

22 Moreover, the statutes of the Faculty of Leuven anticipated the conditions of admission for those who had already studied medicine at another university. P. De Ram, idem, p. 396. Such situations were therefore not exceptional. Spierinc's name does not appear on the rolls of the Universities of Cologne, Heidelberg, or Freiburg. I would like to thank Mme H. De Ridder-Symoens, who permitted me to verify this with her, assisted by her research on students from the Low Countries in foreign universities. For medical studies, during this period we must think especially of Montpellier or, en Italy, of Padua or perhaps Bologna (the importance of Salerno was no longer what it had been a few centuries before).

23 SAG, series 301 n° 44, *Keure 1457–1458*, fol. 92r. Document cited in: M.C. Laleman, D. Liévois, and P. Raveschot, 'De top van de Zandberg. Archeologisch en bouwhistorisch onderzoek', *Stadsarcheologie. Bodem en Monument in Gent*, 10 (1986), p. 37. We warmly thank Marie Christine Laleman for having drawn our attention to this study, and to the unpublished documents to which it refers.

24 In the document cited in note 139, it is explicitly stated regarding this house *ende es eenen steen*. (SAG, series 301, n° 46, *Keure 1460–1461*, fol. 28r). Saint George square was the seat of the important crossbowmen's Brotherhood of Saint George.

25 SAG, series 301 n° 46, *Keure 1460–1461*, fol. 28r.

26 Van Bueren, who is mentioned here as a *scriveyn*, or elsewhere as a *boucscrivere*, was admitted as an illuminator into the Painter's Guild on July 12th, 1463. Van der Haeghen 1899, p. 56. E. de Busscher, *Recherches sur les peintres gantois des XIVe et XVe siècles*, Gand, 1859, p. 110. He still lived opposite the Cour Saint-Georges in July of 1468. V. Fris, *La Restriction de Gand (13 juillet 1468)* (Ghent 1923), p. 66.

27 The *Hoogpoort* connected the old castle of the counts to the Hôtel de Ville, and extended beyond the latter.

28 The price of 26 *livres* of groats was paid in a year and a half: 9 lb. at the close of the sale, 9 lb. on October 1, 1458, and 8 lb. on October 1, 1459. The property was resold for 29 lb., to which was added 2 lb. 8 s. of furnishings. Spierinc obtained 3 more *livres* than he had paid, but this profit was cancelled out by the method of payment. This time, the payments were to be made in five annual installments of equal amount, to be paid on Christmas Eve from 1460 to 1464.

29 *Ende zal voort de selve meester Clais met zijnen wive de achtercamere moghen bewonen een jaer lanc durende zonder zynen cost.* Act cited in note 25.

30 SAG, series 301, n° 48, *Keure 1464–1465*, fol. 16r.

31 In the margin of the Act cited in note 25, above: *deleta per me de consensu magistri Clais Spierinc. Actum 3ª novembris aº 1464.*

32 De Schryver 1969/1, p. 48; Idem, 1969/2, p. 448.

33 It is in these terms that they are identified at the time of the payment to the goldsmith Gaspard de Backere of Brussels for the metalwork ornaments with which their bindings were provided. De Schryver 1969/2, pp. 452 and 455.

34 The Ordinances of the palace positions decreed the obligations and specified the qualifications of what one might call eight different departments in the prince's *hôtel*. They include the specific regulation to which each of these different departments had to conform. The details of the account article proves that the eight books, the one in Vienna and the seven that are lost, were all identically arranged, and that each of these eight Ordinances comprised the same number of articles. De Schryver 1969/2, pp. 439–441, note 30. It is therefore in error that Pächt and Thoss speak of eight examples of the same text: Pächt/Thoss 1990, p. 37 and D. Thoss, *Flämische Buchmalerei: Handschriftenschätze aus dem Burgunderreich*, exh. cat. (Vienna, ÖNB, 1987), p. 63. It is also in error that these authors seem to believe that the *Ordonnance du premier écuyer* (Vienna, ÖNB, Cod. s.n. 2616) was originally intended for Antoine de Bourgogne, whose device *Nul ne sy frote* can be read above the window on the left of the miniature. I have provided a possible explanation for the presence of this device: De Schryver 1969/2, pp. 450–451. It is also possible that the manuscript passed into the hands of Antoine de Bourgogne later on, and that the device was added then.

35 This is what Delaissé assumed based on the fact that he worked there, and departed from there for The Hague. (See L.M.J. Delaissé, *Le Siècle d'or de la miniature flamande : le mécénat de Philippe le Bon*, exh. cat., Brussels 1959, p. 137.)

36 Appendix 1, doc. 4; De Schryver 1969/1, pp. 48–49 and 100; De Schryver 1969/2, pp. 439–440 and 457.

37 This scene does not concern the presentation of a work to the duke. The subject represented is the installation of the *premier écuyer d'écuyerie*, and the duke handing over a copy of the Ordinance whose prescriptions he would have to observe, or have observed by those under his authority. The scene's composition can be compared with that of van Lathem's presentation miniatures. A sketch from Lieven's workshop could have served as a model for the *histoires* in the eight small books.

38 SAG, series 301, n° 53, *Keure 1475–1476*, fol. 77v. This concerns the important Beguine convent with its entrance on the *Lange Violettenstraat*. In Ghent it is called the 'little' Beguine convent, as opposed to the older and still more important Beguine convent of Saint Elizabeth.

39 His house was a few dozen meters from the Convent of the Poor Clares, where Saint Colette died in 1448. Margaret of York gave the convent a very beautiful manuscript of the *Vie de Sainte Colette*. The old convent has disappeared. The nuns, who still preserve their manuscript, are now established in another part of the city, near the Church of Saint Elizabeth, where they went to settle in 1835.

40 This is the case for the Hoogpoort house that he had re-sold in 1460, and the two houses on Burgstraat, not far from the counts' castle, that Nicolas sold in 1479. SAG, series 301, n° 55, *Keure 1478–1479*, fol. 135r.

41 On February 27, 1480, he rented out a property in Zwijndrecht for 12 years to Gilles Lisbrouc. It concerns the land and the buildings on it. SAG, series 301, n° 55, vol. 2, *Keure 1478–1480*, fol. 99v.

42 SAG, series 301, n° 55/2, *Keure 1479–1480*, fol. 127v.

43 SAG, series 301, n° 56, *Keure 1481–1482*, fol. 9r. Act of August 23rd, 1481. It concerns the sale of the abovementioned brewery and the neighboring lots, situated next to Nicolas's residence. One clause reserves him rights over a portion of the land situated in back of and along the house that he owns on Saint Catherine's Street.

44 SAG, series 301, n° 56, *Keure 1482–1483*, fol. 165v.

45 SAG, series 301, n° 58, *Keure 1482–1483*, fol. 162r. This street owes its name to the sanctuary in town that the Cistercian Abbey of Baudeloo in the Waasland owned there.

46 Of the price of 28 lb., he paid only 2 lb. down in cash. The rest would be paid by annuities of 2 lb., payable on the Feast of Saint John (June 24), starting in 1485. SAG, series 301, n° 58, *Keure 1484–1485*, fol. 83v.

47 SAG, series 301, n° 59, *Keure 1486–1487*, fol. 6v.

48 On November 16, 1489, Heyndric van den Doorne purchased an annuity for the very high sum of 23040 *deniers*, or 96 lb. of 40 Flanders groats. It shows up in a study of the property market during the years 1483–1503, which presents only one other case frothis period of a person purchasing an annuity for as great a sum. It concerned the eminent jurist

Philippe Wielant, councillor of the Dukes of Burgundy, president of the Council of Flanders, member of the Great Council, an important and very wealthy figure. M. Boone, M. Dumon and B. Reusens, *Immobiliënmarkt, Fiscaliteit en Sociale Ongelijkheid te Gent, 1483–1503*, (Anciens Pays et Assemblées d'États, vol. 78, Kortrijk–Heule, 1981), p. 211, n. 17.

49 A document of 1499–1500 allows us to locate it at the south of the Marché du Vendredi, toward the corner of the square close to the Church of Saint James. F. de Potter, *Gent, van den oudsten tijd tot heden*, vol. 6 (Ghent 1891–1892), p. 337.

50 Heyndric and Pieter van den Doorne, as well as Jan Spierinc, appear in an enumeration of the members of the Furriers Guild, given in a document of August 18, 1481. Heyndric was then one of the four Jurors of the profession. SAG, series 301, n° 56, vol. 2, *Keure 1481–1482*, fol. 4r; published: F. de Potter (see prior note), pp. 58–60. The guild was divided into two branches, according to the nature of their affiliates' activities. The van den Doornes had each chosen a separate branch, and could therefore have practiced the two types of occupation maintained for members of the guild.

51 Jan was both a furrier and a wardrober (see below). This explains the intervention of members of the two guilds in this reconciliation, and confirms that the dispute that was the root of the affair was of a professional nature. Here we are confronted with one of the cases where corporate entreaties in some way took the place of the aldermen's judicature. On this subject, see M Boone, 'Les gens de métiers à l'époque corporative à Gand et les litiges professionnels', in *Statuts individuels, statuts corporatifs et statuts judiciaires dans les villes européennes (moyen âge et temps modernes)*, Actes du colloque tenu à Gand les 12–14 octobre 1995, eds. Marc Boone and Maarten Prak, (Leuven/Apeldoorn 1996) pp. 23–47.

52 SAG, series 301, n° 58 vol. 3, *Keure 1485–1486*, fol. 81r.

53 *te quytten enne ontheffene tegen heere en wette, surigien ende medechyne met al datter ancleve ... zonder Pieters cost ofte last* (Act cited in the prior note). It is rather curious to note that one of the guilty parties, Thomas, was himself a doctor...

54 J. van Herwaarden, 'The effects of social circumstances on the administration of justice: the example of enforced pilgrimages in certain towns of the Netherlands (14th – 15th centuries)', Centrum voor Maatschappijgeschiedenis, Erasmus Universiteit Rotterdam, Informationbulletin n° 5, 1978, pp. 7–11; J. van Herwaarden, *Opgelegde Bedevaarten… in de Nederlanden gedurende de late middeleeuwen (ca 1300 – ca 1550)* (Assen/Amsterdam 1978), pp. 75–81. For the price of pilgrimage reparations in

Ghent: idem, pp. 628–640; A. Viaene, 'De Tarieflijst van gerechtelijke Bedevaarten van Geraardsbergen en van Gent', *Handelingen van het Geschiedkundig Genootschap, Société d'Emulation*, 104 (1967), pp. 203–214; republished in: A. Viaene, *Vlaamse Pelgrimstochten*, (Bruges 1982) pp. 88–99.

55 F. De Potter 1891–92, p. 337, n. 3.

56 Act of January 22, 1495, alluding to debts contracted toward him for treatment provided. He is explicitly cited as *medicijn*, and also qualified as *meester*. SAG, serie 301, n°61, *Keure 1494–1495*, fol. 98v.

57 SAG, serie 301, n° 58, *Keure 1484–1485*, fol. 114r and 121v.

58 Act cited in the prior note, and SAG, series 301, n° 60, vol. 2, *Keure 1488–1489*, fol. 122v and n° 62, vol. 2, *Keure 1493–1494*, fol. 31v and 47r.

59 April 18, 1488: acknowledgement of Thomas's debt to his brother Jan (SAG, series 301, n° 59, vol. 3, *Keure 1487–1488*, fol. 87r). January 22nd, 1495: Act settling a matter of debts among Thomas Spierinc, his father-in-law Joos metten Evenen, and his father Nicolas (SAG, series 301, n° 63, *Keure 1494–1495*, fol. 98v).

60 SAG, series 301, n° 59, *Keure 1487–1488*, vol. 3, fol. 82v.

61 SAG, series 301, n° 60, *Keure 1488–1489*, fol. 19r. Jan's widow declares in this Act that the annuities previously agreed upon between Master Clais and his son Jan are null and void. For more details on Jan's biography and professional activities, see below.

62 SAG, series 301, n° 64, *Keure 1496–1497*, fol. 124v.

63 SAG, series 301, n°65, *Keure 1498–1499*, fol. 101v. Such a garment was often a costly luxury. The document speaks of a *keerle*, which was usually a valuable garment made of fine materials and often lined with fur. E. Verwijs and J. Verdam, *Middelnederlandsch Woordenboek*, vol. 3, col. 1366–1367. Spierinc obtained it from Lieven de Vettere, who had married Jan Spierinc's widow, and who apparently continued Jan's activities as a furrier and *wardrober*.

64 *Item vander versterften van meester Claeys Spierinc vanden vier deelen van viven vanden gheheelen goede dat deelden Thomaes Spierinc, Clemme Spierincx met Joos metter Evene, haeren man, ende diere meer ancleven 6 schelling 6 denier groot*. SAG, series 400, n° 35, *Comptes de la ville 15 août 1500 – 15 août 1501*, fol. 19r, under the rubric *Yssuen* (inheritance taxes). (In translation: 'Item, of four parts out of five of the estate of Master Claeys Spierinc, divided by Thomas Spierinc, Clémence Spierinc with Joos metter Evene, her husband, and the other interested parties, 6 s. 6 d.').

65 See document cited in note 31.

66 SAG, series 301, n° 54, *Keure 1477–1478*, fol. 29r. Cited by van der Haeghen 1899, p. 58 and E. Corne-

lis, 'De Kunstenaar in het laat-middeleeuwse Gent. II'. *Handelingen der Maatschappij voor Geschiedenis en Oudheidkunde te Gent*, nieuwe reeks, 42 (1988), p. 134.

67 She was Pieter Rousseel's widow. She is mentioned in the obituary of the Paris of Saint John, where she died one June 23 at the end of the 15 or beginning of the 16th century. *Obituarium sancti Johannis: Nécrologe de l'église St. Jean...*, ed. N. de Pauw, Bulletins de la Commission royale d'Histoire, 5th series, t. 1 (1890), p. 125. On November 4, 1483, Master Claeys Spierinc was the guarantee for one Gilles Spierinc during a sale of six tons of Flemish honey (*Vlaemsche huenich*). SAG, series 301, n° 57, *Keure 1482–1483*, fol. 52r. Gilles must be a relative of Nicolas. Was he his nephew and a son of Elisabeth?

68 Ghent, Archives of the Church of Saint James, n° 1472, fol. 15r. It is in error that this inscription has been dated to 1484: G. Hulin de Loo, 'Jean Spierinc', *Biographie Nationale de Belgique*, vol. 23 (Brussels 1921–24) col. 340. The register where it appears was indeed begun in 1484, but one can prove that the names copied in the same hand at the beginning of the list are those of older members. As was frequently the case in the opening of a new register for such confraternities or associations, one first copied the names of living members who had affiliated previously. This *Chambre de Rhétorique* was officially recognised by the aldermen on August 14, 1478. M. Beyaert, *Opkomst en bloei van de Gentse Rederijkerskamer Marien Theeren* (Ghent 1978), pp. 10 and 28.

69 J. Weale, 'Documents inédits sur les enlumineurs de Bruges', *Le Beffroi*, (4, 1873), p. 298. It is out of confusion that F. Lyna has Jan as a member of the Painters Guild or the Guild of Saint Luke in Bruges. It is also in error, and out of confusion with his homonym from Holland, that this notice suggests that Jan would have worked in Holland ('Jan Spierinc', Thieme and Becker 1907–50, XXXI, p. 373). The two mistakes were unfortunately repeated without verification by: E. Cornelis, 'De kunstenaar in het laat–middeleeuwse Gent. I' *Handelingen der Maatschappij voor Geschiedenis en Oudheidkunde te Gent*, nieuwe reeks, 41 (1987) p. 110, note 100; Idem, 42 (1988), p. 134.

70 A.W. Byvanck and G.J. Hoogewerff, *La Miniature hollandaise* (The Hague 1926), pp. XXIII and 65, n°154, pl. 158 and Fig. 100; G.J. Hoogewerff, *De Noord-Nederlandsche Schilderkunst*, vol. 2 (The Hague 1937), pp. 342–343; A.W. Byvanck, *La Miniature dans les Pays-Bas septentrionaux* (Paris 1937), p. 108.

71 De Schryver 1969/2, pp. 434–435. To arguments based on the quite mediocre quality of these Dutch manuscripts, one might add that the *ck* ending of the Dutch name Spierinck, in comparison with the *c* of *Spierinc* in the Ghent archives, already constituted an indication.

72 De Schryver 1969/2, pp. 434–435, where note 12 refers to an archival document of 1490 declaring Jan's death.

73 At present we know of 16 manuscripts signed by him, of which 15 are dated (1486–1519): K. van der Hoek, 'De Noordhollandse verluchter Spierinck. Haarlem en/of Beverwijk, circa 1485–1519', *Middeleeuwse handschriftenkunde in de Nederlanden 1988: Verslag van de Groningse Codicologendagen* (Grave 1989), pp. 163–182; Idem, 'The North Holland Illuminator Spierinck: Some Attributions Reconsidered', *Masters and Miniatures* 1991, pp. 275–286.

74 Pächt/Jenni 1975, p. 104, regarding Cod. 2734 in Vienna, containing one miniature signed by the Dutch illuminator Spierinck and dated 1487. Pächt/Jenni claim erroneously, and without providing a reference, that Jan lived in Antwerp. They have apparently confused him with the bookbinder Nicolas Spierinc the younger, who Weale confirms passed through Antwerp before leaving for Cambridge. See *infra* and note 200. In a notice on the small book of hours of Mary of Burgundy, F. Anzelewsky also attributed an identification to me that completely contradicts what I had written about Nicolas Spierinc: *Zimelien: Abendländische Handschriften des Mittelalters aus den Sammlungen der Stiftung Preussischer Kulturbesitz Berlin*, exh. cat., (Berlin-Dahlem, Staatliche Museen, 13 Dez. 1975–1 Febr. 1976) p. 227, n° 154. There is even confusion in G. Morello, *Libri d'Ore della Biblioteca Apostolica Vaticana. Catalogo della Mostra. Salone Sistino* exh. cat. (Vatican, Salone Sistino, 1988), (Zurich 1988) p. 52: the index notes *Nicolas Spierinc, enlumineur*, to refer to Ms. Ottob. lat. 2916—signed and dated by the Dutch Spierinck, whose first name is unknown, and who had nothing to do with Nicolas!

75 SAG, series 301, n°56, *Keure 1480–1481*, fol. 75r; SAG, series 301, n° 56, *Keure 1481–1482*, fol. 99v. For this affiliation, as for the preceding one, Jan's father-in-law is the first of his two guarantors.

76 The act was only passed on July 8, 1484, but states explicitly that he obtained the exemption at Easter. SAG, series 301, n° 57, *Keure 1483–1484*, vol. 2, fol. 201v. Félix Brijssincx, Jan's father-in-law, was the first of his two guarantors this time as well. On the same date of July 8th, a second act was recorded, fol. 202r, specifying that Jan had the right to buy new and prepared skins from other members of the guild of curriers (*grauwwerkers*) to make them into the garments that he sold as a wardrober, but he was not authorized to be unprepared skins to prepare them or have them prepared.

77 In the 14th century this was still two houses, *den Grooten Pollepel* and *den Cleenen Pollepel*, that had

been combined. The house had an important wood façade that survived until 1773. F. de Potter, 1891–92, vol. 6, pp. 303–304.

78 SAG, series 301, n° 56, *Keure 1481–1482*, fol. 92r.

79 SAG, series 330, n° 38, *Staten van Goederen 1489–1490*, fol. 107r; series 301, n° 60, *Keure 1488–1489*, fol. 118r.

80 SAG, series 301, several references to purchases and sales of houses, and purchases of annuities in Ghent, in the registers of the aldermen of the *Keure* during the years 1480–1490.

81 SAG, series 301, n° 56, *Keure 1481–1482*, fol. 151v.

82 W.H.J. Weale, *Bookbindings and Rubbings of Bindings in the National Art Library South Kensington*, London 1898, pp. xxxvij–xxxix. G.J. Gray, *The Earlier Cambridge Stationers and Bookbinders and the first Cambridge Printers*. (Illustrated Monographs issued by the Bibliographical Society 13), Oxford 1904, pp. 43–53, pl. VIII–XVIII ; J.B. Oldham, *Shrewsbury School Library Bindings: Catalogue Raisonné*, Oxford 1943, p. 38–41, 84–85 ; H.M. Nixon, *Five centuries of English Bookbinding*, London 1978, n° 7. These authors all use the spelling 'Spierinck'. Gray publishes the variants of the name in the English documents, where the forms end in *g*, alternating with those that end in *ck* (Gray 1904, p. 44).

83 Without citing his sources, Weale (prior note) asserts, p. lxi, that Nicolas the Younger was also an illuminator and that he went to establish himself in Antwerp, whence he would have emigrated to England. Gray repeated this last assertion, which it seems to me deserves attention, even though at present I have found no source that confirms it (Gray 1904, pp. 43–53). Despite the seriousness of Weale's studies, I think it is not impossible that at least one part of what he asserts concerning the Spierincs results from errors or confusions with information that does not refer to the Spierincs, or that relates to homonyms rather than the family of artisans that interests us. It is rather troubling that Weale speaks of a 'family of Netherlandish stationers, illuminators and bookbinders, some of whom were established at Lille and Bruges, others at Audenarde, Antwerp and

Lyon', but neglects Ghent and Brussels, to which our documents refer.

84 A Nicolas, mentioned as a *stationarius* at this latter date without his family name indicated, is very likely Spierinc. Gray 1904, p. 43.

85 This name seems to have been favored in the family. It can be found in several generations since the 14th century. This seems to confirm that the Cambridge binder was indeed the son of Duke Charles's illuminator. For his bindings Nicolas moreover had a plaque engraved (decorating 27 surviving bindings) representing Saint Nicholas and the three children, and bearing his mark, family name, and first name. Gray 1904, pp. 44–48, pl. XVI; Oldham 1943, pp. 84–85, pl. VIII. The carver of this plaque gave the binder's name the ending *ck* : *Spierinck*. Even though we could see in this an argument for doubting that the binder is indeed the son of the master illuminator of Ghent, I nevertheless consider this father–son relationship to be very probably, taking into account the facts as a whole.

86 SAG, series 20, n° 15, "Conestable bouc", fol. 78r. This document has been studied by M. Boone et al., 1981, pp. 116–133. My thanks to Marc Boone, who kindly pointed out to me the reference to Sperienc in this document. Out of a total of 1495 people, Spierinc appears among the 34 who have the most property in this important city parish, which included among other things the *Marché du Vendredi*, where the residences of many wealthy families were located on the border.

87 In a discussion following a J. de Smet exhibition, 'Quelques mots à propos d'Hubert van Eyck', *Bulletin de la Société d'Histoire et d'Archéologie de Gand*, 20 (1912), p. 526.

88 The lists of deans, jurors, and masters have been published in van der Haegen 1899, pp. 46–63. They allow us to verify that the acquisition of the professional franchise of several deans of the corporation has left no trace in the archives.

89 Ghent 1975, n° 607; Marrow 1987, p. 308 and note 27.

90 See Chapter 3, note 28.

91 De Schryver 1969/1, pp. 95–97.

THE GRAPHIC DECORATION OF THE TEXT PAGES

The cadels, arabesques, and drawn motifs with which the text pages of the prayer book are adorned appear to be the fruit of a sort of exuberance of the pen, somewhat baroque and purely gratuitous. Their decorative effect is sometimes enriched with the bright touches of a light and rather matte gold.

The words of the first line of many text pages have cadeled initials, or other more or less developed *jeux de plume*, not justified by the importance of the word or beginning of the sentence. These initials, which the text did not require, had no reason to exist apart from being ornamental. In height, they encroach upon on the margin; in width, however, some of them occupy much more space on the line than a letter in normal script would have occupied. Therefore, they must have been drawn at the moment the calligrapher wrote the text, unless he reserved the necessary width of the line at the time, so that he could add them there afterwards. Whichever the case, one can perceive the care, attention, experience, and skill that the execution of these lines of script required.

Although the cadels give the impression of having been drawn spontaneously at the same time as the letters that they extend, we must remember that they were often added only afterwards. Despite the surety of hand to which the majority of them testify, a difference in ink density on the letters' ascenders often allows us to distinguish where the pen was placed again in order to embellish them with cadels. This same phenomenon can be seen in the manuscript of the *Ordonnance du premier écuyer d'écuyerie* (Vienna, ÖNB, Cod. s.n. 2016), the Vienna Hours of Mary of Burgundy (Vienna, ÖNB, Cod. 1857), or even in the Hours of Engelbert of Nassau (Oxford, Bodleian Library, Ms. Douce 219–220). [1]

Certain whimsical features, which are lost in the margin, lead to a small dragon's head, viewed in profile and very lightly sketched, which by its reappearance on fols. 18v, 27v, 39r, 55v, 64v, 77r, 81r, 83v, 115r, and 121r almost takes on the value of a signature. This small head, which is also found in some cadeled initials, is in fact only a characteristic—but discrete—interpretation of an old motif of Gothic illumination.

Folios 38v and 113v of the prayer book are decorated with a flower that has a design close to that of the stylized Rose of York. Must we see here an allusion to the duke's wife? This rose is also found in the Vienna Hours of Mary of Burgundy, on fols. 7v, 53v, and 77v, which would appear to confirm the presumption that this

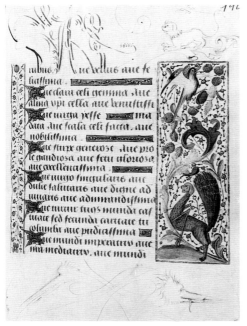

Fig. 5: *Folio from the Litanies of the Virgin : dog in the margin.* Book of Hours. Madrid, Biblioteca Nacional, Ms. Vit. 24-10, fol. 190r.

manuscript was originally intended for Margaret of York. However, this Rose of York could have appealed to Spierinc for its decorative qualities alone. Indeed, he repeated it twice at the bottom of fol. 190v of Ms. Vit. 24-10 in the Biblioteca Nacional, Madrid, where it does not appear to have an emblematic intention.

Certain motifs were inspired by the texts that they adorn. In the prayer where the duke invokes Saint Christopher to avert conspiracies or other dangers, the initial of the word *Conspirationes* transforms into a winged dragon (fol. 27v). With its menacing expression, the little monster unquestionably was intended to illustrate the evil and fearsome character evoked by the word for which it forms the initial.

It is again in connection with the text that, on fol. 41 in two symmetrical cadel loops, a dog pursues another animal. In the margin of the text invoking Saint Hubert, the allusion to the hunt, frequent as a marginal decoration and familiar to illuminators for nearly two centuries, this time was not chosen by chance.

One could believe that all of these motifs were drawn spontaneously at the moment that the ornament of the cadels and other fantasies of the pen were added to the page of script. Some of them, however, were borrowed from model sheets or books, where the illuminator kept his discoveries in reserve. The dog on fol. 41r can be found thus on fol. 190r of Madrid Ms. Vit. 24-10 and very lightly traced on fol. 136r of the Vienna Hours of Mary of Burgundy, two other manuscripts written by Spierinc (Figs. 5–6). Certain repeated floral motifs, like the flower that can be found on fols. 13, 37, 59, and 59v, also suggest the use of models.

Through his cadels and penwork fantasies, Spierinc introduced three-dimensionality and trompe-l'œil into calligraphy.[2] The cadels' characteristic play of tracery, the thick and thin strokes that intertwine, appearing to pass successively before or behind the others, create a sense of space.[3] Spierinc moreover sometimes created the illusion that the lines pass through the parchment, then behind it, and pierce back through the folio to reappear. Some illuminators had already timidly played with this trick well before this.[4] But Spierinc accentuates the illusion by the more suggestive manner in which he rendered the small shadowed holes across which the lines or

the acanthus leaf stems are supposed to pass. On fols. 15r, 26v, 28r, 36v, 38v, and 64v, he thus already plays with a kind of *trompe-l'œil*, for which he multiplied the variants in the Vienna Hours of Mary of Burgundy[5] and which, more than a century later, would find its full realization with Hoefnagel. The latter would play virtuosically with this type of effect, not for calligraphy but for the elements of a kind of herbarium. Hoefnagel liked to give the illusion that the stems of certain plants, of which he created images of stunning verisimilitude, passed behind the folio through a slit in the parchment, to reappear a bit lower through another.[6] He pushed the artifice to the point of depicting in *trompe-l'œil* on the reverse of the folio the section of the stem that was supposed to pass there.

Acanthus leaves frequently enhance the cadels' loops or ascenders. They sometimes also nicely decorate the margin, bas-de-page, or upper margin, for example on fols. 35r, 36v, or 40r. Shaded by delicately nuanced touches of wash, they often appear in stunning relief. Other motifs also are rendered with an analogous *trompe-l'œil* effect, such as the flowers on fols. 26v or 37r, and the columbine with its flowers hanging turned down on fol. 59r, which is repeated by transparency on fol. 59v. On fols. 37r, 41r, and 48v, curious imaginary flowers let their petals curl and coil up, just as the acanthus leaves do.

The tracing of pen motifs, like the affixing of wash to nuance shadows owes more to the art of drawing than to that of illumination. These *trompe-l'œil* and relief effects remain one of the characteristic elements

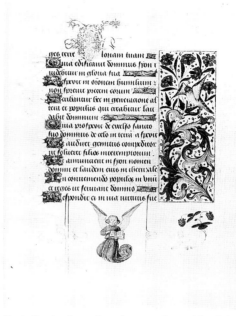

Fig. 6: *Illumination and pen decoration from a folio of the Penitential Psalms (detail).* Hours of Mary of Burgundy. Vienna, ÖNB, Cod. 1857, fol. 136r.

of text pages of the books issued from Spierinc's workshop. In introducing this suggestion of space even into calligraphy, and into the motifs that follow from it, in his way Spierinc participated in the emergence of the new conception of marginal decoration that was still developing. The relief of his flowers and winding acanthus leaves anticipate in their marvelous *trompe-l'œil* the most beautiful borders painted in the course of the 1470s and 1480s.

Endnotes

1 De Schryver 1969/2, p. 444; J.J.G. Alexander, *The Master of Mary of Burgundy. A Book of Hours for Engelbert of Nassau* (New York 1970), pp. 11–12.
2 De Schryver 1969/2, pp. 444–446.
3 Is it not significant that, doubtless because of this impression of space that the cadels suggest, one has

applied the literal meaning of the word *cadelé* to the inequality of surfaces in a relief? La Curne de Sainte-Palaye, *Dictionnaire historique de l'ancien language François…*, vol. 3 (Paris-Niort, 1877), p. 175; De Schryver 1969/2, p. 445.

4 Gorissen 1973, pp. 825–826, Figs 138–140.

5 On fol. 78r of this manuscript, the ascender of a *d* on the second line of text appears to pass through the parchment under the first line of script, to the extend itself in the upper margin. This example is in addition to those mentioned in De Schryver 1969/1, p. 63, note 99.

6 L. Hendrix and T. Vignau-Wilberg, *Mira Calligraphiae Monumenta. Inscribed by Georg Bocksay and Illuminated by Joris Hoefnagel* (The J. Paul Getty Museum), (London 1992), recto and verso of fols. 20, 37, 41, 67, 89, 112, 124, 126.

PLATE XV | 89

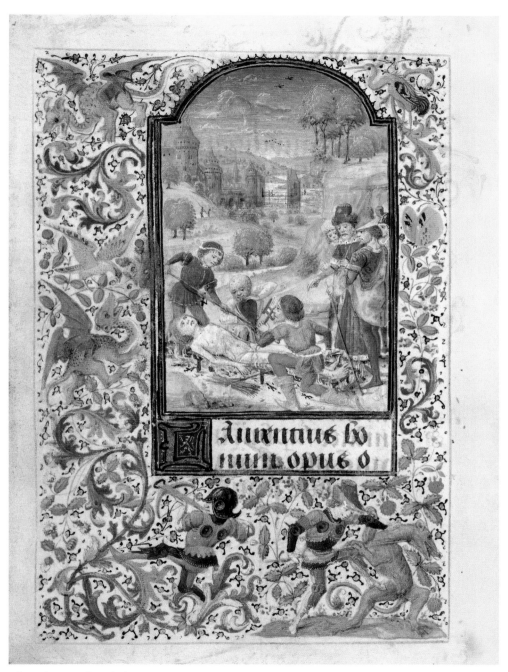

Fol. 31v: The Martyrdom of Saint Lawrence.

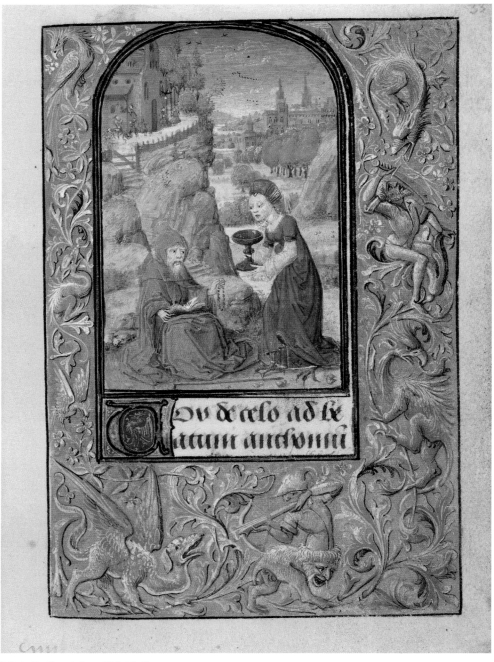

Fol. 33r: The Temptation of Saint Anthony.

PLATE XVII | 91

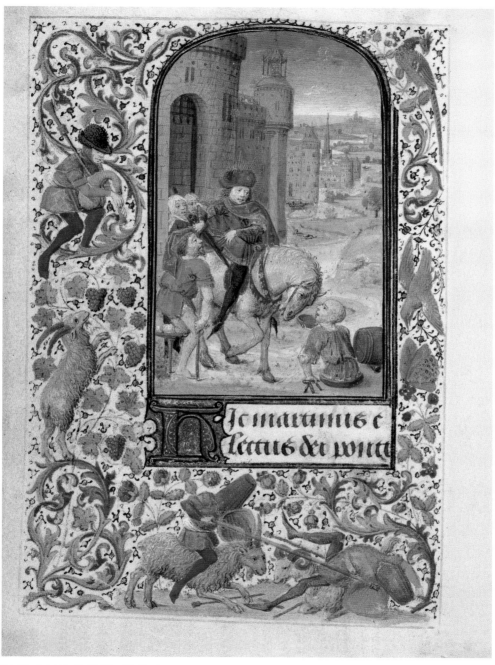

Fol. 34v: Saint Martin Dividing his Cloak.

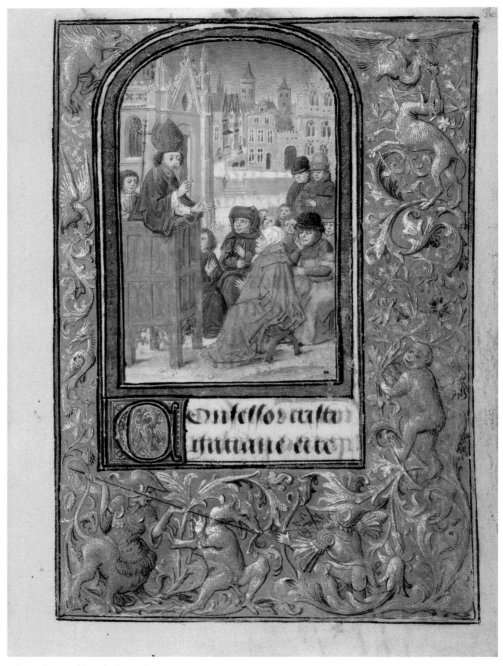

Fol. 36r: The Preaching of Saint Gatien.

PLATE XIX | 93

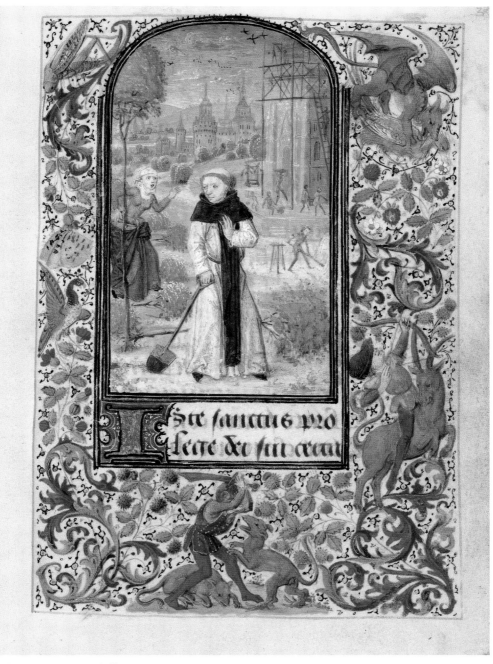

Fol. 38r: Saint Fiacre assailed by a woman.

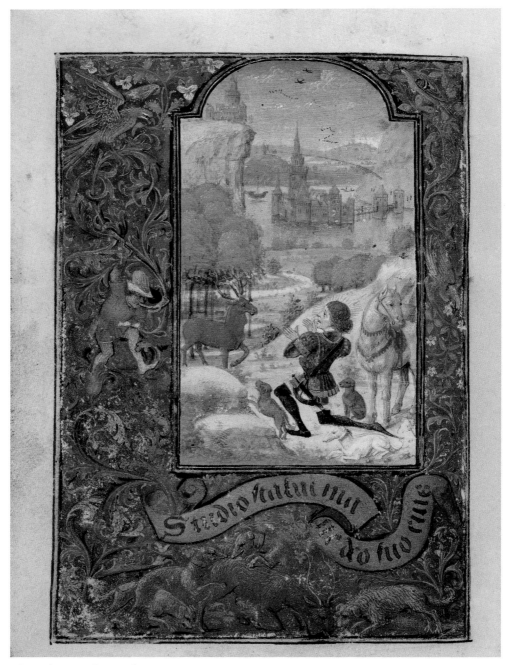

Fol. 39v: The Vision of Saint Hubert.

PLATE XXI | 95

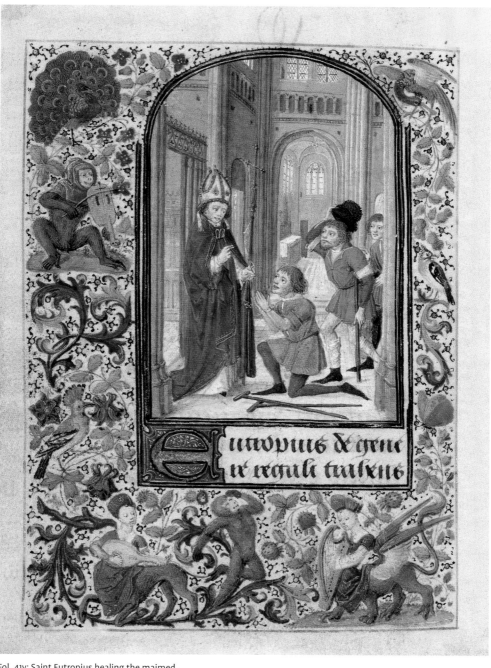

Fol. 41v: Saint Eutropius healing the maimed.

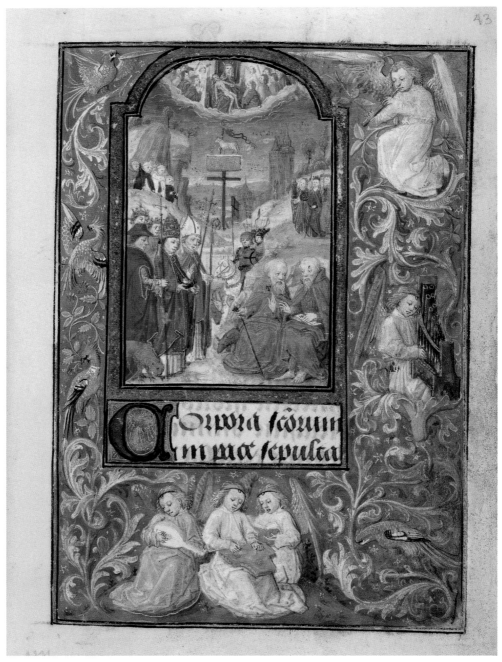

Fol. 43r: All Saints adoring the Lamb.

THE MINIATURES IN THE DOCUMENTED CORE AND THE DEVOTIONAL DIPTYCHS

This chapter will discuss and succinctly describe the miniatures in the documented core and the devotional diptychs.[1] Some elements of the iconography are nevertheless objects of more developed commentaries. The following chapter presents a stylistic analysis of the group of miniatures that van Lathem painted in the prayer book. Therefore, style will only be treated here when it seems useful to emphasize an aspect of it or to present certain significant parallels.

The border decoration of the documented core is commented on and analyzed in a separate chapter; the borders are therefore only taken into consideration here inasmuch as they include figures or scenes that relate to the subject of the miniature or constitute a narrative or typological complement to it.[2] The borders of the devotional diptychs include no drolleries, but only motifs in accord with the devotion that these diptychs illustrate. It appears to have been thought unseemly or not very appropriate to decorate with grotesque or fantastical motifs the borders of the folios where the duke was represented at prayer.

It may be that in the documented core, certain intentional connections between the decoration of the border and the subject of the miniature have escaped us. Indeed, the decorative vocabulary that late-medieval illuminators used still certainly preserves motifs, imaginary or not, for which only decorative virtues and a taste for the fantastic and strange assured permanence or survival. Often the latter were no more than hackneyed symbols, whose meaning had been dulled or lost over the course of time; one cannot always establish whether some of them were chosen for the symbolic values with which at one time they could have been invested. In one particular case, which will be discussed in Chapter 10, a deliberate symbolic intention must have governed the choice of motifs in some of the borders.

A. THE MINIATURES OF THE DOCUMENTED CORE

6.1 THE VIRGIN AND CHILD IN A GARDEN (FOL. 10R)

The Virgin is seated in a garden and is preparing to nurse the Child, who rests naked on her knees. Two angels are seated on either side on the low grass-covered wall forming an enclosure behind her.

Van Lathem appears to have taken particular care with the painting of this folio, which

Fig. 7: *Patroclus killing queen Mirro, and other episodes from the story of Jason.* In: *La Conquête de la Toison d'or*, Paris, BnF, Ms. fr. 331, fol. 158v.

ure on her left. The fullness of her mantle pulled back toward her knees on the right, forms a drapery of violet shadows that falls to the ground in a cascade of folds.

In front of the Virgin, small flowering plants dot the vegetation with minute white, red, or yellow splashes. The quality and the precision of their painted details evoke the marvelous flowering lawns of van Eyck, which inspired van Lathem on a number of occasions.[3]

At the back of the garden, in front of the brick wall that encloses it, the figure of Joseph is silhouetted leaning on a stick. His remoteness, suggested by his extremely reduced scale and by the extremely diluted lilac tones of his clothing, contributes to the illusion of depth and space.

6.2 THE HOLY TRINITY (FOL. 14R)

The Trinity was often represented in the fifteenth century in the form of the 'Trinitarian Pietà', as Gorissen and Steppe have very aptly named it.[4] This type of representation of the Trinity, often also designated as the Throne of Grace (*Gnadenstuhl*), shows God the Father supporting the body of Christ as the Man of Sorrows, bearing all the marks of his Passion and pointing with his right hand to the wound at his side. The Holy Spirit usually appears in the form of a dove, sometimes posed on Christ's shoulder, or placed in another way between God the Father and God the Son. The best-known examples of this iconography are undoubtedly the various versions offered by the paintings attributed to the Master of Flémalle, or coming from painters in his circle (Fig. 8).[5]

was at the beginning of the documented core. The splendor of the colors in the Virgin's clothes, the delicious freshness of the landscape, and the sumptuousness of the border, together give this page an exceptional luster.

It is surely only by virtue of her absolute pre-eminence that, among all the saints represented in the prayer book, this Virgin is the only one to be clothed in brocade. The decoration of the borders, with gold and silver contrasting against black, echoes this rich fabric. Over her garnet and gold brocade dress, the Virgin wears a blue robe under an ample white mantle, lined in red that envelops her from head to toe. The vividness of the blue and red is highlighted by the contrast of these two colors against the whiteness of the mantle that lines the Virgin's fig-

One could also cite the Trinity in one of the embroidered antependia from the Treasure of the Golden Fleece in Vienna, or the very beautiful miniature painted by the Master of Girart (Dreux Jehan?) in the prayer book of Philip the Good (Fig. 9),[6] and recall that still other works apparently testify to the particular devotion of the Dukes of Burgundy for the Trinity.[7]

The Trinity in Duke Charles's prayer book, on fol. 14r, constitutes a particular type of the Trinitarian Pietà. The Holy Spirit is not represented in the form of a dove, but as a winged human figure who sits at the Father's side on a substantial gothic wooden throne. The Father and the Spirit together support the Christ of Sorrows under his arms.[8] The feet of the figure of Christ rest on a blue globe with crystalline reflections.

Fig. 9: *The Trinity*. Prayer Book of Philip the Good. Paris, BnF, Ms. n.a. fr. 16428, fol. 44r.

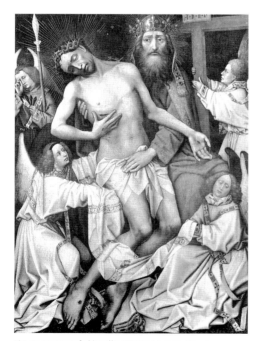

Fig. 8: Master of Flémalle, *Trinity*. Leuven, Museum Vander Kelen-Mertens.

It is quite rare for the Holy Spirit to be represented as a winged human figure. However, we find it represented this way in some works of the fifteenth century that appear to have no connection among them. As Rosy Schilling, Panofsky, and Panhans-Bühler thought, it appears likely that a lost work by van Eyck was the source of this particular iconography.[9] Certain details of the oldest examples of this type of the *Trinity* allow us to presume this.[10] The hypothesis of an Eyckian origin is further reinforced by the occurrence of this same iconography in the Hours of Folpard van Amerongen and Geertruy van Themsecke (Los Angeles, J. Paul Getty Museum, MS Ludwig IX 7, fol. 25v), where the illumination clearly testifies to the influence

of van Eyck.[11] Finally, one of the most beautiful versions of this type of Trinity, that which illustrates the Book of Hours of Pauwels van Overtfelt, could be attributed to Petrus Christus.[12]

As is common in such cases, several artists have reversed the composition of the prototype that, in the first decades of the fifteenth century, was at the root of the diffusion of this particular iconography. In conformity to sacred texts, this prototype unquestionably shows Christ and the Spirit to the right of the Father.[13] Now, in the miniatures cited and in several more examples, this image is inverted, with Christ and the Holy Spirit found each time at the Father's left. It is doubtless significant that Petrus Christus makes an exception and does not reverse the arrangement of the prototype.

In the majority of known examples of this iconography, the Holy Spirit is represented as a middle–aged man with a beard. His appearance thus most often brings him closer

to the figure of Christ.[14] Van Lathem, however, departs from his predecessors in representing the Holy Spirit with the characteristics of an angel.[15] A small painting later than van Lathem's miniature represents the Trinity in an analogous manner (Fig. 10).[16] The figure of the Holy Spirit is here quite similar to that in the miniature, and likewise clothed in a white robe.[17]

In the miniature, the Trinity's imposing throne is surrounded by a mandorla with a grey background, populated with the heads of angels sketched with a few lilac brushstrokes. In the top and bottom of the miniature, a retinue of adoring cherubim or seraphim is painted in monochrome against a strong blue background.

6.3 SAINT MICHAEL FIGHTING THE DEMONS (FOL. 15V)

Saint Michael, in an Eyckian type, carries out his battle against the demons in a marine landscape. The demons are presented in the form of dragons and other terrifying monsters. In the second and third planes, on the right and left, steep rocks emerge from the waves. Far beyond, bluish hills stand out toward the horizon. At the very top of the miniature, the clouds take on orange tones and form a kind of festoon, above which an opening allows us to see in the sky God's empty throne, flanked by several angels. Two of these angels hold swords, doubtless signifying that they assisted Saint Michael in his battle. The defeat and damnation of the rebel angels are suggested below by the struggle of several of them. Tiny dark silhouettes, with golden glints, these fallen angels will perish

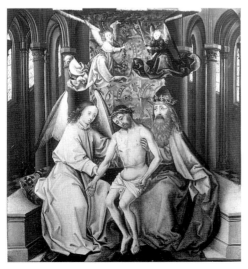

Fig. 10: Anonymous Master, *Trinity*. Location unknown.

in the waves, or come to the same fate as the one that we see on the right, tumbling down and crashing onto the rocks.

6.4 THE BEHEADING OF SAINT JOHN THE BAPTIST (FOL. 17R)

The scene takes place in the foreground, in the presence of a witness stationed in the doorway of a building at left. Saint John the Baptist is on his knees, hands joined, while the executioner holds him by his hair and prepares to raise his sword for the execution. At the right, Salomé, accompanied by a

Fig. 11: Master of Catherine of Cleves, *Trinity with Christ showing his wounds* .Hours of Catherine of Cleves. New York, PML, M.945, fol. 88r.

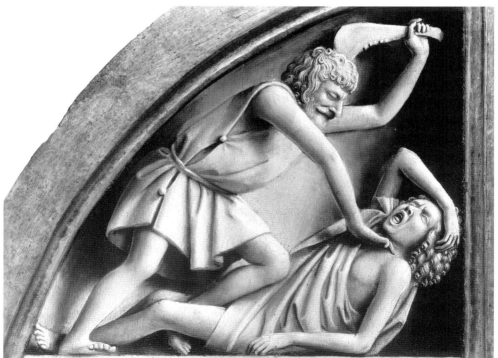

Fig. 12: Van Eyck, *Abel killed by Cain* (detail of the Eve panel in the Ghent Altarpiece). Ghent, Saint Bavo's Cathedral.

follower, holds in her hand the plate on which the severed head will be placed.

In the background, at left, an episode following the main subject is represented. There we see Salomé coming to present John's severed head to Herodias and Herod Antipas at a table inside an open architectural structure.

The border moreover contains two scenes that relate to the Beheading of John the Baptist. On the right, a demon seizes a woman, who must be either Salomé or Herodias, both of whom played guilty roles in the fate of the holy Precursor. I do not know whether texts allude to the intervention of the devil repre-

Fig. 14: *King Appolo learns how the Golden Fleece could be won. (border with repetition of the motif of Cain's fratricide).* In *La Conquête de la Toison d'or*, Paris, BnF, Ms. fr. 331, fol. 78v.

Fig. 13: Hugo van der Goes, *Saint Genevieve*, cornerpiece in the upper right hand corner: *Murder of Abel by Cain.* Vienna, Kunsthistorisches Museum.

sented in this border, or whether this epilogue to the story can be attributed to van Lathem's fertile imagination.

In the lower border appears an impressive painting of Cain murdering Abel. Considered as the prototype of murder or of an unjust execution, this first murder of biblical history is therefore equated with the execution of John the Baptist. The scene of fratricide, treated with a startling sensitivity and vigor, could have been inspired by van Eyck's version in the Ghent Altarpiece, executed in grisaille above the figure of Eve (Fig. 12). It is less certain that van der Goes's interpretation, the image in one of the corner pieces above the grisaille *Saint Genevieve* on the

reverse of the Vienna diptych's *Lamentation* could have served as a source of inspiration (Fig. 13).[18] Cain's pose and the violence of his movement, like the manner in which he seizes in both hands the jawbone with which he deals his blows, constitute a powerful, poignant, and original interpretation of the terrible crime.[19] The gesture of distress of Abel's raised hands is found with van der Goes.

6.5 SAINT JOHN ON PATMOS (FOL. 18R)

John on Patmos is represented seated on a tiny island, in front of a deep landscape. A few years earlier, the same subject had been painted in quite a similar way in the Sachsenheim Hours (Fig. 15) (Stuttgart, WLB, Cod. brev. 162, fol. 16r).[20]

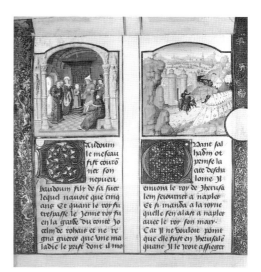

Fig. 16: *Baldwin IV the Leper has his young nephew crowned Baldwin V*, in the *Chroniques de Jérusalem abrégées*, Vienna, ÖNB, Cod. 2533, fol. 15r, col. 3.

Several artists participated in the illumination of the Sachsenheim Hours. The miniatures of this manuscript were once attributed to Phillippe de Mazerolles, and therefore now to Lievan van Lathem.[21] I once scoffed at this attribution[22] but, after re-examination, I now think that it ought to be reviewed. Thus I join Delaissé, who thought that the miniatures attributed to van Lathem in this manuscript were not by his hand, despite the compositions and warmth of color, which closely resembled those unique to van Lathem's production.[23]

In the Sachsenheim Hours miniature of Saint John on Patmos, John's face and hair and the drapery of his mantle are treated with more subtlety that in the duke's book. The more fluid drapery of the mantle is unquestionably not as close to van Lathem's drapery as it is to the Master of Girart's; see, for example, the figure seated in the

Fig. 15: *Saint John on Patmos*. Sachsenheim Hours, Stuttgart, WLB, Cod. brev. 162, fol. 16r.

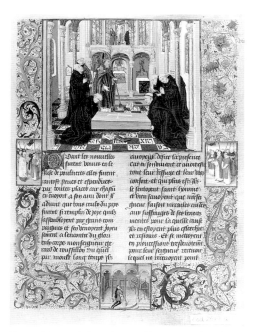

Fig. 17: Master of Girart de Roussillon, *Girart's burial in the Church of Pothières*, in the *Roman de Girart de Roussillon*, Vienna, ÖNB, Cod. 2549, fol. 181r.

Fig. 18: Jan van Eyck, *Saint Christopher*. Paris, Musée du Louvre, Département des Arts Graphiques.

foreground of the miniature on fol. 15r (column 3) of the *Chroniques de Jerusalem* (Fig. 16) or the habits of the monks kneeling in the miniature on fol. 181r of *Girart du Roussillon* (Fig. 17).

The two miniatures also diverge in their conception of landscape. In the Sachsenheim Hours, the rocks evoke crystal formations with their facets at clearly marked vertical stops. In this they to some degree recall the rock formations in the lovely drawing of Saint Christopher attributed to van Eyck and preserved in the Cabinet des dessins at the Louvre (Fig. 18). Van Lathem's rocks, more eroded, offer less geometric forms.

In the miniature from the duke's book, the landscape appears to be seen from above; as is usual with van Lathem, the

space develops progressively until the horizon, which is situated quite high in the composition. In the miniature from the Sachsenheim Hours, the landscape is not conceived in the same way. As the horizon approaches, the hills and shorelines, with their successive planes rendered summarily, appear as if perceived by an observer on the surface of the ground or the water. In relation to the island and the whole foreground, which are viewed from above, the perspective therefore presents a certain incoherence. This is not too conspicuous, because of the rocky slopes forming a screen on either side of the second plane and opening the vista toward the distance.

The landscape of the Stuttgart miniature is quite close to that of the miniatures of the

Fig. 19: *Capture of Antioch by the Crusaders,* in the *Chroniques de Jérusalem abrégées,* Vienna, ÖNB, Cod. 2533, fol. 4v, cols. 2 and 3.

Vienna *Chroniques de Jérusalem abrégées* (ÖNB, Cod. 2533).[24] The way in which the rocks and the movement of the water are rendered; the distances, with a view of the city and its church spire; the very far–off silhouettes of ships in the background of the landscape, where the heads of the rowers are marked out as tiny little dots; are so many details that amazingly find equals in the miniatures of fols. 3r, 4r (column 1) and 4v of the *Chroniques* (Fig. 19).[25] The way the illuminator makes the small trees growing on the summits of the rocks bend down or lean over a little, as if to avoid having their branches cropped by the frame, is found in the John on Patmos miniature from the Sachsenheim Hours (Fig. 15), as in the miniatures of the *Chroniques*.[26]

In the Sachsenheim Hours, Saint John writes on a scroll that he holds on his knees. In the miniature from the duke's book, John lifts his pen, as if he were reflecting a moment before continuing to write, not on a scroll, but in the open book that rests on his knees. A book with a red binding is placed on the ground next to him. An eagle, symbol of the Evangelist, stands on the book, holding a penner in his beak; from this hangs an ink horn where John can thus easily dip his pen. The eagle fulfils the same function in the Stuttgart miniature, although he is represented in a less static manner.

The contemplative or dreamy expression of the two Saint Johns, like the style of the landscape, again recalls Dirk Bouts. In the Stuttgart miniature, the site in front of the two massive and imposing rocks, where Saint John sits on his island, would seem very wild and inhospitable if the passage between the rocks did not open in the background to distances that lighten up to the horizon. The conception of this landscape is similar to that of the landscapes in the Saint John the Baptist and Saint Christopher panels of the Munich *Pearl of Brabant* triptych, which has a quite similar composition (Figs. 20–21).

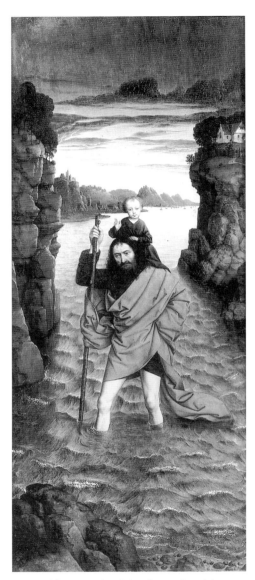

Fig. 20: Dirk Bouts, *Saint John the Baptist*. section of the 'Pearl of Brabant' retable. Munich, Alte Pinakothek.

Fig. 21: Dirk Bouts, *Saint Christopher*. section of the 'Pearl of Brabant' retable. Munich, Alte Pinakothek.

A small book of hours in Cambridge (Fitzwilliam Museum, Ms. 143) also contains a miniature of John on Patmos, fol. 219r (Fig. 22), which could be considered another version of the one in the Sachsen-heim Hours. The Cambridge miniature does not attain the refinement of the one in Stuttgart, but must have been executed by an illuminator very close to the creator of the latter and perhaps having access to his

models. In contrast to his red robes and deeper rose mantle in Stuttgart, this time John wears a blue robe like van Lathem's Saint John, but of a much darker blue. His pinkish mantle, fallen from his shoulders, is draped over his knees. As in the Stuttgart miniature, John writes on a parchment scroll and the eagle that holds the inkwell is placed in the same manner with wings extended. If the composition of the rocks, although very similar, is not identical, their faceted structure in the two miniatures is analogous. The rockier ground and the escarpment that it forms just behind Saint John is common to the two miniatures, although in van Lathem's miniature the island is flat and without rocky projections.[27]

Fig. 23: Dirk Bouts (or his circle?), *Saint John on Patmos.* Rotterdam, Museum Boijmans Van Beuningen (inv. n° 1083).

Fig. 22: *Saint Jean on Patmos.* Book of Hours, Cambridge, Fitzwilliam Museum, Ms. James 143, fol. 219r.

In the miniature from the duke's book, Saint John appears to be surrounded by a greener and more pleasing landscape. The rocks only appear set back toward the right of the composition. The narrow open passage between their slopes, the green expanses broken by patches of water at the left, the sky and clouds occupying the full breadth of the top of the composition, all differentiate the two interpretations of landscape. That of van Lathem is rather closer to the Boutsian painting of *Saint John on Patmos* in Rotterdam (Museum Boymans-van Beuningen) (Fig. 23).[28] Without claiming that there is a direct connection between the miniature and this painting, which could be almost contemporary, and despite a perceptible difference in the relation of figure to surrounding landscape, it cannot be denied that there is some relationship between them. The elements of the landscape in the painting and in the miniature are far from all comparable, but the outlines of their compositional

schemes clearly present an analogy. The green and flowering character of the island is found in both. Van Lathem, much like Bouts and his circle, was one of those who, under the influence of van Eyck, often took delight in detailing with finesse the grasses and the flowering plants covering the earth in the foreground of their paintings.

At the upper right hand corner of the border for the Saint John on Patmos miniature, the motif appears of the pelican piercing her breast to save her little ones, quite similar to the one which can also be seen beneath the miniature of the Holy Face on fol. 2r. The motif is less appropriate here and perhaps was chosen this time only for its decorative character.[29]

6.6 SAINT PETER AND SAINT PAUL (FOL. 19V)

The appearance of Christ to Saint Peter after the Resurrection, and the Conversion of Saint Paul on the road to Damascus are represented in the foreground of the same landscape. At the left, the standing Christ appears to Saint Peter, who is kneeling with hands joined in front of him. Christ blesses Peter with his right hand, and holds in his left the cross, symbol of his victory over death. The scene appears to be situated in front of the cave where Saint Peter retreated to do penance after his triple renunciation.[30]

The Conversion of Paul is represented at right, somewhat set back and below the rocky platform where Christ appears to Saint Peter. While his horse collapses beneath him, Saint Paul, half–thrown, lifts his right hand to his eyes, dazzled by the ap-

Fig. 24: Master of the Amsterdam Cabinet (Housebookmaster), *The Conversion of Paul.* Amsterdam, Rijksprentenkabinet.

pearance of the Lord, and issues his interrogation, *D(omi)ne quid vis me facere*, which can be read on the scroll that floats above him. At the top of the painting, the Lord appears in a luminous yellow and orange cloud, from which golden rays emanate in the direction of Saint Paul. The Master of the Amsterdam Cabinet (aka, the Housebook Master), treated the Conversion of Saint Paul in quite a similar way a few years later (Fig. 24).[31] It has been noted on several occasions that he must have profited from contact with the work of illuminators, and in particular with that of van Lathem.[32]

6.7 THE CRUCIFIXION OF SAINT ANDREW (FOL. 21R)

Two executioners squatting or kneeling on the ground tie the limbs of Saint Andrew, who lies down on the cross. Andrew's lilac clothing is generously highlighted with gold glaze. A rather motley group of a judge and three assessors assists without great emotion in this placing on the cross. The scene takes place outside the city; its ramparts and towers, as well as the surrounding countryside, can be seen in the distance.

6.8 CHRIST BLESSING SAINT JAMES THE GREATER ON HIS DRIFTING ISLAND (FOL. 22R)

Durrieu had believed that this miniature represented Christ appearing to Saint James the Less.[33] Saint Paul (1 Cor. 15:3–8) and Saint Jerome alluded to this appearance,[34] which however does not appear among the ten apparitions of Christ after his Resurrection, as enumerated by Petrus Comestor in his *Historia Scholastica*.[35] This enumeration was repeated by Jacobus de Voragine in his *Legenda aurea*, but with three added apparitions, of which one is that of James the Less.[36] The legend relates that when Jesus died, James was to have taken a vow of abstinence until his master was risen. Jesus was to have appeared to him the same day as his Resurrection. A few representations of Jesus preparing a meal for Saint James the Less, or sharing a meal with him, are known in Catalonia or in Italy,[37] but this subject does not seem to have been represented in the Low Countries or in France. Unless I am mistak-

en, we know of no depiction of Christ appearing to Saint James the Less. Moreover, no example of it has been recorded by the authors of the great iconographic indices.

Durrieu was therefore mistaken in identifying the subject of this miniature. That the episode represented concerns not James the Less but James the Greater is, indeed, confirmed by the texts. The antiphon *Tradent enim vos*, which follows the miniature, is borrowed from the Vespers of the Common of One Apostle, out of Easter. It is said at Vespers of the Feast of James the Greater (the 25th of July), but not at that of James the Less (the 1st of May), who was still celebrated during the Easter season. The prayer *Esto, Domine, plebi tuae sanctificator*, which follows it, on fols. 22v–23r, is that of the Mass of Saint James the Greater and is also found in the Breviary, in the Office for the day when his feast is celebrated.

The story of the translation of Saint James the Greater's relics, as the *Legenda aurea* relates it, is well known.[38] Saint James, who had returned to Palestine after having preached the faith in Galicia, was arrested by Herod Agrippa and decapitated. His disciples removed his body and placed it on a boat. Miraculously, his body was carried up to the Galician coast, where the disciples left it on a rock in Padrón (ancient *Iria Flavia*). Under the influence of a miracle, this rock, melting as if it were wax, would be fashioned into the form of the holy body that it had held.[39]

Another version of the Legend of Saint James alludes to the moment when Christ would have vested James with his mission in Galicia and apparently connects the miraculous voyage to Spain with the episode that

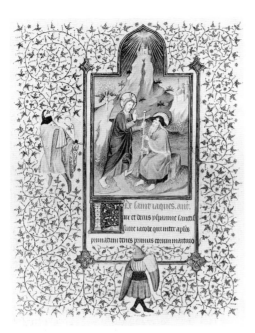

Fig. 25: *Christ sends Saint James to preach in Galicia.*
Hours of François de Guise. Chantilly, Musée Condé,
Ms. 64-1671, fol. 185v.

would therefore have taken place during the apostle's lifetime. Early depictions illustrating this version show James seated at a place by the shore, on a small rocky island, receiving a staff from Christ that symbolizes in some way the evangelical mission with which he was entrusted. Christ hands over the staff with his left hand, while blessing with his right. For example, it is thus that the scene is represented about 1425–1430 in the Hours of François de Guise (Chantilly, Musée Condé, Ms. 64, fol. 185v) (Fig. 25). Other representations show the saint asleep on his rocky island, which leads us to presume that in one of the versions of the legend, James was told of his mission in a dream. In the various versions of the scene, one sees Christ standing on the shore, stretching a foot toward the is-

land where James is seated. The island is in fact a rock that detaches from the bank under the pressure of Christ's foot, and while Christ blesses James with his right hand, the rock goes adrift, beginning the miraculous journey that will bring him to Galicia.

These versions of James story cannot be reconciled with the old Compostelan accounts of the translation of the apostle's body after his beheading in Jerusalem, collected in the *Liber Sancti Jacobi*, the *Codex Callixtinus*, the source that the account in the *Legenda aurea* goes back to. It is understandable that such versions of the miraculous voyage, which open the door to many confusions and contradictions, did not find favor in the eyes of the authors or adherents to the version of the *Codex Callixtinus* at Compostela. However, one may ask if the account recognized at Compostela has not sometimes been contaminated by the account of the rocky island set adrift. The latter could be the source of the version relating that James's body arrived in Galicia on a ship of stone.[40]

We do not know much about how or why these versions, stigmatized at Compostela as *somnia et fabulas*,[41] were familiar to the glassworkers and sculptors of the Île–de–France, Champagne, and Picardy in the thirteenth and fourteenth centuries, and were quite widespread in the fifteenth and sixteenth centuries in the Southern Netherlands.[42] The oldest representations of this legend seemed to have emphasized the *traditio baculi*, while it seems to be the depictions of the saint asleep on his island that were the most widespread in the Southern Netherlands.

Van Lathem painted the apostle seated on the ground and asleep on a tiny island. He is

apparently plunged in a deep sleep, as indicated by the way in which he supports his inclined head with his right hand. A soft lash seems to be wrapped around the staff held in his folded arm.[43] The Flemish creator of the polyptich of Saint James at the Art Museum of Indianapolis represented the same scene (Fig. 26) in a very similar way.[44]

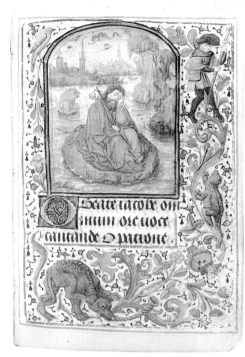

Fig. 27: *Saint James asleep on his island.* Book of Hours, Cambridge, Fitzwilliam Museum, Ms. James 143, fol. 205r.

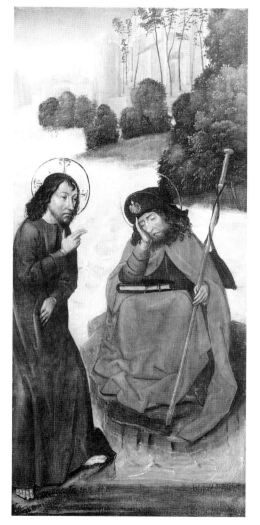

Fig. 26: Brussels Master (?), *Christ blessing Saint James asleep on his island.* Outer left portion of the Saint James Retable. Indianapolis, Art Museum.

Van Lathem's miniature could also be compared to the one that appears on fol. 205r of the book of hours in Cambridge (Fitzwilliam Museum, Ms. James 143) for which *Saint John on Patmos* caught our attention above. There one finds the island with Saint James asleep, and his staff around which are wound several straps (Fig. 27).[45] These two miniatures probably go back to the same workshop model, if not to a picture or a wall–painting. However, the figure of Christ is missing in the Cambridge miniature, as in some of the examples discussed by Madou or Jacomet.

If one sets aside the absence of the figure of Christ in the Cambridge miniature, the

analogy between the small paintings in the two devotional books is very strong. However, in the Cambridge miniature, the composition is completely reversed, except for the city that can be seen on the edge of the water in the distance. The apostle asleep on the island, the rock that emerges from the water in the middle distance behind him, and the high overhanging rock, at the left in van Lathem's miniature and at the right in the Cambridge miniature, are all reversed. In the Cambridge manuscript, Saint James and the island are so conspicuous in the foreground that they appear disproportionate in relation to the elements of the landscape that surround them. This version of the subject, duller in hue and rougher in workmanship, does not display the charm of van Lathem's succession of planes of landscape, with his more detailed view of the city.[46]

The border of van Lathem's miniature offers no motif relating to Saint James, in contrast to the border of the Cambridge miniature, where a wayfaring pilgrim, leaning on his staff, evokes the pilgrims of Compostela.

6.9 THE LAST SUPPER (FOL. 23V)

Dirk Bouts had completed his famous triptych of the *Last Supper* less than two years before the time when van Lathem made this miniature. Van Lathem appears to have known the painting and did not fail to benefit from it. This is partially the case for the design of the interior perspective, including the foreshortening of the two windows piercing the left wall. If we compare the apostles from one work to the other, we are struck by the similarity in the way several of them car-

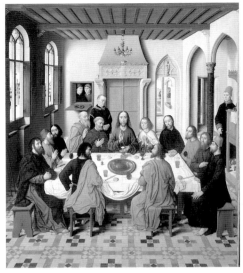

Fig. 28: Dirk Bouts, *The Last Supper.* Central panel of the retable of the Holy Sacrament. Leuven, Church of Saint Peter.

ry their heads, and even by the direction of their gaze (Fig. 28). Judas, however, who turns his head to the left in the miniature, turns it to the right in the painting. There is still a greater difference in the case of Saint John, who here leans on Christ's breast, and in a way disappears, his head hidden by Jesus' left arm. Like Bouts, van Lathem took into account the texts that identified James the Less as the Lord's brother (*frater Domini*) and also the physical resemblance that would have existed between him and Jesus.[47] In both the painting and the miniature, Saint James, who is seated next to John at Jesus' left, has features identical to those of Christ.[48]

In the miniature, the space where the scene takes place is narrower, and likewise the arrangement of characters around the round table. More fundamental is the difference in function of the Last Supper. The subject of this miniature is not the institution of

the Eucharist; rather, it serves to illustrate devotions to the apostles. It is for this reason that van Lathem does not represent the moment of the benediction of the bread and the wine, but the moment when Jesus sets his hand on the plate placed in the middle of the table, having just announced to the apostles that one of them will betray him. The shock and consternation can be read on their faces, and certain glances turn toward Judas, whom one only sees from the back. The profile of his face can scarcely be discerned, although he turns his head toward his neighbor on the left, who seems to question him with his glance. This illumination is one of those of the documented core in which the figures' facial expressions best reflect the emotions proper to the situation represented.

In a rather curious manner, and one less appropriate to the subject, the back of the room opens generously toward the outside, as if van Lathem had wanted here as well to give himself the pleasure of having to paint one of his favorite open architectural structures with a vista opening toward the distance.

6.10 THE STONING OF SAINT STEPHEN (FOL. 24V)

Saint Stephen is depicted on his knees in prayer, his eyes raised toward heaven, where the Lord appears to him in a cloud. Like a deacon, he is clothed in a red dalmatic over a white alb.

Set back from the scene on the left, we see a city and a group of figures crossing through the gate, where we recognize Stephen in his red dalmatic. He is surrounded

by persecutors, who drive him out of the city to stone him, as the sources for his martyrdom relate.[49]

Stephen is between two of his executioners who cast stones at him. Two stones have already reached his head. A third thief picks up a stone to join his associates. The young richly clothed man seated in the left front of the composition is Saul, whose presence at the stoning is attested by the *Acts of the Apostles*, which furthermore evoke Saul's role as persecutor and specify that he approved the murder. One reads there that the false witnesses, having accused Stephen, laid down their clothes at Saul's feet before beginning to stone their victim. These clothes are often represented either held in Saul's hands, as in the Hours of Catherine of Cleves,[50] or covering the rock or the ground on which Saul is seated, as we see here. This last option is from an old tradition. We find it already in the thirteenth century in the Picture Book of Madame Marie (Paris, BnF, Ms. n.a.fr. 16251).[51] We can observe its persistence in the fourteenth and fifteenth centuries, as it is illustrated in the Breviaries of Blanche of France (Vatican, BAV, ms. Urb. Lat. 603) and of Charles V (Paris, BnF, lat. 1052), and the books of hours of the Maréchal Boucicaut (Paris, Musée Jacquemart-André, ms. 2) and of Étienne Chevalier (Chantilly, Musée Condé, ms. 71), among others.[52] Saul's gesture with his pointed finger goes back to the same tradition. It can already be seen in the sculptures on the tympanum of the South Portal of Notre Dame in Paris, and it reappears in the manuscripts just cited, except in the Boucicaut Hours and the Hours of Catherine of Cleves. Van Lathem has represented Saul as

a young man. Fouquet had done so as well, and, before that, the master of the *Livre d'images de Madame Marie*,[53] each offering an equally faithful version of the text of the *Acts of the Apostles*. This is in contrast to those versions of the scene that prematurely adopt the traditional image of Saint Paul, in representing Saul as an older man with a beard.[54]

6.11 SAINT CHRISTOPHER (FOL. 26R)

The miniature of Saint Christopher is an interpretation of an iconographic scheme that was very widespread in the Northern as well as the Southern Netherlands. It could be considered parallel to the very beautiful drawing in the Louvre's Cabinet des dessins, which Friedländer thought belonged to the hand of Jan van Eyck (Fig. 18),[55] as well as to

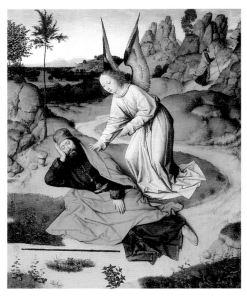

Fig. 30: Dirk Bouts, *Elijah in the desert*. Panel of the right section of the retable of the Holy Sacrament. Leuven, Church of Saint Peter.

the right–hand panel of the so–called 'Pearl of Brabant' retable (Munich, Alte Pinakothek) (Fig. 21).[56] In relation to these two works, the miniature gives a reversed version of the subject. The vast landscape developed in depth recalls those of Bouts, in particular those in the panels of the *Gathering of the Manna* and *The Prophet Elijah in the Desert* (Figs. 29–30), included in the wings of the *Last Supper* retable in Leuven, which the landscapes of the *Pearl of Brabant* moreover also to some degree resemble (Figs. 20–21). The light is reflected in the water, which extends to the horizon between the banks in changeable contours. The rocks crowned with buildings, occupying the middle distances on both left and right, are quite similar to those that border the painting of Saint Christopher in Munich. As in the Louvre drawing, van Lathem has represented the

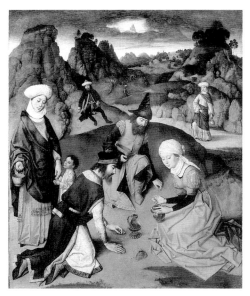

Fig. 29: Dirk Bouts, *The Gathering of Manna*. Panel of the left section of the retable of the Holy Sacrament. Leuven, Church of Saint Peter.

hermit who, on the rocky bank, waits for Christopher by the light of his lantern. The latter appears quite useless in the golden light of the landscape where he depicted the scene. The city with its port, which is situated to the left above the figure of the saint, is itself very comparable to that which can be seen above Saint John the Baptist in the background of the other wing of the same retable in Munich (Fig. 20). Would the miniature then be a version of the subject combining elements borrowed from the two wings of this retable? If the response to this question were to be affirmative, the *Pearl of Brabant*, which has been believed to date after 1470,[57] would definitely be older by several years, and in any case would have to date to before 1469.[58] The connections between

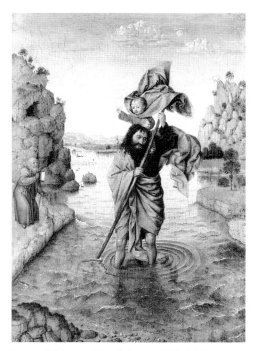

Fig. 31: Dirk Bouts, *Saint Christopher*. Philadelphia, Museum of Art, John G. Johnson collection.

Saint Christopher in the prayer book and the Boutsian work further complement one another by the presence in the foreground, on the edge of the water, of colored stones or shells that seem to recall those found on the lower edge of the panel in Munich, and which are found yet again in the Saint Christopher in Philadelphia (John G. Johnson Collection) (Fig. 31) or in the one where Albert Bouts undoubtedly copies one of his father's paintings (Modena, Galleria Estense) (Fig. 32).[59]

6.12 THE MARTYRDOM OF SAINT SEBASTIAN (FOL. 29R)

Sebastian, attached to the thin trunk of a tree, faces front in the center of the painting. Three archers and the Emperor Diocletian are arranged almost symmetrically before him in the arc of a circle. Diocletian appears in the foreground at the right, and is distinguished from the archers by his costume and attributes. He holds a justice's staff in his right hand, wears a green hat with a crown and is clothed in a magnificent blue robe. His scimitar hangs from his belt in a richly decorated sheath. The rather narrow disposition of figures demonstrates the difficulties inherent in the vertical format imposed. It is found with some variants in several books of hours of so-called 'Ghent–Bruges' production, such as the Hours of Mary of Burgundy in Berlin (Kupferstichkabinett der Staatlichen Museen, Ms. 78 B 12),[60] the Hours of Isabella of Castile (Cleveland Museum of Art, inv. 63.256, fol. 177v), and the first Hours of William of Hastings (Madrid, Fundación Lázaro-Galdino, inv. 15503, fol. 34v).[61]

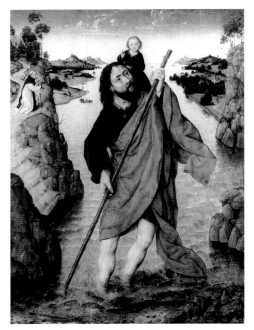

Fig. 32: Albert Bouts, *Saint Christopher*. Modena, Galleria Estense.

6.13 THE MARTYRDOM OF SAINT LAWRENCE (FOL. 31V)

Saint Lawrence, lying on the grille arranged on a slight slant at the front of the composition, is surrounded by three executioners who busily stir the fire that torments him. At the left, the Emperor Decius and three other figures form the classic group of witnesses to the execution. The gesture that the emperor makes with his hand suggests that he is giving the orders to the executioners.

6.14 THE TEMPTATION OF SAINT ANTHONY (FOL. 33R)

Saint Anthony, seated in a landscape, moves a rosary through his raised left hand and

holds in the other hand an open book that rests on his knees. The pig that usually accompanies him is partially hidden behind him. The hermit is importuned by a woman who offers him a drink from her cup and attempts to seduce him. The demonic nature of this apparition is revealed by her griffin's feet.

Two supplementary episodes of the hermit saint's story are evoked by the small figures distributed in two scenes. The figures appear close to the hermitage, perched high on the rocks to the left. They illustrate the story of Anthony, who went in search of Saint Paul. Having found him, he shared the ration of bread brought by the raven who, day by day, miraculously supplied Saint Paul. That day the ration was miraculously doubled. Seated to the right of the hermitage, the two hermits are represented on a very small scale, speaking together while above them the nourishing raven appears bringing the bread.

Before being led by a wolf to Saint Paul's hermitage, Anthony had found a centaur on his way who pointed out the path.[62] The centaur that we distinguish at the left of the hermitage perhaps intended to allude to this episode, which was very compatible with van Lathem's imagination and his taste for the marvelous and fantastic.

6.15 SAINT MARTIN DIVIDING HIS CLOAK (FOL. 34V)

Saint Martin, his head crowned with rays of gold, clothed like a great lord, is mounted on a powerful, sumptuously harnessed white horse. He has drawn his sword and is pre-

paring to divide his cloak with the poor cripple near whom he has halted his mount. At the right, a legless man seems to address him while begging. The cripples occupy the two corners of the painting's foreground. Behind Saint Martin we can see the heads of two figures who are also witnesses to the dividing of the cloak.

Saint Martin on horseback recalls the knights of the left panels of the Ghent Altarpiece (Fig. 33). Van Lathem knew the polyptych well and would have admired it from the beginning of his career in Ghent.

The *Legenda aurea* specifies that Martin met the unfortunates whom he helped while passing the gate of Amiens.[63] Van Lathem profits from this localization of the episode by depicting one of those cityscapes that he excelled in rendering. Beyond the gate, imposing and massive, the ramparts bordered by water become lighter and retreat diagonally into the distance, where the bends of a river lead among the hills that turn blue toward the horizon.

6.16 The Preaching of Saint Gatianus (fol. 36r)

Saint Gatianus addresses a group of the faithful from above, from a pulpit placed near a church in a city square. The bishop saint, represented with miter on his head, accompanies his speech with expansive hand gestures. Near him on the left, an acolyte holds his cross. The square is bordered in the background by architectural structures, and between them, beyond a bridge, runs a street passage. The preaching of Saint Gatianus was

rarely represented. We find one other example, in the important missal of Guillaume Lallemant, a manuscript from Tours dating to about 1510–1515.[64]

6.17 Saint Fiacre assailed by a woman (fol. 38r)

This miniature illustrates the story of Fiacre as it was told in the lives of saints added to Voragine's *Legenda aurea*. The account is found in a French version, for example, in a manuscript in Brussels (Bibliothèque royale, Ms. 9282–5, fols. 343v–344r). Fiacre, of Irish origin (and not Scots, as the manuscript cited says) came to France, where he joined Saint Faro, Bishop of Meaux, who gave him a plot in his woods. Fiacre creates a hermitage there, clears the woods, working ceaselessly and with fervor. He builds a church in honor of the Virgin, which the miniature shows in the middle-distance on the right, and a house where he offers shelter to the poor. Desiring to expand his farmland, he goes to find the bishop, who authorizes him to add to his field the part of the woods that he would be able to clear and plough with his own hands in a day. On returning to his hermitage, after having offered a prayer, he is miraculously aided in his work. When he drags a staff on the ground to delimit the new piece of land, trees uproot by themselves and the earth turns itself before he has planted his spade. A woman who was passing by observed these miracles and was scandalized by them. She went to the bishop's to accuse Fiacre of sorcery, and then returned to insult him and tell him that the bishop ordered him to cease his work. It is this last episode that van Lathem

has illustrated. We see the uprooted trees, lying on the ground, and the shrew that overwhelms with invectives the holy man visibly moved and wounded by such aggression.[65]

The last phase of the story is not depicted. There we learn that Fiacre, much saddened, sat down on a stone. The stone miraculously became soft, and took on a slightly concave shape, in order to serve perfectly as a seat. The bishop, who arrived at the place to ascertain what had happened, witnessed the miracle and understood that there was no need to doubt Fiacre's merits, and honored him even more than before.[66]

Fiacre (d. 670) was well known, especially north of the Loire in France and up to the Southern Netherlands. One knows that his virtues as a monk and clearer of the land, diligently taking care of his farmland, led to his adoption as the patron of nurserymen, gardeners, and market-gardeners.

6.18 THE VISION OF SAINT HUBERT (FOL. 39V)

The miniature of Saint Hubert is the only one in the documented core that, together with its border, occupies the entire page. The importance allocated to him in this manuscript thus certainly intends to underscore the particular devotion in which Charles the Bold held the patron saint of hunters.[67] It could have been a response to the express demand of the duke or his agents.

Spierinc and van Lathem were apparently in agreement that the beginning of the text could nevertheless find a place in the miniature, as with the other miniatures of the documented core. Indeed, the border is decorat-

ed with a banner that bears the first six words of the antiphon: *Studio stabat mane deo suo eius.*[68] The text continues on the next folio : *bone voluntatis scuto sperans et desiderio coronari martirio.*[69]

According to the legend, Saint Hubert, who lived at the court of Pepin of Herstal, was a young lord leading a worldly life. A miracle was to have been at the origin of his conversion. He had abandoned himself to hunting in the Ardennes, when a stag arose with the cross appearing between his antlers.[70] The miniature shows Hubert, having dismounted, kneeling on the ground and lifting his hands in a gesture of astonishment before the apparition of the stag halted at the edge of the wood. A white greyhound lies behind Hubert. Two other dogs are beside him.

The particular reverence in which the duke held Saint Hubert is also manifested by his foundation of the chapel of Saint Hubert at Chauvirey in Franche-Comté,[71] where he owned a castle. He had given the horn of Saint Hubert to this chapel. This precious relic, now preserved at the Wallace Collection in London, had been offered to him by Louis of Bourbon, prince-bishop of Liège, after the capture of that city in 1468.[72] Without doubt it is precisely because of the duke's special reverence for Saint Hubert that Louis of Bourbon thought of offering him this relic, preserved until then at Liège.[73] The horn, 49.5cm long, is covered in *gesso duro* with gothic architectural motifs in relief. This decoration, in which the remains of gilding and blue and green color are still perceptible, is only partially preserved. The ornamentation of the object, which is complemented by

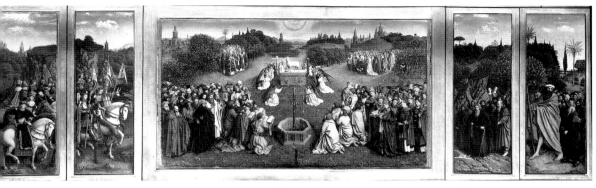

Fig. 33: Hubert and Jean van Eyck, *Adoration of the Lamb* (Lower register of the Ghent Altarpiece, open). Ghent, Saint Bavo's Cathedral.

hoops of silver, can only be dated to quite late in the fifteenth century. It could therefore have been added by Louis of Bourbon, or even by Charles the Bold.

6.19 SAINT EUTROPIUS HEALING THE MAIMED (FOL. 41V)

Saint Eutropius, clothed in a beautiful blue cope over a red robe and wearing a richly decorated white miter, blesses the cripples who have come to implore his aid. The first of the latter has put one knee to the ground and, hands joined, gives Eutropius a moved and grateful look. His crutches, lying on the ground next to him, indicate that the saint's intervention has miraculously cured him.[74]

6.20 ALL SAINTS ADORING THE LAMB (FOL. 43R)

The miniature of All Saints is inspired in outline by van Eyck's Ghent Altarpiece, principally by the lower register of the open polyptich (Fig. 33). Three prelate saints are situated at the head of the group of charac-

ters depicted at the front of the miniature on the left. We recognize Saint Jerome, dressed in red with the lion at his feet, and Saint Cornelius, dressed in a blue cope and wearing the papal tiara, holding the pontifical cross in his left hand, and in his right the horn that, through a play on his name [translator's note: i.e., *corne*, horn, and *Corneille*, Cornelius], became his attribute from the fifteenth century on. The third prelate is Saint Hubert, wearing a white miter and a rose–colored cope on top of a green chasuble. He leans on his crosier and makes a gesture of benediction with his right. The stag by his side permits us to identify him. We see only the head of the animal and identify there the cross that he carries between his antlers. The presence of Saint Hubert in this group of pontiff saints once again underscores the duke's devotion to this saint.[75] The group is inspired in part by the group on the right in the retable of *The Adoration of the Lamb* (Fig. 33).

Behind the prelates, we distinguish two figures wearing crowns. They are repeated from those that appear at the back of the group of the Knights of Christ on the section

at the left of the Ghent Altarpiece. The one who wears the looped imperial crown must be Saint Charlemagne, who figures among the *Christi milites* in the polyptych.[76]

Saint Anthony and Saint Paul, seated on the right and appearing to converse, make a pendent to the group of prelates.[77] These two saints, whom we see depicted in similar fashion as an accessory scene in the miniature of the Temptation of Saint Anthony, intending here to echo the panel of the Hermit saints (*Heremite sancti*) in the polyptych, where they form a pendant to the Knights of Christ. We would therefore expect to find them depicted standing, as the prelates are. However, they were intentionally not painted this way. It was necessary to allow for the possibility of letting the group of knights, who emerge from behind a slope, appear behind them toward the middle of the composition.[78] Now, as we shall see, this group bears an importance that did not permit it to be sacrificed.

The unexpected group of knights is directly inspired by the panels of the Knights of Christ on the left of the Adoration of the Lamb. The presence of Saint George in this group of cavaliers would have been enough for the illuminator, taking the duke's particular devotion into account, to think it necessary to include him in the composition anyway, and it is probably so that this is possible that the two hermit saints were depicted sitting down. As with van Eyck, one sees George mounted on a white horse and carrying his shield and banner with a red cross on a field of gold. He is accompanied by Saint Sebastian carrying a banner with the cross of Jerusalem.[79]

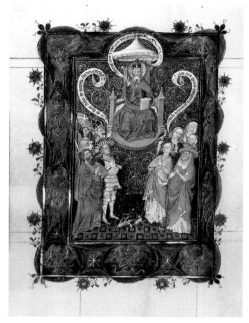

Fig. 34: Master of Catherine of Cleves, *All Saints before the Throne of God the Father.* Hours of Catherine of Cleves. New York, PML, M.945, fol. 115v.

The group of Virgins is found at the upper right, at the same place as in the polyptych. There we recognize Saint Barbara with her tower and Saint Catherine with her wheel in the first row.[80] Their group echoes that of the Confessors, which appears at the same height on the left and is also inspired by the polyptych in Ghent. Van Lathem, who was forced to reduce the number of figures in each group, reduced that of the confessors to several representatives of various religious orders.

The altar with the lamb is very curiously depicted. It rests not on the ground, but sits quite high above a large cross, and thus stands out against the background of sky above the horizon. Visually, this cross stands on the central axis of the composition, ex-

actly like the column of the Fountain of Life at the center of the *Adoration of the Lamb* in the polyptych. The altar is just above the summit of the cross exactly as it is with van Eyck, where it is just above the statue of the angel at the top of the fountain. In the painting, the suggestion of space prevents our having the impression that the altar is in the same plane as the column in the middle of the fountain. The miniature, by contrast, gives the impression that the altar in some way sits on the top of the cross. Van Lathem's intention was perhaps that the Cross, as the evocation of the Passion, by itself replaces the Instruments of the Passion that are displayed by angels, set back on either side of the altar in the polyptych. Has the standing cross not, moreover, been introduced here as a symbol equivalent to the Fountain of Life in the polyptych? The altar frontal is red, as in the painting. The chalice is placed before the Lamb, but the flow of blood that it is intended to collect, visible in the polyptych, is not visible here. The Lamb holds the oriflamme of victory on a red cross.[81] The top of the latter's shaft is adorned with a cross potent. Another cross potent serves as a halo behind the Lamb's head, in place of the rays that shine from his head in the polyptych.

At the top of the miniature, above a festoon of clouds with orange tones contrasting against the strong azure of the sky, we see the Holy Trinity appear, represented as a Throne of Wisdom.[82] On this point the miniature therefore departs considerably from the iconography of the polyptych. Christ as Man of Sorrows rests on the knees of the Father, whose throne is encircled on both sides by saints and angels paying hom-

age to the Trinity. The image of the latter could not be lacking at the heart of a representation of All Saints.[83] Late–medieval texts call the wound at Christ's heart a *fons paradisi*;[84] a Trinity, and in particular the Father with Christ as a Man of Sorrows on his knees, therefore assumes its full meaning in a painting of All Saints. The miniature's creator, or perhaps a cleric from whom the artist received advice concerning less common iconography, saw no problem in the redundancy of the image in which the second person of the Trinity is represented twice—first by the Lamb, and then by the display of Christ as the Man of Sorrows. It strongly signifies that the sacrifice of the Lamb is the source of redemption and grace, and therefore also the source of the eternal life in which all the saints participate.

The angel musicians in the border here appear as a variant on those of the polyptych. One may compare them to the angels that populate the borders of the first two diptychs in the prayer book, in particular the angel musicians in the diptych of the Virgin. Like these images in the diptych, they are closely associated with the subject of the miniature, and here pay homage to the Lamb. They are executed with more care and polish than those seen in the diptych.

Indeed, this miniature and its border constitute a kind of paraphrase or pastiche of the van Eycks' famous work. The elements, borrowed from different portions, echo various components of the polyptych in Ghent; however, the choice of saints summoned here to represent the celestial community appears to have been dictated above all by the preferences of the work's patron.

The illuminator appears to have doggedly tried to produce an adaptation of van Eyck's Ghent Altarpiece, a work too vast and too dense to be able to be transposed or condensed into a painting higher than it is wide and of very reduced dimensions. Despite the devices that he conceived, one begins to think that if van Lathem had not had that immense and fascinating retable on his mind, the resources of his talent would have allowed him to invent a simpler and more pleasing interpretation of the All Saints theme.[85] He opted for a complex iconography that, in the given format, made his task very difficult. It is not impossible that it was suggested to him, that he was expressly asked to draw his inspiration from the polyptych, or at least that he

did not set himself the challenge of giving it a miniature interpretation. Although a bit disconcerting, the case constitutes in any event an additional testimony to the extraordinary influence exercised by the work of the van Eycks on contemporary artists and on those of the following generations.[86]

6.21 THE VIRGIN AND CHILD WITH SAINT ANNE (FOL. 45R)

The Virgin nursing the Child is seated on the right of Saint Anne, who seems to caress the Infant's feet. The scene takes place beneath a square portico, with a vault resting on four columns of red marble. The front of the portico, parallel to the picture plane, forms an aperture with its two columns and the arch that surmounts them that is partially hidden by the miniature's frame. The three other sides of the portico open onto the landscape where two episodes from the story of the Virgin's birth are represented.

Close to the height of the capital of the column behind the Virgin, we can see a man in the distance, resting near a herd of sheep on the side of a hill. It is evidently Joachim, who, grieved and humiliated by the reproaches addressed to him at the temple on account of his sterility, 'therefore withdrew near his shepherds,' where, sometime later, 'one day when he was alone', an angel appeared to him and announced that his wife would give birth to a child that he will call Mary. We see this angel, quite high in the sky, flying toward Joachim. It is painted entirely in red, to indicate, as the text says, that it was 'completely radiant'.[87] The following stage of the account is evoked at the right, where we

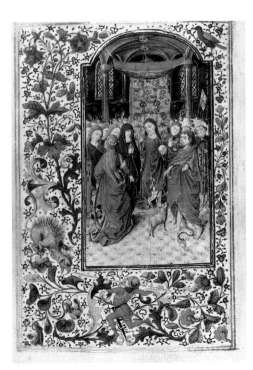

Fig. 35: *All Saints*. Sachsenheim Hours, Stuttgart, WLB, Cod. brev. 162, fol. 64v.

see Anne and Joachim meeting at the Golden Gate. The narrative character of each of the little prayer book's depictions of saints, which at first glance one could have believed absent here, is thus provided by these two scenes discreetly arranged in the background. They illustrate once more the familiarity of artists and their clientele with a number of accounts, without distinction regarding their biblical, apocryphal, or legendary origins.

6.22 CHRIST APPEARING TO SAINT MARY MAGDALENE (FOL. 46V)

Christ appears to Mary Magdalene, who bows down with one knee to the ground, while the Lord blesses her with his right hand. In accordance with tradition, Christ is represented as a gardener, a spade in his hand. He bears the stigmata of the five wounds. His red mantle, open at the front to show the wound, is abundantly highlighted with hatches of gold. The saint presents the jar of spices that she brought with the intention of anointing Christ's body in the Tomb. Between the two figures and slightly set back, at the center of the composition, a slender tree stands with its leaves drawn quite high up on its trunk. The enclosure where the scene takes place is enclosed by a low wicker fence and a small wooden gate, beyond which extends a vast landscape with a city in the background.

The sweet atmosphere conveyed in this miniature once more evokes those of the paintings of Dirk Bouts. Christ appearing to Mary Magdalene is visible in the background of a *Resurrection* by Dirk Bouts or a member of his circle, and in two other *Resurrections*

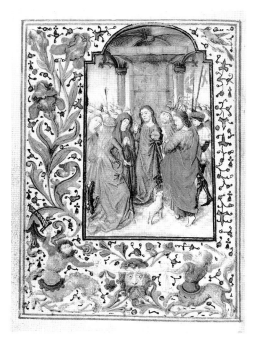

Fig. 36: *All Saints (with a curious tournament in the border)*. Book of Hours. Cambridge, Fitzwilliam Museum, Ms. James 143, fol. 40v.

that are generally acknowledged to go back to a lost work of Dirk. These are the paintings at the Pinakothek in Munich, at Mauritshuis in The Hague, and the Ehningen retable in the Stuttgart museum. Christ appearing to Mary Magdalene appears each time, treated in a quite similar manner to that of the miniature.[88]

6.23 THE MARTYRDOM OF SAINT CATHERINE (FOL. 48R)

Shown in three–quarter view, Saint Catherine kneels, hands joined, at the foot of the terrible machine that should have martyred her (had divine intervention not made it fly into fragments, striking terror into the

executioners). Three of the latter lie hurled to the ground. A fourth flees, throwing an anxious glance behind him. The miraculous intervention has been conveyed by the figure of God, who appears in a luminous yellow and orange cloud, from which emanate golden rays, and with the simple intervention of a small white angel who breaks the wheels of the machine with a hammer. On the right, the emperor Maxentius and his retinue witness the scene. In light of the circumstances, the stupefaction of these witnesses remains astonishingly passive.

Behind the emperor, at the right along the frame, a figure whose glance is turned to the spectator draws our attention. His costume identifies him as a doctor of the university. Indeed, the long cowl–necked robe he wears, and the round cap on his head, are recognizable as the costume of a Master of Arts of the University.[89] The artist no doubt wished to represent one of the wise orators who, according to the *Legenda aurea*, was summoned by the emperor to put Saint Catherine to the test. Impressed and appreciative of the young girl's wisdom and rhetoric, they were converted by her and so were ultimately, in turn, condemned to death.[90] The right-hand character's glance toward the viewer could indicate that the artist has given him his own features. Would van Lathem have introduced a self-portrait by way of a signature into this manuscript, which he himself must have unquestionably considered one of his masterpieces? If so, the quality of the character to whom he gave his features could reveal the consciousness that the artist had of his own worth. This however is merely a hypothesis. One could also imagine that the figure whose

portrait van Lathem gives us was a clerk in the duke's circle, who would have played an important role at the time of the realization of this commission by giving advice on the iconography, possibly after having contributed to the choice of texts.

6.24 SAINT MARGARET (FOL. 49V)

Saint Margaret is depicted holding a gold cross between her joined hands and towering above the terrifying dragon that she has conquered. She apparently escaped from a prison, the wall of which is open, where we see a second dragon who seems to follow the first. In the lower border David and Goliath are represented. The latter has already been laid low, while David still threatens him with his sling. Margaret is thus placed in parallel with David who, like her, vanquished a fearsome enemy.

6.25 THE MARTYRDOM OF SAINT APOLLONIA (FOL. 50V)

The saint, standing with hands joined and held by an executioner against a post on the right of the miniature, seems to submit with serenity to the torture that is inflicted upon her by a second executioner. Using large pincers, the latter proceeds deliberately to extract his victim's teeth. As is proper, the torture takes place under the gaze of the persecutors who have commanded the execution. The emperor seems to give instructions that he accompanies by a gesture of his right hand, pointed toward the saint. By his side an assessor, seen in profile, attentively follows the progress of the scene.

B. THE DEVOTIONAL DIPTYCHS

6.26 THE DIPTYCH OF THE HOLY FACE (FOLS 1V–2R)

In considering the diptych in its context, one may perhaps be surprised that van Lathem did not conceive of it in such a way that the subjects of the miniatures on each folio would appear to be situated in a continuous space. On the right side of the diptych, the perspective of a succession of rooms escaping sideways toward the right behind the figure of the duke differs from the central perspective in the miniature of Saint Veronica. This type of incoherence that, *mutatis mutandis*, is found in the two other diptychs, is not rare for the period. The remarkable perspective of the interior where the duke is kneeling will be the subject of a commentary in the following chapter (see section 7.5, below).

As is common in representations of Saint Veronica, the image of the Holy Face is large, and is here wearing the Crown of Thorns braided with green branches and long sharp barbs. Indeed, the effigy imprinted on the linen that Veronica displays occupies nearly a quarter of the miniature's height. The blood beads on the forehead of this face that, with its grave and sorrowful expression, seems to appraise and question the spectator.

Christ's head is the most finished part of this miniature, the rest of which has several unfinished areas (as we have seen in section 2.3, above). The rapid features of the under-drawing thus clearly stand out in the folds and contours of the cloth that bears the imprint of the Holy Face, as well as in the archi-tectural elements, both in the steps leading to Veronica's aedicule and the contours of the moldings and sculptures that decorate the three arcades.

Among the acanthus *rinceaux* and the flowering stems of the two borders, seven angels carry the Instruments of the Passion. An eighth angel, the one closest to the patron's portrait, has his hands joined as if it were sharing the duke's prayer.

Below the St Veronica miniature, the motif of the Pelican sacrificing herself for her young also evokes the Passion. The beautiful bird that appears at the bottom of the diptych's left side has no other function than that of balancing the decorative composition formed by the two facing borders. By their proud appearance and the elegance of their silhouettes, such birds are very characteristic motifs in van Lathem's borders. The pelican is not unlike the phoenix that the Master of Catherine of Cleves depicted on several occasions.[91]

6.27 THE DIPTYCH OF THE VIRGIN AND CHILD SURROUNDED BY ANGEL MUSICIANS (FOLS. 5V–6R)

The subject of the Virgin surrounded by angels found increasing favor in the painting of the Low Countries in the fifteenth century.[92] The miniature on fol. 5v is comparable to Dirk Bouts's Virgin surrounded by angel musicians (Fig. 37).[93] The Virgin, seated beneath a portico, is surrounded by four singing angels. In the miniature, the posture of the Child, who holds out his arms toward the

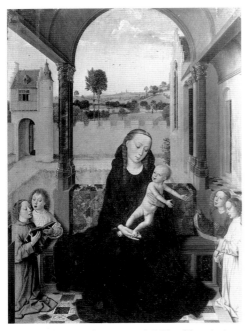

Fig. 37: Dirk Bouts, *The Virgin and Child and four singing angels*. Granada, Capilla real.

right against the wall at the back of the court, does not appear in the painting.

The close connection between the miniature and the painting is confirmed by similarities in the details of the Virgin's bench. In the two paintings, the columns that support the arcade above the Virgin are of marble, supported on the stone back of the bench. The marble of the columns is reddish in the painting. In the miniature, it is greenish on the right and reddish on the left. The portico is surmounted by a wooden vault in the miniature, as in the painting.

The two paintings correspond in their conception of the relationship between the foreground and the space that develops beyond. This space is bordered on either side by the wing of a building that is perpendicular to the picture plane.[95] The perspectives of the two compositions are similar, although that of the miniature could not offer the same rigor as that of the painting.[96] Finally, one will also observe a certain equivalence between the crenellated wall that encloses that garden in the painting, and the walls bordering the river at the back of the enclosed space behind the Virgin in the miniature. The portico where the Virgin is seated in the two paintings is part of an imposing residence, placed in the open countryside in the painting, but situated right in the city in the miniature.

angels, is very similar to that of the Child in the painting, and while the inclination of the Virgin's head and the pose of that of the Child are not identical, one will notice the gesture of the Virgin supporting the Child's foot, which is common to the two representations. In the miniature, the angel behind the Child plays the lute and appears to sing, his eyes turned toward the scroll that he holds in his hand.[94] It constitutes something like a reduced repetition of the two angels in the painting who hold a scroll on which one can see the musical notes that they are supposed to sing. The four angels in the painting are kneeling, as in the miniature are the angel harpist and the angel singer. The discreet presence of Joseph, dressed in blue and wearing a red hat, who appears to be seated on the

The drapery of the Virgin's mantle is highlighted with small hatch-marks of gold that mark the curves of the folds. With the exception of the miniature of *Sainte Anne trinitaire*, fol. 45r, van Lathem has not used gold to highlight the magnificent blue draperies in the other miniatures in the book. These

quite exceptional hatch-marks could perhaps result from the intervention of a hand other than van Lathem's. Are they not farther apart, and of another technique, than the touches or hatch-marks of gold added by van Lathem—for example, in certain red vestments in the miniatures of the documented core? It is difficult to determine with absolute certainty. But if it is indeed the case, the difference in workmanship must no doubt have been in keeping with the observations, discussed above (under section 2.3), regarding the circumstances of the diptychs' execution and the assistants who intervened in their completion.

Each of the borders for this second devotional diptych is decorated with four angel musicians who thus participate in the miniature's concert of musical angels. Among the floral *rinceaux* of these borders several birds also appear, among them a peacock spreading his tail in the outer border on the right.

6.28 THE SAINT GEORGE DIPTYCH

The right side of the third diptych, fols 67v–68r, shows the duke kneeling in a church under the protection of an angel. His prayer is addressed to Saint George, depicted at left, on horseback fighting the dragon. Halfway up the slope on the left, the king's daughter prays as she witnesses George's sword-fight against the dragon, who is already wounded by the lance that George has broken in attacking it.

The view into the landscape's distance is restricted on the miniature's left by the steep hillside of the escarpment, on the top of which tower the ramparts and the lowest

buildings of the city. The rocks that occupy more than half of the background function very effectively as a foil, reinforcing the effect of the landscape's depth, flooded with light, which extends to infinity on the right. That this landscape, rather more than in the other miniatures, has been left in the state of a light but suggestive sketch could result from the particular conditions discussed above (in section 2.3) under which the diptychs must have been created.

The border illustrates two secondary episodes from Saint George's legend. We see an angel giving George his helmet and sword. Below, George stands and bends slightly toward the king's daughter, who kneels and takes both his hands with emotion to thank him for having saved her. Alternatively, the scene could conform to the account in the *Legenda aurea*, and show the moment before the battle when she tries to dissuade George from attacking the dragon that she believed invincible.

Endnotes
1 See chapter 1.1 and 1.2 for the importance of the devotional diptychs to identify the receiver of the manuscript.
2 'Typological' is understood here in a broad sense. Most often it has to do with an analogy between two episodes, one biblical and the other hagiographical, without it being, in the strict sense, the question of an Old Testament prototype and a New Testament antitype.
3 For example, in the foreground of the miniature on fol. 158v of *La Conquête de la Toison d'or* (Paris, BnF, Ms. fr. 331) (Fig. 7). Very similar plants grow on the water bank in the foreground of the miniature in the left column of fol. 4r of the *Chroniques de Jérusalem*, (Pächt/Jenni/Thoss 1983, pl. 104). These correspondences seem to indicate a relationship between the illumination of these *Chroniques* and the art of van Lathem.

4 Gorissen 1973, p. 982; J.K. Steppe, 'Het paneel van de Triniteit in het Leuvense Stadsmuseum. Nieuwe gegevens over een enigmatisch schilderij', *Dirk Bouts en zijn tijd*, exh. cat. (Leuven, Sint-Pieterskerk, 1975), pp. 447–495. A fundamental and especially well–documented study on the iconography of the Trinity in general, and on the Leuven Flémallesque painting in particular.

5 Friedländer, vol. 2, 1967, Pl. 88, 92 and 99. Pl. 99 also reproduces the hood of the cape embroidered with the arms of Jacques de Savoie, Count of Romont, in Berne (Historisches Museum, Inv. Nr. 53) and one of the drawings (Oxford, Ashmolean Museum) used as a pattern for its realization. M. Sonkes, *Dessins du XVe siècle: groupe Van der Weyden* (Brussels, 1969), pp. 161–162, Pl. XXXIX c (Les Primitifs Flamands. 3. Contribution à l'étude des Primitifs Flamands). That this Trinitarian iconography connected with the sacraments is indicative of the meaning with which it was invested. Steppe 1975, pp. 458–461.

6 Paris, BnF, Ms. n.a. fr. 16428, fol. 44r. Color reproduction: *Le Livre*, exh. cat. (Paris, Bibliothèque nationale, 1972) p. 208, n° 648, Pl. VI; Thomas 1976, pp. 90–91. Steppe 1975, p. 467, found, like Thomas after him, that this miniature repeats almost literally the Flémallesque Trinity in the Leuven museum.

7 Steppe 1975, p. 466.

8 A very beautiful small book of hours once belonged to library of the Trivulzio princes in Milan, under the n° 472. This manuscript, destroyed in the fire of the Turin Library in 1904, would have contained a miniature of the Trinity similar to that of the Duke's prayer book, and of the same technique as the latter. Durrieu 1916, p. 107 (p. 39 of the off–print), which refers to the brief description of this volume by G. Porro, *Catalogo dei manoscritti della Trivulziana* (Turin 1884) pp. 331–332.

9 R. Schilling, 'Das Llangattock-Stundenbuch. Sein Verhältnis zu van Eyck und dem Vollender des Turin-Mailänder Stundenbuches', *Wallraf-Richartz-Jahrbuch* 23 (1961); *Thirty–five Manuscripts including… The Llangattock Hours,… Catalogue 100*, H.P. Kraus, New York, 1962, p. 60, citation of a letter of Panofsky; U. Panhans-Bühler, 'Eklektizismus und Originalität im Werk des Petrus Christus' *Wiener kunstgeschichtliche Forschungen* 5, Vienna 1978, p. 18. This last author envisaged the possibility of a van Eyck prototype that would have been incorporated into a composition of the Master of Flémalle.

10 Among the latter: the type of the figure of the Father and the fact that, in several of the manuscripts where this iconography is found, the Father is wearing the tiara like the figure of the Divinity in the Ghent Altarpiece (Fig. 91).

11 Euw/Plotzek, vol. 4, 1985, pp. 115–141. The Trinity miniature is discussed on pp. 137–139. The style of this manuscript is particularly close to that of the Turin–Milan Hours.

12 Brussels, KBR, Ms. IV 95, fol. 155v. Ainsworth/Martens 1994, pp. 176–180. Color reproduction.

13 Ps. 110, 1; Mt. 26, 64; 23, 41–44; Heb. 10, 12; etc. Although this iconography is in fact an *ostentatio* where the father sometimes shows Christ in holding him before Him, one will observe that, in the three paintings of the Master of Flémalle group and in the Vienna antependium cited above, Christ is supported each time at the right of the Father.

14 Even so one cannot speak of 'der Heilige Geist als geflügelte Christusfigur' as do Pächt/Jenni/Thoss 1983, p. 20, concerning a Trinity of this type that appears in a curious diptych contained in a prayer book that once belonged to Philip the Good (Vienna, ÖNB, Cod. 1800).

15 In this way, the Spirit has the same appearance as the angel who is found behind the duke in the miniature on fol. 1v and fol. 68r. The Spirit would have the appearance of a very young man in a French miniature of the Trinity dating to the fourteenth century, where the Father has the appearance of an old man and the Son that of a mature man. Timmers 1947, p. 66, n° 55; Timmers 1978, p. 25, n° 14; A.H. Didron, *Iconographie chrétienne* (Paris 1843), p. 223.

16 It appears under the attribution to the Master of Saint Giles in two sales at the Palais des Beaux–Arts in Brussels: on the 9th of March, 1953, as n° 59 du catalogue (with reproduction); and on February 28, 1963, as n° 873. Panel, approximately 25,5 × 22 cm. This painting again appeared for sale on the 31st of March, 1993, at Drouot-Richelieu in Paris (Commissaires-Priseurs Associés Laurin-Guilloux-Buffetaud), this time attributed to Jacques Daret. If I am not mistaken, it was not pointed out that its panel was not oak but limewood.

17 In this painting, the Trinity is enthroned on a stone bench in the choir of a gothic church, beneath a rectangular dais and in front of a cloth of honor of red and gold brocade. In front of it flutter two angels, one holding the lily of peace and mercy, and the other the sword of justice and truth. The attitude of Christ, supported by the Father under the armpits, presents some similarity with that of the painting of the Master of Flémalle in Frankfort. He does not hold his hand at his chest to show his wound, and appears to rest on the Father's right knee. In the Hours of Catherine of Cleves, the Spirit is represented in human form in four miniatures of the Trinity. Each time it is clothed in a white robe, with the stole crossed on its chest. Plummer 1966, n° 32, 35, 36 and 39 (Fig. 11, 62). Christ only bears the marks/signs of the Crucifixion in miniature (fol. 88r), where his feet rest on the terrestrial orb (Fig. 11).

18 E. Dhanens, *Hugo van der Goes* (Antwerp 1998), p. 224, gives an insight into the divergent proposals put forth for the dating of the Vienna diptych.

19 In the border of the *Conquête de la Toison d'or*, Paris, BnF, ms. fr. 331, fol. 78v, one finds the scene executed according to the same model (Fig. 14). In this manuscript illuminated by van Lathem, several borders are the work of an assistant. Abel's face and raised hands are far from being as expressive as those in the prayer book. The subject, repeated in reverse, has in this secular manuscript no connection with either the text or the subject of the miniature that it accompanies. Proving his ignorance or a rather irreverent humor, the creator of this copy flanked the scene of Abel's murder with two armed and helmeted combatants who appear to be running to the victim's aid.

20 V.E. Fiala and W. Irtenkauf, *Die Handschriften der Württembergischen Landesbibliothek Stuttgart. Codices Breviarii*, (Wiesbaden 1977) pp. 195–196.

21 Winkler 1915, p. 305, Fig. 21 and 1925, p. 182; Durrieu 1916, p. 108, note 1; O. Pächt, *Flemish Art 1300–1700*, exh. cat. (London, Royal Academy of Arts, 1953–1954) p. 153, n° 572.

22 De Schryver 1969, pp. 133–135, Fig. 18.

23 Brussels 1959, pp. 161–162, N° 206; Roosen-Runge, (Wiesbaden 1981), vol. 2, p. 301.

24 Durrieu 1916, p. 108, note 1 considered the Saint John as one of the miniatures in the manuscript in which he best recognized the style of de Mazerolles, that is to say at present of van Lathem. But it must be noted that Durrieu still considered the *Chroniques de Jérusalem* as the work of the same illuminator as that of the little prayer book.

25 Pächt/Jenni/Thoss 1983, figs. 103–105.

26 For example, Pächt/Jenni/Thoss 1983, figs. 117 and 122.

27 A. Arnould dated Ms. 143 to c.1470. *Splendours of Flanders*, exh. cat. (Cambridge, Fitzwilliam Museum, 1993), ed. J.M. Massing and A. Arnould, p. 72, N° 19. The Sachsenheim Hours and Ms. 143 date to about the same period. The date proposed by Arnould is too advanced. The hypothesis of a relation between the Siege of Neuss, begun at the end of July 1474, and the reference to Saint Quirinus in Ms. 143 cannot be maintained. A miniature of Saint Quirinus also appeared on a folio extracted from the Suffrages in the Hours of Catherine of Cleves, and the saint is mentioned on the 20th of October in this manuscript's calendar: Plummer 1964, pp. 349 et 355.

28 *Van Eyck to Bruegel: Dutch and Flemish painting in the collection of the Museum Boymans-van Beuningen* (catalogue) (Rotterdam 1994), pp. 56–59.

29 The fact that it also appears in the border of the miniature of Saint John on Patmos of MS James 143 in Cambridge, already mentioned above, is a complementary sign that this manuscript was created in van Lathem's circle (Fig. 22).

30 The Master of Catherine of Cleves represented Saint Peter doing penance in his cave (Plummer 1964, Pl. 18). Gorissen 1973, p. 315.

31 J.P. Filedt Kok et al., *'s Levens felheid: de Meester van het Amsterdamse cabinet of de Hausbuchmeester, ca. 1470–1500*, exh. cat. (Amsterdam, 1985), p. 136, n° 40.

32 Boon 1985, pp. 13–17.

33 Durrieu 1916, p. 129.

34 *Acta Sanctorum*, May, vol. 1 (Antwerp 1680), p. 22.

35 Migne, *Patrologia latina*, CXCVIII, col. 1645. These ten apparitions are repeated in the Netherlandish Bible of 1360, for example in the copy of Evert van Zoudenbalch in Vienna: Cod. 2772, fol. 73v (color reproduction in Pächt/Jenni 1975, Plate VII). On this Netherlandish Bible of 1360, see: J. Deschamps, *Middelnederlandse handschriften uit Europese en Amerikaanse bibliotheken* (Brussels 1970, 1972²), no. 50.

36 Voragine 1967, 1, pp. 277, 334–335.

37 Réau 1955–59, III-2, 1958, pp. 703–704; LCI, vol. 7, col. 51. The representations of this meal with James the Less are inspired by apocryphal accounts. The analogy with the episode of the pilgrims of Emmaus (Luke 24, 13–35) lets us presume that these accounts are derived from it.

38 Voragine 1, p. 474. On the oldest texts relating to the *translatio*: R. Plötz, 'Traditiones Hispanicae Beati Jacobi: Les origines du culte de saint Jacques à Compostelle, *Santiago de Compostela: 1000 ans de Pélerinage Européen*, exh. cat. (Ghent, Abbaye Saint–Pierre, Centrum voor Kunst en Cultuur, 1985), pp. 37–39. In the same catalogue, see also: J.K. Steppe, 'L'Iconographie de Saint Jacques le Majeur (Santiago)', pp. 129–153.

39 The stone to which this marvelous characteristic was attributed is preserved at Padrón, where it was set in under the main altar of the cathedral. M. Madou, 'Zittende Jacobus', *De Jacobsstaf* (1994, n° 22), p. 53; H. Jacomet 'L'énigmatique Odyssée de saint Jacques', *Archeologia* (December 1995, n° 318), p. 66.

40 J. Vieilliard, *Le Guide du Pélerin de Saint-Jacques de Compostelle* (Mâcon 1938), p. 138.

41 By the sermon *Veneranda dies* that the *Codex Calixtinus* assigns to the Feast of the Translation of the apostle. The author remarks that if one acknowledges this version of the story, the miraculous stone would have originated on the coasts of Palestine; 'Now,' he says—becoming a geologist—'I recognized it as being from Galicia'! Madou 1994, p. 52; Jacomet 1995, p. 64.

42 M. Madou 1994, pp. 44–54; Jacomet 1995, pp. 58–67.

43 According to the *Liber Sancti Jacobi* (Codex Calixtinus), some believed that Christ had given James a staff, after having torn away part of the bark, an image indicating that the devout who came in a spirit of

prayer to his sanctuary, would see themselves purified of their stains. H. Jacomet 1995, pp. 64–65. The strap that one sees wound around the staff in van Lathem's miniature does not allude to the bark removed from the staff, as do certain older representations. As in the painting of the same scene in the retable in Indianapolis, it definitely seems that here we already have the staff of a pilgrim, equipped with the straps on which will be hung the gourds or the pilgrim's other attributes.

44 The subject of van Lathem's miniature is painted in a very similar fashion to one of the scenes in the frontispiece border for the cartulary of the hospital of Saint Jacques de Tournai (Tournai, Bibliothèque de la Ville, Cod. 4A). The scene is painted in a somewhat incongruous manner. Saint James is represented asleep when Christ appears to want to give him the pilgrim's staff. The scene is certainly inspired by older representations in which the apostle, awake, accepts the staff. This folio was painted by the master of the Dresden Hours, and dates to about 1490. See the Note by D. Vanwijnsberghe in: Smeyers/Van der Stock 1996, pp. 186–187; B. Brinkmann, 1997, pp. 235–236, color figure 48. In this manuscript, the figure of Saint James, wearing a hat decorated with a shell, is quite close to that in the panel or the Indianapolis retable. The landscape in the background of the two representations also seems related.

45 These two representations could therefore be added to the examples indicated by Madou 1994, pp. 50–54 and Jacomet 1995, pp. 62–63, 66–67. The posture of Christ pushing with his foot against the rock where Saint James is seated already appears on the seal of the Abbey of Saint-Jacques de Provins in 1352. However, there Saint James is not represented asleep, but receiving the staff, symbol of the mission with which he is entrusted, from the hands of Christ.

46 The reduced height of the miniature could have constrained the illuminator to stick with a less panoramic perspective.

47 According to a letter attributed to Ignatius of Antioch, it could have been believed that Jesus and James were twins. Voragine, vol. 1, pp. 333–334; Timmers 1947, pp. 936–937.
As the son of Alpheus and Mary Cleophas, James (like Judas) was in fact related to Jesus. Cousins were also called as brothers in Hebrew and Aramaic, which explains why they were called 'brothers of the lord' in the Gospels (Matthew 12:46, Mark 3:31–33 and 6:3; Luke 8:19–21).

48 This resemblance was also respected in other paintings where Christ and Saint James appeared. M. Smeyers in: Dirk Bouts en zijn tijd, exh. cat. (Leuven, Sint-Pieterskerk, 1975), pp. 239 and 351–352. The Master of Catherine of Cleves had, in the Last Supper, also taken into account the resemblance of James, but had

placed him at Peter's right. Plummer 1966, n° 77; Gorissen 1973, pp. 490–491.

49 Acts of the Apostles, 7, 55–60 and 8, 1–3; Voragine, 1, pp. 75–79. The account of Saint Stephen's martyrdom in the Légende dorée, summarizes that of Chapters 6 and 7 of the Acts.

50 Plummer 1966, pl. 131.

51 Reproduced in A. Bräm, Das Andachtsbuch der Marie de Gavre (Paris, Bibliothèque nationale, Ms. nouv. acq. fr. 16251): Buchmalerei in der Diözese Cambrai im letzten Viertel des 13. Jahrhunderts (Wiesbaden 1997), p. 313; L'Art au temps des rois maudits, Philippe le Bel et ses fils 1285–1328, exh. cat. (Paris, Galeries nationales du Grand Palais, 1998), p. 295.

52 K. Morand, Jean Pucelle (Oxford, 1962), Pl. IIIc and XXVc; Meiss 1968, ill. 7; C. Schaefer, Jean Fouquet: an der Schwelle zur Renaissance, Dresden, Basel, 1994, p. 119, fig. 66.

53 A. Bräm 1997, p. 347, ill. 33.

54 For example in the Boucicaut Hours and those of Catherine of Cleves (Plummer 1968, Pl. 131). On this, see: Gorissen 1973, pp. 636–637.

55 Friedländer 1967, vol. 1, p. 73, pl. 68.

56 Without entering the controversy on the subject of the attribution of the retable, recall that some consider it a work of Dirk Bouts, others that of his son Dirk the Younger, and still others as the work of an unidentified emulator. Friedländer 1968, vol. 3, N° 24, plates 38–40, pp. 79–82.

57 Friedländer 1968, vol. 3, pp. 21 and 24, 80–81; D. Schöne, Dieric Bouts und seine Schule, Berlin, Leipzig 1938, p. 208ff.

58 Theoretically, it is not out of the question that the Pearl of Brabant itself reflects an older work that would not have reached us, and that it is this lost work that was the source of inspiration for the miniature.

59 Friedländer 1968, vol. 3, pl. 82, n° 71 and 100, n° 97.

60 Lieftinck 1969, ill. 258.

61 De Winter 1981, p. 399, Figs. 118–119.

62 The episode goes back to the Life of Saint Paul the Hermit written by Saint Jerome. Voragine 1967, vol. 1, pp. 121–122. Meiss 1974, pp. 128–130. Although quite rarely depicted, the episode of the centaur was illustrated by the Limbourg brothers (New York, Cloisters, Belles Heures, fol. 192; Paris, BnF, n. a. lat. 3093, p. 240: Meiss 1974, Figures 479 and 500). Anthony and the centaur also appear in the painting of the Meeting of Saint Anthony and Saint Paul (National Gallery of Art, Washington), attributed to the Osservanza (Siena, approximately middle of the fifteenth century), K. Christiansen, L.B. Kanter, C.B. Strehlke, Painting in Renaissance Siena, 1420–1500, (exh. cat., Metropolitan Museum of Art, New York, 1988), pp. 120–123 (ill.)— Saint Anthony questioning the centaur, who indicates to him the path to take, was also represented by Robinet Testard as the subject of a miniature evoking Up-

per Egypt in *Les Secrets de l'histoire naturelle* (Paris, BnF, Ms. Fr. 2297). Paris 1993, p. 404, Fig. 228. The account appears to involve some variants. Anthony would have also met a faun, and it would be the latter who would indicate the way. *Abbas querebat Paulum faunusque docebat*, reads the inscription on the tympanum of the church of Saint-Paul de Varax (Ain), where the episode is represented twelfth century). V.H. Debidour, *Le Bestiaire sculpté du moyen âge en France* (Paris 1961), p. 241, Fig. 342.

63 Voragine 1967, vol. 2, p. 336; Sulpice Sévère, *Vie de saint Martin*, ed. J. Fontaine, Sources chrétiennes n° 133 (Paris 1967), p. 257.

64 Lallemant was a canon and archdeacon of Tours, as well as canon of Tournai and Bourges. New York 1982, p. 86, n° 112; Paris 1993, p. 317.

65 This account deviates in more that one point from the others relating to the legend of Saint Fiacre to which P. Perdrizet refers: Perdrizet 1933, pp. 214–215; E. Brouette, in *Dictionnaire d'Histoire et de Géographie ecclésiastiques*, vol. 16 (Paris 1967), cols 1379–1382.

66 The text also teaches us that '*en tesmoing de ce miracle, la pierre est encore gardee en son eglise, et le lieu demonstré ou elle estoit quant il si assist. Et ont esté gueris plusieurs malades pour y touchier seulement.*'(Brussels, KBR, Ms. 9282–5, fols. 343v–344r). One will notice the analogy with the legend of the stone where the body of Saint James rested, a stone that was itself also venerated as a relic at the heart of a sanctuary. See note 42 above, under 6.8.

67 In 1457, the embroiderer Jehan de Louvain was paid 4lb. 16s. for *avoir fait et délivré deux escuchons broudez de soye et de fil d'or et d'argent aux armes de mondit seigneur*, which were put on a chasuble that Charles had had made in order to give *à l'église de Saint Hubert d'Ardenne*, where he had made a pilgrimage. ADN, B. 3661, fols 68r–68v, 83v. In 1468, the duke sent some people to burn candles in the church of five places of pilgrimage, of which one was Saint Hubert en Ardennes: Vaughan 1973, p. 161.

68 The idea of having the beginning of a text run on a banner placed beneath the miniature anticipates the work of later illuminators, who would sometimes paint *trompe-l'œil* banners in their miniatures on which could be read the first lines of text. There are many examples in the Spinola Hours (Los Angeles, J. Paul Getty Museum, Ms. Ludwig IX 18). Euw/Plotzek, vol. 2, 1982, pp. 262–263, Figs 399–402. See in particular the remarkable miniature of the Last Judgment at the beginning of the Penitential Psalms, on fol. 165v. It includes the beginning of the antiphon *Ne reminiscaris*. Idem, Fig. 437.

69 The same antiphon is found beneath the miniature of Saint Hubert, fol. 106 of Ms. 639 (Paris, Bibliothèque de l'Arsenal), which forms with Ms. 638 an important book of hours for which the illumination is in part in a style related to that of Simon Marmion. A. de Schryver, 'The Louthe Master and the Marmion Case' *Margaret of York, Simon Marmion, and The Visions of Tondal*, T. Kren ed., (The J. Paul Getty Museum, Malibu, 1992) pp. 173–175. The manuscript in Louvain-la-Neuve, Université Catholique de Louvain, Ms. A.2, was for a long time erroneously considered the Hours of Thomas Louthe. The true recipient of this manuscript was recently identified by Lorne Campbell, *The Fifteenth Century Netherlandish Schools (National Gallery catalogues)*, (London, 1998), pp. 381–383. Therefore from now on it is necessary to abandon the label of the 'Louthe Master' that I had used to designate the creator of the manuscript's illumination. As I came to understand in 1990 (De Schryver 1992, pp. 171–180), it was mistake to have believed it necessary to withdraw this manuscript and others related to it from the group of works attributed to Marmion.

70 It was only in the fifteenth century that the hagiography of Saint Hubert was augmented by this tale, born of the confusion with the story of Saint Eustace who was celebrated on the same day, November 3rd. P. Bertrand, in *Dictionnaire d'Histoire et de Géographie ecclésiastiques*, vol. 25 (Paris 1994), col. 23, s.v. Hubert.

71 Today Chauvirey-le-Châtel in Haute-Saône.

72 J. Mann, 'The Horn of Saint Hubert', *Burlington Magazine* 92 (June 1950), pp. 161–165; P. Hardwick, *Discovering Horn* (London 1981), pp. 46–49. I address my great thanks to J.K. Steppe, who drew my attention to the existence and the story of this Horn of Saint Hubert. My thanks go also to the Publications Service at the Wallace Collection for the information provided.

73 Hubert was the Bishop of Maastricht from 703–706 to the 30th of May, 727, the day of his death. It has often been asserted that Hubert was also Bishop of Liège, but the translation of the Episcopal seat from Maastricht to Liège was after his death. P. Bertrand 1994, cols 21–26.

74 Concerning Saint Eutropius and the questions his presence poses in Duke Charles's manuscript, see above under 1.3.

75 This figure of Saint Hubert is very similar to that of the historiated initial on fol. 163v of the Sachsenheim Hours (Stuttgart, WLB, Cod. brev. 162, fol. 163v).

76 Dhanens 1965, p. 55 and Fig. 19.

77 It is through the writings of Saint Jerome that the Life of Saint Paul the Hermit, or Saint Paul of Thebes, is known. Is this the reason why the figures of Saint Jerome and of Saint Paul are pendants here?

78 This group appears in the composition somewhat like the procession visible in the right background of the panel of the *Meeting of Abraham and Melchisedech* in Bouts's *Last Supper* triptych. Friedländer 1968, vol. 3, Pl. 28.

79 With their respective banners, they both appear in the panel of the Knights of Christ. These two rectangular

banners correspond to those of important Ghent fraternities of Saint George (crossbowmen) and Saint Sebastian (archers), to which van Eyck perhaps wished to allude. Dhanens 1965, p. 54, Fig. 19.

80 The shape of Saint Barbara's tower is very similar to the one in the painting. On the other hand, Catherine's wheel does not appear, although one presumes that it is indeed Catherine that van Eyck painted beside Saint Barbara (Dhanens 1965, p. 53), as the miniature seems to confirm in having added her attribute.

81 This is the same oriflamme that the first horseman carries at the front of the panels of the Knights of Christ.

82 The extremely reduced dimensions of these figures does not really permit us to distinguish whether the Holy Spirit is represented in the form of a dove, as it usually appears in this iconography, sometimes also called the *Pietà du Père*.

83 Panofsky 1953, pp. 212–215; Steppe 1975, pp. 460–463.

84 Steppe 1975, p. 461.

85 In this he could have been inspired by other versions of the subject: the iconography showing the saints grouped around the Father, as in the Hours of Catherine of Cleves, Plummer 1966, n° 61 (Fig. 34); or that in which they are grouped around Christ, as in two books of hours closely related to the duke's prayer book: the Sachsenheim Hours, fol 64v (Fig. 35), and MS 143 at the Fitzwilliam Museum in Cambridge, fol. 40v (Fig. 36). These iconographies were probably not unknown to him.

86 J. Duverger, 'Kopieën van het « Lam-Gods »-retabel van Hubrecht en Jan Van Eyck', *Bulletin Koninklijke Musea voor Schone Kunsten*, Brussels, 2 (1954), pp. 50–68. Dhanens 1965, pp. 41–42. Dhanens 1989, pp. 211–225. A miniature from the end of the fifteenth century, inspired by the Ghent Altarpiece (Madrid, Museo del Instituto de Valencia de Don Juan, inv. 91), is far greater in dimensions (21 × 16 cm) than that of the little prayer book, and only reworks elements from the central panel of the polyptych: *Les Primitifs Flamands, II Répertoire des peintures flamandes des quinzième et seizième siècles. Collections d'Espagne 1*, Antwerp 1953, pp. 37–38, Pl. LV; J. Duverger, idem ut supra, p. 53 and Fig. 1. The narrow border on the right side of the folio indicates that this miniature appeared on a verso in the manuscript from which it comes.

87 Voragine 1967, vol. 2, pp. 174–175. Like a number of other didactic authors of the Middle Ages, Voragine took the account of the *Livre de la Nativité de Marie* that goes back to a great extent to the Proto–gospel of James and to the Gospel of pseudo–Matthew. The text has been translated and annotated by Rita Beyers, in *Écrits apocryphes chrétiens*, ed. F. Bovon and P. Geoltrain (Bibliothèque de la Pléiade, 442) (Paris 1997), pp. 141–161; E. Amann, 'Apocryphes du Nouveau Testament', *Dictionnaire de la Bible*, Supplement, vol. 1 (Paris 1926), cols 482–483.

88 Friedländer 1968, vol. 3, pp. 61–62 (n° 20), p. 66 (n° 56), p. 70 (n° 78), Pl. 35, 69 and 89.

89 Numerous examples from the iconography of King Charles V often represented in this costume. Panofsky 1953, p. 37. See also: *La Librairie de Charles V*, exh. cat. (Bibliothèque Nationale, Paris 1968); C. Richter Sherman, 'Representations of Charles V of France (1338–1380) as a Wise Ruler' *Medievalia et Humanistica. Studies in Medieval & Renaissance Culture*, (new series, 2, 1971), pp. 83–96.

90 Voragine 1967, vol. 2, pp. 387–391.

91 Gorissen 1973, pp. 882–883, ill. 272; Pieper 1966, pl. 9.

92 The subject is at first rarer in manuscripts that in paintings. Flemish painting multiplied the interpretations, from the Master of Flémalle's Virgin in the apse, to those offered by Memling, Metsys, or Gossaert, and many others.

93 De Schryver 2001, pp. 214–217. Friedländer 1968, vol. 3, pl. 25; R. Van Schoute, *La Chapelle royale de Grenade* (Brussels 1963) (Corpus de la peinture des anciens Pays-Bas méridionaux au quinzième siècle, 6), N° 94, color pl. XXXIa; *Dirk Bouts (ca. 1410–1475): een Vlaams primitief te Leuven* exh. cat. (Sint-Pieterskerk en Predikherenkerk, Leuven 1998), pp. 446–448, N° 128, color plate.

94 Slight damage does not allow me to distinguish very precisely the form of the scroll or document held by the angel.

95 It is necessary to take into account the fact that the painting has been cropped on four sides. The left side has been cropped more than the right. Van Schoute 1963, pp. 29 and 32; Louvain 1998, pp. 446–448, N° 128.

96 M.W. Ainsworth 1994, pp. 142–145, has analyzed the painting's interesting perspective, in commenting on Petrus Christus's *Madonna and Child Enthroned on a Porch*, (Madrid, Museo del Prado), from which Bouts drew inspiration.

THE STYLE OF LIEVEN VAN LATHEM'S MINIATURES

The manuscripts that today we consider to be illuminated by van Lathem had already long held the attention of art historians[1] when Paul Durrieu and Friedrich Winkler, enticed and intrigued by the quality of the illuminations, embarked on a study of them and attempted to unravel what was still the complete mystery of their creator's identity.[2] They gradually became convinced that this master was none other than Philippe de Mazerolles, an artist of French origin established in Bruges, and official illuminator to Charles the Bold. The discovery of the book of prayers had largely contributed to presumptions that were fundamental to the attribution to de Mazerolles.[3] Although it was ultimately proven false,[4] in its time this attribution was generally well received and many have even long held it to be indisputable.[5]

That erroneous attribution to de Mazerolles led to the assumption that the book was produced in Bruges. From the moment it was established that this work was van Lathem's, it became important not to lose sight of the fact that the book does not come from Bruges. Of course van Lathem was summoned to Bruges more than once, including in 1468 for preparations for the Chapter of the Golden Fleece and the duke's wedding celebration. The fact remains that—after Ghent and other cities, among which one could perhaps count Utrecht—it was Antwerp where he principally worked over the course of thirty years.[6]

That van Lathem obtained important commissions from Louis of Bruges, Lord of Gruuthuse, has fostered the confusion and reinforced the false conception that associated van Lathem with Bruges. There is no reason to suppose that the manuscripts he was engaged to make for Louis de Gruuthuse were commissioned or executed in Bruges.[7] It is necessary to remember the importance of the diplomatic, political, and military role played by Gruuthuse in the service of the dukes, especially in Holland and Zeeland, where his marriage to Marguerite van Borsele contributed to establishing his authority as governor or duke's lieutenant general. The assignments with which he was entrusted and the missions that he had to fulfill by no means took place principally in Bruges, in particular during the years in which we may date the manuscripts attributed to van Lathem. Bruges production unquestionably experienced van Lathem's influence, but it was probably disseminated by the admiration that van Lathem's works excited rather than by the artist's visit in

1468. The library of Louis de Gruuthuse could have contributed to the diffusion of this influence.[8]

The folios that van Lathem illuminated in the prayer book illustrate wonderfully all of the richness of his talent as a painter and designer. The pages that follow attempt to isolate the principal characteristics of van Lathem's paintings.

7.1 COMPOSITION

The illustration of a devotional book, more readily than that of narrative texts, was influenced by the conventions that traditionally governed the conception of images intended to serve as cult or devotional objects. This no doubt explains why the scenes represented in the miniatures of the prayer book almost all take place strictly in the foreground of the composition. Van Lathem thus conformed to the presentation traditionally favored in devotional paintings. This provision, however, excluded the secondary episodes associated with the main subject, which appear in the backgrounds of several miniatures. In the miniatures created a few years earlier for Louis de Gruuthuse's *Gillion de Trazegnies* (Chatsworth, Collection Duke of Devonshire and the Chatsworth Settlement Trustees, Ms. 7535),[9] or Philip the Good's prayer book (Paris, BnF, Ms. n.a. fr. 16238), van Lathem had presented the action unfolding in more depth and on several planes. But the larger dimensions and proportions of these manuscripts offered the illuminator possibilities that are not comparable to the ones to which he had to accommodate himself in order to illuminate a very small little book, in which the field reserved for miniatures was reduced to less than 70 mm in height and 40 to 45 mm in width.

Van Lathem needed much imagination, ingenuity, and talent to compose a scene of martyrdom, or another subject with several figures, in the narrow spatial limits that had been reserved for him. Although inevitably compressed, the arrangement of characters in the majority of miniatures nonetheless proves to be very well designed and agreeably balanced, as, for example, in the Stoning of Saint Stephen or the Martyrdom of Saint Lawrence, fols. 24v and 31v. In two particular cases, van Lathem appears not to have truly succeeded in creating a perfectly satisfying arrangement. The miniature of Saints Peter and Paul, fol. 19v, had obliged him to juxtapose two episodes in the same miniature, nevertheless taking care that they be treated in an equivalent manner. In the All Saints miniature, fol. 43r—for which, as indicated above, he wished or needed to draw inspiration from the Ghent Altarpiece—he had to take on the challenge of transposing a monumental, horizontal composition onto a little painting higher than it is wide.

7.2 FIGURES

The characters' faces are often painted in small, sometimes quite disorderly strokes. Their technique recalls that of the Master of Girart. The painting of the cheekbones, often rather red and prominent, sometimes lends certain figures a bit of a rough

or plebeian expression. Female figures are generally graceful, as much in their features as in their attire. Saint Veronica and several other female figures are adorned with tall, complex, and elaborate coiffures.

Costumes of precious fabrics indicate the high rank or great dignity of certain characters. Whether it is the emperor who attends Saint Catherine's or Saint Apollonia's martyrdom, fols. 48r and 50v, or the other great lords or judges who attend the martyrdoms of Saint Andrew, Saint Stephen, or Saint Lawrence, on fols. 21r, 24v, and 31v, we notice that these characters all wear brocade robes or mantles bordered or lined with ermine. The artist projected into these scenes, thought to have taken place in a distant age, details belonging to his own time.

The rapt, dreamy, and contemplative expressions of many of van Lathem's figures are quite close to those of the figures of Dirk Bouts. Their faces are nevertheless generally not very individualized. The scenes of martyrdom do not emphasize the victim's sufferings, the cruelty of the treatments inflicted, or the roughness and brutality of the executioners. The accent is rather on the steadiness, constancy, and courage of the martyrs, which once more leads us to recognize a relationship with Bouts in their spirit, and to evoke an analogy with the manner in which he represented the *Martyrdom of Saint Erasmus* (Fig. 38). With Bouts as with van Lathem, the witnesses stand by with an air that is serious and content, if not impassive, to the worst torments. The tension that Saint Lawrence's face betrays, fol. 34v, is the

Fig. 38: Dirk Bouts, *Martyrdom of Saint Erasmus*. Leuven, Church of Saint Peter.

exception, as is the fear that can be read on the face of the executioner in the Martyrdom of Saint Catherine, fol. 48r, who is thrown to the ground through divine intervention. The expressions of this figure and the one who lies down at the emperor's feet could be compared to those of the exhausted combatants, lying on the ground, head turned backward, that van Lathem painted in tournament or battle scenes in the secular manuscripts that he illustrated.[10] For such figures, van Lathem was perhaps inspired by battle scenes illustrating the Vienna *Girart de Roussillon*.[11] Indeed, he could have had a very good opportunity to see this manuscript, or the workshop sketches or cartoons that were used for its realization, since he worked for Philip the Good from 1456 on; that is to say, at the time when the magnificent illustration of *Girart* had just been completed[12] and when another masterpiece was about

to be undertaken in part by the same artists: the famous *Chroniques de Jérusalem abrégées* in Vienna. If it is accurate, as I presume, to say that van Lathem was himself associated with the execution of the *Chroniques*, he inevitably would have had the chance to become familiar with the models used by his colleagues, who were there side-by-side.

The figures' movements or postures are often quite well-captured. As is often the case with miniatures, characters' emotions or sentiments are expressed more through gestures and postures than through facial expressions. Saint Michael fighting the demons, the executioners stoning Saint Stephen, the woman interrogating Saint Fiacre, and Saint George fighting the dragon (fols. 15v, 24v, 38r, and 67v) are just so many examples of this. The movements of these figures lack neither vigor nor allure.

It is not uncommon for the same figures to be found in several miniatures in similar roles. The emperor who attends the Martyrdom of Saint Catherine seems to be the same character as the one who attends the torture of Saint Apollonia or Saint Lawrence, or the one whom we see presiding as Saint Andrew is nailed to the Cross. We cannot avoid being surprised by a certain correspondence between these judges and witnesses of torture in the miniatures and those that Bouts painted to attend the martyrdom of Saint Erasmus (Leuven, Church of Saint Peter) (Fig. 38), or those of quite similar appearance who are depicted in the right section of Bouts's Saint Hippolytus triptych (Bruges, Saint Sauveur Cathedral) (Fig. 39). Chronology does not prevent us

from contemplating a connection between the triptych of Saint Erasmus and our miniatures. If one accepts the possibility that the memory of the right wing of the Saint Hippolytus triptych could also have been present in the illuminator's mind when he

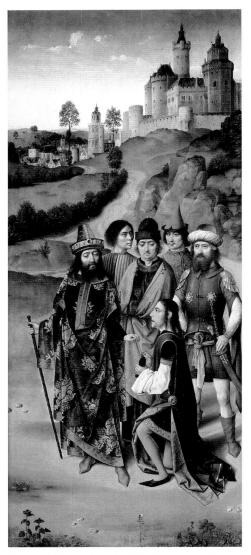

Fig. 39: Dirk Bouts, *Legend of Saint Hippolytus*, right wing of a triptych. Bruges, Groeningemuseum, Saint-Sauveur Cathedral.

painted these miniatures, that would imply that one may consider the beginning of 1469 as a *terminis ante quem* for the painting's execution, which does not contradict the new data recently published on this subject.[13] Van Lathem perhaps could have seen the painting during his work in Bruges in 1468.

On a number of occasions Bouts introduced profile figures with highly accentuated silhouettes into his paintings, such as the man with his hand leaning on a staff at the right of the Crucifixion section in the *Descent from the Cross* in Granada (Fig. 40) or the one adopting a similar pose in the *Trial by Fire* in Brussels (Musées royaux des Beaux-Arts) (Fig. 41). Lieven van Lathem also quite willingly and repeatedly used analogous figures. On this subject, I had formerly suggested several connections.[14] The figure standing along the border at the right of the Martyrdom of Saint Lawrence, likewise found on the left of the Martyrdom of Saint Apollonia, is characteristic. Wearing a hat with the peak pointed forward and the brim lifted at the back, his hand rests on an elegantly held staff. Almost always dressed in a cape that falls on only one of his shoulders and on the other side is held under his arm, this typical character is found many times in van Lathem's miniatures, either immobile or in action.[15] The cape, green in all the examples cited, in the majority of cases contrasts with red breeches, which leads us to assume the use of a color model. This character incarnates the figure of one of the judge's assessors, or of the lord present with him at scenes of martyrdom.

Fig. 40: Dirk Bouts, *Crucifixion* (section of the Deposition triptych). Granada, Capilla real.

The artist represents martyrdom scenes as contemporary judicial executions that he knew and had been able to observe. By the manner in which he depicts the lord or judge and his assessors, he seems to associate the idea of authority with that of distinction and a certain nobility of attitude, perhaps in the image of people whose behavior he had been able to observe in the court of the Duke of Burgundy, where he was certainly not a stranger. In a general way, the elegance and bearing of such figures, which the artist undeniably liked to accentuate in stylizing the allure and am-

plifying the diversity and vivacity of the costumes' color, contribute this lively and festive character to his paintings, which without doubt charmed and flattered his patrons and constituted one of the most highly prized elements that assured his success.

These repetitions of characteristic figures were certainly facilitated by recourse to model books or workshop cartoons. Certain compositional schemes would have been available in the workshop in the form of more or less complete models.[16]

In the miniature on fol. 22r depicting Christ blessing Saint James the Greater on his island, the model after which the figure of Christ was represented was reworked later, by adapting the position of the feet, in the miniature of Christ appearing before Pilate in the Vienna Hours of Mary of Burgundy.[17]

7.3 COLOR

We cannot examine a manuscript illuminated by van Lathem without being immediately struck by the exceptional vividness and the great freshness of the color. The principal figures of the scenes depicted generally catch the eye with the richly saturated color of their clothing, often also bordered with an edge of gold. The reds and the blues, green and orange, and strong yellow accents dominate. Red and blue are sometimes particularly highlighted by opposition to white, as in the clothes of the Virgin in the Garden, or in the Martyrdom of Saint Stephen. The latter's white alb contrasts with the red of his dalmatic and

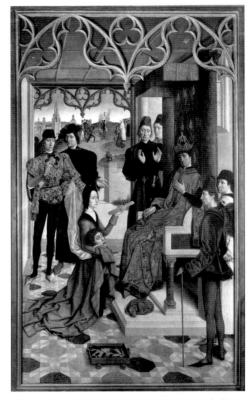

Fig. 41: Dirk Bouts, *Justice of Emperor Otto III: Ordeal by Fire*, Brussels, Musée royal des beaux-arts.

the blues in the costumes of the figures surrounding him. Elsewhere, the strongest, dominant colors match other, softer ones, like the pale greens or the beiges and grays of the landscapes, or like the pinks of the clothing of secondary figures, such as those of the miraculously cured man kneeling before Saint Eutropius, or those of the executioner, seen from the back in the foreground of the Martyrdom of Saint Lawrence. In the drapes of white clothing, it is characteristic for the shadows to take purplish tones, such as the ones we observe, for example, in the miniatures of Saint Ve-

ronica holding the cloth with the imprint of the Holy Face, fol. 2r ; the Virgin in the Garden, fol. 10r; the Martyrdom of Saint Stephen, fol. 24v; Saint Eutropius, fol. 41v; or Saint Anne with the Virgin and Child, fol. 45r.

The sumptuousness of the harmonies and contrasts of strong and saturated colors, including a blue of incomparable softness,[18] evoke the splendor and vividness of van Eyck's palette. The luminosity of van Lathem's miniatures is to some degree also due to the freshness of the strongly diluted colors that a light and virtuosic brush has left all their transparence. This is conspicuous in the clear sandy tones of the paths, sometimes sliding into yellow or russet; in the tones of certain rocks; and in the pavements or in the exterior or interior ornaments of the architecture. The clothing of the angels appearing in certain borders or in the two miniatures of the Virgin are also painted in diluted tonalities. The same softer and lighter tones are often found in the effects of gradation visible in the scenes with figures situated at a distant perspectival point, as we see in the miniatures of Saint John the Baptist, Saint Stephen, and Saint Fiacre (fols. 17r, 24v, 38r). Likewise, the greenery, when very distant in the landscape, sometimes becomes a dull blue–green before turning completely into blue toward infinity.

The deep azure of the heavens, where a few white or gray cumulus clouds often float, responds to that of the hills, which stand out in the distance against the clear line of the horizon. The same blue responds to the water of the rivers, lakes, or ponds that, reflecting the clarity of the air, take up so much space in these landscapes. The miniatures of Saint John on Patmos or Saint Christopher (fols. 18r and 26r) are two very good examples, among others. The sparkling of the water and its changing reflections kept no secrets from van Lathem, who seems to have studied their effects. These reflections sometimes participate in that vibration of air and light, so perceptible in certain distances; this is seen at the back of the landscape in the Martyrdom of Saint Lawrence, fol. 31v, at the approaches of the little bridge, or in the miniature of Christ blessing Saint James on his island, fol. 22r and in the miniature of Saint Hubert, fol. 39v.

In the miniature of Saint Anthony, fol. 33r, the rocks take on greyer tones, where elsewhere they generally have a more brown tonality. Perhaps we see here an indication of the illuminator's care to harmonize the color of the painting with the silver gray of the border motifs. Likewise, one sees that the gold accents are multiplied in this miniature to echo the border's gold background. Applying an analogous principle, the gold is used no more sparingly in the miniatures of Saint Sebastian and Saint Margaret (fols. 29r and 49v), framed by borders of the same type of grisaille against a gold ground. In painting the miniature, the illuminator therefore took into account the tonalities of the border decoration with which the folio would be provided.

Gold accents shine in the landscapes on rocky slopes or hillsides, on the spires of towers, on the ridges of gables, on the sides

of roofs and walls, on the edges of thickets and on tops of leaves. It is the gold that again marks the light in the drapery and flow of certain fabrics. Red and pink cloth is very frequently highlighted with touches or hatch–marks in gold. The play of gold reflections could also be developed in costumes of brown, orange, or lilac tonalities. We observe this in Saint Andrew's clothing, fol. 21r ; that of Saints Anthony and Paul, on the left of the All Saints miniature, fol. 43r ; and in the figure of the executioner at the center of the miniature of the Martyrdom of Saint Apollonia, fol. 50v. In the beautiful deep blues that constitute one of the most sumptuous accents in almost every miniature, draperies are treated entirely by shading and without gold highlights. Saint Anne's robe, fol. 45r, is the only blue costume in the documented core where gold highlights are provided. We also see them in the Virgin's mantle in the second diptych, fol. 5v.

The blue is sometimes contrasted with a very vivid yellow, or with orange tones, both also sometimes opposed to a strong green. The miniatures of Saint John the Baptist, the Last Supper, Saint Stephen, Saint Sebastian, and Saint Antony (fols. 17r, 23v, 24v, 29r, 33r) constitute only a few examples among others. This type of contrast, which was favored by certain Holland masters, is found in the illuminated folios of the Hours of the Cross. Van Lathem, who seems to have liked to use them, time and again repeated and exploited their effects.

The beauty of the folios that van Lathem illuminated in the little book of prayers is based in large measure on the splendor of their colors and on the homogeneity and the harmony of the page seen in its totality. Although it will be necessary to return to this question in discussing the borders, we cannot avoid noticing the attention, the taste, and the talent that, in the course of realizing the illumination of the documented core, must have been constantly deployed in order to assure for each historiated folio these luxurious contrasts or these harmonies of subtle and original tones that above all unite and connect miniature and border.

7.4 LANDSCAPE

Van Lathem excelled in rendering the space and the atmosphere of the places where the scenes depicted take place. In his paintings, the gaze is led ingeniously toward the distances by a picturesque succession of hillsides, slopes, clusters of trees, rocks crowned by greenery, bodies of water or rivers, castles with great round towers, views of cities more or less distant, with their ramparts, their roofs, their gables, and their steeples. All of these elements of the landscape create the illusion of extending completely naturally into the depth of a space, perceived as the image of an observed reality. The natural world that the artist spreads unfurls before our eyes is only, in truth, a magical but deceptive arrangement. The paradisiacal splendor that he lyrically offers is indeed a work of imagination and dreams.

This representation of space is characteristic of the period, and one finds it in

the work of many talented painters and illuminators who were van Lathem's contemporaries, but he particularly excelled at it. He was certainly not ignorant of the work of several of the most gifted miniaturists among his elders or contemporaries, such as the Girart Master or Simon Marmion, and still others whom research has not yet recognized. One imagines that he also profited greatly from his acquaintance with the paintings of van Eyck and his emulators, and, still more, from those of Dirk Bouts and other masters of the northern Netherlands. The slender and willowy tree that stands in the middle distance in the miniatures of the Virgin in the garden and Saints John the Baptist, Fiacre, and Mary Magdalene (fols. 10r, 17r, 38r and 44v), and several other trees, isolated or in clusters, as in the miniatures of Saints John on Patmos, Lawrence, and Hubert (fols. 18r, 31v, and 39v), make us think of those that appear in a number of Dirk Bouts's paintings, as well as in those of his emulators (Fig. 43). The slender and isolated tree, like an intermediary or hyphen between the successive planes, is a motif often used in the circles marked by Bouts's influence. The vegetation on the ground and the rocky slopes are also very close to those that appear in the paintings of the master of Haarlem and those of his circle.

As was still very frequent at the time, van Lathem's perspectives often seem to be observed from an elevated point of view with horizon lines situated quite high in the composition. All of van Lathem's work testifies to his interest in the problems of the representation of space and demon-

Fig. 42: *Presentation of Aristotle's manuscript to Alexander.* In *Livre des Secrets,* Paris, BnF, Ms. fr. 562, fol. 7r.

strates his great skill in this matter. From this emerges his predilection for compositions with vast vistas. The miniatures of the documented core and its devotional diptychs are, moreover, with about two or three exceptions, all conceived in such a way that their subjects are situated in or in front of a deep landscape or architectural perspective. It is in this respect quite significant that van Lathem unexpectedly took the liberty of deviating from the tradition situating the Last Supper in a more or less closed interior, and allowed it to take place in a room with a background largely open to the landscape.

To intensify the charm of the landscapes and accentuate their suggestion of space,

Fig. 43: *Ecce Agnus Dei (with donor kneeling under the protection of Saint John the Baptist identifying the Christ).* Munich, Alte Pinakothek.

van Lathem played with light and color with consummate mastery. Often he used the alternation of an architectural structure or a massive rock in shadowed tones in the foreground or middle distance, which functioned as a foil for the clear, sunlit space that extended beyond until the borders turn blue and are lost in the horizon. He applied this method in a variety of ways, as illustrated in the miniatures of the Beheading of Saint John the Baptist, the Temptation of Saint Anthony, and Saint Martin parting his cloak, among other examples. In these compositions, and in others with analogous effects, van Lathem likewise also subtly played with tested methods or invented new ones, varying the

effects of lighting in his views of boundless expanses. He multiplied the visions of a joyful nature and seemed to exalt nothing but the splendors of summer.

The attraction of van Lathem's vast hilly landscapes is often increased by the minute details that he has distributed in the background of his paintings, thus rendering the space more tangible, as van Eyck, the Master of Flémalle, Roger van der Weyden, Dirk Bouts, and still others have done. Because of the extreme reduction of their scale and the different technique of execution from that of paintings, these details are hardly outlines and, most often, only sketched in a light wash. A few rapid touches of a fine brush was thus enough to evoke in a suggestive way the silhouettes of figures, animals, or objects sometimes scarcely perceptible but coming all the same to enrich or complete the scenery in which the scene or the subject represented is located. Although tiny, these details nonetheless reveal van Lathem's capacities for invention, his fantasy and the acuity of his observation of reality.

On fol. 10r, behind the Virgin in the Garden, upper floor of a house on the left, one can discern a woman putting her linen out to dry on the window.[19] A little above, a white cat strolls along the gutter. In the landscape that extends behind the Virgin, two swans glide along the water of a pond. This conventional detail, frequent in paintings of the period, is found in the background of the miniatures of the Virgin on fol. 5v, Saint Andrew on fol. 21r, Saint James on fol. 22r, and Saint Anne at the right, on fol. 45r. In this last miniature,

however, the swans are not white but black.

One can also find the boats and the port with its crane behind Saint James or Saint Christopher, on fols. 22r and 26r, the boat and the small bridges behind Saint Hubert, fol. 39v, or even the crane at the port in the distance in the miniature of Mary Magdalene, on fol. 46v.

We can see figures on the bridge in the back of the miniature of Saint Lawrence, fol. 31v.[20] Workers are busy constructing the church at the right in the landscape behind Saint Fiacre on fol. 38r. In the distance of the landscape that we see above the figure of Saint Apollonia, fol. 50v, a horseman and other tiny figures make their way toward the city port beyond the river that traverses the landscape in the distance.

Among these minute details, the formations of wild geese or other migrating birds that cross the skies in many of van Lathem's miniatures are worthy of note. They occur in a around ten miniatures in the documented core, for example, in those of Christ blessing Saint James, on fol. 22r, the Temptation of Saint Anthony, on fol. 33r, and Saint Hubert, on fol. 39v. Durrieu, who had drawn attention to the frequency of these flights of birds in the prayer book and in the master's other manuscripts,[21] thought that one could almost accord them the significance of a signature, provided, of course, that the 'qualités d'exquise finesse et de science du dessin' particular to these manuscripts could be recognized.

In Flemish painting, van Eyck was perhaps the first to have introduced this motif of flights of birds into his paintings. They occur in the *Three Marys at the Tomb* in the van Beuningen Collection in Rotterdam, and, among the definite works of van Eyck, we find it in the Hermits section of the Ghent Altarpiece (Fig. 33) and, when the polyptych is closed, in the view of the city visible through the window of the room where the Annunciation takes place (Fig. 44). We find it again, on the upper right of the tower in *Saint Barbara* in Antwerp and high in the sky above the infant Jesus in the *Madonna of the Chancellor Rolin* in Paris. The motif also appears above Saint Elizabeth in the *Virgin and Child with Saints and Donor* (New York, Frick Collection), a painting that, if not painted by Jan van Eyck, was certainly painted within his circle.

Petrus Christus in turn re-used these flights of birds. They are found in the Exeter Madonna (Berlin, Staatliche Museen Preussischer Kulturbesitz) that moreover derives from the Frick Collection painting cited above. They appear again in two paintings in the National Gallery of Art in Washington: the *Portrait of a Female Donor* (Samuel H. Kress Collection 1961.9.10–11) and the *Nativity* (Andrew W. Mellon Collection 1937.1.40).[22]

Miniaturists sometimes borrowed these flights of birds from van Eyck. In the Hours of Folpard van Amerongen and Geertruy van Themseke, a manuscript for which we know that many of the miniatures are marked by van Eyck's influence, we can see it in the miniature of the Adoration of the Magi.[23] They are also in a miniature of Saint George on horseback, with several details that lead us to presume it transmits

precisely the image of a lost painting by van Eyck or of one of his followers.[24] The comparison between the somewhat maladroit flights of birds in these miniatures and those in the miniatures of van Lathem brings out the disparity between a poor, and an inspired interpretation.

The method, particular to van Lathem, of subtly rendering the minute flights of birds appears perhaps for the first time in the *Chroniques de Jérusalem abrégées*. They occur there in the landscapes of remarkable quality and depth in several miniatures (Fig. 45). Their presence constitutes one of the factors that most strongly confirm the presumption that van Lathem's hand was not a stranger to the execution of this exceptional book.[25] We find the same flights of birds again in the miniatures of the *Histoire du bon roi Alexandre*, *Gillion de Trazegnies*, and the *Miracles de Notre-Dame*,[26] manuscripts dating to the last decade of Philip the Good's reign,[27] and again in so many small paintings in the columns of Antoine de Bourgogne's luxurious copy of Froissart (Berlin, SBPK, Breslau Deposit, Ms. I, 1–4).[28] They are likewise present in the Vienna Hours said to be for Mary of Burgundy.

Van Lathem maintained a constant predilection for this charming motif. In a miniature, that one studies at close range and can encompass as a whole in a single glance, one such flight of birds, as minute as it is, nevertheless takes on a different significance than in larger paintings, where the motif sometimes remains scarcely perceptible when one has the painting before one's eyes.

Fig. 44: Van Eyck, *Cityscape through the window in the Annunciation* (detail of the reverse of the Adam panel in the Ghent Altarpiece). Ghent, Saint Bavo's Cathedral.

In the cityscape onto which the Annunciation window opens in the Ghent Altarpiece (Fig. 44), van Eyck painted many birds posed on the gables of houses, or flying above them. Being closer by, this group of birds functions as an intermediary and leads the gaze to discover the minute formation in a V that, farther away, is visible at the right of the colonnette on which rest the two arcades in the window's semicircular arch. Likewise, in his miniatures van Lathem has sometimes painted several dispersed birds flying in a less distant plane, on the one hand, and, on the other hand, much farther away, the formation of the

Fig. 45: *Bands with a silk damask motif against a black background, bordering miniatures of episodes from the Crusades,* Vienna, ÖNB, Cod. 2533, fol. 4r, cols. 3 and 4.

minute silhouettes of birds lost in the blue immensity of the sky.

The flights of birds observed in the paintings of van Eyck or of Petrus Christus are usually arranged at an angle along two rectilinear axes. One does not find this geometric rigor in van Lathem's formations, which move according to a more flexible line that is often slightly curved. They are thus more natural, and this freer composition adds to the discreet charm of this motif, evocative of places unknown, mysterious, and unattainable.

7.5 ARCHITECTURAL SPACE

In their composition and atmosphere, van Lathem's interiors are to some degree de-pendent on the Eyckian tradition. In small book's first miniature, the duke kneels in a room that connects through a double bay to a second, rather vast room, beyond which the perspective continues through a corridor appearing to open at the end onto the exterior. Despite the slight damage that this miniature has suffered, the quality of its perspective and the play of light allows us to judge it quite favorably. We recognize in this perspective something like an echo of that in the Nativity of Saint John the Baptist in the Turin-Milan Hours (Fig. 46).[29] The bed with blue curtains in the corner of the room at the middle distance corresponds to the red curtained bed in the Nativity of Saint John the Baptist. The room's oak-joisted roof also corresponds

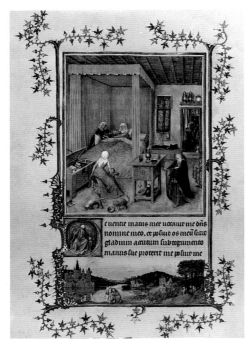

Fig. 46: *Birth of Saint John the Baptist.* Turin-Milan Hours, Turin, Museo Civico d'Arte Antica, Inv. N° 47, fol. 93v.

to the one in the room of that Nativity. The two routes giving access to the corridor at the back are also found in both miniatures. In the miniature from the little book, these paths are also repeated at the level of the passage from the first room to the second.[30]

In spite of their apparent variety, much of van Lathem's architecture consists of variants on quite similar arrangements, or reworks the repeating elements by combining them differently. The arcades, for example, opening the passage from one space to another, are frequently encountered in his miniatures, whether they connect two adjoining rooms, as in the miniature where the duke is kneeling, or open

toward the exterior, as in the Virgin with angel musicians, on fol. 5v, the Last Supper, on fol. 23v, or Saint Anne, on fol. 45r. Van Lathem has used these arcades, whether double or single, with a visible pleasure, to take advantage of the opportunity to paint the spaces they open into, and to suggest expanse or depth. The architectural elements themselves, and the nature of the materials, are excellently rendered. Often the light shines joyously on the surfaces of the constructions, on the pavements and on the polished shafts of the red or green marble columns. We can see this in the three miniatures just cited, but also in many of the others.

Although the small prayer book does not include an example of this, let us recall that in some larger miniatures in secular manuscripts, wider than they are high, van Lathem succeeded many times in dividing his composition in two. He then combined an interior scene and the adjacent space onto which it opened or with which it communicated, creating a single coherent perspective. He provides us with perhaps the most beautiful examples of this in Antoine de Bourgogne's Froissart.[31] Representing two spaces this way, by means of an open architectural structure, did not in itself constitute a novelty: it had already been timidly attempted in the fourteenth century. Some of Lieven's predecessors or contemporaries, including the Mansel Master, Simon Marmion, the Girart Master, and the illuminators in the latter's circle, created such compositions with more or less success. But it seems clear that van Lathem, taking an interest in the problem,

succeeded in creating the most coherent arrangements. He managed better than his precursors to articulate these adjoining spaces.[32] He innovated through the originality of the perspectives he developed and the skill with which he took up the challenges that he posed himself. One senses that he did not hesitate to confront the difficulties of problems that interested him, or to try to exploit as best he could the solutions that he found.

Endnotes

1 G. F. Waagen, *Die vornehmsten Kunstdenkmäler in Wien*, Vienna 1867, vol. 2, pp. 50–53.

2 They first designated him as the 'Master of the *Conquête de la Toison d'or*', in reference to Ms. fr. 331 in the Bibliothèque Nationale, Paris. The artist was sometimes also more briefly designated as the 'Master of the *Toison d'or*'.

3 The first publication revealing the book's existence was a brief article on prefiguration in the borders of the Little Hours of the Passion, Durrieu 1910. The detailed study concluding in the attribution to de Mazerolles was : Durrieu 1916. Without developing the argument, Paul Durrieu had already put forward this attribution in a synthesis lecture presented in Ghent : 'Les Miniaturistes Franco–Flamands des XIV^e et XV^e siècles', *Annales du 23^e Congrès de la Fédération archéologique et historique de Belgique* (Ghent 1914), vol. 3, pp. 235–238. (Fol. 34v with the miniature of Saint Martin is there reproduced for the first time as Plate XXXIII).

4 I have retraced the principal phases of the development of the old theory concerning the attribution to Philippe de Mazerolles and explained the arguments that demonstrate that it cannot be retained : De Schryver 1969/1, pp. 23–34.

5 Especially because Durrieu, *La miniature flamande au temps de la cour de Bourgogne* (Brussels-Paris, 1923), p. 26 and Winkler 1925, pp. 89–90 and, following them, L. Baer, 'Philippe de Mazerolles', Thieme/Becker 1907–1950, 24 (1930), p. 300, present the attribution as definitively established.

6 See Chapter 3. It seems quite likely that he maintainted contacts with Ghent, perhaps by the intermediary of Spierinc, among others.

7 On Louis de Gruuthuse, see J. Van Praet, *Recherches sur Louis de Bruges, seigneur de la Gruthuyse*, Paris 1831; C. Lemaire 'De bibliotheek van Lodewijk van Gruuthuse', in Lemaire 1981, pp. 207–277; Martens 1992, pp. 13–45.

8 Van Lathem's influence is very perceptible in the Froissart for which Liédet illuminated the first two volumes for Louis de Gruuthuse in about1470. Liévet and other Bruges illuminators who obtained commissions from Gruuthuse without doubt had the opportunity to see volumes illuminated by van Lathem in the library of the Bruges lord. The latter could have suggested to Liédet to draw inspiration from them for the illumination of Froissart, which could explain why the first two volumes of these chronicles were provided with significant borders after the taste of van Lathem, when Liédet seemed to have renounced the execution of borders in most of his production of the period. Lemaire 1981, p. 246; De Schryver 1989, pp. 57–74.

9 The large miniatures in *Gillion* are reproduced in color in : Martens 1992, pp. 114, 118, 120, 165, 166, 168, 170, 197.

10 See, for example, the color reproductions of *Gillion de Trazegnies* in: Martens 1992, pp. 120 and 166.

11 In the *Girart*, certain of these figures seem to go back to Italian models, as has been demonstrated by Pächt/Jenni/Thoss 1983, p. 55. One wonders how the Girart Master could have known them.

12 The draft of the text was completed in December of 1455. Pächt/Jenni/Thoss, pp. 74–76.

13 C. Van den Bergen–Pantens, 'Étude et datation du Triptyque de Saint Hippolyte (Cathédrale Saint-Sauveur à Bruges)' *Bouts Studies: Proceedings of the International Colloquium (Leuven, 26–28 November 1998)*, B. Cardon et al. ed., (Leuven–Paris–Sterling, Virginia 2001), pp. 11–18.

14 De Schryver 1969/1 and 1969/2, pp. 137–138 and pp. 449–450, respectively. The remarks made there about the compositional scheme van Lathem used on a number of occasions, and that of the *Trial by Fire*, are to be modified and corrected, as has been commented by : Van Buren 1975, pp. 298–300.

15 The same type of figure found at the left in the frontispiece of the *Secrets d'Aristote* or at the right in the miniature on fol. 58v of the *Conquête de la Toison d'or* (Paris, BnF, Ms. fr. 562 and fr. 331, respectively). Reproduced in: De Schryver 1969, Figures 16 and 17. For example, one sees him appear in *Gillon de Trazegnies*, fol. 158v ; and in Christ's appearance before Pilate in the Vienna Hours of Mary of Burgundy (De Schryver 1969, p. 137; Van Buren 1975, p. 299). We run into the same type in the illustration of the *Histoire d'Alexandre* (Paris, Musée du Petit Palais, coll. Dutuit, fol. 89v and 90v). These figures are not unlike the character farthest to the right in the frontispiece of the *Chroniques de Hainaut* in Brussels (Brussels, KBR, Ms. 9242), or,

without attaining the same highest allure, to the magus king on the left in Roger van der Weyden's Saint Columba retable at the Pinakothek in Munich.

16 As one will observe below, under section 9.11, on the subject of Christ appearing before Pilate.

17 De Schryver 1969, p. 136. In this publication, I still gave the subject of the miniature of Saint James conforming to the erroneous identification that Durrieu had given of it. One will here find under section 6.8 the development of this question.

18 Which is found in almost all of the miniatures. And often as one of the colors of the clothing of the principal actors in the scene.

19 This small detail of a woman hanging her linen on a horizontal bar, resting on frames fixed to the wall, of which the ends in the form of rings are intended for a round bar to slide into, on which linen could be hung, is found in the miniature of the *Visitation* in the Hours of Folpard van Amerongen and Geertruy van Themseke (Llangattock Hours), Los Angeles, J. Paul Getty Museum, Ms. Ludwig IX 7, fol. 68v. Delaissé 1968, pp. 76–77, underlined the intimist character of this detail, seeing in it, rightfully so without doubt, a feature particular to the art of the Northern Netherlands. This miniature is also reproduced in Euw/Plotzek 1982, Fig. 123—the frames fixed to the façade like those in question above are preserved (the sole instance in Flanders) at the old patrician house called *Ryhovesteen* in Ghent. One can make them out in the photograph of the rear façade, reproduced in : M. Boone, M.C. Laleman, D. Lievois, 'Van Simon sRijkensteen tot Hof van Ryhove. Van erfachtige lieden tot dienaren van de centrale Bourgondische staat', *Handelingen der Maatschappij voor Geschiedenis en Oudheidkunde te Gent*, nieuwe reeks, 44 (1990), p. 55, Fig. 4. The usage of such frames on façades was very widespread in Italy, as illustrated among other examples by the frescoes of the Capella Brancacci in Florence.

20 They anticipate those that the Master of the Hours of Nassau or the Master of the Prayer Book of Maximilian painted in the background of certain of their miniatures. In the frontispiece of the *Chroniques de Clèves* (Munich, BSB, Cod. gall. 19, fol. 1r) and in the *Visitation* in the Hours of Isabella of Castile (Cleveland Museum of Art, Ms. 63.256, fol. 115v). De Winter 1981, pp. 406, 380–381, Figures 74–75.

21 Durrieu 1916, pp. 79–81 (11–13 of the off–print) gives in a note a list of some forty occurrences of these flights of birds in the *Miracles de Notre-Dame* (Paris, BnF, Ms. fr. 9199) and in the Froissart of Anthony of Burgundy (Berlin, SBPK, Breslau Deposit, Ms. I, 1–4), referring to the plates in H. Omont, *Miracles de NotreDame*, vol. 2 (Paris 1906) and A. Lindner, *Der Breslauer Froissart* (Berlin 1912).

22 Reproduced in: M.W. Ainsworth (with M.P.J. Martens), *Petrus Christus, Renaissance Master of Bruges*, New York 1994, pp. 103, 133, 159.

23 Los Angeles, J. Paul Getty Museum, Ms. Ludwig IX 7, fol. 88v. Euw/Plotzek, vol. 2, 1982, Fig. 125.

24 In the Book of Hours: New York, PML, Ms. M. 421, fol. 28v. Reproduced in: *Flanders in the Fifteenth Century: Art and Civilization*, (exh. cat.), Detroit, The Detroit Institute of Arts, 1960, p. 383; J.W. Steyaert, *Laat–gotische Beeldhouwkunst in de Bourgondische Nederlanden*, (exh. cat.) Ghent, Museum voor Schone Kunsten, 1994, p. 312.

25 Durrieu 1916, pp. 104–105, considered the illumination of the *Chroniques de Jérusalem* (Vienna, ÖNB, Cod. 2533) and even the Vienna *Girart de Roussillon* (ÖNB, Cod. 2549) as being from the same hand as that of the prayer book. He did not sufficiently take account of the fact that these two manuscripts were certainly realized collaboratively.

26 Paris, BnF, Ms fr. 9199, passim. All the miniatures in this manuscript are reproduced in A. de Laborde, *Les Miracles de Notre Dame, compiles pas Jehan Miélot*, Paris 1929. There were generally considered as belonging to the same hands as that of the little prayer book. They had been attributed to de Mazerolles, that is to say now to van Lathem. (Durrieu 1916, pp. 78 and 98–99; Winkler 1925, pp. 90 and 193). Delaissé 1959, pp. 97–98, had envisaged that the grisailles of this volume could be the work of Tavernier, illustrated the most advanced phase of his style, under the influence of van Lathem. I hesitate to accept this proposition. Certain types of composition and the style of certain figures seem indeed very close to those of Tavernier: the helmeted figure, seen from the back in the background of the miniature on fol. 9r, for example. Could the work be the product of a collaboration ? Its style, however, appears to us much closer to that of van Lathem than that of Tavernier.

27 The motif of a flight of birds already appears in the miniature on fol. 74v of *Girart de Roussillon* in Vienna, where it nevertheless remains exceptional, while one sees it constantly repeated in the *Chroniques de Jérusalem* and in the *Miracles de Notre-Dame*.

28 A. Lindner, *Der Breslauer Froissart* (Berlin 1912). F. Winkler attributed several folios of Volume I of this *Froissart* to Liédet : 'Loyset Liédet, der Meister des goldenen Vlieszes und der Breslauer Froissart', *Repertorium für Kunstwissenschaft*, 34, 1911, pp. 228–229; Durrieu 1916, p.105; Winkler 1925, p. 161. The dazzling series of miniatures and borders in the four volumes of this manuscript must be attributed to van Lathem. Two other much less gifted illuminators

executed only a few miniatures. It is one of these that Winkler had taken for Liédet. These miniatures, the style of which is comparable to that of Liédet, cannot be attributed to him. There are no grounds to make the case, as did Durrieu 1916, p. 106, note 2, for the distribution among several hands of Antoine de Bourgogne's Froissart, in parallel with that of Gruuthuse's Froissart, by supposing that they would both have been started by Liédet. First of all, it is a matter of only a few folios by the rather mediocre hands; all the rest go back to van Lathem. Second, Liédet took care of Volumes I and II, other Bruges masters (the Master of the Dresden Hours, Philippe de Mazerolles, and doubtless several assistants) shared Volumes III and IV.

29 Color reproduction in: Meiss 1974, Fig. 645; Châtelet 1980, p. 29.

30 Certain details of the miniature are not very clear on account of use and damage. In the second room, a large fireplace that occupied the left wall and a small piece of furniture beneath the window, between the fireplace and the bed, cannot be clearly distinguished. Could this piece of furniture be a vague reminiscence of the one that occupies the middle of the room in the Nativity of Saint John the Baptist ?

31 See, for example, Winkler 1925, pls 49–50.

32 Winkler 1925, p. 89 had already called attention to this type of composition.

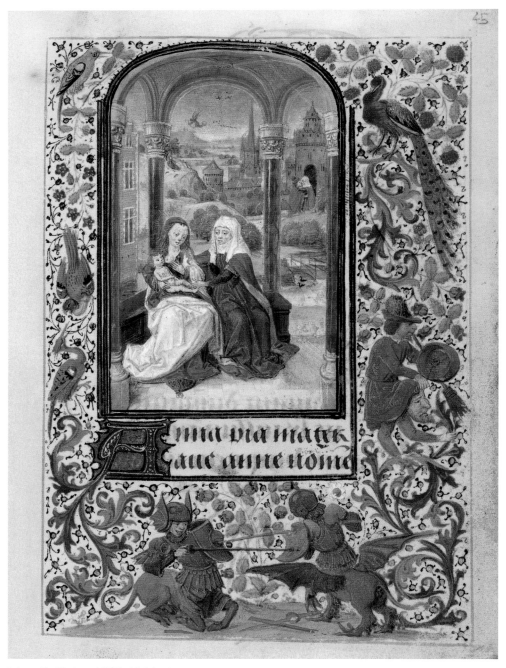

Fol. 45r: The Virgin and Child with Saint Anne.

PLATE XXIV | 151

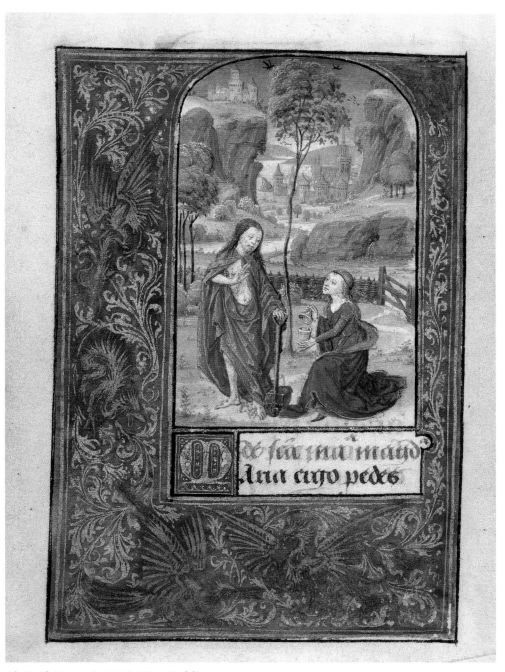

Fol. 46v: Christ appearing to Saint Mary Magdalene.

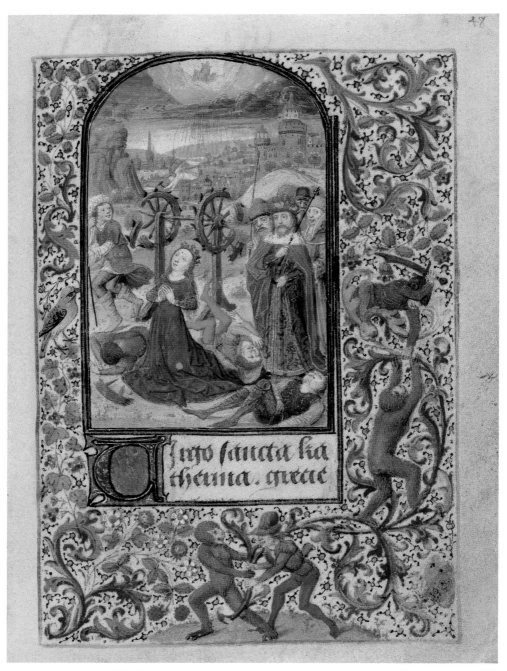

Fol. 48r: The Martyrdom of Saint Catherine.

PLATE XXVI | 153

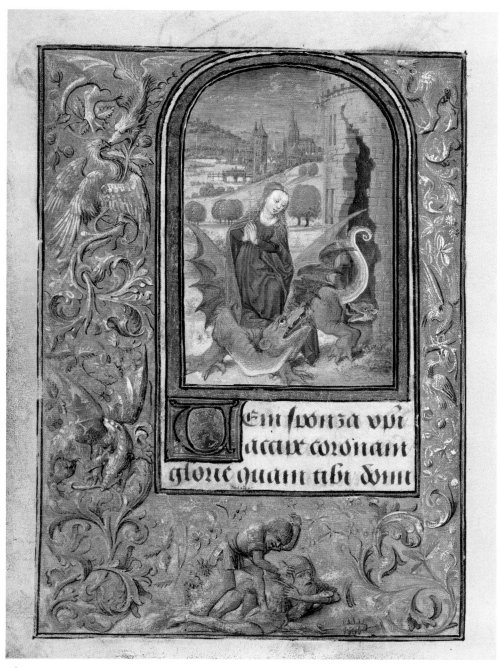

Fol. 49v: Saint Margaret.

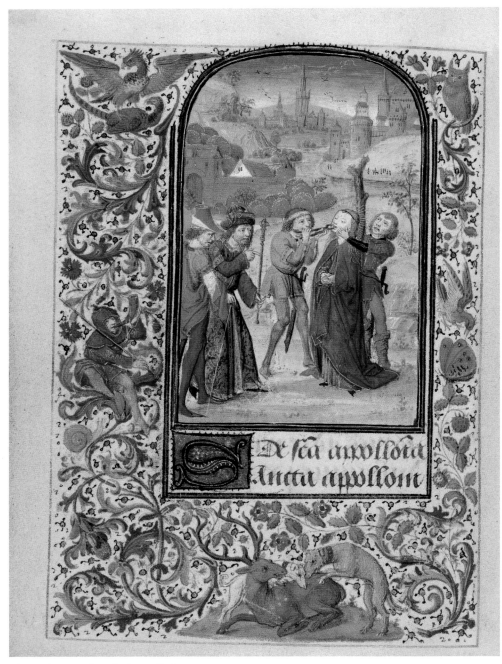

Fol. 50v: The Martyrdom of Saint Apollonia.

PLATE XXVIII | 155

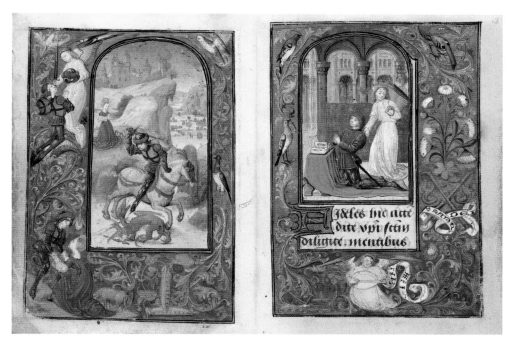

Fol. 67v–68r: The Saint George diptych. Left-hand leaf : Saint George fighting the dragon.
Right-hand leaf : Charles the Bold presented by an angel.
(Figures are reduced by approx. 50%.)

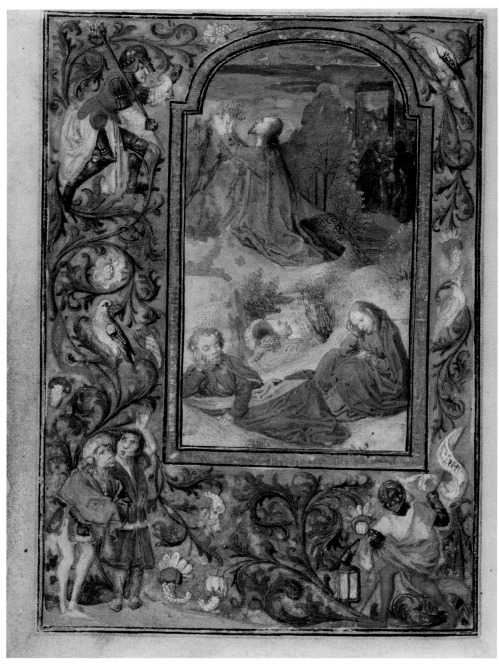

Fol. 70v : Christ's prayer at Gethsemane.

PLATE XXX | 157

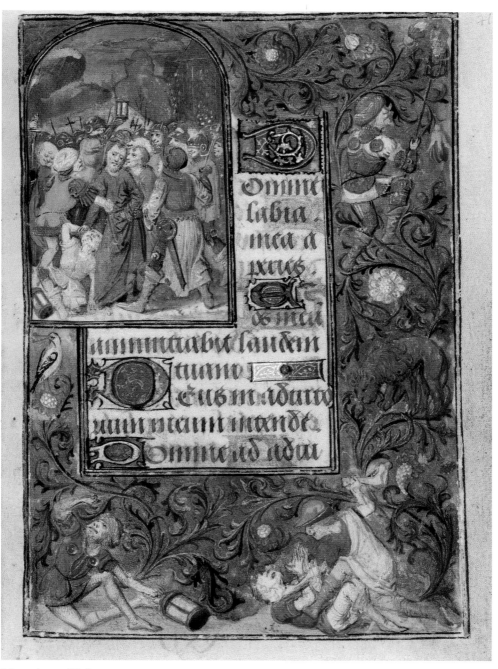

Fol. 71r : Arrest of Christ.

THE FULL BORDERS OF THE DOCUMENTED CORE

The marvelous repertoire of figures, drolleries, and real or imaginary animals that van Lathem deploys in his borders seems to be entirely his creation. It is not uncommon for the same figures, the same chimerical beings, the same animals, and in particular the same birds to reappear from one border to the next. However, in the prayer book, they almost never repeat themselves identically.

Apart from the figures and drolleries, the decoration of the borders with plain backgrounds is mostly made up of acanthus branches in blue and gold, with pink tones that introduce shades and modeling. There are also light *rinceaux* with very fine and supple stems bearing a few leaves, flowers, and fruits, and little discs of gold circled by a black line and provided with black *antennes*. These last motifs do not appear in the borders with colored backgrounds, where the acanthus *rinceaux* and the other branches appear in very different tonalities than those of the borders on plain grounds.

Each folio with a miniature was conceived as a whole. From border to miniature, the tones respond to one another and correspondences are established, which greatly contribute to the chromatic harmony and delightful homogeny of each of these pages.

The beauty of the decoration also depends on the rhythm born in the play of alternation among the strong accents of the figures, animals, and drolleries, and the lightness and grace of the flowering stems and winding of acanthus among which they are arranged. In the generally quite dense decoration of these borders, figures and drolleries only rarely appear isolated. Their actions, gestures, movements, or attitudes in one way or another show them in relation to others, which confers a greater cohesion on the border as a whole. The characters, the animals, and the fabulous beings are implicated in violent confrontations. A tension and a permanent aggressiveness seem to reign among them. Terrifying dragons and other menacing monsters evoke a world of fear, anguish, and danger. They often nastily confront, or are attacked by armed men who vigorously combat them. Other chimeras battle centaurs armed with a variety of weapons. These monsters and hybrid beasts testify to the persistence of motifs which had long been part of the medieval bestiary, but under van Lathem's brush they take on a new ardor and a striking vitality.

The fantastic can also wear a kinder, smiling face, as demonstrated by the female centaur musicians on fol. 41v, among others; or a more comical one, like the curious

fellow on fol. 45r, who seems to sit on the shoulders of a bearded man whose arms seem to serve as the musician's legs. Having seized some household utensils, he pretends to play them like musical instruments, thus mimicking and ridiculing the musicians.

The fantastic and the grotesque do not reign alone in these borders. We find many real animals there, such as the monkey, an animal familiar in the Middle Ages, or even the billy goat and the ram. The dog, too, had to be represented; in particular, we find him participating in the turbulent scenes of stag or wild boar hunts. The lion, whom the ducal menagerie in Ghent or Brussels made it possible to observe, was also present.[1] Among the many birds that populate his borders, van Lathem only rarely depicts sparrows. He preferred to depict birds that better lent themselves to decorative effects: herons, woodcocks, storks or other waders, as well as peacocks and pheasants with multicolored plumes. He loved the beautiful allure and the aggressive expressions of birds of prey, and did not hesitate to resort to fantasy and imagination sometimes to endow them with superbly colored feathers.

8.1 SPECIAL MOTIFS IN THE BORDERS WITH PLAIN BACKGROUNDS: THEIR ANTECEDENTS AND REITERATIONS

A curious tournament occupies the lower border of the miniature of Saint Martin, on fol. 34v. One of the two combatants is mounted on a billy goat, and the other, who has just been thrown by his adversary, straddles a ram. The two adversaries protect their heads by wearing sacks or tall bas-

kets with the rims resting on their shoulders. They are also each provided with a winnowing basket that serves as a shield. It is thus very much a rustic parody of a tournament.

This burlesque tournament already appeared in a border of Philip the Good's prayer book (Paris, BnF, Ms. n.a. fr. 16428, fol. 48r) (Fig. 47). Van Lathem executed a series of miniatures in this manuscript, but not their borders. He could therefore have noticed this motif and noted so that he could interpret it later with greater rigor and exactitude, as he did in the prayer book.

Chroniclers have fervently glorified the sumptuous tournaments that the Dukes of Burgundy organized, and the exploits to

Fig. 47: *The Annunciation to the shepherds.* Prayer Book of Philip the Good. Paris, BnF, Ms. n.a. fr. 16428, fol. 48r.

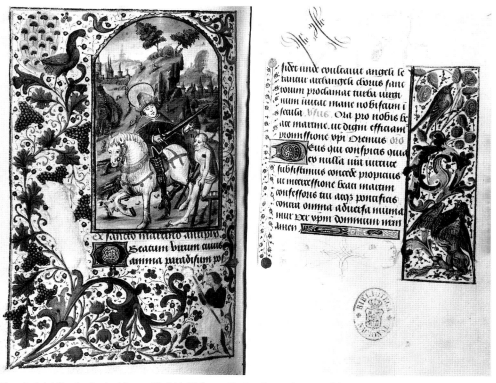

Fig. 48: *Saint Martin*. Book of Hours. Madrid, Biblioteca Nacional, Ms. Vit. 24-10, fol. 170v.

which they gave rise. Seeing such chivalric feats parodied in the margin of books intended for the duke's personal use consequently makes us smile. Let us wager, however, the Philip the Good and Charles the Bold were themselves also amused, and that the irony of such motifs was accepted with humor.

In the Paris manuscript the light humor of this rural motif accorded well with the text alluding to the *grant joye* that *les pastoureaulx* had in announcing the birth of Jesus *vray pasteur*, and with the subject of the miniature on the page : the Annunciation to the Shepherds, the most rustic of the subjects in the Infancy cycle. In our prayer

book, this tournament has no connection with the miniature of Saint Martin below which it appears. But here it is the various components of the border that together, independently of the miniature, evoke the rural milieu. To the burlesque tournament is added the piper on the upper left and, below, a billy goat standing on his hind legs and trying to reach the bunches of grapes on a vine. We also find a billy goat, although less well grasped and in reverse, in a border on fol. 170v of manuscript Vit. 24-10 in Madrid (Biblioteca Nacional), a book of hours copied by Spierinc. As in the prayer book, it borders the miniature of Saint Martin (Fig. 48).

Fig. 49: *Drunkenness of Noah*, in the *Speculum humanae salvationis*, Brussels, KBR, Inc. 31596, p. 44.

This billy goat may have been borrowed from the illustration of the Drunkenness of Noah in the xylo–typographic edition of the *Speculum humanae salvationis*, where it is represented in a very similar way (see, for example, Brussels, KBR, Inc. 31596, p. 44, Fig. 49). The motif had already appeared in older manuscripts of the *Speculum*.[2]

The burlesque tournament is also repeated in Madrid manuscript Vit. 24-10, on fol. 84r (Fig. 50). The Federwolken Master (Master of the Feathery Clouds) made only one very mediocre version of it, but, as in the prayer book of Philip the Good in Paris, it accompanies the miniature of the Annunciation to the Shepherds. These recurrences of motifs among the two ducal prayer

books and the Madrid manuscript written by Spierinc reveal quite close contacts among the illuminators concerned, despite sometimes very unequal levels of talent.

Two other tournament scenes in the prayer book could also have comic connotations. In the border of the Last Supper miniature, two centaurs confront one another. One has wings and wears a helmet, and the other wears some sort of hat. Instead of lances, each one holds a scimitar in his right hand and, in his left, one of the ends of a band of yellow cloth, from which is suspended a man's head on which a bird of prey has landed. Higher in the border, on the left, the same bird of prey is repeated, this time having landed on a pig's back. One

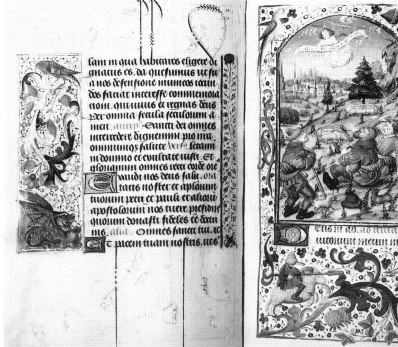
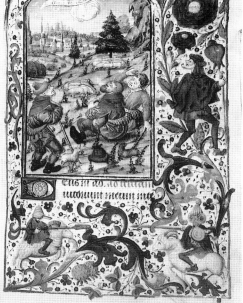

Fig. 50: *Annunciation to the shepherds (in the margin: burlesque tournament).* Book of Hours. Madrid, Biblioteca Nacional, Ms. Vit. 24-10, fol. 84r.

could be led to believe that the two motifs are connected, without their possible meaning able to have the slightest link with the Last Supper, the miniature's subject.[3]

This enigmatic scene also appears in the border of an All Saints miniature on fol. 40v of a book of hours in the Fitzwilliam Museum in Cambridge, Ms. James 143 (Fig. 36). We have discussed above (under sections 6.5 and 6.8) the connections between the miniatures of Saint John on Patmos and Saint James in this manuscript with those of van Lathem.[4] The Cambridge version of the combat of centaurs holding the ends of a band of cloth from which a head is suspended differs from that of the prayer book. The centaurs are not arranged in the same way. The suspended head, here without the bird perched on it, is seen head–on and his bulging eyes make a terrifying expression. In relation to the reduced height of the centaurs, it seems to take on giant proportions.

In the lower border of the miniature of Saint Anne, fol. 45r, two centaurs, helmeted and armed like knights, fight one another with lances. The centaur on the right is winged. The posture and movement of the two adversaries suggests that they are confronting one another violently. The same tournament is repeated literally at the bottom of the folio with a miniature of the Presentation at the Temple attributed to the Master of Mary of Burgundy (Berlin, Staatliche Museen Preussischer Kulturbesitz, Kupferstichkabinett, n° 1754)(Fig. 51).[5] A Dutch illuminator repeated this centaur combat in the lower border of the Last Judgment miniature in a book of hours in Utrecht.[6]

Beneath the miniature of Saint Andrew, on fol. 21r, the border is decorated with a pond lined with reeds; a heron flies overhead, at the point of landing or perhaps to attack the imposing frog visible at the edge of the water. A second long-legged bird is posted farther away, next to a tuft of reeds. However, the peace that seems to reign over this quiet corner of nature is menacing. Higher in the border, on the right, a man emerging from a flower prepares to shoot an arrow from his cross–bow at one of the two birds. The whole of this lovely border finds a feeble echo in the border of one of the Suffrages from the Vienna Hours of Mary of Burgundy, fols. 125r and 125v (Vienna, ÖNB, Cod. 1857) (Fig. 52). The charm of

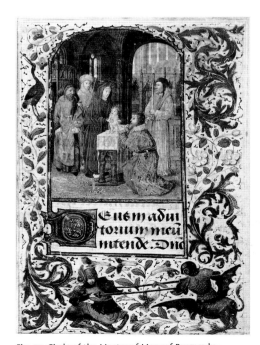

Fig. 51: Circle of the Master of Mary of Burgundy, *Presentation at the temple*. Detached folio from a book of hours. Berlin, SBPK, n° 1754.

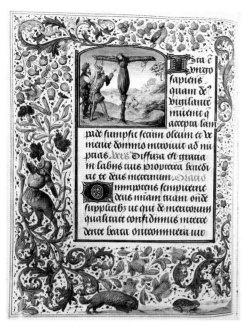

Fig. 52: Circle of the Master of Mary of Burgundy, *Sainte Wilgeforte (Ontcomera)*. Hours of Mary of Burgundy. Vienna, ÖNB, Cod. 1857, fol. 125v.

Fig. 53: Circle of the Master of Mary of Burgundy, *Saint Christopher*, Detached folio from a book of hours. Berlin, SBPK, n° 1755.

the little landscape has disappeared; the heron is also in flight, but a long-haired dog has been introduced, along the model of that in the lower right border of Saint Hubert's miniature in the prayer book (fol. 39v).

Illuminators in the circle of van Lathem and Spierinc therefore made use of models or sketches of certain figures and animals from their repertoire. The cases just noted are not the only ones that prove this. The borders of the Suffrages in the Vienna Hours of Mary of Burgundy furnish other examples.[7] They were inspired more by models of isolated figures that by models of complete borders; this explains why the repeated figures are rarely found integrated into their borders as pleasingly as they were

in van Lathem's designs. They borrow the vocabulary, but not the style that inspired them.

In the lower border of the miniature of Saint Eutropius, on fol. 41v, a monkey seems to dance to the sound of the music played by two female centaurs, one playing the lute and the other playing the harp. Another monkey, wearing a hood and placed higher up in the border, participates in the concert by playing the viol. The centaur playing the lute was repeated in the border of a folio with a miniature of Saint Christopher attributed to the Master of Mary of Burgundy, from a small book of hours (Berlin, Staatliche Museen Preussischer Kulturbesitz, Kupferstichkabinett, n° 1755)(Fig.

53).[8] The monkeys in Saint Eutropius's border, and those in the border of the miniature of Saint Catherine on fol. 48r, are very similar to those that van Lathem depicted in the margins of a manuscript at The Hague, on which he collaborated with the Master of Catherine of Cleves (The Hague, Meermano-Westreenianum Museum, Ms. 10 F 50).[9]

Hunting scenes are attractively illustrated in the borders of the miniatures of Saint Christopher and Saint Apollonia, on fols. 26r and 50v. The trumpeter and the dogs painted there recall those in the margins of the Hague book of hours (Fig. 54–55). The dog attacking a stag on fol. 50v, beneath the miniature of Saint Apollonia, and the long–haired one appearing in the lower right hand corner of Saint Hubert's border (fol. 39v) also appear in the borders of *Gillion de Trazegnies* at Chatsworth (Duke of Devonshire Collection, Ms. 7535, fol. 53v) (Fig. 56).[10] Winkler had called attention to the exceptional gifts in the depiction of animals possessed by the man he still believed to be Philippe de Mazerolles. In discussing the discovery of the Hague manuscript, K.G. Boon confirmed and called attention in turn to this aspect of van Lathem's talent.[11]

Fig. 54: Master of Catherine of Cleves and Lieven van Lathem, *Border hunting scenes*. Book of Hours. The Hague, Museum Meermanno-Westreenianum, Ms. 10 F 50, fols. 70v–71r.

Fig. 55: Lieven van Lathem, *Dog scratching himself*. Book of Hours. The Hague, Museum Meermanno-Westreenianum, Ms. 10 F 50, fol. 160v.

Fig. 56: Lieven van Lathem, *Battle of Gillion and Hertan against the Saracens (with a dog in the lower border)*, in *Gillion de Trazegnies*, Chatsworth, Duke of Devonshire Collection, Ms. 7535, fol. 53v.

8.2 A NEW TYPE OF MARGINAL DECORATION, C. 1460

It was in the course of the 1460s that the type of marginal decoration van Lathem would adopt first appeared, of which the prayer book offers the most accomplished versions. This type of decoration, described at the beginning of this chapter, immediately reveals its author through his particular qualities and by the very nature of the repertoire that he uses. Lieven van Lathem was not, however, the only artist the Burgundian Netherlands—or even the first—to use this new type of decoration. Several de-

votional books, executed at the beginning of the 1460s, allow us to a certain degree to see these new designs take shape and develop. Among them, the Prayer Book of Philip the Good (Paris, BnF, Ms. n.a. fr. 16428) and the Hours of the Lord of Sachsenheim (Stuttgart, WLB, Cod. brev. 162) merit special attention.

8.2.1 THE BORDERS IN THE PRAYER BOOK OF PHILIP THE GOOD (PARIS, BNF, MS. N. A. FR. 16428)

The folios in the first quire of this manuscript, and the bifolio formed by folios 84

and 89, stand out in this prayer book for the quality of their borders. They are of particular interest in their connection to the new type of marginal decoration here in question.

Although he executed several miniatures for this manuscript, van Lathem does not seem to have been involved in the execution of its borders. The first quire of the prayer book (now folios 43 to 50[12]), however, has borders that are clearly related to those of van Lathem.[13] It seems as though the borders of this first quire were entrusted to an illuminator specially chosen on the basis of his talent as a decorator.[14] He was also the one who painted the decorated initials with Philip the Good's marks of ownership on the first four folios.[15]

Fig. 58: *David singing the psalms* (historiated initial), *border with interlaced dragons.* Book of Hours. New York, PML, M.866, fol. 79r.

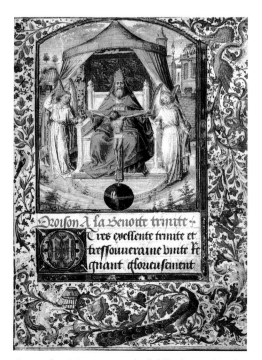

Fig. 57: *The Trinity.* Prayer Book of Philip the Good. Paris, BnF, Ms. n.a. fr. 16428, fol. 43r.

This illuminator is probably originally from Holland. Indeed, we find several motifs in his decorations that are particular to illuminators in the north. The tails of the monsters fighting on the bottom of fol. 44r (Fig. 9) extend by changing into naturalistic acanthus foliage. The dragons with long, intertwined necks, whose tails also terminate in acanthus foliage in the upper right corner of fol. 43r (Fig. 57) seem to echo those with which the Master of the Morgan Infancy Cycle composed a remarkable border at the beginning of the Penitential Psalms in his eponymous manuscript (Fig. 58).[16] The dragons with intertwined necks are found in several borders in the Hours of Catherine of Cleves (New York, PML,

Ms. M. 917, fol. 284, and M. 945, fol. 27v) (Fig. 59–60). These motifs enjoyed a certain favor in the north and in the Lower Rhine, on the eastern borders of the Low Countries,[17] as illustrated by the Book of Hours of Gijsbrecht de Brederode (Liège, Bibliothèque de l'université, Ms. Wittert 13)[18] and still another manuscript (London, BL, Harley Ms. 1662).[19]

Unless I am mistaken, neither the motif of dragons with intertwined necks, nor that of monsters' tails extending into acanthus foliage can be found in the works of van Lathem, which seems to confirm that the artist of the borders in the first quire of Philip the Good's prayer book cannot be

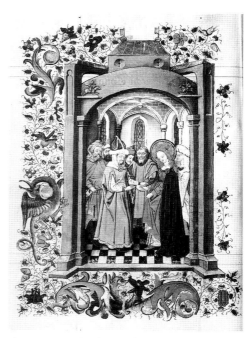

Fig. 60: Master of Catherine of Cleves, *Marriage of the Virgin (dragons with interlaced necks in the border)*. Hours of Catherine of Cleves. New York, PML, M.945, fol. 27v.

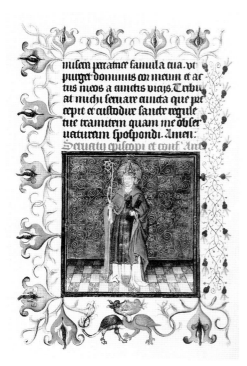

Fig. 59: Master of Catherine of Cleves, *Saint Servatius (dragons with interlaced necks in the border)*. Hours of Catherine of Cleves. New York, PML, M.917, p. 284.

identified with van Lathem. These borders also reveal numerous affinities with the work of the Master of Catherine of Cleves. The little naked child carrying a cone–shaped wicker cage on fol. 43r (Fig. 57) recalls several borders of the Master of Catherine of Cleves.[20] The wicker cage this little child carries seems to be inspired by a favorite motif of the Cleves Master. In the latter's work, the cage served to shelter a brood of chicks, who, threatened by a bird of prey, take refuge beneath the wings of their mother, who shoots the predator an angry look. This motif can be found, for example, in the Hours of Katharina van Lokhorst (Fig. 61) and the Hours of Catherine of Cleves (Fig. 62).[21] The illuminator of

the Paris manuscript did not venture to borrow this subject literally. He proved his ingenuity by depicting the wicker cage in a different context and created a simple and new motif by placing it in the hands of a little child. He liked the ingenuousness of the child who imagines he can use it to capture the peacock toward whom we see him advancing.

The Master of the Morgan Infancy Cycle and the Master of Cleves represented Jesus and John the Baptist as two naked children, quite appropriately, near the miniature of the Visitation, illustrating the meeting of their mothers (New York, PML, M.366, fols. 23v–24r; New York, PML, M. 945, fol. 32r) (Fig. 63–64).[22] In Philip the Good's

prayer book, this subject underwent a curious metamorphosis. In the lower border of the Visitation, on fol. 46r (Fig. 66), it is no longer Jesus and John the Baptist whom we see playing, but two baby centaurs gaily mimicking a joust with their moulinets.[23] The little centaurs' tails extend into foliage like those of the dragons just discussed. This sort of profanation of the group of Jesus and John the Baptist seems like the work of an artist with a rather malicious sense of humor, gladly abandoning himself to his imagination and fantasy, rather than conforming to the traditions of some pious legend.[24]

In the upper right of the border on fol. 44r, a heron is battling violently with a curi-

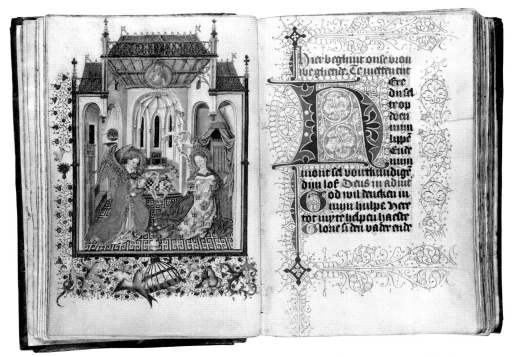

Fig. 61: Master of Catherine of Cleves, *Annunciation*. Hours of Katharina von Lokhorst. Münster, Westfälisches Landesmuseum für Kunst und Kulturgeschichte, Ms. 530, fol. 16v.

ous little winged quadruped monster over-turned beneath him (Fig. 9). This group seems to be related to the one in the upper right of fol. 36r of Duke Charles's prayer book. Van Lathem interpreted it and gave it more character. The heron has here been changed into a menacing bird of prey, and the curious animal he fights seems much more dangerous and has a new vigor compared to the somewhat puny winged monster in the border of the Paris manuscript. The latter's curious posture is much less natural than the attitude of the animal with whom van Lathem replaced him, whom he stands in a posture perfectly appropriate to the aggression that he suffers. This type of giant dog can be found fighting with a centaur at the bottom of the same border, and also appears, following the same model, fighting a man on the bottom of fol. 31v. The way in which van Lathem has rendered these conflicts reveals a talent superior to that of the artist of the first borders in the manuscript of Philip the Good.

The latter was apparently one of the artisans from the north, who had come, perhaps in passing, to offer to collaborate with colleagues in the great centers of Flanders or Brabant. The participation of van Lathem and one of the masters of *Girart* in the illustrations of this book for Philip the Good would in fact lead us to believe that the artist of these borders was active in Antwerp or Brussels. Van Lathem, whose ties to the artisans of the north have been acknowledged, could be the source of this Dutch artisan's participation in the illumination of Philip the Good's book of prayers. Van Lathem drew inspiration from some of

Fig. 62: Master of Catherine of Cleves, *Trinity. Border with a mother hen and her threatened brood.* Hours of Catherine of Cleves. New York, PML, M.945, fol. 88r.

the latter's discoveries, such as the burlesque tournament that he interprets in his own way on fol. 34v of Charles the Bold's book. The lion who conquers a monster in the lower border of the Nativity on fol. 47r (Fig. 67) of the manuscript in Paris can be found in the documented core, under the miniature of Saint James on fol. 22r. A similar lion appears in the same fashion in the lower border of fol. 74v of the Vienna *Girart de Rousillon*, where he brings down a horse (Vienna, ÖNB, Cod. 2549).[25] The motif, which could have been reworked from the Girart Master, was therefore familiar to illuminators in the milieu to which Lieven van Lathem belonged.[26]

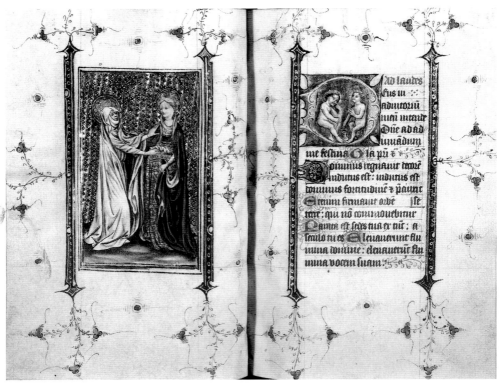

Fig. 63: *Visitation and historiated initial with Jesus and Saint John the Baptist as Children.* Book of Hours. New York, PML, M.866, fols. 23v–24r.

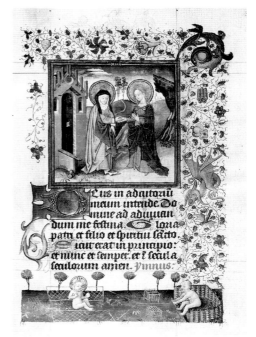

Fig. 64: Master of Catherine of Cleves, *Visitation. Border with Jesus and John the Baptist with bird-catchers.* Hours of Catherine of Cleves. New York, PML, M.945, fol. 32r.

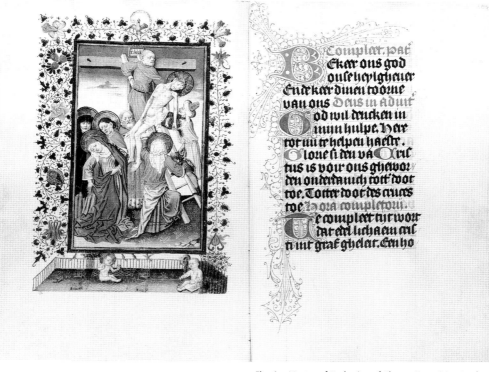

Fig. 65: Master of Catherine of Cleves, *Deposition*. In the bas-de-page: *Jesus and Saint John the Baptist as children*. Hours of Katharina von Lokhorst. Münster, Westfälisches Landesmuseum für Kunst und Kulturgeschichte, Ms. 530, fol. 106v.

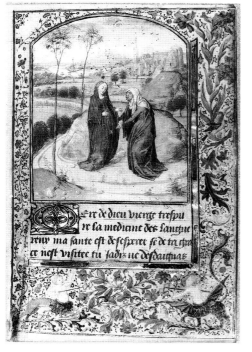

Fig. 66: *The Visitation*. Prayer Book of Philip the Good. Paris, BnF, Ms. n.a. fr. 16428, fol. 46r.

The borders of fol. 84r, which has the beautiful Crucifixion miniature attributed to Simon Marmion (Fig 68), and that of its conjoint folio, fol. 89r, with a miniature of the Ascension (Fig. 69), are of a remarkable quality. However, their workmanship differs from that of the borders of the manuscript's first quire. The nature and style of most of the border motifs of the Crucifixion folio are close to those that we find in van Lathem, but the two large birds painted with a very delicate brush, at the right of the border, are striking in their meticulous realism. Their great conformity to nature is more strongly reminiscent of the birds in the lower borders of the *Histoires romaines* (Paris, Bibliothèque de l'Arsenal, Ms. 5087–

5088) (Fig. 70) than of the great multicolored birds that van Lathem liked to depict. The illumination of the *Histoires romaines* was paid for in 1460 to Loyset Liédet, then established in Hesdin, whose style was still closer to Marmion's, but he did not execute the borders.[27] Van Lathem could have had the occasion to see the *Histoires romaines* or other works by the artist of these stunning borders, whom Liédet entrusted with the execution of this manuscript's borders. One may wonder whether the branches or flowering plants that abound there did not incite him to multiply such motifs in the borders of *Gillion de Trazegnies* at Chatsworth (Duke of Devonshire Collection, Ms. 7535) (Fig. 71). The border artists

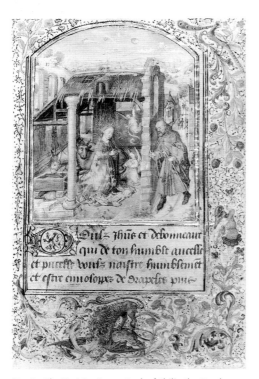

Fig. 67: *The Nativity.* Prayer Book of Philip the Good. Paris, BnF, Ms. n.a. fr. 16428, fol. 47r.

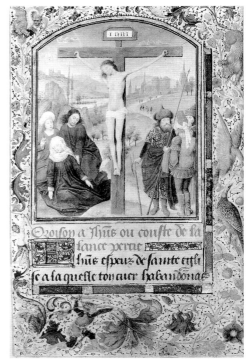

Fig. 68: *The Crucifixion.* Prayer Book of Philip the Good. Paris, BnF, Ms. n.a. fr. 16428, fol. 84r.

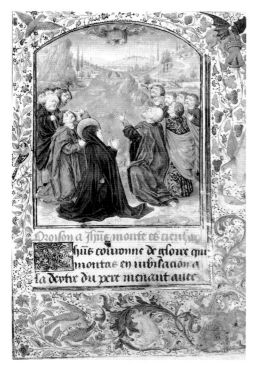

Fig. 69: *The Ascension*. Prayer Book of Philip the Good, Paris, BnF, Ms. n.a. fr. 16428, fol. 89r.

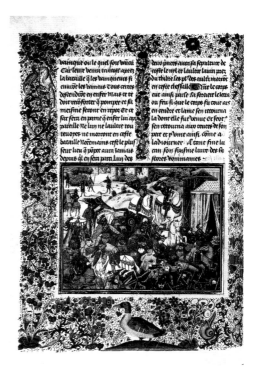

Fig. 70: Loyset Liédet and a collaborator, *Battle scene and border*, in *Histoires romaines abrégées*, vol. 2, Paris, Bibliothèque de l'Arsenal, Ms. 5088, fol. 229v.

of both these manuscripts revealed themselves to be flower–painters of admirable talent. These two manuscripts bear witness to a kind of decorative exuberance—wild in the case of the *Histoire romaines* illuminator, more disciplined in *Gillion*—in their magnificently composed borders.

8.2.2 THE BORDERS OF THE SACHSENHEIM HOURS (STUTTGART, WLB, COD. BREV. 162)

As we have seen, the attribution of the miniature of Saint John on Patmos in the Sachsenheim Hours to van Lathem must be revised (fol. 16r, Fig. 15).[28] This is also true for

the other miniatures in this manuscript that were believed attributable to van Lathem, especially the four miniatures of the Evangelists at the beginning of the manuscript. Apart from the style and the genre of its border motifs, there are similarities above all between the miniatures of Saint Luke and Saint Matthew, on fols. 18v and 23r in the Sachsenheim Hours (Fig. 72–73), and those of Saint Matthew and Saint Mark, painted by van Lathem, on fols. 31r and 33r in the Vienna Hours of Mary of Burgundy (Vienna, ÖNB, Cod. 1857) (Fig. 74), which was the origin of the attribution of the Sachsenheim Hours to van Lathem. I discussed these miniatures in 1969,[29] calling attention to how much better

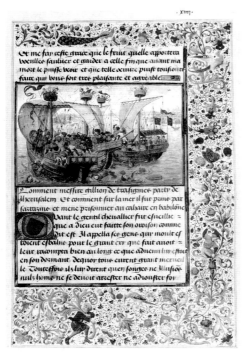

Fig. 71: Lieven van Lathem, *Naval battle (border: figure with foliage over his shoulder)*, in *Gillion de Trazegnies*, Chatsworth, Duke of Devonshire Collection. Reproduced by permission of the Chatsworth Settlement Trustees, Ms. 7535, fol. 14r.

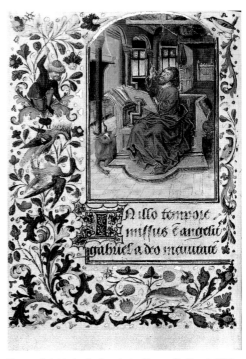

Fig. 72: *Saint Luke*. Sachsenheim Hours, Stuttgart, WLB, Cod. brev. 162, fol. 18v.

rendered the Stuttgart Saint Luke's posture and expression were than those of Saint Mark in Vienna, and remarking elsewhere on the Sachsenheim Master's flaws in perspective and van Lathem's superiority in the construction of space and perspective in the Vienna miniatures. In contrast to what I would then conclude, I am now convinced that it is not the same hand that we find in the two manuscripts; rather, in the Hours in Vienna, van Lathem adapted the compositions of the Sachsenheim Master, or at least they both used the same models.

I have therefore espoused the hesitations that Delaissé expressed concerning the at-

tribution to van Lathem, and I return to the opinion of Marie and Heinz Roosen-Runge, who situate the manuscript in the circle of the Master of Girart and also allude to its connections with the Breviary of Saint-Adrien de Grammont, preserved at the Abbey of Maredsous.[30]

In the Sachsenheim Hours, the miniatures representing the Evangelists at the beginning of the Gospel pericopes are all painted by the same hand, who was also responsible for their borders. I will call the artist of these folios Master A. His borders and miniatures easily distinguish him from those of the two other illuminators who partici-

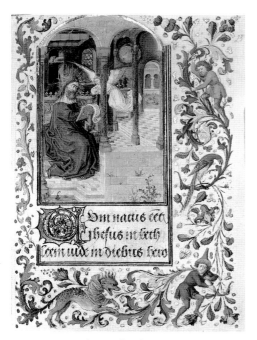

Fig. 73: *Saint Matthew*. Sachsenheim Hours, Stuttgart, WLB, Cod. brev. 162, fol. 23r.

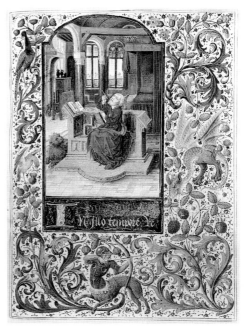

Fig. 74: Lieven van Lathem, *Saint Mark*. Hours of Mary of Burgundy. Vienna, ÖNB, Cod. 1857, fol. 33r.

pated in the execution of this manuscript, and whom I will call Masters B and C.

Delaissé had quite correctly picked up on the Dutch character of the Sachsenheim Hours.[31] In a border in Master B's hand, on fol. 127r, a man and woman are depicted standing on a rose–colored ground in a kind of medallion formed by foliage (Fig. 75). A large initial at the beginning of the second volume of the large *Bible historiée* in Vienna, made in Utrecht, contains the same subject on a background of green and gold acanthus (Vienna, ÖNB, Cod. 2772, fol. 10r).[32] The style of Master B of the Sachsenheim Hours is close to that of the Master of the Feathery Clouds, who participated in the illumination of the Vienna Bible with the Masters of Evert Zoudenbalch and Gijs-

brecht de Brederode, who were its principal creators.

Master B's borders are characterized among other things by the type of the acanthus and the globular fruits that decorate them (Fig. 75), for example on fol. 127r,[33] and with which B had already decorated the borders of the Breviary of the Abbey of Saint-Adrien de Grammont (Maredsous Abbey).[34] This breviary, the four volumes of which were written by Wilhelmus de Predio,[35] was probably illuminated in Ghent around 1450.[36] Van Lathem's contacts with artisans of the north could therefore have gone back to the beginning of his activities in Ghent. The Dutch features revealed in the Sachsenheim Hours by no means imply that this book was made in the north.

Master C executed a rather large portion of the volume's illumination. The folios that he decorated do not attain the level of quality of the evangelist folios. Fol.42v, with a beautiful miniature by Master A of the Trinity represented as the Throne of Wisdom, is the first folio of the manuscript with a border by C (fol. 42v, Fig. 76). The borders that he executed for A's miniatures, like the repertoire of motifs that he uses, clearly demonstrate that he is close to Master A.[37] Some six or seven large miniatures were painted by Master C. He is also responsible for the execution of the numerous historiated initials and borders of the Suffrages, which begin on fol. 139r. The seven illuminated folios of the quaternion formed by fols. 151 to 158, however, were illuminated by Master B.

In the border of fol. 161v of the Sachsenheim Hours (Fig. 78), Master C re-uses, in slightly modified form, the nude infant holding a willow cage and heading toward a peacock, which appears on fol. 43r of the Prayer Book of Philip the Good in Paris (Fig. 57)—a variant on the motif of the Master of Cleves discussed above (Fig. 61–62). In the borders of fols. 147r and 148v, with historiated initials of Saint Jerome and Saint Mary Magdalene (Fig. 79–80), Master C distributed four motifs of birds and monsters re-used from the border of fol. 44r in

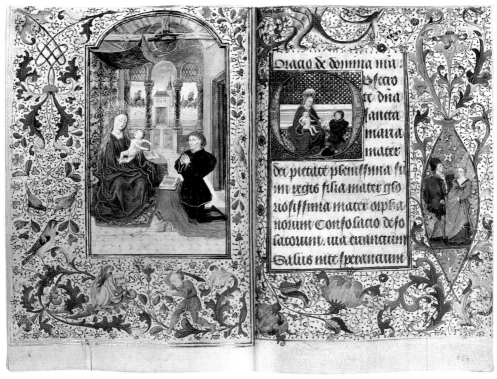

Fig. 75: *The lord of Sachsenheim kneeling before the Virgin.* The subject is repeated in the initial for the *Obsecro te.* Sachsenheim Hours, Stuttgart, WLB, Cod. brev. 162, fols. 126v and 127r.

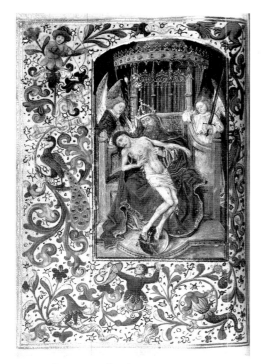

Fig. 76: *The Trinity.* Sachsenheim Hours, Stuttgart, WLB, Cod. brev. 162, fol. 42v.

the Paris manuscript. We find them in exactly the same pose and arranged in an analogous manner.[38] These borrowings suggest that quite close relationships must have existed between C and the creator of the borders in the first quire of Philip the Good's prayer book. We could also deduce from this that the execution of the Sachsenheim Hours is probably later than that of the book for Philip the Good.[39]

8.3 LIEVEN VAN LATHEM AND THE MARGINAL DECORATION OF THE HAGUE HOURS MS. 10 F 50

The book of hours 10 F 50 at The Hague (Museum Meermanno Westreenianum),

probably made for a member of the Lochorst family, is considered the last known witness to the activity of the Master of Catherine of Cleves. It is of particular interest on account of the originality and quality of the marginal decoration on its text pages, the execution of which the Master of Cleves shared with Lieven van Lathem. Many folios are adorned with figures and animals freely arranged in their three outer margins, with some acanthus *rinceaux* and flowering plants among them.[40] Van Lathem brilliantly took advantage of this free and loose arrangement of motifs, often treated with humor and always with accuracy. (Fig. 55, 81).

His collaboration on this manuscript had led me to believe that he could have worked in Utrecht for a time, after his

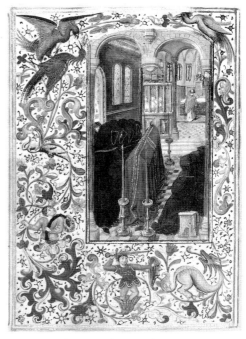

Fig. 77: *Mass for the Dead.* Sachsenheim Hours, Stuttgart, WLB, Cod. brev. 162, fol. 49v.

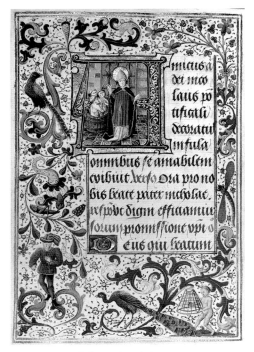

Fig. 78: *Saint Nicholas*. Sachsenheim Hours, Stuttgart, WLB, Cod. brev. 162, fol. 161v.

known work by van Lathem.[44] Dating it to around 1460 seems difficult to reconcile with the results from the analysis of the borders of Philip the Good's prayer book[45] and of the Sachsenheim Hours explained above. In that case, this work would precede by some five years the illumination of *Gillon de Trazegnies* in Chatsworth, which is the first known book that really displays the border style that would make van Lathem famous. As the *Gillon* manuscript was copied in 1464, its illumination could probably have been completed only in 1465 at the earliest.

The figures and animals in van Lathem's decorations in the margins of the Hague manuscript appear to be not only of the

depart from Ghent and before we find him settled in Antwerp; that is, between 1459 and 1462. Boon had adopted this same idea.[41] The familiarity that Lieven appears to have had with the art of Utrecht illuminators seemed to reinforce the hypothesis. Apart from the fact that he seems to have seen van Ouwater's *Resurrection of Lazarus* in Haarlem,[42] we have at present no firm data at our disposal on the subject of van Lathem's movements and activity during these few years.

The execution of the Hague manuscript must date to 1460 at the latest.[43] If we grant that the two illuminators worked on it together, it follows that, as Boon had remarked, this book would contain the first

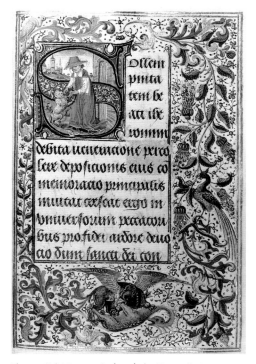

Fig. 79: *Saint Jerome*. Sachsenheim Hours, Stuttgart, WLB, Cod. brev. 162, fol. 147r.

same family, but also of the same technique as those in the borders with plain backgrounds in our prayer book, as well as those that we find in the other manuscripts illuminated by Lieven toward the end of the sixties and throughout the seventies. The Vienna Hours of Mary of Burgundy (Vienna, ÖNB, Cod. 1857), for example, provides a great many particularly convincing possibilities for comparison.

The hypothesis that van Lathem met the Master of Cleves in Utrecht, and that they came to work together, is not the only one that could explain their sharing of the Hague hours' illumination. Would it not be necessary to consider, rather, the possibility that these hours were left incomplete by the Master of Cleves and that, several years later, van Lathem was asked to complete its marginal decoration? This hypothesis seems to be a better match with the chronology of the marginal decoration proposed above. It does not seem to be contradicted by the manner in which the two artists' shares are divided in the manuscript's quires.[46]

Whatever the circumstances of this manuscript's execution, in which the work of the two artists lays side-by-side, it is evident that Lieven knew the art of the Master of Cleves. He would have shared with his predecessor the same passion for observing the details of everyday reality. One can also distinguish in both of them, despite the quite pronounced difference in their figure styles, their amused view of human behavior. The intimate tone of so many of the Master of Catherine of Cleves's miniatures can be found even in the serenity and peaceful rusticity of the figures in his borders. This as-

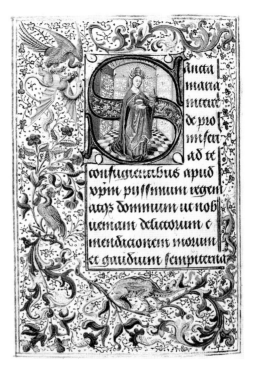

Fig. 80: *Saint Mary Magdalene*. Sachsenheim Hours, Stuttgart, WLB, Cod. brev. 162, fol. 148v.

pect becomes less perceptible with van Lathem, whose borders present a more dynamic character. There, the gracious fluidity of the winding *rinceaux* joins the robust vitality of the figures and animals. The style of van Lathem's borders, the brilliance of their color, matches the sumptuous ceremonial of the ducal court, and the style or aristocratic pretensions that had currency there.

8.4 THE SOURCE OF VAN LATHEM'S BORDER TYPE

The borders of the Prayer Book of Philip the Good and the Sachsenheim Hours clearly demonstrate that, toward 1460,

certain illuminators of Dutch origin were attempting to renew the art of border decoration and increase its charm and variety. Van Lathem, who had painted several of the miniatures in the first of these manuscripts, appears to have been inspired by the more original borders with which the Prayer Book of Philip the Good was provided, and to have subscribed to the trend manifested there. Committed to this path, he did not delay in impressing his decoration with a personal mark and in taking it to a level of exceptional quality.

The dragons and other fabulous beasts with which van Lathem generously provided his borders appear much more real in their colors and appearance than the majority of those painted by his Dutch[47] predecessors, and in particular than those in blue and yellow, or entirely in red or blue painted by the Master of Cleves.[48] Van Lathem painted them in full action, and they truly and dangerously seem to belong to the same world as the one where the people, imaginary beings, or animals who confront them struggle against one another.

Most often represented on the same scale as the figures in the miniatures, van Lathem's border figures are characterized by the vivacity and exactitude with which their postures and movements have been grasped and by their harmonious arrangement among the floral and vegetal motifs that surround them. The vividness and novelty of Lieven's marginal decorations must have caused a stir at the time they appeared in Flemish manuscript production c. 1465 for the Duke of Burgundy or high-ranking figures in his circle.

Fig. 81: *Man shearing a pig.* Book of Hours. The Hague, Museum Meermanno-Westreenianum, Ms. 10 F 50, fol. 106v.

If the motifs of northern artisans therefore constituted one of the sources that enriched Lieven van Lathem's repertoire, the original decorative conception that he devised seems to be rooted in other soil. In particular, his borders appear to reflect the conception of those that had been created several years earlier in Provence, which contribute to the fascinating splendor of the book of hours Ms. M. 358 at the Morgan Library and Museum in New York (Fig. 82).[49] François Avril has demonstrated that this book's illumination is largely attributable to the Master of the Aix Annunciation, identified as Barthélemy d'Eyck. Some folios, of equally beautiful quality, belong to the hand of Enguerrand Quarton.[50] If not

Morgan M. 358 itself, then manuscripts provided with similar borders, or models of this type of border, could have inspired Lieven van Lathem's border decoration. The novelty of this type of border must have excited the emulation of the most promising talents.[51]

In the absence of precise information concerning the paths by which the border type of Morgan M.358 could have become familiar in the milieu where van Lathem developed, we can however advance a few hypotheses. One may picture that Lieven could have undertaken a journey to Provence during the few years when we lose track of him, between 1459 and 1462.[52] However, it is not necessary to assume so, for he surely could have discovered the style and the vocabulary of certain works that were produced there in some other way. Artists from the Low Countries were at work in the circle of René d'Anjou, and among the latter was the painter Bartélemy d'Eyck. Bartélemy's mother, Ydria Exters, was herself also originally from the north. After the death of her husband, she was remarried to a fellow countryman, the painter and embroiderer Pierre du Billant (a Gallicization of van Bijland), who was for a long time in the service of René d'Anjou. The family contacts that these artists will naturally have maintained with their native land[53] could have doubled the chances of exchange with the circles where they had themselves been trained and practiced their craft, before going to seek success and fortune in other climes.

Therefore it would not be surprising for a new type of border, devised and realized in Provence, to be transmitted to the Low

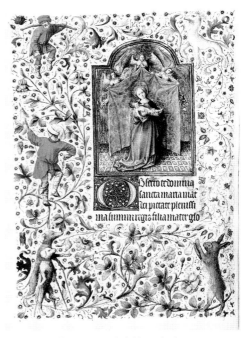

Fig. 82: *Standing Virgin and Child*. Book of Hours. New York, PML, M.358, fol. 20v.

Countries in a flourishing milieu of book artisans with a penchant for novelty. Van Lathem, like the creators of the best borders in the Prayer Book of Philip the Good or the Sachsenheim Hours, evidently belonged to such a milieu. A good illuminator from the Mosan region—Brabant or Utrecht—who had joined his relations or colleagues in Provence for a while and then gone home to his country, could suffice to explain the transmission to and influence on the Low Countries of the models of miniatures or borders successfully made in Provence. A trip back, temporary or not, to his native land by one of the artists in the circle working for King René, or one of their collaborators, is a possibility that cannot be ruled out.

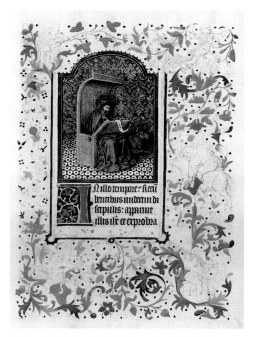

Fig. 83: *Saint Luke.* Book of Hours, New York, PML, M.358, fol. 19r

Master A of the Sachsenheim Hours, who painted the folios of the four Evangelists, could be one of those behind the transmission northward of this new conception of border decoration. Indeed, the Sachsenheim Hours seem very much to echo the illumination of Morgan M. 358, which Sachsenheim Master A, directly or indirectly, must have known. The similarities between Saint Matthew, on fol. 23r of the Sachsenheim Hours (Fig. 73), and Saint Luke on fol. 19r of the Morgan hours (Fig. 83) provide proof of this. The same Evangelist type and the manner in which the beard, hair, and face of Saint Matthew are painted here appear to echo the figure of Saint Luke in the New York manuscript. The drapery of his beautiful blue robe can be compared to that which

appears in the paintings steeped in Eyckian influences in the Morgan manuscript. In painting these two figures, their creators doubtless remembered the craggy features and worried or tired look that van Eyck had given to certain hermits, pilgrims, or apostles in the Ghent Altarpiece (Fig. 33), or other faces, such as those of the group of drawings of apostles in the Albertina in Vienna (Fig. 84).[54]

The figure in the lower right hand corner of the border of the Sachsenheim Hours' Saint Matthew (fol. 23r), who clings with both hands to a stalk that he seems to draw behind him while bending over, confirms its direct connection with the milieu in which the illumination of the Morgan

Fig. 84: After Jan van Eyck, *Saint Thomas, Apostle.* Vienna, Graphische Sammlung Albertina.

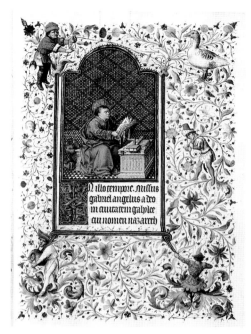

Fig. 85: *Saint Mark (with border figure dragging foliage over his shoulder)*, Book of Hours. New York, PML, M.358, fol. 15r.

manuscript was realized. Exactly the same motif can be found in the border of the folio with a miniature of Saint Mark (Fig. 85) in the Morgan hours (fol. 15r).[55]

Finally, we also find the same figure with a stalk in one of the magnificent borders of Louis de Gruuthuse's *Gillion de Trazegnies*, fol. 14r (Chatsworth, Duke of Devonshire Collection, Ms. 7535) (Fig. 71).[56] This particularly sumptuous manuscript, including the work of artists other than van Lathem,[57] is the first known work of Lieven's where his new border type appears in such an accomplished manner.

The motif of this figure with a stalk, of which I know no other occurrences, indeed finds its origin the in famous Book of Hours of René d'Anjou (London, BL, Egerton Ms.

1070). An angel dragging an uprooted acanthus stalk over his shoulder is repeated several times in the margins (Fig. 86–87). This angel with an uprooted acanthus stalk belonged, it seems, to the heraldry of the Anjou family,[58] and was painted around 1410 when the manuscript was commissioned by a member of the family.[59] King René inherited the manuscript and had the famous Eyckian miniatures attributed to the Master of the Aix Annunciation added to it in about 1442–1443.[60] The emblem of a sail inflated by the wind, bearing his enigmatic *devise*, *En dieu en soit*, appears beside these angels.[61]

Nicole Reynaud had remarked that the two Virgins of the Master of the Aix Annunciation 'sont, exceptionnellement dans

Fig. 86: *Emblems of René d'Anjou in the bas-de-page.* Hours of René d'Anjou. London, BL, Ms. Egerton 1070, fol. 30r.

la peinture du Nord, vêtues de brocart d'or'.[62] The lovely Virgin in the Garden on fol. 10r of the duke's prayer book is herself also clothed in a robe of gold brocade. Could it be that here we see a sign of further connections, which certainly demand to be more fully explored, between the art of van Lathem and that of painters from to the Low Countries working in Provence?

The play of exchanges that could have taken place between the Low Countries and Provence, in both directions, is moreover not limited to the Eyckian and Flémallian influences exhibited by the Master of the Aix Annunciation, or to new types of borders. Enguerrand Quarton's David in Prayer

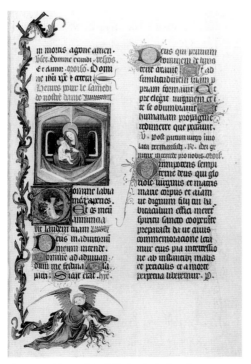

Fig. 87: *Emblems of René d'Anjou in the bas-de-page. Hours of René d'Anjou. London, BL, Ms. Egerton 1070, fol. 79r.*

in Morgan M. 358, fol. 106r,[63] indeed appears derived from that which illustrates the Hours of Willem van Montfoort (Vienna, ÖNB, Cod. s.n. 12878, fol. 76v) (Fig. 88–89). These two miniatures display analogous compositional schemes. The characteristic silhouette of the Utrecht Cathedral tower, which Quarton may not have known, and which appeared in the landscape of the Montfoort hours, was not faithfully reproduced in the Morgan hours.[64] Quarton reduced the depth of the landscape and brought the architectural structures more toward the centre of the composition. The connection between these two miniatures could lead us to presume that the Morgan Hours is later than the Montfoort Hours, and therefore could not date to before 1450.[65] However, we cannot rule out the possibility that the David in Prayer in the Montfort Hours is a copy of an older model that appears to have known quite a large circulation in Utrecht and Bruges.[66]

At the time when a Pieter van Bijland or a Barthélemy d'Eyck did their apprenticeships and began their practices, Utrecht was a very active centre. It could be that it was there that they received their training and worked before their appreciation and adoption in Provence.[67] They could have maintained contacts with colleagues that they had known there. Such contacts can explain the exchanges between illuminators, as well as the relationships between manuscripts that were nevertheless produced in places quite distant from one another.

Antwerp's contacts with the other centers of Brabant and with those of Flanders were important; likewise with the cities of

the north, as well as with the Mosan and Rhenish regions further east. Artistic activity in Antwerp in the fifteenth century remains relatively less well known. However, the city was certainly an important crossroads in the diffusion of multiple influences, and its prosperity, as was the case with Bruges, attracted artisans and artists of various origins. Antwerp seems to have played no insignificant role in the blossoming and diffusion of a new conception of marginal decoration during the period that van Lathem came to be established there. As we have seen, this development, in which van Lathem would take part, was favored and enriched by contacts with artists who had worked or were at work in Utrecht.

On that subject, one cannot disregard the role that could be played by Jacques Meyster, Lieven's father-in-law, a book artisan and merchant from Amsterdam. Having come to be established in Antwerp at the period when the illumination of the northern Netherlands had known a remarkable flowering of talents—from the Master of the Infancy Cycle to the Master of Catherine of Cleves—Meyster could have introduced Lieven to the interests and trends of his northern colleagues. Moreover, it is possible that at the beginning of his establishment in Antwerp, Lieven worked with his father-in-law, who had been admitted to the Guild of Saint Luke as a master in 1457.[68] Perhaps they even worked together to produce the illumination of some of the manuscripts discussed above. In a more general way, Meyster could be, in this crossroads that Antwerp represented, one of the agents of diffusion and

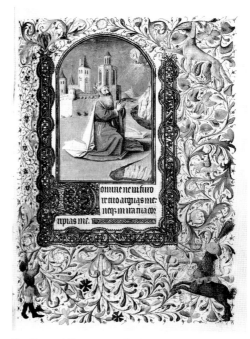

Fig. 88: *David in prayer.* Book of Hours. New York, PML, M.358, fol. 106r.

exchanges that, from north to south and south to north, influenced the production of illuminated manuscripts in the Low Countries—an influence not always noticed, untangled, or measured today, and of which, in their time, the written sources did not always record an echo or register a trace.

8.5 BORDERS WITH COLORED BACKGROUNDS: A NEW CONCEPTION OF MARGINAL DECORATION

For the folios with miniatures in the documented core, Lieven van Lathem had planned that each border with a plain background would be followed by a border with a colored background, and vice-versa. The

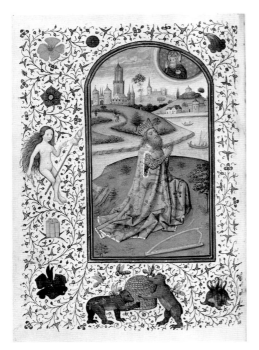

Fig. 89: Willem Vrelant, *David in prayer*. Montfort Hours. Vienna, ÖNB, Cod. s.n. 12878, fol. 76v.

folios with the first two miniatures in the documented core, that of the Virgin in the Garden and that of the Trinity, fols. 10r and 14r, however, each have a border with a colored background. This sole exception to the principle of alternation appears intended to underline the importance of the cult of the Virgin and that of the Trinity. In the border of the Virgin in the Garden, a white dove, who perhaps alludes to the Holy Spirit, flutters to the left of the miniature among some foliate scrolls against a black background. To the right and below the miniature, the border imitates a brocade woven of black silk and gold and silver thread. The innovation constituted by this imitation of precious textiles as border decoration can be

found in the work of the Master of Mary of Burgundy,[69] and after or following him in other luxury manuscripts of the school known as Ghent-Bruges.[70] They even used borders that imitated brocades in tapestries.[71]

Three other borders have decoration imitating the appearance, the motifs, and the shimmering of fabric made from gold, silver, and silk thread. Those with red backgrounds, surrounding the miniatures of Saint Stephen and Saint Mary Magdalene, fols. 24v and 46v, and one with a brown background, fol. 19v, surrounding the miniature of Saints Peter and Paul. Among the gold *rinceaux* can be found silver birds, fabulous monsters, and griffins, and, on fol. 19v, a handsome lion rampant. These motifs, with their silver somewhat oxidized and tarnished, originally had more splendor then they now retain. The expressive silhouettes of these animals, which draw themselves up and confront one another in menacing postures, are borrowed from the decoration of silk damask. Rare and precious fragments of preserved fabrics allow us to compare their motifs with the ones in these borders, where we find them interpreted or reproduced with a stunning fidelity and skill (Fig. 90).[72] Such fabrics form a rich screen behind Christ in the Ghent Altarpiece (Fig. 91).

Designs of a similar conception on red, blue, or black backgrounds had already previously adorned the pages of the *Chroniques de Jérusalem abrégées* in Vienna, made for Philip the Good (Vienna, ÖNB, Cod. 2533; Fig. 16, 19, 45). Of particularly sparkling execution are the black bands adorned with

Fig. 90: *Fragment of a chausable, silk (silk damask)*, 14th century. The Cleveland Museum of Art, Purchase from the J.H. Wade Fund, 1928.653.

the *briquets* of Burgundy, the *devise*, *Aultre naray*, and the duke's sign of two facing '*e*'s (Fig. 45).[73] Van Lathem could be associated with the production of these designs or perhaps even initiated them, at the time when he won the esteem and protection of Philip the Good, for whom he worked in 1456.[74]

In the border of the Beheading of John the Baptist, fol. 17r, the windings of pale blue and lilac-pink acanthus *rinceaux*, and of highly graceful green stems with leaves and flowers, are painted with extreme delicacy. The extraordinary harmony of colors in this border is based entirely on complementary pale blues, lilac-pinks, and soft greens, standing out magnificently against a background of quite dark greenish-grey. The border of the miniature of Christ bless-

ing Saint James the Greater, fol. 22r, is a sort of cameo. The motifs stand out, in nuances of a lighter blue, sometimes almost white, against the background of a rather dark blue. Some shadows and almost black contours accentuate the relief of the acanthus *rinceaux* and of some of the figures. The bird and the small monster occupying the upper corners of the border, the wings of the dragon halfway up on the right, and the lion in the lower border are oddly executed in an acid yellow turning to green, which gives them a more pronounced relief. Analogous effects, but in very different tones, characterize the border for the miniature of Saint Hubert, fol. 39v. A hunting scene is depicted in a cameo of brown and gold in the lower border. There is a stag at bay, surrounded by four dogs, of which two are

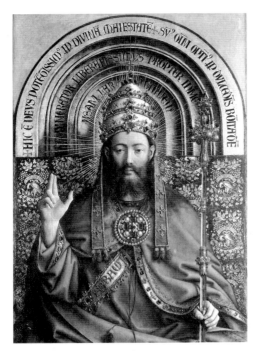

Fig. 91: Van Eyck, *Christ-God (the cloth of honour behind him : an example of textiles analogous to those imitated in the borders of fols. 19v, 24v and 46v)* (detail of the Ghent Altarpiece). Ghent, Saint Bavo's Cathedral.

nus, fol. 36r, is executed in a rather dark grisaille, with the background also in grey. The motifs stand out against the background by luminous touches, or by the darker grays of the shadows and the almost black lines of some contours. The rather dark grey that dominates in this border makes it appear duller than the others. This folio perhaps lacks harmony, usual on the other folios, between the color of the border and that of the miniature. The tones in the miniature respond to none of those in the grisaille that frames it. However the large band of gold adorned with meanders of stamped *pointillé* lends splendor to the small painting executed in bright tones.

The borders of fols. 29r, 33r, and 49v, surrounding the miniatures of Saint Sebastian, Saint Anthony, and Saint Margaret, are all of the same type. Their motifs are magnificently executed in an exquisite silver–toned grisaille, astonishingly enhanced by their very delicate gold backgrounds.

A supreme sense of decoration and color asserts itself with a stunning originality and variety in the incomparable refinement and marvelous diversity of the borders with colored backgrounds in the documented core of this prayer book. Their decorations abound in novel effects or the vividness of sumptuous contrasts, the contest of rare harmonies of mingled and delicate tones. Combining a tremendously skilled technique with an unequalled gift for invention, the creator of these borders appears and makes his mark in this book as the innovator *par excellence* of marginal decoration at the moment of the development of the style that has been called 'Ghent-Bruges'. He

white greyhounds, while a valet dressed in green sounds the call. Acanthus *rinceaux*, flowers, and birds further lend this decoration unexpected accents of gold, blue, strong green, and orange–red, with their brightness standing out magnificently against the bronze background.

The border of the All Saints miniature is decorated with angel musicians clothed in robes of gentle blue, rose, and white tones, which stand out against an olive–green background, as do the acanthus *rinceaux* in blue and lilac tones, and the birds and floral motifs in soft green enlivened by some stronger red or yellow accents (fol. 43r). The border of the miniature of Saint Gatia-

opened the door to those who, along with him, began the new developments in Flemish production from the 1470s onward. However, we cannot pass silently by the remarkable precedent of the new designs that had already been offered by several folios of the *Chroniques de Jérusalem abrégées* in Vienna (ÖNB, Cod. 2533; Figs. 16, 19, 45). The illustrations there of the genealogies of the kings of Jerusalem are enhanced by designs on a brown–gold background in a medial decorative band.[75] These designs are a lovely prelude to the future development of *trompe-l'œil*. Their effect and color are however quite different from those displayed by the borders in the prayer book.

If we compare the set of borders in the prayer book that have plain backgrounds with the series of those that have gold or colored backgrounds (except those imitating precious fabrics, which constitute a separate category), we come to wonder whether these novel contrasts and these subtle harmonies of new tones, which would be unique in van Lathem's work, can well have been created by him. Certainly the motifs, figures, and drolleries of these borders are of the same family as those in the borders with plain backgrounds and are almost all recognizable as belonging to the characteristic repertoire particular to him. He could, however, have sketched them, but left the coloring to a talented associate. It is very likely that Lieven, in cooperation with Spierinc, will have wanted to seize the opportunity of the prayer book's commission to try to win the duke's favor, as he had succeeded some twelve years earlier in winning that of his father.

Formulating the hypothesis that Lieven van Lathem could have entrusted the coloring and completion of these borders to an associate obliges us to wonder who could be the particularly talented collaborator given this responsibility. The modes of a division of labor in the manuscript's documented core are examined in Chapter 10 (see 10.5).

Endnotes

1 Vaughan 1970, p. 145. Dürer would surely not have been the first artist to take an interest in the lions at the Ghent 'Prinsenhof': F. Koreny, *Albrecht Dürer and the Animals and Plant Studies of the Renaissance* (Boston 1988), pp. 160–165. Princes loved arranging menageries with rare animals. The lion and the bear (who could also be observed in the park in Brussels) were represented in the old playing cards that illuminators often used as models. A. van Buren, S. Edmunds, 'Playing Cards and Manuscripts: Some Widely Disseminated Fifteenth-Century Model Sheets', *Art Bulletin* 56 (1974), pp. 12–30.

2 For example: London, BL, Add. Ms. 11576, fol. 46r. My thanks to Bert Cardon for having alerted me to this occurrence. Cases of borders containing this motif that are more or less similar: Pächt/Jenni 1975, pp. 30–31, Figs 27 and 31, Color Plate III.

3 In the Middle Ages, the pig was often used as a symbol of incontinence or lust, and still appears as such in Ripa's *Iconologia*. Is this the case here? The band of cloth held by the centaurs from which the head is suspended—is it yellow because yellow is the color of infamy? What exactly are these centaurs doing? Are they fighting over this head, or is it on the contrary a trophy or object of derision? It is rather difficult to accept that such a motif would have been only the product of an unbridled imagination, with no meaning in the eyes of the illuminator.

4 This Ms. James 143 had caught the attention of Byvanck-Hoogewerff 1922–1925, Pl. 179. G.J. Hoogewerff had already underlined the fertile imagination of the creator of the borders and observed the relation with van Lathem's borders (whose work was then still taken for that of Philippe de Mazerolles); Hoogewerff 1937, p. 319.

5 Winkler 1925, p. 160, Pl. 60; Pächt 1954, p. 55, n. 26; De Schryver 1969/1, p. 85, n. 133; Lieftinck 1969, p. 33; Pächt/Thoss 1990, pp. 83–84, Fig. 71.

6 Utrecht, Rijksmuseum Het Catharijneconvent, Ms. BMH 66, fol. 37v. De Schryver 1969/1, p. 85, n. 133.

Reproduced in: A. W. Byvanck, 'Noord-Nederlandse Miniaturen. V. Nieuwe Onderzoekingen en Ontdekkingen', *Bulletin van de Koninklijke Nederlandse Oudheidkundige Bond* 9 (1956), p. 18, Fig. 9.

7 Repeated from fol. 48r of the book: a monkey, fol. 117r, and another on fol. 120r; from fol. 45r: a centaur with a lance, fol. 123r; from fol. 41v: centaurs with a lute, fols. 124r and 124v; repeated from fol. 21r. Already noted in: De Schryver 1969, pp. 94–95. One will note that it was an error to attribute the borders of the Suffrages to Spierinc.

8 Winkler 1925, p. 160; De Schryver 1969/1, p. 93; Pächt/Thoss 1990, vol. 1, p. 84, Fig. 69; vol .2, Fig. 148.

9 Boon 1964, cols 246–248, Fig. 17; De Schryver 1969/1, pp. 84–86; Pächt/Thoss 1990, p. 83, Fig. 64–66.

10 One, reversed, on the lower right of fol. 142v, the other at the bottom of fol. 53v. Reproduced in: Martens 1992, pp. 118 and 168. This last can be found, drawn after the same model, at the bottom of a text page in the Book of Hours designated Paris, BnF, n.a. lat. 215, fol. 157r. Reproduced by Brinkmann 1989, p. 193.

11 Winkler 1925, p. 90; Boon 1964, cols 245–251.

12 In the sixteenth century, this prayer book was bound with a text of the *Vision de Lazare*, which explains why fol. 43 of the current manuscript corresponds to the first folio of the prayer book. The *Vision de Lazare* has been studied by T. Kren, 'Some Illuminated Manuscripts of The Vision of Lazarus from the Time of Margaret of York', *Margaret of York, Simon Marmion, and The Visions of Tondal* ed. T.Kren (Malibu, California, 1992), pp. 141–156.

13 As has been noted by Paris 1993, p. 88. Thomas 1976, p. 94, had thought that they could be by van Lathem.

14 The first folios of a manuscript were often executed with particular care. One also notices this in the Sachsenheim hours, discussed below. Likewise, in the *Conquête de la Toison d'or* (Paris, BnF, Ms. fr. 331), van Lathem seems to have reserved the execution of the borders of the first historiated folios, fols. 1r, 2r, and 20r, for himself, and to have let assistants intervene in the following borders.

15 As indicated by Thomas 1976, p. 86, the initials on fols. 43 to 46 are successively decorated with the sign of two facing Es, often employed by Philip the Good; the arms of Burgundy ; the *briquets* of Burgundy ; and the lion of Flanders. Note that on fol. 44r, the illuminator mistakenly painted an initial O (as he had done on the preceding folio, for *O très excellente Trinité…*), instead of a V for *Vray Dieu….*

16 New York, PML, M. 866, fol. 79. See: J. Marrow, 'Dutch Manuscript Illumination before the Master of Catherine of Cleves: The Master of the Morgan Infancy Cycle', *Nederlands Kunsthistorisch Jaarboek*

19 (1968), p. 100, Fig. 20; Utrecht 1989, p. 60; H.L.M. Defoer et al., *The Golden Age of Dutch Manuscript Painting*, exh. cat. (Utrecht 1989), p.60.

17 Monsters and hybrid beings whose tails extend into acanthus folioage also appear in the borders of the folios with miniatures of Christ's Descent into Limbo and the Resurrection, fols. 87r and 88r, of the prayer book of Philip the Good. We also find them in the borders of the book of hours, BnF, n.a. lat. 215. For example, on folios 92 and 96v.

18 In this manuscript, we also find dragons whose tails extend into foliage ; see J. Brassinne, *Livre d'heures de Gysbrecht de Brederode, évêque élu d'Utrecht… Ms. Wittert 13 de la Bibliothèque de l'Université de Liège* (Brussels, s.d.), Pl. 28, 29 and 33 (fols. 125r, 125v and 128v).

19 J. Marrow, 'A Book of Hours from the Circle of the Master of the Berlin Passion: Notes on the Relationship between Fifteenth–Century Manuscript Illumination and Printmaking in the Rhenish Lowlands' *The Art Bulletin* 60 (1974), Fig. 3.

20 Plummer 1966, pl. 10, 11, 31, 34.

21 This motif also appears, drawn in pen, in the manuscript at The Hague (Rijksmuseum Meermanno–Westreenianum, Ms. 10 F 50, fol. 88r; Boon 1964, fig. 8; Brinkmann 1989, p. 192, fig. 6).

22 Marrow 1968, pp. 61–63, Fig. 4–5. The Master of Cleves presents the two children as bird-catchers in a bas-de-page scene (Fig. 64). There is an analogous representation, but with only Jesus naked, in the Lokhorst Hours, this time beneath the miniature of the Descent from the Cross (Fig. 65).

23 The border of this folio is decorated on the right with a large flowering iris plant, here doubtless introduced as a symbol of Mary's virginity. The iris is repeated in quite a similar manner in the border of the All Saints miniature, fol. 45v, in the James 143 Hours in Cambridge (Fig. 36).

24 Legends relating to Jesus and John as children are recounted by Jean d'Outremeuse. Gorissen 1973, pp. 280–281.

25 Reproduced: Pächt/Jenni/Thoss 1983, figure 68. Regarding the lion from *Girart*, these authors have suggested, pp. 54–55, Figures 50–51, a connection with the ancient sculpture group of the lion attacking a horse, of which a fragment is preserved at the Palazzo dei Conservatori in Rome.

26 He appears in several books of hours illuminated by van Lathem or in his circle: the Vienna Hours of Mary of Burgundy, fols. 8r and 8v; Ms. James 143 in Cambridge, fol. 67v (Byvanck/Hoogewerff 1922–1925, Pl. 179 E); Rouen, Bibliothèque municipale, Ms. 192, fol. 120v.

27 G. Doutrepont, *La Littérature Française à la cour des Ducs de Bourgogne* (Paris 1909), pp. 137–138; G. de Poerck, *Introduction à la Fleur des Histoires de Jean*

Mansel, (Mons et Frameries, 1936), pp. 53–54 and 95; Brussels 1959, pp. 69–72; Paris 1993, pp. 92–94.

28 See section 6.5

29 De Schryver 1969/1, pp. 132–135.

30 Brussels 1959, pp. 161–162, n. 206; Roosen-Runge 1981, vol. 2, pp. 300–301. See section 6.5 here also. It is in error that Delaissé had envisaged that this breviary had some connection with Mons (Delaissé 1958, pp. 106–107). He based this on a hypothesis that located *Girart de Roussillon* at Mons, which was acknowledged to be without foundation (De Schryver 1964).

31 Brussels 1959, p. 161, n° 206.

32 Pächt/Jenni 1975, p. 64, pl. VI; Utrecht 1989, pp. 201–204.

33 Master B painted the borders and the miniatures of fols. 57v (Descent of the Holy Spirit), 95r (the Virgin in the *hortus conclusus*, outside of which two other saints appear, on either side, in the middle distance), and 103v (the Last Judgement), as well as the borders and historiated initials, all on rectos, of fols. 43, 65, 74, 81, 88, 104, 127, 151 to 156, and 158.

34 L.M.J. Delaissé, 'Les techniques du livre dans le bréviaire bénédictin de Grammont', *Scriptorium* 12 (1958), pp. 104–107, Pl. 1–2; Pächt/Jenni/Thoss 1983, Fig. 72.

35 Th. Delforge, 'Le Bréviaire de Saint-Adrien de Grammont', *Scriptorium* 12 (1958), p. 103; R.F. Poswick, 'Le bréviaire bénédictin de Grammont (Geraardsbergen)', *Le livre et l'estampe* (XXXXIII, 1997, n° 148), pp. 21–112.

36 I had indicated the elements that suggest that the manuscript could have been made in Ghent. The localisation to Mons once envisaged by Delaissé cannot be maintained. See A. De Schryver, 'Miniatuurkunst', *Gent: Duizend jaar kunst en cultuur*, exh. cat. (Ghent 1975), pp. 258–359.

37 The border of the Mass of the Dead, fol. 49v, is executed by Master C (Fig. 77). But the two birds that confront one another in its upper corner are a repetition of those that Master A had painted mid-way up the border of the miniature of Saint Luke on fol. 18v, and appear to be by the hand of A (Fig. 72). The latter could have left the task of finishing the border to C after having sketched these birds, unless C copied one of his master's models. Be that as it may, this border proves that C was close to A.

38 At the bottom of fol. 147r are monsters who tear each other apart, and whose tails end in acanthus *rinceaux*, and, in the upper left hand corner, the isolated heron from the border of fol. 44r of the prayer book in Paris. On fol. 148v, the group of a heron attacking a small winged monster is repeated, and below, the heron who draws up its neck to observe what takes place above, reproducing literally the motifs from the border of fol. 44r in Paris.

39 One of the Sachsenheims perhaps had the occasion to have this little book made or presented during a mission to the Burgundian Netherlands. Several members of the Sachsenheim family held various offices in service to the counts of Württemberg. It would be necessary to try to find out whether Jörg or Hermann the Younger of Sachsenheim were part of the embassy of Count Eberhard IV of Württemberg, fêted on several occasions by Philip the Good in Brussels and Lille, during the period 1462–65. G. Chastellain, *Oeuvres*, ed. Kervyn de Lettenhove, vol. 4, (Brussels 1864), p. 429; H. Van der Linden, *Itinéraires de Philippe le Bon, duc de Bourgogne (1419–1467) et de Charles, comte de Charolais (1433–1467)*, Brussels 1940, pp. 450, 461 and 487.

40 The division of labour was made by quire and in some cases by bifolium. The miniatures are missing. On this manuscript, see Utrecht 1989, pp. 163–164.

41 De Schryver 1969/1, pp. 84–85; Boon 1985, pp. 16–17.

42 De Schryver 2001, pp. 217–221.

43 Boon 1964, col. 251; Boon 1985, p. 16; Utrecht 1989, p. 163.

44 Boon 1964, col. 251; Boon 1985, pp. 16–17. Influenced by the old attribution of the work of van Lathem to de Mazerolles, Boon still erroneously situates van Lathem's production in Bruges.

45 Boon 1964, of course did not yet know of the existence of this book of prayers, discovered around 1970, and shown to the public for the first time in 1972 at the *Le Livre* exhibition in Paris (Paris 1972, n. 648) and in 1975 in Ghent (Bijlokemuseum). It had been acquired by the BnF in 1973 and was introduced in a first study by Marcel Thomas in 1976.

46 The hand of the Master of Cleves is found almost alone in quires I to VII, IX and XI–XIII. In quires VIII, X, XV–XVII and XX, he executed the miniatures and historiated initials, and van Lathem the marginal decoration. After quire XIII, all of the marginal decoration is Lieven's. Utrecht 1989, p. 164.

47 For example, those of the 'Master of the Morgan Infancy Cycle' reproduced in Marrow 1968, pp. 83–84, Fig. 20–21, or of the Masters of Zweder van Culemborg in the Egmont Breviary, New York, PML, M. 87, reproduced: Utrecht 1989, p. 114.

48 Some border dragons from the Hours of Catherine of Cleves can nevertheless have inspired van Lathem. For example, those from the border of the Prayer in Gethsemane, Christ Before Pilate, or the Office of the Dead, Plummer 1966, n° 16, 20 and 44.

49 I submitted this idea to François Avril during a conversation at the Bibliothèque nationale, and he declared himself likewise convinced.

50 François Avril and Nicole Reynaud, like Charles Sterling, agree in identifying the Master of the Aix Annunciation with Barthélemy d'Eyck (F. Avril,

'Pour l'enluminure provençale. Enguerrand Quarton peintre de manuscrits?', *Revue de l'art* 35, 1977, pp. 9–40; C. Sterling, *Enguerrand Quarton. Le peintre de la Pietà d'Avignon*, Paris 1983, pp. 173–183; Paris 1993, pp. 223–225, 230–231). This identification is contested by Albert Châtelet, who also calls into question the attribution to the Master of the Aix Annunciation of a portion of the miniatures of manuscript M. 358 in New York (A. Châtelet, 'De Jean Porcher à François Avril et Nicole Reynaud: L'enluminure en France entre 1440 et 1520', *Bulletin Monumental* 152–II (1994), pp. 220–222).

51 Avril 1977, pp. 28–32, demonstrated that 'la nouveauté du style de l'artiste du Morgan 358 a été très tôt ressentie et a suscité des adeptes dans le milieu des enlumineurs de cette région'. See also New York 1982, pp. 28–29; Paris 1993, pp. 223–225.

52 On 31 December 1458, Lieven granted power of attorney to Gerard van Crombrugghe to represent him during the settlement of the dispute that pitted him against the Dean and Jurors of the Painters Guild in Ghent. We find no mention of him until 1462, the date of his affiliation with the Antwerp Painters Guild. See Chapter 3.

53 Barthélemy's brother Clément d'Eyck is cited as a 'noble homme du diocèse de Liège' in an agreement reached in Aix before a notary on 28 June 1460, relating to the estate of his mother, Ydria Exters. Sterling 1983, pp. 179–180 and 209. The terms of the document lead us to believe that Clément was then only in Aix temporarily. He could only have come there on account of this estate. Ydria Exters is said to be a native *de Alamania*. We know that the Mosan and Rhinish regions of the Low Countries that formerly belonged to the Empire are often designated this way, as proven by the document describing Pol de Limbourg as *natif du païs d'Alemaigne*. F. Gorissen, 'Jan Maelwael und die Brüder Limburg: ein Nimweger Künstlerfamilie um die Wende des 14. Jhs.', *Gelre: Bijdragen en Mededelingen* 54 (1954), p. 218, n°166; Meiss 1974, p. 81.

54 Friedländer 1967–76, vol. 1, pl. 69.

55 Without attaching too much significance to this, one will observe that, just as in the historiated folios of Morgan 358, the borders of the Evangelists' folios in the Sachsenheim Hours are not provided with the simple or double framing line with which so many of the borders of the contemporary production are provided.

56 Color reproductions in: Martens 1992, p. 165.

57 As revealed, among other things, by certain historiated initials with landscapes that are remarkable but of another technique.

58 M. Meiss, *French Painting in the Time of Jean de Berry: The Boucicaut Master* (London, 1968), fig. 209; O. Pächt, 'René d'Anjou-Studien I', *Jahrbuch der Kunst-*

historischen Sammlungen in Wien 69, 1973, p. 115, fig. 114, and p. 124, fig. 124–125; N. Reynaud, 'Barthélemy d'Eyck avant 1450', *Revue de l'art* 84, 1989, pp. 33–35. Angels gracefully holding acanthus stalks decorate certain borders of manuscripts executed in the circle of the Boucicaut Master. See Meiss 1968, p. 95 and Fig. 343. However, one does not find this way of holding the acanthus by passing it over the shoulder.

59 Reynaud 1989, p. 32 and note 36; Paris 1993, p. 226.

60 Reynaud 1989, pp. 32–35.

61 On the emblem of the ship's sail: C. de Mérindol, *Le Roi René et la seconde Maison d'Anjou: Emblématique, Art, Histoire* (Paris, 1987), pp. 123–126. The motif of the angel with the uprooted stalk passed over his shoulder was repeated in Naples and is encountered there, among other places, in the book of the Brotherhood of Saint Martha under the arms of Alphonso of Aragon on fol. 9r: Pächt 1973, p. 117. Egerton Ms. 1070 as a matter of fact had been brought by King René during the four years of his sojourn in Naples (1438–1442). This manuscript, or perhaps another, lost work where the same motif appeared, could have served as a source of inspiration.

62 Reynaud 1989, p. 41. This concerns the Virgin of the Aix Annunciation and the one in the painting of the *Sainte Famille à la cheminée* (Le Puy Cathedral). The Reynaud article cited attributes this painting to the Master of the Aix Annunciation.

63 In color: Paris 1993, p. 222.

64 Delaissé 1968, p. 75; the same tower also appears in the landscape in miniatures of David in a book of hours in the style of Vrelant, produced perhaps in Bruges (Glasgow, University Library, MS Gen. 288): Smeyers/Cardon 1991, pp. 102–103, Fig. 9–10. Van Eyck had himself represented the Utrecht tower, or a tower of the same type, in the cityscape in the background of the *Virgin and Child with Chancellor Rolin*, and in the landscape in the central panel of the Ghent Altarpiece. It is in error that Pächt/Jenni 1975, p. 29, refer to its appearance in Jan van Eyck's *Madonna* at the Frick Museum. It was believed that the presence of this tower in the central panel of the Ghent Altarpiece was the result of a later addition: P. Coremans et al., *L'Agneau Mystique au Laboratoire* (Antwerp 1953), pp. 112–114. However, this idea must be re-examined: J.R.R. Van Asperen De Boer, 'A Scientific Re–examination of the Ghent Altarpiece', *Oud Holland*, 93 (1979) fasc. 3, p. 195–200.

65 The calendar of the Montfoort Hours is followed by a table for calculating the date of Easter beginning in 1450. Pächt/Jenni 1975, p. 25; Utrecht–New York 1989–1990, p. 161.
A date has been suggested for the Morgan Hours 358 of between 1440–1450: Avril 1977, p. 21; Paris 1993,

p. 230. Sterling 1983, p. 179 believed to 1444–1445, probably on account of to the fact that Barthélemy d'Eyck and Quarton together witnessed a contract of 19 January 1444, which proves their mutual contacts, and from which one can deduce that they had to be established in Aix in 1443.

66 Smeyers/Cardon 1991, pp. 102–104.

67 J.–C. Klamt called attention to the importance of the artistic activity that developed in Utrecht from the fourteenth century, and to its relationships with other important centres. 'Sub Turri Nostra: Kunst und Künstler im mittelalterlichen Utrecht' *Masters and Miniatures* 1991, pp. 19–38. Speaking of Utrecht goldsmiths who had worked for the courts of Paris and Dijon, Klamt took up Anne van Buren's line regarding other artists from the Low Countries who worked there : 'Those who were called must have had good teachers at home' ('Thoughts, old and new, on the sources of early Netherlandish painting', *Simiolus*, 16 (1986), p. 103). The same quotation could be repeated on the subject of artists working in the entourage of René d'Anjou. On the importance of Utrecht and its relations with Bruges, see: Smeyers/Cardon 1991, pp. 89–108.

68 Rombouts/van Lerius 1864, p. 11. As indicated in Chapter 3, Meyster had been established in Anvers since before October 14, 1452.

69 In the *Voustre demeure* Hours in Madrid, Ms. Vit. 25-5, fol.187, and surrounding the miniature that originally faced it, now fol. 17 in ms. 78 B 13 at the Kupferstichkabinett in Berlin. Lieftinck 1969, Fig. 141 and 151.

70 Mayer van den Bergh Breviary (Antwerp, Museum Mayer van den Bergh, inv. 946, fol. 572r, 575r), M. Smeyers and J. Van der Stock, *Flemish Illuminated Manuscripts 1475–1550*, (Ghent, 1996) exh. cat. (Saint Petersburg, State Hermitage Museum and Florence, Museo Bardini), p. 39, Fig. 42; Breviary of Queen Isabella of Castille (London, BL, Add. Ms. 18851, fol. 297), Kren 1983, p. 46, Fig. 5e; the « Roth-schild » Hours (Vienna, ÖNB, Cod. S.n. 2844, fol. 28v–29r, 241r), D. Thoss, *Flämische Buchmalerei: Handschriftenschätze aus dem Burgunderreich*, (Graz 1987), exh. cat. (Vienna, ÖNB, 1987), pp. 122–123, Fig. 28.

71 Tapestry said to be from Tournai, end of the fifteenth century. Valenciennes, Musée des Beaux-Arts, Inv. OA.87.19.

72 Examples are analyzed and reproduced in, among others : I. Errera, *Catalogue d'étoffes anciennes et modernes. Musées royaux des Arts Décoratifs de Bruxelles* (Brussels 1927); *2000 Years of Silk Weaving*. exh. cat. (Cleveland Museum of Art; Detroit, Institute of Arts; Los Angeles, County Museum of Art, 1944); 'Gothic Art 1360–1440' (exhibition), *The Bulletin of The Cleveland Museum of Art*, 50 (1963), p. 214–215, Nr. 94, 102; B. Klesse, *Seidenstoffe in der Italienischen Malerei des 14. Jahrhunderts* (Bern 1967); A. Coulin Weibel, *Two Thousand Years of Textiles. The Figured Textiles of Europe and the Near East* (New York 1972); A.E. Wardwell, 'The Stylistic Development of 14th- and 15th-Century Italian Silk Design', *Aachener Kunstblätter* 47 (1976–1977), pp. 177–226, Figs. 33, 37, 40, 43, 61, 63; Barbara Markowsky, *Europäische Seidengewebe des 13.–18. Jahrhunderts* (Kat. Kunstgewerbemuseum der Stadt Köln), (Cologne 1976); B. Tietzel, *Italienische Seidengewebe des 13., 14. und 15. Jahrhunderts* (Kat. Deutsches Textilmuseum, Krefeld), (Cologne 1984).

73 Pächt/Jenni/Thoss 1983, pls 104, 106–109, 111–114, 117–118.

74 De Schryver 1964, pp. 73–74. This type of decoration offers an analogy with those of gold *rinceaux* against a colored background, frequent in miniatures and historiated initials of the fourteenth and beginning of the fifteenth centuries. Even the Hours of Catherine of Cleves abounds in rather late examples of these colored backgrounds.

75 Pächt/Jenni/Thoss 1983, p. 63: described and illustrated as 'Typus II'.

PLATE XXXI | 197

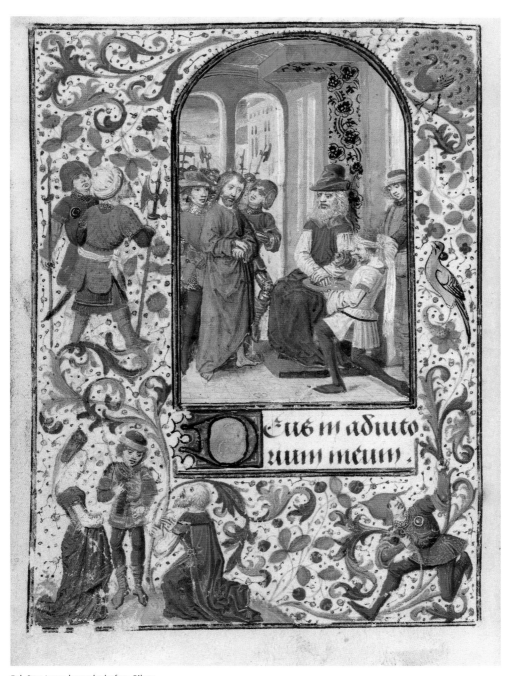

Fol. 82v: Jesus brought before Pilate.

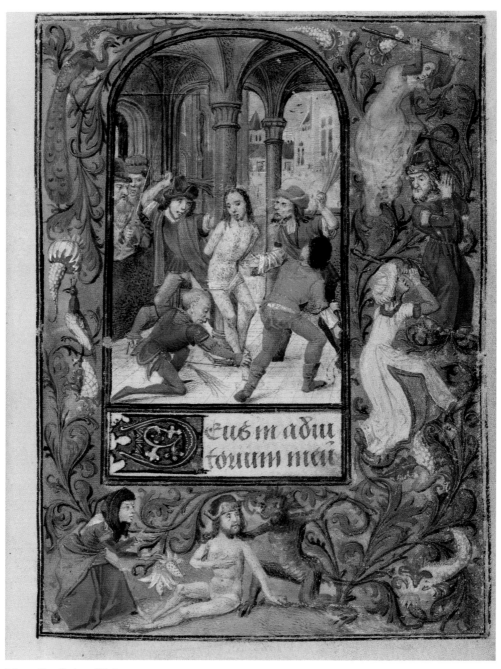

Fol. 90r: Flagellation of Christ.

PLATE XXXIII | 199

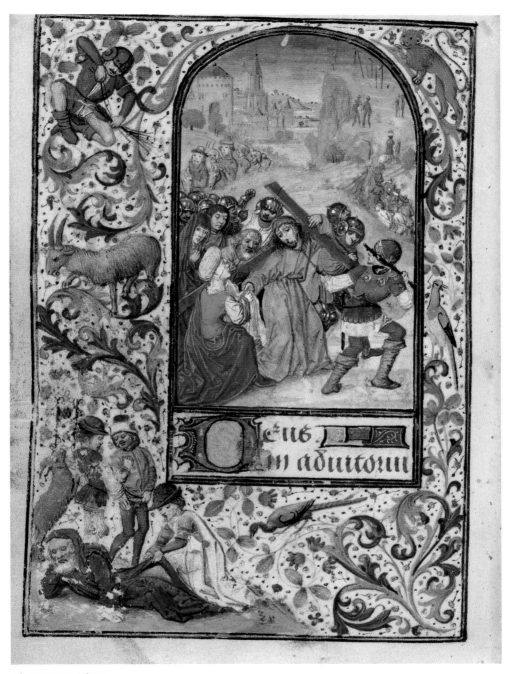

Fol. 95v: Way to Calvary.

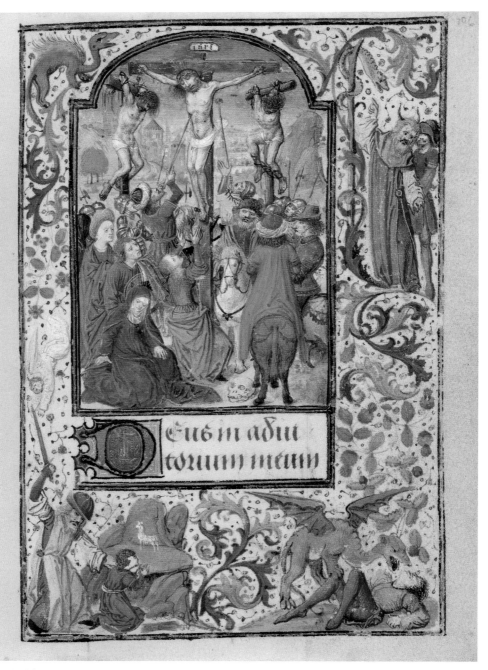

Fol. 106r: Calvary.

PLATE XXXV | 201

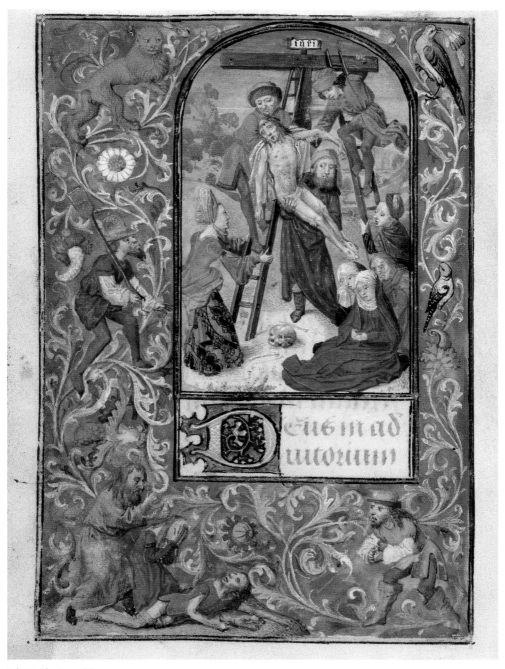

Fol. 111v: The Deposition.

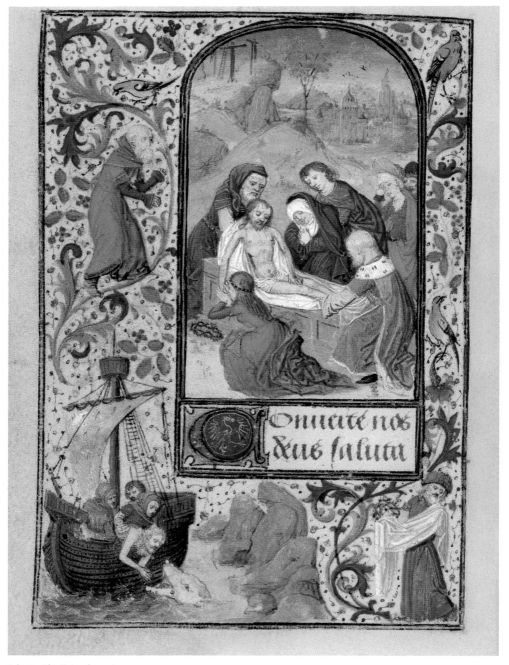

Fol. 119v: The Entombment.

THE ILLUMINATION OF THE LITTLE HOURS OF THE CROSS

No indication external to the manuscript allows us to determine with certainty when the Hours of the Cross were added to the duke's prayer book. If we refer to the duke's biography and itinerary,[1] the duration of his absences and the relative distances of the places where he lived make it rather unlikely that this addition could have been made after the summer of 1475. Dating the addition of these Hours to approximately 1472–75 appears to be a reasonable conjecture.

Even though they are of the same type, the partial borders of the Hours of the Cross and those of the documented core exhibit the differences in motif and technique already indicated in section 2.4. One can add to these observations that the birds there are a fraction larger. They frequently have pointed or raised beaks. Also quite often—for example, on fols. 72v, 73v, 79r, 79v, 88v, 93r, 93v—they turn their heads to the sides, in a motion not found among the birds in the borders of the documented core. These partial borders were not painted by the same hand that painted the marginal decoration of the text pages in the documented core. It seems that there was another hand from Spierinc's workshop or circle at work there.

Each scene of this Passion cycle is accompanied by a border of Old Testament scenes that prefigured it.[2] Other figures in the borders complement the miniature's subject. The creators of the illustration of these Hours of the Cross apparently followed a carefully focused iconographic program.

It was Spierinc who directed the production of the Hours of the Cross. The eight miniatures and their borders do not have the same level of finish as those in the documented core. The miniatures that have borders with plain backgrounds are of a style closer to that of van Lathem. They could be inspired by his models, or perhaps even have been drafted by him. Their execution could be the work of one of his assistants who also executed the borders of these folios.

The borders with colored backgrounds and the miniatures that they frame constitute a separate group with a quite different technique. They are painted by small, rather spontaneous and rapid touches. They succeed excellently in translating the sentiments and emotions of the figures, not only by their postures and gestures, but often also by the expression of a face or a glance alone. By their wit and by the particular tonality of the sentiments expressed, these pages resemble the art of the Master of Mary of Burgundy.

The colors consist of shimmering blues and reds, bronze, green, mauve, blue-grey, and several other mixed tones. A soft rose, used rather generously for the costumes of

certain border figures in particular, is repeated on many occasions. In the miniatures and borders of these eight folios, one is also struck by the repeated use of very bright yellow accents, which contrast with the deep blues and strong reds or with the greens. In this yellow hue, chosen many times for sleeves or hats, the play of shadows is often marked by a bright orange tone shifting toward red. Exactly this vividness of yellows has been underlined in several paintings of Northern primitives such as the Master of the Manna,[3] or even in the paintings grouped together by Karel Boon as the work of the [Master of the Tree of Jesse in the Buurkerk in Utrecht.[4] In the foreground of the *Arrest of Christ* in Munich, by a follower of Bouts (Fig. 92), one will also notice the yellow accent represented by Malachus' clothing.[5] The frequency of these yellow accents in the historiated folios of the Hours of the Cross leaves us with the sense that the creators of these illuminations must have particular ties with the art of the Northern Netherlands.

The vividness of the yellows sometimes contrasts with a strong green, and the green sometimes also contrasts with a bright orange tone, as we see, for example, in the costume of the torturer seen from the back at the right in the Flagellation. These contrasts seem to have been popular with the different creators of these pages. Van Lathem also sometimes used them. We also encounter them with the Master of the Dresden Hours.

In the Arrest of Christ, the illuminator made limited use of an iridescent yellow in the sleeve and lower part of the drapery of

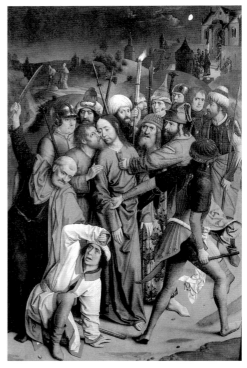

Fig. 92: Dirk Bouts, *Arrest of Christ*. Munich, Alte Pinakothek.

the blue-grey costume worn by the soldier seen from the back on the right. Like painters, illuminators achieved very beautiful effects through this process, which had only recently become popular. We can see marvelous examples of it in the Crucifixion triptych at the Church of Saint John in Ghent (now the Cathedral of Saint Bavo), such as the two women who seem to converse at the left in the painting, at a distance in relation to the groups of figures in the foreground (Fig. 93). The light plays on their clothing, which it makes shimmer with yellow glints on the grey-blue or lilac backgrounds of the fabrics. The most talented artists of the period did not fail to exploit the process with

refinement. The Master of the Dresden Hours readily used such effects.[6] Van Lathem had quite often already used iridescent color: the highlights or accents tending from bright orange to red are not uncommon in the yellows of his figures' costumes, as they are here in these pages illustrating the Passion. Among the borders with colored backgrounds in the documented core there are those that also display very distinctive and beautiful iridescent effects, for example on fol. 22r, where a surface yellow on a dull blue-green monochrome has been executed with stunning skill.

9.1 THE MINIATURES AND BORDERS OF VAN LATHEM'S ASSISTANT

9.1.1 CHRIST APPEARING BEFORE PILATE (FOL. 82V)

As Thomas has noted,[7] the model used in this miniature appears to be the same one used for the miniature of Christ before Pilate in the prayer book of Philip the Good (Paris, BnF, n.a. fr. 16428, fol. 73r) (Fig. 94)[8] and the Vienna Hours of Mary of Burgundy (Vienna, ÖNB, Cod. 1857, fol. 74v) (Fig. 95).

The similarities between the two miniatures of Christ before Pilate in the dukes' prayer books are quite close. The figure of Jesus is almost identical in the two miniatures. The tilt of the head, the position of the hands, and the pose of the feet are the same. The colors of all the figures' clothes are usually the same in the two miniatures. The beautiful azure of Pilate's robe, the servant's green doublet and red shoes, his white scarf

or belt, and finally the strong yellow accent of his sleeves is found in the two paintings. Jesus' slate-blue robe and the color of his guards' costumes, one green and the other red, also appear, but reversed. The cloth of honor behind Pilate is red in the Paris miniature, but is replaced in the small miniature by a black and gold brocade. Pilate's sleeves are of the same strong yellow as that of the servant in the small miniature. They are in gold and garnet brocade in the Paris manuscript. Several of these color similarities can also be found in the miniature of Christ before Pilate in the Vienna Hours of Mary of Burgundy. The multiple color correspondences leads us to assume the use of models that were either colored or that included instruction for color, unless we suppose that the illuminator had access to a prayer book, even that of Philip the Good.

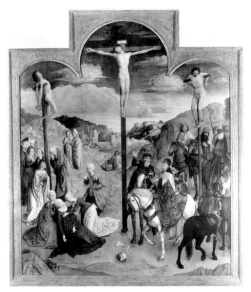

Fig. 93: Unidentified Ghent Master, *Crucifixion,* (central panel of the Calvary triptych). Ghent, Saint Bavo's Cathedral.

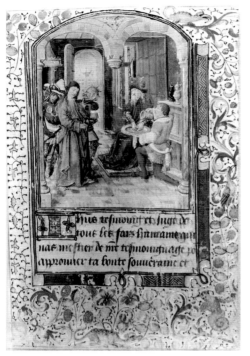

Fig. 94: *Christ appearing before Pilate*. Prayer Book of Philip the Good. Paris, BnF, Ms. n.a. fr. 16428, fol. 73r.

Lathem used on several occasions for presentation scenes or for analogous subjects, like that of the miniature in the *Ordonnance du premier écuyer* (Fig. 2) from the workshop of Lieven van Lathem. In the miniature of Christ before Pilate from Duke Charles's book, we perceive in the double opening of the wall in the background something like an echo of the double arcature that opens onto the landscape in the background of the frontispiece miniature to the *Livre des Secrets* (Paris, BnF, Ms. fr. 562). A perfect example of the type of composition in question here (Fig. 42), the broader format of the latter obviously offers a looser arrangement than that of the miniatures in the two prayer books. The double arcature of this painting will be repeated yet again by van Lathem in the less

The composition of the miniature of Christ before Pilate in the little book differentiates itself from that of the Paris manuscript by its eccentric perspective, which profoundly modifies the spatial impression. The very pronounced recession of the orthogonals toward the left allows us to imagine that the armed cohort arriving after those who bring Christ before Pilate extends well past the fraction of the space perceived within the frame. This perspective furthermore compensates somewhat for the necessarily contracted character of the narrow composition.

The arrangement of figures corresponds in its larger outline with the one that van

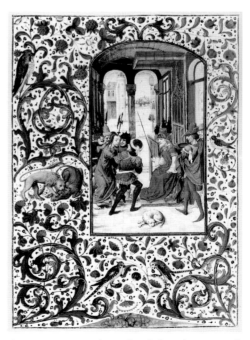

Fig. 95: Lieven van Lathem, *Christ before Pilate*. Hours of Mary of Burgundy. Vienna, ÖNB, Cod. 1857, fol. 74v.

contracted Christ before Pilate in the Vienna Hours of Mary of Burgundy (Fig. 95).[9]

The figures issuing from one of the bays penetrating the wall where the throne stands repeat in various ways in the miniatures where van Lathem takes up the same compositional scheme. This bay from which the figures emerge did not appear again in the miniature of Christ before Pilate in Philip the Good's prayer book (Fig. 94). Shortly thereafter, it became for van Lathem a characteristic and obligatory element of this compositional scheme, as illustrated by the frontispieces of the *Histoire de la Conquête de la Toison d'Or* or the *Livre des Secrets* (Fig. 42).[10]

Two armed men, who are doubtless supposed to belong to the group of Christ's guards, appear in the border to the left of the miniature. Below, the bottom corner of the border is occupied by a group of three figures: a man facing us, with a woman at his right in a tall hat, who is seen in profile. Both have their eyes turned toward a bearded man, half-kneeling, who addresses his speech to them. It could be the messenger coming to announce the death of Naboth to Jezebel and Ahab. Durrieu suggested that this group is an allusion to the unjust execution of Naboth, at Jezebel's instigation.[11] Indeed, it is one of the scenes appearing in the *Biblia pauperum* as a type for the appearance of Jesus before Pilate.[12]

9.1.2 THE WAY TO CALVARY (FOL. 95V)

The miniature of the Way to Calvary, fol. 95v, the same subject in the Prayer Book of Philip the Good in Paris (Fig. 96), both derive from the Eyckian composition trans-

mitted by the well known *Way to Calvary* painting in Budapest (Fig. 97).[13] The copies and interpretations of this composition testify to the admiration that it excited in quite a number of artists, even though some of them probably only knew it through versions derived and adapted from the original composition.[14] A *Way to Calvary* at the Metropolitan Museum of Art in New York provides an interesting example of an adaptation of the original composition (Fig. 98). As we will see below, this version or a very similar one was undoubtedly known by the artist of the Way to Calvary miniature examined here.

Although the miniatures of the Way to Calvary in each of the ducal prayer books

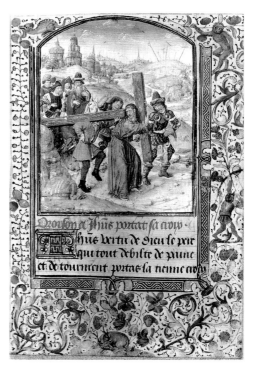

Fig. 96: *The Way to Calvary*. Prayer Book of Philip the Good. Paris, BnF, Ms. n.a. fr. 16428, fol. 79r.

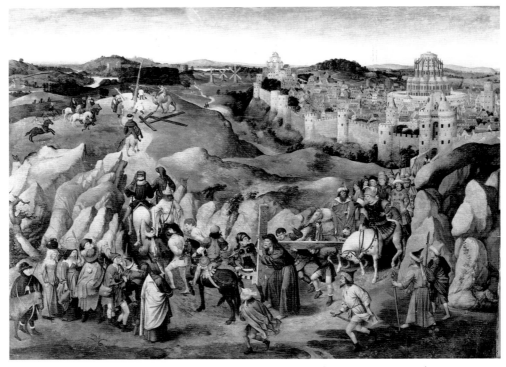

Fig. 97: After Jan van Eyck, *Way to Calvary*. Budapest, Musée des Beaux-Arts (Szépmüvészeti Muzeum).

have much in common, they nonetheless testify to different approaches to the subject. In the Paris miniature, the essential information is displayed in the foreground. Christ bearing the cross, surrounded by two henchmen who manhandle him, appears to turn his glance toward the spectator as in the painting in Budapest. A colorful group of horsemen follows close behind. An undulating landscape extends behind the figures, with Golgotha to the right and the city of Jerusalem to the left. The scene, the depiction of which is reduced to the essentials, seems to unfold in a very vast space.

In the miniature in the prayer book, the procession is not limited to a few figures grouped in the foreground. Remaining in

this respect more faithful to the Eyckian model, it represents a much more numerous procession, which describes a large arc turning from the gates of Jerusalem until the foot of the Mount of Calvary. A hill occupies the center of the composition. In the middle distance on either side of its slopes, we notice on the right the head of the procession that recedes, and on the left, the tail of the procession that advances, while the group of Christ bearing the cross appears in the foreground, at the point where the path coming from Jerusalem is supposed to describe a curve before receding toward the Mount of Calvary. Jesus is surrounded by helmeted soldiers, more numerous than the two rough soldiers who we see alone in the Paris miniature. The

group at the head of the procession, which we already see in the distance, in a crevasse path at the right, ends with the two thieves, whom we can distinguish walking almost naked with their hands tied behind their backs. On the left, in the middle distance, some horsemen emerge from beyond the slope of the hill. They lead us to assume that the rest of the procession follows behind them, coming from the gate of Jerusalem that they have just crossed. None of these elements is missing in the painting in Budapest, where they could be arranged in a looser manner in a composition wider than it is high (Fig. 97). The illuminator found himself confronted with the problem of managing to rework everything in a vertical painting of very small dimensions. Here he could have been helped if he had the version of the Way to Calvary in New York as a model (Fig. 98). Indeed, it could well be this version of the subject, treated by a Dutch artist in a vertical format that was known to him.[15] The figure of Veronica, absent in the Budapest version, is represented in the lower left of the painting and the little miniature. The group of Holy Women, who appear in the middle distance of the New York painting and who constitute a distinctive feature, does not appear in isolation in the miniature. However, the illuminator added the figures of the Virgin and Saint John on either side of Veronica and behind Simon of Cyrenus. The perspective is rather clumsy in the New York painting and in the miniature, where the landscape is nevertheless in the manner of van Lathem.

The different versions of the Way to Calvary vary in the way they render the progress or posture of Christ and express the sorrow

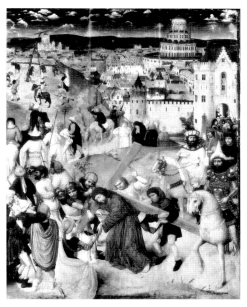

Fig. 98: North Netherlandish Master, *Way to Calvary*. New York, The Metropolitan Museum of Art, Bequest of George D. Pratt, 1935. (43.95).

that overcomes him. The illuminator apparently wished to emphasize the popular episode of Veronica's intervention. Christ turns his glance toward Saint Veronica and, from the hand he extends toward her, seems to return the cloth on which his face had been dried. This moving gift, repeated or adapted from the New York painting, anticipates in some way the interpretations that will be realized by other artists. Martin Schongauer would create an adaptation of it in his Passion series (Fig. 99). The latter would, in turn, inspire the interpretation that, some thirty years later, the Master of James IV of Scotland would present in the miniature of the Way to Calvary in the Spinola Hours, where we see Christ and Veronica each still holding with one hand one corner of the cloth. They seem to be displaying the

miraculous imprint of the Holy Face, and Christ's eyes are no longer turned toward Veronica, but toward the spectator who thus in a way finds himself questioned by a double effigy of the Lord.[16]

Without giving them the scale that they possessed in the miniature from Philip the Good's book (Fig. 96), the prayer book's Way to Calvary reworks in the background all the elements of the landscape that van Lathem had painted in the Paris version. We find the view of Jerusalem on the left, and, on the right, Golgotha, where towering gallows clearly designate the procession's destination. In essence, these elements were already found in the Budapest painting as in the one in New York. In the little book, the composition is inversed, as in the Paris miniature.[17]

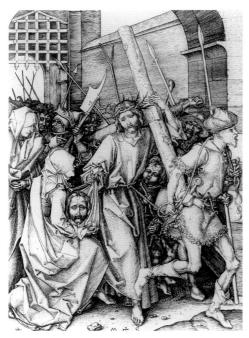

Fig. 99: Martin Schongauer, *Way to Calvary*. Vienna, Graphische Sammlung Albertina.

The lower left hand corner of the border for the Way to Calvary shows the Drunkenness of Noah as a prefiguration.[18] To the left, behind one of Noah's sons, a billy goat, drawn up on his hind legs, tries to reach the grapes of a young vine. The motif clearly alludes the to vine that Noah had planted, and to the wine that was the source of his drunkenness. Lying on the ground, his head resting on his elbow, Noah is asleep. Ham is behind him, addressing his two brothers. His posture and expression clearly show that he is mocking his father. One of the brothers leans toward Noah and covers his nakedness with his coat. The scene reworks each of the elements from the illustration in the xylo-typographic editions of the *Speculum humanae salvationis*, in an arrangement slightly adapted to the reduced space of the border (Fig. 49).[19]

The Drunkenness of Noah had also been represented as a prefiguration in the Turin-Milan Hours, where it is painted by Hand K in the bas-de-page. There it accompanies the miniature of Christ at the Column.[20] We see the billy goat on the left, enticed by the grapes of a vine forming the base of the design in the painting of the bas-de-page. It appears there more discreetly than in the engraving. The print in the *Speculum* could play a role in the diffusion of the motif of the billy goat drawn up on his hind legs, head reaching toward the bunches of grapes. This motif was already represented in the oldest manuscripts of the *Speculum*.[21] It can also appear in these manuscripts as the image of Capricorn, the sign of the Zodiac illustrating the December page of the calendar.[22] This motif appeared, therefore, from the first half of the fifteenth century, in man-

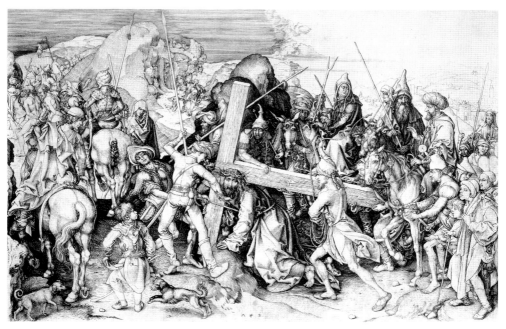

Fig. 100: Martin Schongauer, *Great Carrying of the Cross.* Zürich, Graphische Sammlung der Eidgenössischen Technischen Hochschule.

uscripts of a text that knew a very wide diffusion. The picturesque character of the motif explains why it was often repeated outside of its original iconographic context (fol. 34v).[23] The motif is found in several luxury manuscripts from the Northern Netherlands, including the Hours of Catherine of Cleves (New York, PML, M.917 and M.945) and the Hours of Willem van Montfoort (Vienna, ÖNB, Cod. S.n. 12878).[24]

Higher in the border of the Way to Calvary, a second goat appears and, in the left corner, a soldier is seated on the ground, busy tying up a bundle of sticks. This motif seems to have been introduced here by mistake. Doubtless borrowed from a model book or model sheets illustrating the Passion, this figure was intended to be used in or near a scene of the Flagellation, from

which it takes its meaning.[25] Sufficient verification for this can be found in the man performing the same task in a Flagellation of the Master of the View of Ste Gudule (The Winnipeg Art Gallery), or in the sculpted Flagellation of the Passion Altarpiece of Geel,[26] or even in remembering that there was a time when, in the Church of Saint John in Ghent (now Saint Bavo's Cathedral), one could see a figure tying a bundle of sticks in a Flagellation painted by Gerard Horenbout on one of the wings of a sculpted retable.[27]

9.1.3. THE CRUCIFIXION (FOL. 106R)

The miniature of the Crucifixion, fol. 106r, is derived from the painting at the Metropolitan Museum in New York, attributed to van Eyck or to one of his imitators (Fig. 101).

However, the miniature lacked the height that had been necessary to rework the terraced composition of superimposed registers particular to this painting. The arrangement of the whole miniature blatantly depends on that of the painting. Some figures were repeated without making any significant change, but a few of them go back to other sources of inspiration.

The horseman at right, seen from the back, corresponds to one of the three horsemen seen from the back in van Eyck's painting. The folds that make up the fullness of the bottom of the coat resting on the horse's hindquarters are perfectly comparable to those in the model, while the green color of the costume corresponds to that in the painting. The position of the three crosses, the lance's blow to the heart, the other lance still raised with the sponge, are just so many details that agree with the model. The illuminator was, of course, forced to impoverish and adapt by reducing the superabundant figuration of the Eyckian model.[28] The figure of Mary Magdalene, who in the painting wrings her hands, in the right foreground, is placed at the foot of the cross in the miniature. Her posture is different and is recognizable more as a reminiscence of Roger van der Weyden, but her sleeves and the garment draped at her hips over her skirt are green, as is Mary Magdalene's robe in the New York painting.

Among the interpretations to which this exceptional painting of van Eyck gave rise, one must include the Crucifixion painted for the Grimani Breviary and attributed to the Master of James IV of Scotland.[29] Although the miniature in question here is nearly a half-century older than that of the famous breviary, the juxtaposition of these two Crucifixions is unavoidable. Two of the three horsemen seen from behind, at the right of

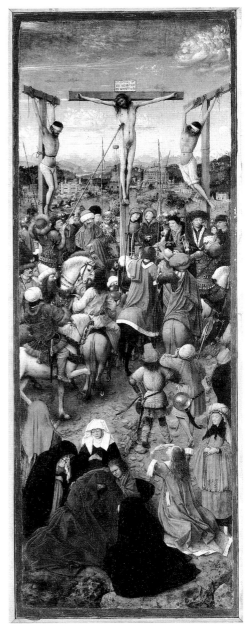

Fig. 101: Jan van Eyck, *Crucifixion*. New York, The Metropolitan Museum of Art.

the painting, are repeated in the Breviary's miniature. The arrangement of folds from one of their coats was also faithfully repeated there.[30] A horseman with a sharp profile, visible at right near the border of the painting in the Grimani Breviary, appears to be in just the same place in the miniature from the little prayer book. The two figures' hats are not identical, but as for the rest, there is no doubt that the two heads derive from the same model, which does not seem to correspond to one of the figures in van Eyck's painting. The horseman in question could derive from the Crucifixion of the Master of Evert van Soudenbalch, on fol. 55v of the Amerongen Hours (Fig. 102), which itself also reflects the influence of the work of van Eyck.[31] In this miniature, the Master of Evert van Soudenbalch represented several figures with a quite marked profile: among the latter, the two horsemen, near the edge of the composition on the right, could be the source of the figure in question. In the miniature in the little prayer book and in that of the Grimani Breviary, this figure seems to be merely a silent witness, withdrawn into himself, his gaze fixed before him. The two figures by the Master of Evert van Soudenbalch, on the contrary, appear to experience the event with emotion, as their tense gazes, lifted toward Christ, lead us to presume. The painter of a Crucifixion closely related to that of the Master of Evert van Soudenbalch (Providence, Rhode Island School of Design Museum) was not insensitive to this aspect of the miniature when taking it as a source of inspiration for his painting (Fig. 103).[32]

The Virgin supported by Saint John in the Crucifixion in the duke's prayer book ap-

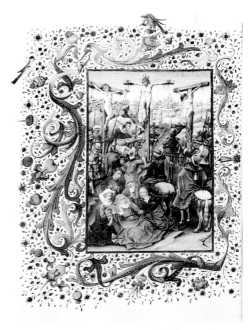

Fig. 102: Master of Evert van Soudenbalch, *Crucifixion*. Hours of Jan van Amerongen. Brussels, KBR, Ms. II 7619, fol. 55v.

pears to be related to the Virgin, crushed by sorrow and supported by the Holy Women, in the lower left hand corner of the miniature in the Amerongen Hours. The figures of Saint John and of the Virgin could be inspired by the group in the Utrecht master's miniature, or by an analogous representation from the same master or the same circle, such as, for example, the Providence Crucifixion just cited. The pose of the Virgin's arms in the miniature of the duke's prayer book better corresponds to the painting than to the Virgin in the Amerongen Hours.

The figure of Longinus striking the blow with his lance in the Crucifixion from the duke's book appears nearly the same in the Grimani Breviary miniature. The postures of the arms and head are not identical, but

the analogy between the two bearded faces remains striking. Their heads, like their hair, appear to correspond to that of the horseman just below Longinus in the Eyckian painting in New York (Fig. 101). It remains however very uncertain that the two miniatures go directly back to the van Eyck painting. They could both derive from the same model that was itself already an interpretation of the painting.

The bodies of the three crucified men are very well rendered, except perhaps for the shoulder and the right arm of the thief on the right. The manner in which the thieves are painted, twisted with pain, and in which their disheveled hair is rendered, recalls the expressive figures of the thieves by the Master of Evert van Soudenbalch in four successive miniatures from the Hours of Jan van Amerongen.[33]

The perceptible relationship between the Crucifixion in the duke's book and that of the Master of Evert van Soudenbalch on fol. 55v Hours of Jan van Amerongen, proves that its creator was familiar with Utrecht production. It seems likely that this putative assistant of van Lathem was an immigrant from the North.

The prayer book's miniature and the Crucifixion from the triptych at Saint Bavo's Cathedral in Ghent (Fig. 93) differ greatly in the manner in which figures are situated within the space. However, they have several features in common, by the arrangement in the left foreground of a diagonal axis formed by the Holy Women and the Virgin, and by the rather compact group of horsemen that forms a pendant to them on the right. In the miniature, however, Saint John supports the

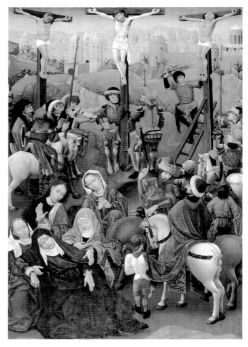

Fig. 103: North Netherlandish Master, *Crucifixion*. Providence, Rhode Island School of Design Museum of Art.

fainting Virgin, while the Holy Women support her in the painting. The way Saint John carries his head, and his lost gaze, resemble those of Saint John in the painting. The Virgin's posture, without being identical, is quite comparable.[34]

Abraham's sacrifice is represented in the lower left hand corner of the border for the Crucifixion miniature. The second prefiguration, Moses and the brazen serpent, occupies the upper border on the right, at the same height as the crosses of Calvary in the miniature. Accompanied by a helmeted man, Moses points to the brazen serpent raised up on a fork, as in the *Biblia pauperum*.[35]

In the lower right hand corner of the border for the Crucifixion, a man lies on his back on the ground. His knees are bent and

his head turned back, as if he is dead. Beside him, a winged dragon leans toward his face, opening its mouth with a menacing look. This dragon could be copied from one of those that appears in the book's borders, for example the one in the upper border of the miniature of Saint Lawrence, fol. 31v. The man lying on the ground somewhat recalls the dead Abel visible in the print from Adam and Eve's lamentation of his death in the *Speculum humanae salvationis*.[36] But with his knees lifted and his head turned back, the figure is much closer to the man struck down in the foreground from the scene of Saint Catherine's martyrdom, on fol. 48r.

9.1.4 THE ENTOMBMENT (FOL. 119V)

The miniature of the Entombment in the Prayer Book of Charles the Bold, and that of the Prayer Book of Philip the Good in Paris, fol. 86r (Fig. 104), are quite similar in their general composition. Joseph of Arimathea, who supports the body of Christ by the shoulders, is placed at the head of the tomb. Across from him, at the other end of the tomb, Nicodemus, bending in front, helps support Christ's legs. Nicodemus is seen somewhat from the back in the two miniatures, and his figure stands out in front of the other figures in the scene.[37] In the Paris miniature, the Virgin raises Christ's arm in both her hands, and kisses his hand. She has her hands joined at her breast and her head more bent over in the little prayer book's miniature, which, in the arrangement and postures of the figures, is comparable to the Entombment of the Master of Zweder van Culemborg in the important Egmont Breviary (Fig. 105) (New York, PML, M. 87, fol. 202v).[38] Mary Magdalen,

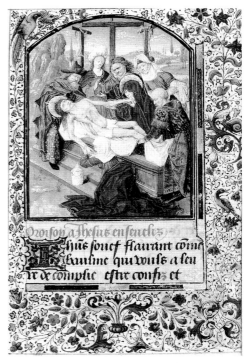

Fig. 104: *The Entombment*. Prayer Book of Philip the Good. Paris, BnF, Ms. n.a. fr. 16428, fol. 86r.

who is kneeling before the tomb and kissing Christ's hand in the foreground of the prayer book's miniature, does not appear in that of the Egmont Breviary.

Many images of the Entombment represent Christ still wearing the crown of thorns. Those of the Egmont Breviary, the Prayer Book of Philip the Good, or Bouts' painting in the National Gallery in London portray it thus (Figs. 104-106). By contrast, in the prayer book's miniature, the crown of thorns is left on the ground, in front of the tomb to the left. The artist indeed had anticipated depicting the crown of thorns as a precious relic, carried, in accordance with the legend, by Joseph of Arimathea, in the border's lower right hand corner. This attention to the

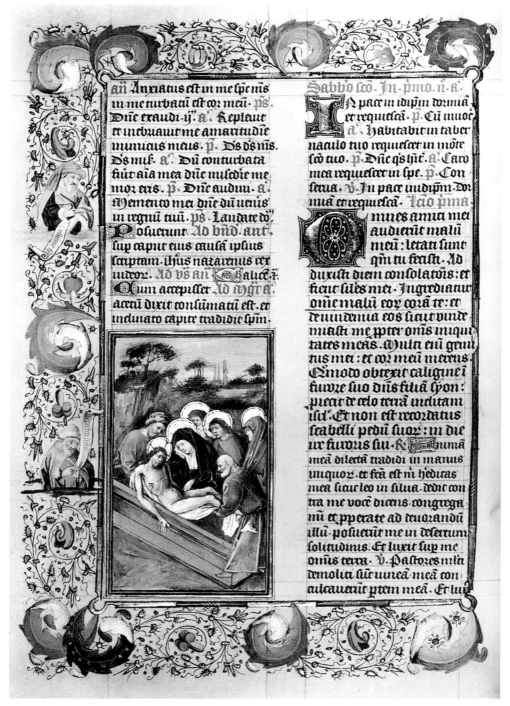

Fig. 105: Master of Zweder van Culemborg, *Entombment*. Egmont Breviary. New York, PML, M.87, fol. 200v.

crown of thorns, and the allusion to the cult with which the relics of the Passion were to be surrounded, is striking.[39]

Could it not have been stimulated by a direct or indirect knowledge of van der Goes' famous diptych, now preserved in Vienna? In the panel of the *Lamentation*, the veneration of the Passion relics is particularly emphasized (Fig. 107). On the right, with one knee on the ground, Nicodemus[40] seems lost in sorrow and contemplation. The Crown of Thorns lies very close to him in the foreground. In order not to have to put such a precious relic on the ground, out of respect it is placed on a hat resting on the ground. Above, the disciple behind the Virgin gives the nails of the Crucifixion to two weeping women who collect them with piety and compassion, and thus avoid having them fall under the Virgin's gaze.[41] That this Goesian version of the Lamentation could contribute to the iconographic conception of the Entombment folio appears to be confirmed by the tearful figures of the Virgin and Saint John. Their postures reproduce in reverse those that van der Goes had given them. Even Saint John's features appear to be copied from those in the painting. Only the Virgin's gesture has been altered: she has her arms folded with her hands joined at her breast, and not extended toward Christ as in the painting.

Van Lathem reworks a very similar composition for the Entombment in the Vienna Hours of Mary of Burgundy (Fig. 108). The Crown of Thorns is likewise placed on the ground, but Joseph of Arimathea does not appear in the border, which has no element connecting it to the iconography of the sub-

Fig. 106: Dirk Bouts, *Entombment*. London, National Gallery.

Fig. 107: Hugo van der Goes, *Lamentation of Christ*. Vienna, Kunsthistorisches Museum.

Fig. 108: Lieven van Lathem, *Entombment*. Hours of Mary of Burgundy. Vienna, ÖNB, Cod. 1857, fol. 111v.

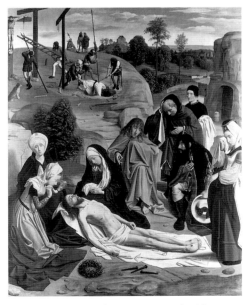

Fig. 109: Geertgen tot Sint-Jans, *Lamentation*. Vienna, Kunsthistorisches Museum.

ject. Geertgen tot Sint Jans, like van der Goes, highlighted the Crown of Thorns and the nails in his *Lamentation* (Fig. 109).

Van der Goes had matched the landscape in the background of his *Lamentation* with the sentiment of desolation that animates the scene. The Entombment in the little book, by contrast, takes up a verdant landscape typical of van Lathem. He reproduced in reverse the model that he used for the miniature of the Way to Calvary. It differs only in the tree added to the first hill in the background. Therefore, we see the gallows on the Mount of Calvary on one side; the City of Jerusalem in the distance on the other; and in the background, the mountains silhouetted against the horizon. In spite of what it unquestionably borrows from van de Goes' *Lamentation*, the Entombment miniature thus proves, on account of this landscape and its atmosphere, to be closer to that of the Egmont Breviary (Fig. 105).

The differences between the miniature of the Entombment and the one in the Paris prayer book (Fig. 104) are quite pronounced. The landscape of the latter is not hilly, as van Lathem's becomes in the distances.[42] It is more comparable to the background in Bouts' painting, with its single massive rocky face on the left, and low-sloping hills or undulations (Fig. 106). The figures in this miniature from Philip the Good's prayer book are quite different from those in most of the manuscript's other miniatures. These more massive figures, with fleshier faces and more studied features, could be inspired by some of van Eyck's figures. The Joseph of Arimathea is related to some of the patriarchs and prophets in the central panel of the

Ghent Altarpiece in his tense and concentrated expression, or to some of the apostle drawings in the Albertina in Vienna (Fig. 84). Saint John's nervous expression, which is no more in the manner of van Lathem, makes one think of the sorrowful expressions of the Virgin and Saint John in the Berlin *Crucifixion* (Fig. 110), or that of Saint John the Baptist in van Eyck's small grisaille diptych at the Musée du Louvre (Fig. 111), or even of certain tormented expressions such as that of Saint Christopher in a drawing at the same museum (Fig. 18). Perhaps this miniature transmits to us the more or less faithful image of a lost painting, the creator of which would have belonged to van Eyck's circle.

In the upper half of the left border of the little prayer book's Entombment, a rather old man appears to walk along in a worried manner. Doubtless this is Joseph of Arimathea, hurrying to Calvary after having obtained authorization from Pilate to collect Christ's body in order to give it burial. As we see in the lower right hand corner of the folio, this pious duty having been accomplished, Joseph of Arimathea takes the Crown of Thorns, holding it respectfully, his hands covered with a white cloth.

The story of Jonah is represented in the lower left hand corner of the border, as a prefiguration of the Entombment. There we see the prophet, at the point of being cast into the water by three of the boat's other occupants. The scene takes place beneath the eyes of the whale, who, its mouth open, prepares to devour him immediately. This way of representing Jonah and the whale conforms to a very old iconographic tradition, often repeated in the manuscripts of the Low

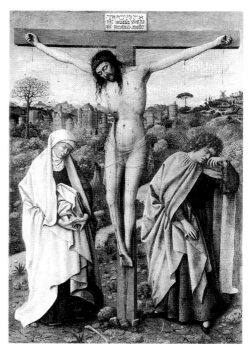

Fig. 110: Jan van Eyck, *Crucifixion with the Virgin and Saint John*. Berlin, Staatliche Museen.

Fig. 111: Circle of Jan van Eyck, *Saint John the Baptist*, section of a diptych, Musée du Louvre, N° RF 38-22.

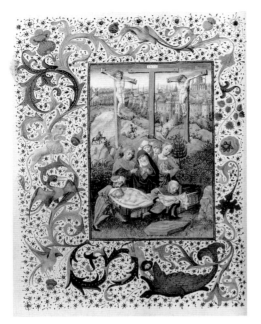

Fig. 112: Master of Evert van Soudenbalch, *Entombment, with the story of Jonah in the border.* Hours of Jan van Amerongen. Brussels, KBR, Ms. II 7619, fol. 67v.

Countries from the fourteenth century, and the multiplication of manuscripts and block-books of the *Biblia pauperum* and the *Speculum* contributed to its endurance.[43] In the prayer book, the scene takes on an engaging and picturesque character in the attention paid to the details of the ship, the movements of the water, and the rocky shore before which the episode takes place.

9.2 THE ILLUMINATION OF FOLIOS WITH COLORED BORDERS IN THE HOURS OF THE CROSS

9.2.1 GETHSEMANE AND THE ARREST OF CHRIST (FOLS. 70V–71R)

The full-page miniature of Gethsemane faces that of the Arrest of Christ, which is of reduced dimensions and verging on the beginning of the text. Gethsemane is a rather disconcerting picture in its distinctive lighting. The arrival of the troops, who, in the background, pass through the garden gate, is treated as a nocturnal scene. We see the shining flames of the torches and lanterns that the soldiers carry. The vividness of the light's reflections can be seen on the leaves of nearby trees and bushes, as well as the silhouettes of the figures at the front of the group who seem to confer with Judas on the manner in which they will recognize the one whom they seek. Christ in prayer in the upper left, and the three sleeping apostles in the foreground, are no longer treated as nocturnal

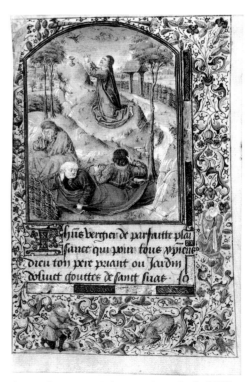

Fig. 113: *The Prayer at Gethsemane.* Prayer Book of Philip the Good. Paris, BnF, Ms. n.a. fr. 16428, fol. 64r.

THE ILLUMINATION OF THE LITTLE HOURS OF THE CROSS

when they accompany the arrival of the group preparing to arrest Christ.

In the foreground, Saint Peter is stretched out on his side, asleep. The apostle's dozing posture is analogous to that of Saint Peter in the miniature on the same subject from the Prayer Book of Philip the Good in Paris, fol. 64r, in which the pose appears somewhat forced and artificial (Fig. 113). It is interpreted in a more natural and relaxed manner in the little book's miniature. This pose of Saint Peter is treated with much greater felicity in the Passion series engraved by Schongauer (Fig. 114).[44] The motif was probably borrowed from a painting. We know that Schongauer must have taken advantage of direct contact with the works of the Flemish masters during a journey, which, for lack of written sources to confirm it, is nevertheless sufficiently proven by the knowledge of Flemish painting to which his work testifies.[45]

In Shongauer's engraving, Saint Peter holds his sword in his right hand. The engraver probably had to reverse the preparatory drawing for the engraving, in order to avoid, by the mirror effect of printing, having Saint Peter hold his sword in his left hand, which was less logical and less faithful to the model.[46] In the Paris miniature's prayer book, Saint Peter does hold his sword in his left hand; the model here is therefore reversed. It is likewise in the small miniature, but, in not copying the sword, the illuminator cleverly avoided allowing the spectator to recognize the inversion of a model.

The drowsiness of the three apostles is rendered with greater veracity and skill in the little prayer book than in the Paris min-

Fig. 114: Martin Schongauer, *The Prayer at Gethsemane.* Paris, BnF, Cabinet des Estampes.

iature. The third apostle is almost completely hidden by the groundswell beyond which he lies. Only his head, resting on one hand, shows between two bushes. The hollow in the ground by which he escapes from view runs into the distance up until the slope above, on which Christ kneels in prayer at left, his gaze and his hands raised toward Heaven. The motif of the sleeping apostles such as we see here, in relative conformity with the common model to which the two miniatures and the Schongauer engraving refer, was repeated many times with several variants in the production of the Master of Mary of Burgundy and his circle,[47] and in later manuscripts of the 'Ghent-Bruges' school.[48] The impact of this model probably was later transmitted by engraving. Among

the illuminators of the later generation, there was more than one who used the engravings of Schongauer.[49]

The rather bright colors—blue, red, and green for the apostles, and a softer green for the landscape—darken against the background. The trees in the background on the right, beyond the rocks at the feet of which Jesus is kneeling, are of a darker green. They are treated in a more delicate manner, in small light touches, rendering well the quivering of their foliage. The dark clouds, whose clear edges cut across the backdrop of the deep blue sky, contribute to the nocturnal effects of the scene in the back right, where the troop of Temple Guards arrives with Judas.

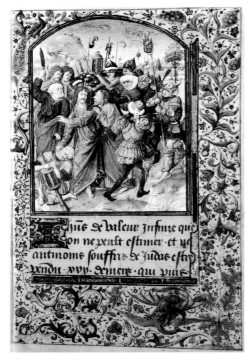

Fig. 115: *The Arrest of Christ*. Prayer Book of Philip the Good. Paris, BnF, Ms. n.a. fr. 16428, fol. 66r.

Like Christ in prayer and the sleeping apostles, the miniature of the Arrest of Christ is too colorful for a scene that ostensibly takes place at night. One finds, in a quite similar arrangement, the crowded figuration of the Arrest in the Paris manuscript. In Paris, the group of figures is inscribed entirely within the space visible inside the frame (Fig. 115). This is also the case in the particularly remarkable Arrest of Christ in the Hours of Katharina von Lokhorst in Münster (Fig. 116), or, for example, even in the painting of the *Arrest of Christ* in Munich (Fig. 92). In our little miniature, by contrast, we see and feel that the group come to arrest Jesus is denser and more numerous. On either side of the composition, figures are cropped by the frame, which suggests that the group includes many more people than the painting allows us to see.

The rendering of the Arrest represented in the little miniature is the very widespread version that represents the kiss of Judas at the same time as the gesture of Christ healing the ear of Malachus, while on the left Saint Peter sheaths his sword.[50]

In the Paris manuscript's miniature, by contrast, as in the Hours of Catherine of Cleves,[51] Saint Peter still has his sword raised and menacing. In relation to the gesture of Jesus, which heals the ear of Malachus, Peter's gesture is no longer logical. The illogicality results from the mutual contamination of two very widespread versions of the Arrest of Christ. One, represented for example by the Parement de Narbonne, shows the kiss of Judas at the same time as this healing gesture of Christ.[52] The other, represented for example by the Arrest in the Turin-Milan

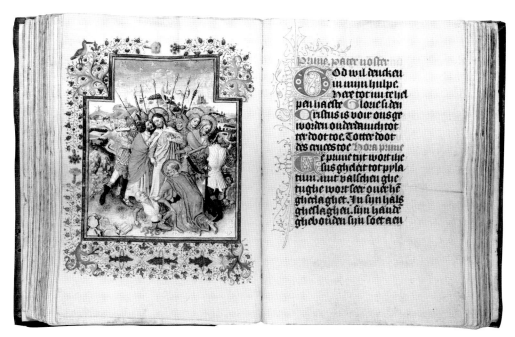

Fig. 116: Master of Catherine of Cleves, *Arrest of Christ*. Hours of Katharina von Lokhorst. Münster, Westfälisches Landesmuseum für Kunst und Kulturgeschichte, Ms. 530, fol. 91v.

Hours, by the painting of the *Arrest of Christ* in Munich (Fig. 92), or even by the magnificent miniature of the Master of Catherine of Cleves in the Lokhorst Hours (Fig. 116), shows simultaneously the kiss of Judas, Saint Peter brandishing his sword, and Malachus frightened and slumped on the ground.[53]

The Gospel of John (18 : 1–11) is the only one to specify that the group arrived 'with lanterns and torches and weapons', details that could not avoid being repeated by the text or texts that inspired this iconography. In the small miniature of the Arrest of Christ, a lantern is held just above Christ's head. This motif appears very frequently from the beginning of the fourteenth century at least.[54] Pucelle depicted it in the Book of Hours of Jean d'Evreux but was not the first to adopt it. The motif is repeated in many later manuscripts, among them princely books with illuminations that often derive from those of Pucelle.[55] Perhaps it is through the intermediary of the Guelders illuminators, who worked for the court circles in France at the end of the fourteenth and beginning of the fifteenth centuries, that this motif is found in the Northern Netherlands, for example in the Hours of Catherine of Cleves[56] and in those of Jan Van Amerongen (Fig. 117);[57] when, unless I am mistaken, it was rarer to encounter in the Arrest of Christ illustrated in older Dutch manuscripts.[58] The importance of the lantern motif is twofold. It must have been adopted to indicate that the scene took place at night.[59] Undoubtedly it also alluded to the Jews' care to avoid mistaking their victim when they wished to seize Jesus.[60] The lantern therefore

often appears among the Instruments of the Passion in the Mass of Saint Gregory, or in other representations where these *Arma Christi* are grouped.

Behind the tightly-packed group of figures in the foreground of the book's Arrest of Christ, the light reflecting off the soldiers' helmets allows us to distinguish the troops in the background on the right, who advance from the garden. Part of the landscape is visible further to the left. In its technique and darker lighting, it matches the background of Gethsemane, the left wing of the diptych (fol. 70v).

The borders of the two folios are decorated with gilded acanthus *rinceaux* with glints of bronze, standing out against a colored background of a not very uniform grey. The acanthus stems are quite thin and

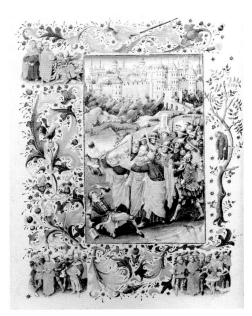

Fig. 117: Master of Evert van Soudenbalch, *Arrest of Christ*. Hours of Jan van Amerongen. Brussels, KBR, Ms. II 7619, fol. 17v.

undulate with great suppleness. In the composition, no doubt intentionally kept in rather dark tones for this diptych, only some birds and flowers bring a note of color and freshness.

The diptych's borders consist of figures conceived as complements to the subjects of the miniatures. Four of them are of soldiers from the cohort in charge of Christ's arrest. One is visible in the upper corner at the top of each folio, one carrying a weapon and the other a lantern. At the bottom of the borders, toward the internal margin, one soldier carries a lantern and a scroll,[61] while another appears to have been thrown to the ground with his lantern. The latter doubtless recalls (reducing the event to a single figure) that, according to Saint John's account (18:6), repeated in typological works and commentaries on the Passion, those who came to arrest Christ retreated and fell to the ground. The link between these two soldiers and the scene of Christ's arrest is made perceptible by the direction of their gazes toward the diptych above.

In the lower right hand corner, the murder of Abel is represented as a prefiguration of the treason of Judas. Cain, with one knee on the ground, leans over his brother thrown back on the ground, and savagely deals him the mortal blows while, with the other hand, he holds him by the throat. In his anguish, Abel lifts his hands in a gesture of distress. His head thrown back and the grimace on his face, although barely sketched out, sufficiently reveal the fatal outcome of the crime. The artist here seems to repeat, interpreting it in his own way, the scene of Abel's murder depicted in the border of the Beheading of

John the Baptist, fol. 17r, and discussed above in section 6.4. The difference in technique between the two scenes, the fact that the latter is reversed in relation to the former as well as the rather rough character of its execution, do not prevent them both from conveying, with a rare intensity of expression, the immense distress of the victim and the terrible anguish expressed by his extended hands.

The two figures standing at the lower left hand corner of the diptych at the opening of the Hours of the Cross must no doubt be interpreted as illustrating a prelude to the tragic dénouement played out in the lower right hand corner. Must we not here see Abel, who, with one hand lifted above his head, gestures toward the heavens, and Cain, who, slightly turned toward his brother, seems to listen to him with an anxious and envious gaze? The illuminator was manifestly interested in his figures' psychology, and demonstrates a remarkable aptitude for expressing their sentiments and passions.

The two scenes arranged symmetrically in the lower corners of the diptych's sections constitute particularly appropriate prefigurations for each of the miniatures they accompany. In a perfect parallel between miniature and prefiguration, we thus see the betrayal slyly plotted in the shadows evoked on the left, and on the right, the sinister fulfillment of the crime.

The Gethsemane miniature is framed by a large gold band. In contrast to those that enclose some of the miniatures in the documented core, it is not decorated with stamped patterns. The illuminators of the Northern Netherlands often had a tendency to increase the width of their miniatures' gold frames, and in the neighboring regions of the Lower Rhine, quite a number of miniatures were framed by such a gold band.[62] The one framing this first miniature of the Passion cycle allows us to presume a Dutch origin for this folio's illuminator.

Near the bird on the left, halfway up the border of the Gethsemane miniature, a narrow band of red fabric hangs from one of the acanthus *rinceaux* and seems to float in waves.[63] This red accent seems to have been placed there deliberately for the effect of the contrast it elicits with the quite bright colors of the birds, flowers, and figures in this border.

9.2.2 THE FLAGELLATION (FOL. 90R)

This miniature of the Flagellation surely seems to have repeated, in reverse, the arrangement of torturers surrounding Christ in the Flagellation painted by van Lathem on folio 74r of the Prayer Book of Philip the Good in Paris (Fig. 118). Their postures and movements, however, are not identical. In the background, on the left, Pilate assists in the torture, the rod of justice in his hand. His figure is cropped by the frame, and one can see behind him that an assessor accompanies him.[64] Pilate's presence had been treated in a completely different way in the Paris miniature. There Pilate was not relegated to the background, but he sat on a throne, at right, to assist in the flagellation with one of his assessors at his right.

In the Flagellation miniatures of the two ducal prayer books, the torturer who binds Jesus' feet is of the same type. This torturer with a bald or shaved head is also repeated

by van Lathem, and is similar to the one also found in the Crucifixion of Saint Andrew, on fol. 21r, in the documented core, or to those who bustle about in the foreground of the mounting on the Cross from fol. 81r of the prayer book in Paris.[65]

In the bas-de-page, inside the border, Job is seated nearly naked on his dungheap. In the lower left hand corner, his wife mocks him, bent forward, taking a large step and gesturing with her hand in his direction. The posture and pointed profile of the hooded woman convey quite well the sharpness of her sentiments, to which Job moreover seems scarcely to pay attention. Indeed, he has turned his head toward a demon who has approached and seeks to torment him. The demon places a paw on Job's shoulder, and gets ready to strike him with the stick that he brandishes in his other paw. Although the figure of Job will appear very similar in other manuscripts of the 'Ghent-Bruges' school, he is surrounded by different figures than those here.[66] As a second pre-figuration of the Flagellation, Lamech, who gets beaten by his two wives, is depicted to the right of the miniature. The harshness of the two wives is rendered just like that of Job's wife.

9.2.3 THE DEPOSITION (FOL. 111V)

In the miniature of the Deposition, two men have just detached Christ's body from the Cross. From the top of their ladders, they support him reverently by the shoulders while cautiously lowering him. Below, at the foot of the cross, Joseph of Arimathea assists them by gathering the Savior's body in his arms. His posture and the manner in

which he support's Christ's body could well be inspired by those of Joseph of Arimathea in the Master of Flémalle's famous triptych of the Deposition, known through the copy in Liverpool. At the left and right of the miniature, each of the ladders is held in both hands by a woman. These two women seem to herald those that Geertgen tot Sint Jans painted in his *Lamentation* (Vienna, Kunsthistorisches Museum) (Fig. 109). These female figures with elongated faces and large round foreheads also recall those that populate the triptych of Calvary in the Cathedral of Saint Bavo in Ghent (Fig. 93), and some of van der Goes' figures of angels or women.

The skull and few bones that lie on the ground in the miniature's foreground simultaneously recall the etymology of Golgotha and the belief that Adam would have been buried at the place where the Cross was erected. In the lower right hand corner, the Virgin, collapsed on the ground and supported by Saint John, seems to be a reminiscence of the Virgin and Saint John in the van der Goes *Lamentation* in Vienna (Fig. 107). On the whole, as is often the case, the Deposition and Lamentation merge into a single picture. The miniature could perhaps have also been inspired by the lost Lamentation window cited by Karel van Mander as a possible work of van der Goes.[67] According to Marcus van Vaernewijck, this window was one of the most remarkable works that adorned the church of Saint James in Ghent, the parish of Nicolas Spierinc.[68]

Christ occupies the center of the painting, and is thus situated at the crossing of the diagonal axes that underlie the composition.

Fig. 118: *The Flagellation.* Prayer Book of Philip the Good. Paris, BnF, Ms. n.a. fr. 16428, fol. 74r.

participate in it. The figures' postures and expressions strongly convey, but in a contained manner, the scene's distinctive atmosphere of grief.

These expressive qualities are accentuated in Adam and Eve's lamentation over the death of Abel, represented in the lower left hand corner of the border as a prefiguration of the Lamentation.[69] The immense sorrow of Adam and Eve, more externalized, more heartbreaking than the mute grief of the figures in the Deposition, is here expressed with intensity. The artist displays an acute sense of the tragic in choosing to depict Abel, after he has been beaten to death. Pallid, and from the depths of his distress, Abel turns his head toward his appalled parents even as the veil of death clouds his extinguishing gaze. A poignant expression, as is that of Eve, who throws herself to her knees at her son's side, her head in her hands.

Halfway up the left border, Cain is depicted carrying his spade over his shoulder.[70] We recognize him once again in the lower right hand corner of the border. Bending forward, hands joined, he suddenly seems frightened by the horror of his crime and seems already to sense the curse that it entails (Genesis 4 : 9–16). The two figures do not have clothes in the same colors, but both have sleeves of a very bright yellow. The acanthus foliage in this border are painted in tones of pink lilac and pale blue, subtly nuanced and turning to white at the outlines of their curves. These delicate tones harmonize extremely well with the olive-green background of the decoration, and contrast with the lively reds, blues, yellows, and greens of the figures' costumes.

One of the diagonals starts from the group of the Virgin and Saint John in the lower right hand corner, and goes up following Christ's legs and torso up until the head of the man who supports him at the shoulders. The other diagonal starts from the chest of the woman holding the ladder on the left, and climbs toward the right according to the direction determined by the arms and shoulder line of the figure at the top of the ladder on the right, who supports Christ's left arm while holding the branch of the cross with his other hand.

An intense emotion emanates from this scene, with its rhythmical and well-ordered composition, integrating the scene's mute witnesses as well as those who reverently

9.2.4 The Artist of the Colored Borders in the Hours of the Cross, and his Participation in the Devotional Diptych Borders of the Original Manuscript

In the borders of the four folios in question, the figures seem to be placed in front of the foliage, which is therefore partially hidden behind them, without much sensitivity from a spatial point of view. In the documented core, the figures, animals, or drolleries in the borders are situated not in front of, but rather between or among the foliage of the decoration.

In these four borders, the foliage bears highly characteristic and rather curious flowers. Their centers are provided with a kind of elongated ear of grain, which appears to be made up of yellow grains. It would remind us of a cob of corn, if it did not often end in a curved point.

The artist of the borders with tinted backgrounds in the Hours of the Cross had already participated in other aspects of the execution of the duke's prayer book. Indeed, he was called in during the execution, in 1469, of the diptychs with effigies of the duke. His hand is recognizable in the borders of the two diptychs that have borders with colored backgrounds : that of the Virgin with angel musicians, fols. 5v–6r, and that of Saint George, fols. 67v–68r.

In this last diptych, the figures are situated in front of the foliage, thus partially hiding its meanders, as we just observed in the tinted borders for the scenes of the Passion. We also find the type of flower and the rather curious cobs that we observed there.[71] The small gold motifs, in the form of rosettes or small flowers, that brighten somewhat the

color of the borders' background in the Saint George diptych are like those that we find in the border of the Deposition. The same bronze foliage with metallic glints appears in the borders of the Virgin's diptych that also decorates the borders of the opening diptych of the Hours and those of the Flagellation. In the borders of the Saint George diptych, the foliage is analogous to that from the border of the Deposition. The distinctive features of these borders and their quite specific coloration is found nowhere in the documented core.

In the diptychs of the Virgin and of Saint George, the manner in which the artist renders the birds' silhouettes in the borders is the same as the one we observed in the borders with colored backgrounds in the Hours. As in the Hours, a black line traced in pen accentuates the contours of their bodies and wings in the border of fol. 5v and in those of the two sections of Saint George's diptych. We find the same slightly over-exaggerated manner of delineating forms in the wings of the angel who presents Saint George with his sword and helmet in the upper left hand corner of the diptych.

This illuminator's participation in the execution of the diptychs in the original prayer book brings us back to the circumstances that surrounded the completion of the book at The Hague, discussed in section 2.3 above. It was at the moment when the execution of the diptychs was in progress or was to be undertaken that this illuminator could have been chosen as a collaborator. He was chosen from among the artisans, undoubtedly from Holland, already present or able to be quickly summoned. Let us call him the

Hague Master. The choice of this artisan, perhaps a beginner, but in possession of remarkable talent and sensitivity, could not have been made by chance. His probable contacts with van Lathem and Spierinc and his good fortune in discovering or being familiar with their work could have persuaded him to join their circle. It could be thus that they once more resorted to him during the execution of the complement added to this same book of prayers.

9.3 FROM THE HAGUE MASTER TO THE MASTER OF MARY OF BURGUNDY

In the right-hand section of the Virgin's diptych, fol. 6r, on the right between the peacock who spreads his tail and the angel musician in the lower corner, the Hague Master inserted a pink-petalled marguerite, the gleaming yellow heart of which is a topaz or other precious stone cut in facets. Giving this marguerite such a precious character surely reveals a particular intention, notably an allusion to Margaret of York, whose husband is depicted in prayer on this very page.

This discreet allusion was repeated and amplified in the border of the magnificent Crucifixion page on fol. 99v of the Vienna Hours of Mary of Burgundy (Fig. 119). Sumptuous and vigorous acanthus foliage, which appears to be of gilded metal, is placed against a somber background that accords with the sentiment of grief inspired by the subject of the miniature. On the right, however, halfway up, we see a shining metalwork marguerite with a ruby heart, and petals of white enamel that contrast vividly with the

Fig. 119: Master of Mary of Burgundy, *Crucifixion*. Hours of Mary of Burgundy. Vienna, ÖNB, Cod. 1857, fol. 99v.

azure petals that surround them. A curious azure and mother-of-pearl flower supplies its pendant in the left-hand border, while an identical flower rests toward the right of the lower edge. These two strange flowers are precious interpretations of the flower we noticed in each of the colored borders of the Hours of the Cross.

In this extraordinary border in Vienna, it seems that even the Instruments of the Passion, carried by two grave Goes-type angels, are intended to be transformed into jewels. The Crown of Thorns and the lance presented by one of the angels appear to be made of enamel and gold. The other angel has been entrusted with the column and rods of the Flagellation, which are made of lapis lazuli and gold.

Fig. 120: Nicolas Spierinc and the Master of Mary of Burgundy, *Calligraphy and marginal decoration*. Hours of Engelbert of Nassau. Oxford, Bodleian Library, Ms. Douce 219–220, fol. 126r.

Fig. 121: Nicolas Spierinc and/or his circle, *Border with pecking cock*. Hours of Engelbert of Nassau. Oxford, Bodleian Library, Ms. Douce 219–220, fol. 175v.

The extraordinary decoration this time makes a double allusion to Margaret of York. First, the marguerite ; and second, the other flowers' seeds made of pearls (in Latin, *margaritae*) confirm remarkably that these Vienna Hours were, originally, intended for Duchess Margaret.[72] It could not be by chance that the delicate idea of the marguerite with a topaz heart in the margin of the Virgin's diptych is thus found magnified in one of the most beautiful pages of the Master of Mary of Burgundy. For the Master of Mary of Burgundy to have thus drawn this idea from the Hague Master, they must have practiced near one another

and perhaps been in a position to exchange models.

Several text pages from the Hours of the Cross have the remarkable characteristic of margins decorated with one or two birds that stand out against the whiteness of the parchment.[73] Among these, only a rooster on fol. 73v could have a connection with the text. Several pages after the miniature of the Arrest of Christ, it surely alludes to Saint Peter's repudiation. It is moreover on one of the pages of the Office for Matins, with texts that allude to the beginning of the Passion.

One bird, on fol. 78r, is striking in his extremely characteristic silhouette. With his

Fig. 122: Nicolas Spierinc and the Master of Mary of Burgundy, *Calligraphy and marginal decoration with birds*. Hours of Engelbert of Nassau. Oxford, Bodleian Library, Ms. Douce 219–220, fol. 151v.

Fig. 123: Nicolas Spierinc and the Master of Mary of Burgundy, *Calligraphy and marginal decoration*. Hours of Engelbert of Nassau. Oxford, Bodleian Library, Ms. Douce 219–220, fol. 10r.

open wings and tail feathers turning upward, we find him on fol. 126r of the Hours of Nassau (Fig. 120), painted after the same model although partially cropped by the binding. He also appears, in slightly different poses, on fols. 10r and 151v. The little pecking rooster on fol. 88v is the same as the one we find on fols. 175r and 175v of the Hours of Nassau (Fig. 121).[74]

A last bird, several of whose family members we recognized in the Hours of Nassau, decorates the page of the prayer book where the text ends, fol. 125r. Raising his eyes toward the end of the text above him, he was evidently placed there to conclude the book

prettily. His placement in the lower margin suggests that perhaps he was painted there before the six lines of the end of the text were written at the top of the page. If the illuminator had executed them after the text was written, he would have balanced the page better, and doubtless would have placed the bird higher when he saw that half of the space intended for writing remained blank. The bird would then have better fulfilled the tailpiece function for which the illuminator had intended it. His placement in the bas-de-page probably confirms that, for this type of luxury manuscript, the execution of the script did not always precede that of the illumination.

The few birds enlivening the margins of the Hours of the Cross are a sort of prelude to those that decorate the pages of the Hours of Nassau, where we find their fellows, captured with the same vivacity and apparently by the same hand (Figs. 122–123).[75] In the margins of the Hours of Nassau, however, this hand has grown bolder. He freely multiplies these demonstrations of the remarkable observations and studies of birds that he has accumulated, and arranges these motifs more felicitously in the margins. Whether or not they belong to the fine series of courtly and hunting scenes or to those of burlesque tournament that we admire in the Oxford manuscript, these birds have long been attributed to the Master of Mary of Burgundy. It therefore seems clear that the latter belonged to the circle of Spierinc, who could have taken the initiative in allowing him to participate in the Hours of the Cross. This unexpected and rather discreet appearance of a few charming birds can only be understood as a kind of graceful fantasy, bestowed by the artist on the occasion of a more substantial intervention. The miniature of the Deposition, at least, which Thomas Kren has already attributed to the Master of Mary of Burgundy,[76] seems to constitute such an intervention. Could it be that during that period the latter also created the other Passion miniatures with tinted borders? An affirmative response to this question would undoubtedly also oblige us to attribute to him the four borders, the spirit and sensitivity of which accord so well with the scenes that they surround. Their less polished technique, however, makes it difficult to suppose that these borders could have been painted

by the same hand as the one that created the hunting scenes and the burlesque tournament that take place in the margins of the Hours of Nassau, or such miniatures as the 'Virgin in the church with the woman at the window,' the Christ nailed to the Cross, or the Crucifixion from the Vienna Hours of Mary of Burgundy (fols. 14v, 43v and 99v). The part played by the Master of Mary of Burgundy in the illumination of the Hours of the Cross seems to have remained very limited,[77] and the greater part of the illumination of these four remarkable folios undoubtedly belongs to the Hague Master.

The normal production process for such devotional books as the duke's prayer book implies that the artisans engaged must have exchanged quires or folios, and we can undoubtedly assume that they were often at work under the same roof.[78] In this case, the Hours of the Cross could well have been entirely completed by Spierinc in his great house on the *Gelukstraat* in Ghent,[79] which Nicolas unquestionably occupied at the time the duke asked him to take back the prayer book and gave him responsibility for completing the Hours of the Cross.

Spierinc was probably the primary master artist of at least four exceptional devotional books in which the Master of Mary of Burgundy assisted. Apart from the Hours of the Cross added to the Prayer Book of Charles the Bold, these are: the Vienna Hours of Mary of Burgundy, the Hours of Nassau, and the 'Voustre demeure' Hours (Madrid, Biblioteca Nacional, Ms. Vit. 25-5 and Berlin, Kupferstichkabinett, Ms. 78 B 13, a collection comprised of historiated folios that come from Vit. 25-5). We do not know for

whom this book of hours was intended, but the quality and luxury of its illumination suggests that it must have been an important figure.

A particular bond seems to have formed between Spierinc and the Master of Mary of Burgundy. We may wonder whether there was not some kind of agreement between these two artists, and if it was not the fact that they were perceived and appreciated as leaders of an outstanding artistic team that attracted the princely commissions on which they prided themselves. For the production of the Vienna Hours of Mary of Burgundy, divided perhaps between Antwerp and Ghent, van Lathem must have joined this team. Later, his nomination as painter and *valet de chambre* to Maximilian could have diverted him from manuscript painting, and led him to concentrate on other occupations.

Endnotes

1 Vaughan 1973; Vander Linden 1936.

2 As Durrieu had already indicated in 1910, pp. 67–69.

3 K.G. Boon, 'Een Hollands altar van omstreeks 1470', *Oud Hoolland* 65 (1950), p. 210; Châtelet 1980, p. 86.

4 Boon 1961, p. 52–53. The same author also pointed out (p. 52, note 5) the yellow accents appearing in the foreground of the *Way to Calvary* in New York already discussed above.

5 Color reproduction: Châtelet 1980, p. 79.

6 Among other places, in certain miniatures from Volume III of Louis de Gruuthuse's Froissart : Paris, BnF, Ms. fr. 2645. See, for example, fols. 82v and 321v (Bruges 1981, pls 22–23). On the attribution of the miniatures in this manuscript: idem, p. 249–252, n° 109; Brinkmann 1997, p. 77–78. M. Pastoureau, *Bibliothèque Nationale, Paris* (Paris 1992), p. 37 ('Musées et Monuments de France', under the direction of P. Lemoine) likewise picks up these new combinations of colors (Fol. 321v of the Ms., reproduced on the cover). Another example of yellow highlighting on green, and of similar yellow/green and green/orange contrasts, from the Master of the Dresden Hours : Kren 1983, Pl. VII.

7 Thomas 1976, pp. 88–89.

8 This manuscript remained completely unknown until the BnF displayed it at the *Le Livre* exhibition in 1972 (p. 208, cat. n° 648) and acquired it in 1973. On this subject, see: Thomas 1976; Paris 1993, p. 88, n° 39.

9 Where we can also find, although inversed, the arrangement of the interior court onto which the bays open, and some of the architectural structures that line it.

10 Several illuminators created pastiches of this type of composition (Bruges 1981, pp. 245–246), in which van Lathem demonstrated his mastery in the area of perspective and his talent at creating the illusion of a vast space.

11 Durrieu 1916, p. 130.

12 Timmers 1947, p. 259, n° 529.

13 Thomas 1976, pp. 92–93.

14 Friedländer 1967–76, vol. 1, pp. 70–71, who cites three derivative works. Martin Schongauer's *Great Carrying of the Cross* also derives from the Eyckian prototype. Colmar 1991, p. 366–369, n° G 83. The group of riders and the two thieves preceding Christ bearing his cross in Memling's *Panorama with Scenes from the Passion* in Turin likewise goes back to the same prototype. Christ's posture, taking support from his hand while falling, and the brutish soldier with a lash, do not however appear here. Despite the quite different interpretations that Memling and Schongauer offer of these two figures, one can believe that these two works are not independent of one another. The Turin painting is reproduced in D. De Vos, *Hans Memling. Het volledig oeuvre* (Antwerp, 1994), pp. 106–108; C. Aru and E. de Geradon, *La Galerie Sabauda de Turin* (Antwerp, 1952) (Corpus de la Peinture des anciens Pays-Bas méridionaux au quinzième siècle, 2), Pl. XXXI and XXXI bis.

15 Boon 1961, p. 52, note 5. Boon pointed out that it is the work of a Dutch and not a Flemish artist, as had been thought by H.B. Wehle and M. Salinger, *A Catalogue of Early Flemish, Dutch and German Paintings*. The Metropolitan Museum of Art, New York 1947, pp. 23–25.

16 J. Paul Getty Museum, Ms. Ludwig IX 18, fol. 8v. Kren 1983, p. 63, Fig. 8c, underlines the quality of this creation which transposes the Carrying of the Cross from Schongauer's Passion series (Fig. 100).

17 In the Turin-Milan Hours miniature, attributed to Hand K, the composition is already also inversed. The head of the procession is more detailed there. The two thieves walking to Calvary and the horsemen who precede them climb the slope by a steep shortcut. Comte Durrieu, *Heures de Turin*, Paris, 1902, pl. XVIII; A.H. van Buren, J.H. Marrow, S. Pettenati, *Heures de Turin-Milan... : Commentary* (Lucerne 1996), pp. 357 and 666. Schongauer himself had been

careful not to inverse the composition he used as a model. Colmar 1991, pp. 366–369. Others who later took inspiration from the engraving would not have the same concern. The direction of the procession's course is thus inversed in a painting made after the engraving. There, the torturer who whips Christ therefore does so with his left hand. See S. Renouard de Bussière, *Martin Schongauer. Maître de la gravure rhénane. Vers 1450–1491*, exh. cat. (Paris 1991), pp. 120–125, Fig. 58–59.

18 The painting of the prefiguration, slightly damaged, has some flaking of color, especially in the blues.

19 Munich, BSB, Xyl. 37, p. 44 (reproduced in R.G. Calkins 1978, p. 148, Fig. 19); Brussels, KBR, Inc. B 1596, p. 44. These prototypographic examples of the *Speculum* date between 1467 and 1471: Brussels 1973, p. 67.

20 Durrieu 1902, Pl. XVII.

21 London, British Library, Add. 11576, *Spieghel der Menscheliker Behoudenesse*, fol. 46r, a manuscript written c. 1410, probably in West Flanders. This illustration, like that mentioned in the following note, was pointed out to me by Bert Cardon, for which he is warmly thanked.

22 Kopenhagen, Det Kongelige Bibliothek, Ms. GkS 79/f°, *Spegel der Minschliken Zalicheid*, fol. 6v. Capricorn was represented most often as a hybrid being whose lower body was that of a sea creature. Here it was easier to take up the model of the billy goat from the Drunkenness of Noah.

23 See section 8.1.

24 Plummer 1966, N° 33. Calkins 1978, p. 148 and Pächt/Jenni 1975, p. 31, pl. III, Figs. 27 and 31.

25 When the Drunkenness of Noah served to prefigure the Mocking of Christ or the Flagellation, as could be the case, this motif of the man binding sticks could very logically accompany the prefiguration of the Drunkenness of Noah. Therefore, here the illuminator may very well have taken the two together, which he found combined in a model, or which he had represented in the same border in other manuscripts where they accompanied the Mocking or the Flagellation.

26 D. G. Carter, 'The Winnipeg Flagellation and the Master of the View of St. Gudule', *Bulletin. Institut royal du Patrimoine artistique*, 15 (Brussels 1975), pp. 52–56, Figs. 1 and 4. An analogous figure can also be seen in the foreground of the flagellation in the Spinola Hours : Los Angeles, J. Paul Getty Museum, Ms. IX 18, fol. 131r. Euw/Plotzek 1979–1985, Fig. 428.

27 Van Mander 1604/1994, fol. 204v, 25–27.

28 The Master of Evert van Soudenbalch was probably inspired by the same Eyckian model for the Calvary miniature on fol. 55v of the Hours of Jan van Amerongen. If it is indeed the case, however, that interpretation is freer and painted with greater sensitivity than the small miniature studied here. The view of Jerusalem in the background here is copied with greater fidelity (see L.M.J. Delaissé, 'Le livre d'heures de Mary van Vronensteyn, chef-d'œuvre inconnu d'un atelier d'Utrecht, achevé en 1460', *Scriptorium* 3, 1949, pl. 23a).

29 Reproduced in Winkler 1925, Pl. 84, where it is still attributed to Simon Bening. Currently it is attributed to the Master of James IV of Scotland.

30 We find a horseman, whose coat is likewise repeated almost identically from one of van Eyck's, to the right of the Crucifixion on fol. 84r of the Prayer Book of Philip the Good, painted by van Lathem or by one of his assistants (Fig. 68).

31 Boon 1961, p. 52; Carter 1962, pp. 6–13; Châtelet 1980, p. 242.

32 On this painting, see Boon 1961, pp. 51–60, Fig. 1 and 5; Carter 1962; Châtelet 1980, p. 243, Fig. 250.

33 Fol. 49v, 55v, 59v, 67v. Delaissé 1949, plate 22c reproduced fol. 49v and not 40v as the caption mistakenly indicates, Pl. 23 a, b, and c; Boon 1961, p. 55, Fig. 2; Châtelet 1980, p. 242, Fig. 246; Utrecht 1989, Fig. 109.

34 The group of the Virgin and the woman who bends toward her, arms extended, in the Ghent triptych, seems closer to the corresponding group in the miniature from the Amerongen Hours than to that in the book's miniature.

35 These prefigurations are found, often treated in a quite similar arrangement, in the works of the school known as 'Ghent-Bruges'. In the Vienna Hours (Vienna, ÖNB, cod. 1857, fol. 43v), they are found as sculpted groups on either side of the window embrasure in the foreground of the Christ nailed to the Cross by the Master of Mary of Burgundy (fol. 43v). They appear again down to the Grimani Breviary (Venice, Biblioteca Marciana, ms. Lat. I,99 (2138)); the Spinola Hours (Los Angeles, J. Paul Getty Museum, ms. Ludwig IX 18, fol. 56v–57r); and the Prayer Book of Cardinal Albert of Brandenburg (Los Angeles, J. Paul Getty Museum, ms. Ludwig IX 19, fols. 179r, 191r and 243r). Pächt/Thoss 1990, pl. X; Winkler, 1925, pl. 87; Euw/Plotzek, vol. 2, 1979–85, p. 257, Figs. 405–406 and p. 288, Figs. 525–528, 533–534.

36 Brussels, KBR, Inc. B 1596, p. 56.

37 In the other version, Bouts by contrast had let his profile stand out against the background.

38 Color reproduction in: Utrecht 1989, p. 95, pl. 36a.

39 The Crown of Thorns would reach Byzantium and was bought by Saint Louis, King Louis IX, from his cousin Baldwin II of Courtenay, the Emperor of Constantinople in 1239. The acquisition of the Passion relics would give rise to the erection of Sainte–Chapelle in Paris. L. Grodecki, *Sainte-Chapelle*, Paris, s.d.

40 It is an error that Winkler designates this figure as Joseph of Arimathea (F. Winkler, *Das Werk des Hugo*

van der Goes, Berlin 1964, pp. 41–42). Like Panofsky 1953, p. 339, one must see him as Nicodemus, often represented beardless, while Joseph of Arimathea is usually represented as old and bearded, as van der Goes has painted him here, behind Christ. However, in the miniature, as in that of the Egmont Breviary, Nicodemus is also represented with a beard.

41 E. Dhanens 1998, pp. 228–229.

42 The cypresses or other trees rising vertically (here on the left, between the cross and the rock, and in the upper right hand corner) are scarcely ever encountered with van Lathem. One finds them with van Eyck and, more often, with Simon Marmion. See, for example, the illustrations in Paris 1993, pp. 70 and 85. Landscape and figures of the Entombment in the Prayer Book of Philip the Good are painted by the same hand as that which painted the Ascension miniature there, on fol. 89r (Fig. 69).

43 Of which the principal stages were recalled by J. Richard Judson, 'Martin de Vos' Representations of « Jonah Cast Over the Side »' *Miscellanea I.Q. van Regteren Altena*, Amsterdam 1969, pp. 82–83. Note the original manner in which the Master of Evert van Soudenbalch integrated Jonah and the whale into an outstanding marginal decoration. The off–hand manner in which Jonas plunges toward the whale's open mouth and appears to abandon himself to his fate adds a note of humor to the design (Fig. 112). The Master of the Feathery Clouds reworks the scene from the *Biblia pauperum* in an historiated initial on fol. 135r of the Hours of Jan van Amerongen (Los Angeles, J. Paul Getty Museum, ms. Ludwig IX 7; M. Smeyers, 'De Invloed der Blokboekeditie van de Biblia Pauperum op het Getijdenboek van Maria van Vronensteyn', *De Gulden Passer*, Nieuwkoop 1974, p. 321. In this manuscript, the subject also prefigures the Entombment, fol. 67v.

44 Colmar 1991, pp. 370–371; Paris 1991, pp. 162–163, pl. 30.

45 Châtelet 1994, p. 10. Wolfson has called into question this journey to Flanders, an opinion that remains controversial, correctly to my thinking. Wolfson 1994, pp. 127–131; Paris 1991, pp. 69–70, with references to older studies.

46 There is another case where Schongauer seems to have wished to avoid creating the inversed image of his model, as in his *Great Carrying of the Cross* (Fig. 100), inspired by the Eyckian painting in Budapest, which was considered above under section 9.1.2.

47 For example: Vienna, ÖNB, Cod. 1988, fol. 13r (Pächt/Thoss 1990, pl. XI b); Hours of Mary of Burgundy, Berlin, SBPK, Ms. 78 B 12, fol. 90v (Lieftinck 1969, Fig. 215); Hours of Queen Isabella of Castile, Cleveland Museum of Art, fol. 57r. (De Winter 1981, pp. 362–363, Fig. 42 and 43); the book of hours of Sir William Hastings, Madrid, Fundacion Lazaro-Gal-

diano, Inv. nr. 15503, fol. 234v. (Lieftinck 1969, ill. 189; Kupfer-Tarasulo 1979, p. 290, ill. 14). The first example of this composition very much seems to go back to an older work than the Berlin Hours of Mary of Burgundy, contrary to what Biermann thought (A.W. Biermann 1975, p. 77).

48 Lieftinck 1969, ill. 189, 215. The motif is also found in the Grimani Breviary (Venice, Biblioteca Nazionale Marciana, Ms. Lat. I, 99); in the Prayer Book of Cardinal Albert of Brandenburg (Los Angeles, J. Paul Getty Museum, Ms. Ludwig IX 19), fol. 98v; and in a manuscript in Munich (Munich, BSB, Cod. 23637); Biermann 1975, pp. 75–77, Figs. 76–79; Euw/ Plotzek, 1979–1985, Fig. 499.

49 Simon Bening, for example, in the prayer book of Cardinal Albert of Brandenburg, cited in the previous note, and the 26 scenes of the Stein Quadriptych (Baltimore, Walters Art Gallery). Kupfer-Tarasulo 1979, p. 277.

50 Cardon and Smeyers, in examining the connections between certain miniatures and engravings, including those of Master E.S.'s Passion cycle, show examples of the same iconography, which is found in several Dutch manuscripts: Smeyers/Cardon, 'L'emploi de gravures par les miniaturistes, un moyen de datation et de localisation des manuscrits enluminés. Le cas du Maître des Federwolken', *Le Dessin sous-jacent dans la peinture. Colloque VII (17–19 septembre 1987)*, Louvain 1989, p. 82, Pl. 52–53.

51 Plummer 1966, N° 17.

52 Meiss, 1967, Fig. 3.

53 On the subject of the antecedents of this iconographic tradition from the beginning of the century, see Marrow 1987, pp. 300–306.

54 Los Angeles, J. Paul Getty Museum, Ms. IX 3, fol. 15r. Euw/Plotzek 1979–85, 2, p.77.

55 The lantern appears in the Arrest of Christ in the Hours of Jeanne de Navarre, in the Parement de Narbonne, in the Très Belles Heures and the Petites Heures du duc de Berry, in the Très Belles Heures in Brussels, and in the Heures from the Seilern collection. See : F. Avril, *L'enluminure à la Cour de France au XIVe siècle* (Paris, New York, 1978) Pl. 3, 17, 39; Meiss 1967, Fig. 2, 22, 106, 129, 191; Meiss 1974, Fig. 628.

56 Plummer 1966, N° 17.

57 Brussels, KBR, Ms. II 7619, fol. 17v. (Also called the Hours of Marie van Vronenstein, who inherited it in 1520). Color reproduction: Utrecht 1989, Pl. VIII-62.

58 Some remarkable examples of the Arrest of Christ are illustrated in: Utrecht 1989, Pl. I-1b, I-8, I-11, II-20 and Fig. 94, all without the lantern. In the eponymous manuscript of the Master of the Morgan Infancy Cycle (New York, PML, Ms. M.866), the lantern appears. Idem, Pl. II-12b. But this illuminator would not exactly have had contact with the tradition illustrated by Pucelle, since it has been remarked that, in another

of this master's manuscripts (Liège, Bibliothèque de l'Université, Ms. Wittert 35), the Slaughter of the Innocents includes a motif that already appeared in the Hours of Jeanne d'Evreux. Idem, p. 62. In the miniature of the Arrest in the Liège manuscript, a lantern is likewise held over Christ's head: Marrow 1987, Fig. 5. In the Arrest in the Turin-Milan Hours or in other versions of the subject related to the latter (for example, a miniature of the Masters of Zweder van Culemborg: Utrecht 1989, p. 105, Fig. 46), torches, very close to Christ's head, replace the lantern.

59 The lantern does not appear in the Arrest from the Hours of Katharina von Lokhorst (Münster, Westfälisches Landesmuseum, Ms. 530, fol. 91v (Fig. 116); Pieper 1966, p. 109, fig. 7 and Utrecht 1989, p. 125). The moon, painted in the sky above Christ's head, here indicates that the scene takes place at night. In what is, moreover, a starry sky, this star can only be the moon, despite its radiant brightness and the representation of the episode in a lighting in which nothing evokes the night.

60 According to the *Golden Legend* (Voragine 1967, 1, p. 333), it was necessary to avoid confusing Jesus and Saint James the Greater, who resembled one another like brothers. See also section 6.9, notes 48 and 49.

61 The scroll held by the soldier in the corner of fol. 70v is yellow with some letters painted in blue. One can decipher there the letters PHMY. If one must search for their significance, it still escapes us, but perhaps one must only see a few marks drawn by chance and with a decorative intent.

62 Some examples : J.M. Plotzek, *Andachtsbücher des Mittelalters aus Privatbesitz* (Cologne 1987, Schnütgen-Museum, exh. cat.), pp. 205–206, n°. 66; *Stephan Lochner Meister zu Köln. Herkunft, Werke, Wirkung* (Cologne 1993, Wallraf-Richartz-Museum, exh. cat.) ed. F.G. Zehnder, pp. 399, 411, 413.

63 It has a few marks, probably without meaning. If these are letters, they are indecipherable, except perhaps the highest, which resembles a P (?).

64 Pilate appears in quite a similar way, but without an assessor, in the background of the Flagellation in the Hours of Catherine of Cleves. Plummer 1966, n° 22.

65 Parallels already found by Thomas 1976, pp. 89–90.

66 For example, in Mary of Burgundy's small book of hours (Berlin, SBPK, Ms. 78 B 12, fol. 194): Lieftinck, 1969, Fig. 251. Later, in the Prayer Book of Cardinal Albert of Brandenburg, in the border of fol. 154, face to face with the miniature of the Flagellation (Euw/ Plotzek, 2, 1979–1985, Fig. 518). In the latter case, the illuminator emphasized the correlation between Job's torment and the Flagellation : he depicts Job beaten

by two demons, whose postures and movements reproduce literally those of the torturers of Christ in the miniature on the adjacent folio.

67 Van Mander said he was not sure if the window was made according to a project of Hugo van der Goes or of Jan van Eyck. Van Mander 1604/1994, fols. 203v, 26–28.

68 E. Dhanens 1998, pp. 100 and 317–318.

69 In accordance with the *Biblia pauperum*: Timmers 1947, p. 298, n° 621.

70 This is the traditional manner of representing Cain. For example, we find him represented this way three times in the *Bible moralisée* illustrated by Pol and Jean de Limbourg: Paris, BnF, Ms. fr. 166, fols. 3v–4r. Meiss, 1974, Figs. 285–286.

71 On fol. 5v, in the upper left hand corner, then further down, halfway up the border, and finally in the lower left hand corner of the miniature. We also find this flower beneath the knees of the kneeling Saint George, in the border of fol. 67v, as well as higher up above him.

72 See Chapter 3, note 28.

73 On fols. 73v, 75r, 78r, 80r, 81r, 81v, 88v, 102v and 125r.

74 It could be repeated from the partial border of fols. 3r and 3v, which could have been executed by the Hague Master. The strict conformity of detail among the occurrences indicated here leads us to presume that it appeared in a model book. Moreover, we also find it on fol. 99v of a Book of Hours in Vienna, Cod. 1988, and on fol. 50r of the 'Voustre demeure' Hours in Madrid. Lieftinck 1969, ill. 38 and 135; Pächt/Thoss 1990, fig. 152. Since Antiquity, the pecking rooster has been a motif that artists have been fond of depicting.

75 Alexander 1970, passim, reproduces several of these folios with birds. Quite similar birds also decorate the margins of a book of hours of which only two folios have been preserved. Their borders take up van Lathem's motifs. (Berlin, Kupferstichkabinett, n° 1754 and 1755). Winkler 1925, Pl. 60.

76 *Masterpieces of the J. Paul Getty Museum: Illuminated Manuscripts*, exh. cat. (Los Angeles, 1997), p. 91.

77 As was the case, for example, with that of Marmion in the prayer book of Philip the Good in Paris. Paris 1993, p. 88.

78 As van Lathem and Spierinc probably did in Antwerp with the prayer book, before its completion at The Hague.

79 We find him explicitly mentioned there in March of 1476 (see Chapter 4), but by then he could already have lived at the house for quite a long time.

SPIERINC AND VAN LATHEM'S PRODUCTION PROCESS
FOR THE DOCUMENTED CORE

It was undoubtedly at the time of the festivities that took place in Bruges on the occasion of his marriage to Margaret of York in July of 1468, or shortly thereafter, that the duke wanted to have a small and sumptuously illuminated prayer book made for himself. A cleric familiar with liturgical books would probably have been asked to establish the selection of texts that it would contain, after having helped to choose the particular devotions that would occupy the manuscript's places of honor.

10.1 AN ELABORATE MISE-EN-PAGE

When Nicolas Spierinc and Lieven van Lathem were assigned the project, they would have had to confer and agree upon a conception of the manuscript as a while. They would therefore have established the book's format and decided on its mise-en-page.

During the course of his work on the text's calligraphy, Nicolas must have known exactly where to leave the spaces intended for the initials, borders, and miniatures that were to enhance, decorate, or illustrate the text. He must therefore have agreed with van Lathem on the illumination program.

The ratio between the format of the pages and that of the chosen ruled frame limited the dimensions of the written space in such a way as to allow for spacious margins. On folios with miniatures, the borders thus have quite a generous available space. The miniatures' dimensions were determined by those of the ruled frame, except in the arch above, where they encroach upon the margin. The external borders of folios with miniatures are each of a width corresponding to about half of the miniatures' width. In the bas-de-pages, the borders are higher than the external borders are wide. This mise-en-page scheme avoids hampering the illuminator with too limited a space for the composition of his borders. It offered the possibility of a pleasing distribution of border motifs, and in a way granted more freedom of movement to the figures and animals intended to animate the decoration and more volume to the foliage with which they alternate. The choice of this mise-en-page is revealing of the two illuminators' aesthetic conception of the book. Great importance was accorded to the borders of folios with miniatures,[1] and to the cadels and 'cybauries' on the text pages.

As indicated in Appendix 2, the composition of the manuscript's quires can be established with precision through the help of quire signatures still visible on the rectos of a number of folios. As the text's calligraphy progressed, Spierinc would have pre-

pared the quires, or had them prepared for him, and provided them with signatures. The discreet manner in which he marked the folios of his quires illustrates his care to avoid the slightest element that could mar the page. In using Arabic numerals, he reduced each of his signatures to two signs, which roman numerals would not have allowed him to do.[2]

The first quire of the documented core is composed of only two bifolios, preceded by a blank and unruled singleton, fol. 9. The quire was probably thus deliberately reduced in order to allow the miniature of the Trinity and the beginning of its accompanying prayer to be at the beginning of the following quire, on fol. 14r. Book artisans often found it convenient to be able to begin a specific section of a manuscript's content at the beginning of a new quire.

The documented core ends with the conclusion of the text on fol. 66v, in the middle of the ninth quire at signature j. Fol. 67r, which faces it, is blank and unruled; it is as if Spierinc, as the end of the text approached, had wanted to do the ruling as soon as the ruled space was sufficient for the text to be completed.

10.2 THE RUBRICS AND LINE FILLERS

The rubrics are written in a beautiful blue color, the same one used to write and enhance the name of the duke in the prayer to Saint Christopher. They can be found either on the pages preceding the miniatures that illustrate the prayers they announce, or below the miniatures themselves. They do not appear to have been executed very systematically, for several prayers are not provided with rubrics.

The line fillers are often baguettes in two alternating colors. They are decorated according to an analogous principle to that of the initials, where the colors of the background and those of the initial itself also alternate. Several line fillers, slighter than the rectangular baguettes, are of another type. They are executed in the same blue as the rubrics. This blue sometimes alternates with a gold of quite beautiful brightness.

Some of his blue line fillers, for example on fols. 11r, 32v, 54r, and 59v, have the form of small bipedal dragons, whose silhouettes stand out against the white background of the parchment. Conceived with a view to its function as line filler, the little monster lent himself well to decorating the space before or after an inscription, without exceeding the height of the letters composing it. We find him in important manuscripts produced in Utrecht, notably in the Missal of Zweder van Culemborg (Bressanone, Biblioteca del Seminario Maggiore, Ms. C. 20),[3] from about 1425, and in the Hours of Catherine of Cleves, from about 1440. In the latter manuscript, this *Bandrollen-Drache*, as Gorissen calls him, appears more than ten times, most often in black.[4] The Master of Guillebert de Mets also used him.[5] Finally, a very similar motif to the one in the little prayer book can be found in several inscriptions surrounding or bordering the miniatures of the famous *Chroniques de Jérusalem abrégées* executed for Philip the Good.[6] Perhaps more unexpectedly, we find it in 1487 with Memling, who used it so that the inscriptions in the frames

of the Martin van Nieuwenhoven diptych would appear centered.[7]

On fols. 54r and 59v of the little prayer book, these small dragons hold a little grass snake in their mouths in the shape of the letter S. One hesitates to see in this merely a matter of chance. The case recalls the one I indicated in the Vienna Hours of Mary of Burgundy. At the top of fol. 159v in this manuscript, a heron holds in his beak a grass snake who draws the form of a large S, doubtless alluding by his initial to the name of Spierinc.[8] These could therefore also be disguised signatures; this need not imply that they were drawn by Spierinc's hand, but they could indicate, as in the Vienna manuscript, the major role that he played in the manuscript's execution.

10.3 THE PARTIAL BORDERS

The execution of the Ordinance manuscripts commissioned from Spierinc was concomitant with that of the prayer book. The Vienna *Ordonnance du premier écuyer d'écuyerie*, the only survivor of the series of Ordinance manuscripts and, consequently, constituting only one sixteenth of the entire commission, has preserved good examples for us of the usual type of borders in Spierinc's workshop.[9] The borders of the prayer book's text pages have a strong similarity with those in this book of Ordinances. Their motifs and the manner in which they are treated are very similar. Van Lathem had probably agreed with Spierinc that he would be responsible for their execution. Lieven in turn assisted Spierinc by taking it upon himself to provide the *histoires* that would

serve as frontispieces to the eight Ordinance manuscripts that he executed (doc. 4). Several drolleries appearing in the margins of the *Ordonnance du premuer écuyer* surely seem to be by the hand of van Lathem,[10] which confirms the harmony that reigned between the two artists, and perhaps also the mutual interest that they bore with regard to the work-in-progress for the duke. Such exchanges of good behavior among colleagues is nothing striking or abnormal, and was probably much more frequent than the absence of documents bearing witness to it might lead us to believe.

In the Vienna *Ordonnance du premier écuyer*, on fols. 1v, 2r, and 3v, several strawberry flowers in the borders are accompanied by a delicately painted shadow, which renders them in relief and makes them appear as if placed on the parchment. This modest trompe-l'œil also occurs in the partial borders of fols. 10v, 23r, 48v, 52v, 57r, 57v, 58r in the prayer book. There are no comparable examples in the full borders, which could indicate or confirm that the same hand did not paint both the partial and the full borders.

For the partial borders, the illuminator often used the process of transferring patterns through the page. The motifs on the recto and verso of the same folio therefore overlap, allowing the artist to avoid having the motifs decorating one side of the folio show through to the other side, on account of the thinness and translucence of the parchment, and disrupt the clarity of the design.[11] Often practiced by illuminators, this process was also used in the Vienna Ordinance manuscript.

The partial borders on several occasions must have taken account of preexisting cadels or penwork linked to the calligraphy.[12] It does not appear to have been a strict rule for the borders to have been executed after the script. The coincidences of the organization of labor and the progress of the work sometimes led to one page or another being provided with a partial border before the text. That is what we are led to believe from fol. 13v, which remains free of script but is decorated with a partial border all the same.[13] On fols. 31r, 41r, and 65r, we notice that the end of a text line covers the frame of the partial border. It therefore surely seems that on these rectos, and perhaps on some others, the partial borders were executed before the text was written. These cases lead us to presume a division of labor for the work among several artisans. Spierinc and van Lathem both probably had assistants to back them up. If it is correct, as we supposed above, that Spierinc would have taken responsibility for the partial borders upon himself, even so it is not therefore certain that he executed them with his own hand. He could have entrusted this task to an assistant, who took care of it while Nicolas was still continuing with the transcription of the text. It would therefore be a mistake to consider the writing of the text on one hand, and the illumination and illustration on the other, as two quite distinct and successive phases. The rest of this chapter, moreover, confirms that the prayer book's illumination was carried out before the text's calligraphy had been completed.[14]

10.4 Drolleries planned according to the text

The composition of the fifth quire, fols. 30–39, is a remarkable illustration of the meticulousness and the attention with which the realization of this precious manuscript and its illumination was carefully designed. This folio is composed of four bifolios and two singletons, fols. 30 and 32 (see the quire structure diagram in Appendix 2). On both sides of these singletons, that is on fols. 30r, 30v, 32r and 32v, the usual partial border for text pages is missing, and has been replaced by a design of drolleries.

Nothing suggests that the irregularities in the quire's material composition could come from a later modification. The six folios that precede the middle of the quire still have their original signatures. The text follows regularly and correctly from page to page. What is more, the quire is part of the manuscript's core, the miniatures, borders, and initials of which were numbered with precision in the statement of payment to van Lathem.

The singletons were introduced in precisely these two places in the quire because it had been decided, with what was certainly a specific intention, to decorate these folios with particular motifs. The partial border of fol. 31r is likewise atypical. It is inhabited by a menacing dragon and a bird of prey with wings extended, and is the only partial border in the prayer book to be decorated with these kinds of drolleries. This partial border draws inspiration from the same conception that the illuminators had

in mind while planning the decoration of drolleries on both sides of the preceding and succeeding folios. If one considers the text that this decoration accompanies, it is easier to understand this choice. These borders effectively attempt to evoke the dangers and pitfalls from which the prayers to Saint Sebastian, fols. 29r–31r, and Saint Lawrence, fols. 31v–32v, appeal for protection. The text alludes to arrows and to the torments of the plague. It asks for the grace not to fall into the devil's traps, to overcome the dangers of all sorts of temptations, and to resist the flames of guilty passions, in the image of Saint Lawrence whom the torture of fire could not weaken.[15] This attention to the text by our two illuminators deserves to be emphasized.

The decoration of these folios obviously attempts to echo what the accompanying text evokes. It is composed of bizarre or dangerous beings, with significance as negative symbols. The dragons are symbols of evil beings. The centaur with a bow and arrow had long been a symbol of the devil.[16] The monkeys and the two small naked figures are certainly symbols of shamelessness and lust. One of the two figures, a dubious musician who plays two instruments at once, has hindquarters in the form of a chubby mask, and rather lewd genitalia. The whoope (*upupa, epops*) just above him confirms this interpretation of these atypical borders. Medieval texts identified this bird as impure on account of the repulsive habits that they attributed to him. On contact with his blood, according to the *Dialogue des créatures*, one runs the risk of being tormented by diabolical nightmares.[17]

The evil cohort alluded to in these pages' marginal decoration of drolleries also extends to the border decoration surrounding the miniatures of Saint Sebastian, Saint Lawrence, and Saint Anthony.[18] The monsters and other drolleries with which they are populated evoke this same perilous, dubious, and pernicious world. There we also see figures trying desperately to battle some of the menacing dragons that surround them. Their combat undoubtedly symbolizes the one that Man must undertake against the ruses and attacks of Evil. In the miniature, the poor hermit fights the same battle against the baleful seductress with griffin's feet who tries to lead him astray. In the border, beneath the miniature of Saint Sebastian, the lion-fighting figure—who could be either Daniel or Samson—also evokes those whose struggles suppress the forces of evil.

The abnormal composition of this fifth quire was therefore premeditated and organized from before the transcription of the text of the prayer to Saint Sebastian that begins on fol. 29r, the last folio of the preceding quire. In inserting these single folios with marginal drolleries, Spierinc envisaged that he could immediately pass them on to whoever was responsible for decorating them with drolleries, while he perhaps still continued his part of the work on other folios in the quire. According to the style of the drolleries, van Lathem or one of his assistants was responsible for executing them.

It may seem contradictory that the illuminators accorded particular symbolic value to the decorative motifs of this quire's

borders, when so many analogous motifs from other borders in this manuscript appear to have been introduced without having any connection to the text and without our being able to detect any specific intention. As indicated at the beginning of Chapter 6, numerous motifs were used only on account of their decorative qualities, as well as the taste for the strange and fantastic. The unexpected case presented here well demonstrates that the meaning they had once been given was still remembered, and could be invested in them once again.

The atypical composition of this quire was therefore shaped by the symbolic impact with which the work's creators wished to endow motifs in some of the margins. Spierinc and van Lathem perhaps also saw the occasion offered by the text to introduce into the decoration of a few text pages of prayers, and almost exactly in the middle of the original book, a diversion and an extra element of fantasy. They would also have taken care that these exceptional pages had an impeccable appearance and equilibrium. It could well be such a preoccupation that explains the presence of an invocation of peace for the souls of the dead on fol. 32v, after the prayer that evokes the virtues of Saint Lawrence. This invocation did not in fact belong there, but without it the page's equilibrium would have suffered. The text would have only filled half of the writing field, and the effect of drolleries bordering just a half-blank page would not have been appealing.

As indicated above, the partial border decorated with a dragon and a large bird on fol. 31r is one of those that seems to have been executed before the text that it borders had been written. Indeed, the script sometimes covers the border's frame at the end of a line. This partial border, however, is dependent on and integral with the full border surrounding the miniature of Saint Lawrence on the verso of the folio, the motifs that they have in common having been copied through the page. The full border on the verso and the partial border on the recto could therefore have both been sketched before the writing.[19] We must therefore conclude that, even if it was exceptional, the illumination could sometimes have preceded the script. This means that van Lathem was already at work while Spierinc still continued to transcribe the text.

All of the observations provided by an examination of the fifth folio indicate the role of the two masters in charge of the prayer book's execution, a great attention and constant concern to take care that the quality, originality, and completion of the work answer to the most stringent demands. They presuppose more than the application of a detailed program, collectively realized. They suggest that the manuscript, such as it appears, is the product of a collaboration and cooperation that was maintained throughout the development of the work. The first two stages of the manuscript's creation, described in Chapter 2—that is to say, the calligraphy, on one hand, and the illumination of the documented core, on the other—must indeed be in large part connected. Some of the choices and decisions discussed above were probably made only while the calligraphy was underway. At the time when Spierinc was paid for

the calligraphy in January of 1469, the execution of the illumination by van Lathem could already have been going on for quite some time. The preceding observations as a whole reinforce the hypothesis, presented in Chapter 4, that Spierinc could have stayed in Antwerp with van Lathem or in his immediate circle during the execution of the documented core and of at least part of the Ordinance manuscripts.

For manuscripts so luxurious, this kind of dialogue among the principal creators goes without saying.[20] All the same, studies concerning precious manuscripts sometimes tend to neglect to take into account the agreement and exchange that artists or artisans must have had during the development and realization of their works. If the texts scarcely allude to this, the works themselves testify to it many times.

10.5 THE BORDERS WITH COLORED BACKGROUNDS

If we take literally the terms of the accounting item registering the payment to van Lathem (doc. 6), it is certain that the authorship of the borders in the documented core is his. As precious as the evidence of the archival documents may be on which the attribution is founded, we must not however lose sight of the fact that the value of the information that these documents provide can perhaps be somewhat relative. There are cases in which they conceal part of the truth concerning the course of events they relate. This is notably the case when a master has one of his assistants, associates, or subcontractors intervene in the execu-

tion of a work that has been commissioned to him.

Two questions must therefore be posed. Must we, on one hand—reading the document literally—consider the miniatures, borders, and initials that van Lathem was paid for executing as completely conceived and executed by him? Must we, one the other hand, take literally the account article concerning Spierinc and conclude that his contribution to the prayer book's execution is limited to the calligraphy and the graphical fantasies that accompany it?

The close association between the two artists and their collaboration at the stage of the program's development, as well as indications that demonstrate this understanding and collaboration continued throughout its execution, persuade us to answer each of these questions only with caution. The line dividing one's part from the other's is probably not as neat as a literal interpretation of the accounts would lead us to believe. Moreover, it is not impossible, at least in the secondary decoration that the two artists could have allowed one or even more assistants to intervene. It seems quite clear, nevertheless, that taking into account the manuscript's recipient, van Lathem, like Spierinc, would only allow particularly gifted assistants to intervene if need be, as much in the documented core as, later, in the Hours of the Cross.

A question of attribution thus presents itself regarding the borders with colored backgrounds. Their exceptional qualities and their novelty, emphasized at the end of Chapter 8, may make us doubt that they are van Lathem's work, but it is not certain that

these doubts are well-founded. Arguments can be invoked in favor of each of two possibilities: the first, which recognizes Lieven as the creator of these extraordinary borders; and the second, which admits that van Lathem entrusted their execution or completion to a brilliant colleague.

This last hypothesis seems to be reinforced by the fact that the folios with miniatures painted by van Lathem in later manuscripts offer no trace of this refined manner of playing with mixed and delicate tones, and the strange iridescent effects that are so admirable and striking in the colored borders of the documented core. The few borders by van Lathem's hand in the Vienna Hours of Mary of Burgundy, for example, all have plain backgrounds, and their coloring has nothing in common with that of the colored borders in question here. If it was indeed Lieven who painted the colored borders in the prayer book, we would logically expect him to continue along the same path. After having created a work on this level and of such originality, an artist would, it seems, seek to take advantage of his inventions and produce multiple variations afterwards. This does not seem, however, to have been the case with van Lathem. Despite their apparent logic, these considerations however appear neither decisive nor sufficient to deny van Lathem these borders' authorship. The question therefore still remains uncertain.

The question of borders that imitate brocades, silk damask, or other precious textiles remains unanswered here. Van Lathem could have created them, having been inspired by similar designs in the *Chroniques de Jérusalem abrégées*, which he probably knew well (Figs. 16, 19, 45). Indeed, this manuscript is perhaps one of the first where he could have participated in the illumination. The other colored borders, on folios 14r, 17r, 22r, 29r, 33r, 36r, 39v, 43r and 49v, are the ones especially subject to debate. They contain the germ of a subsequent evolution of marginal decoration that would contain new and surprising combinations of colors, and in which the illusion of relief and of reality would become more pronounced, to the point of creating a marvelous *trompe-l'œil*.

Underneath the miniature of the Decollation of Saint John the Baptist, fol. 17r, the border is decorated with an impressive interpretation of the scene of Abel's murder. Struck down by his brother's savage aggression, Abel poignantly expresses his agony and distress. This scene is so powerful that it could instill doubt as to the authorship of these borders. One may ask whether van Lathem would have achieved such tension in treating this subject. The scenes of martyrdom that he painted in this prayer book lead us to believe that he was less compelled to express violence and emotion. On the whole, his figures are generally more static. Movement and violence rarely manifest themselves with any vigor, unlike many of the border figures often captured in full motion, or Lieven's scenes of battle and violence in the illustration of Louis de Gruuthuse's *Gillion de Trazegnies* or Antoine de Bourgogne's *Froissart*. Van Lathem nevertheless rarely rendered sentiments and emotions in as expressive a manner as in the scene of Abel's murder. The latter there-

fore would seem to reinforce doubt as to the colored borders' authorship. However, can we absolutely exclude the possibility that this remarkable scene is simply an exceptional and authentic example of van Lathem's virtuosity?

Endnotes

1 The comparison with the mise-en-page design of the Prayer Book of Philip the Good in Paris is quite striking in this regard. The borders there no longer have the same copiousness.

2 The signatures in roman numerals that have been added in a less discreet manner at the bottom of the folios were added later during one of the reconstructions of the binding.

3 In the inscription appearing on the banderole in the Calvary miniature illustrating the Canon. Byvanck 1937, Pl. XXXIV, Fig. 101.

4 Gorissen 1973, p. 795–796. See the inscribed banderolles in the All Saints miniature (Fig. 34) and in that of Saint Mary Magdalene. Plummer 1966, n° 61 and 144.

5 At the beginning of a phylactery bearing an inscription in an historiated initial from a book of hours. *Biblioteca Apostolica Vaticana. Liturgie und Andacht im Mittelalter*, exh. cat. (Erzbischöflichen Diözesanmuseum Köln, 1992), n° 56, p. 268, Ms. Ottob. Lat. 2919, fol. 14r.

6 Vienna, ÖNB, Cod. 2533, fols. 4v, 10r, 12r, 12v, 13v, 16v. Pächt/Jenni/Thoss 1983, fig. 105, 112, 114, 115, 116, 121, Pl. VII. These small dragons can also be found on the banners of certain miniatures from these *Chroniques*, or executed in gold or silver against a blue or pink ground on the decorative bands surrounding the miniature of the Resurrection of Lazarus and the facing folio in the Hours of Mary of Burgundy, Cod. 1857 in Vienna, fols. 146v–147r.

7 De Vos, 1994, pp. 375, 279–282, n° 78; D. De Vos, *Hans Memling*, exh. cat. (with contributions by D. Marechal and W. Le Loup), Bruges, 1994, pp. 130–133, n° 33.

8 De Schryver 1969/1, pp. 73–74; Van Buren 1975, p. 297.

9 De Schryver 1969/2, pp. 444–448.

10 The camel on fol. 3r, the small figure on fol. 8v. The camel appears in the margin of the Vienna Hours of Mary of Burgundy, fol. 149v. We can perhaps also attribute the centaur on fol. 2v to van Lathem. The manner in which the decoration of this page as a whole is conceived, with the centaur integrated into

it and linked graphically to the calligraphy would presuppose a very thorough collaboration between Spierinc and van Lathem. As in the calendar of the Vienna Hours of Mary of Burgundy, Spierinc probably added some of the fine lines that link this marginal figure to the calligraphy after the execution of the centaur in the margin. De Schryver, 1969/1, p. 81; Idem, 1969/2, p. 446.

11 Seeing to what extent the borders of folios with miniatures often show through to the other side of the folio on which they are painted is enough to convince us of this process's utility.

12 We can see this, for example, on fols. 29v, 33v, 35v, 36v, 37v, 42r, 42v, 52v, 58v, 64v et 65r.

13 At the bottom of fol. 13r, the invocation *et anime omnium fidelium defunctorum* stops abruptly at the end of the last line. The phrase does not continue on the folio's blank verso. Was the copyist distracted, or did he judge the rest of the phrase sufficiently well–known for the manuscript's user to complete it by heart ? The rest of the phrase appears in full during another occurrence of this invocation, on fol. 32v : *per piam misericordiam Dei sine fine requiescant in pace. Amen.*

14 Here it is necessary to emphasize the importance of the signatures for numbering and marking the folios or the bifolios of quires. Too often, their function is considered only in relation to their usefulness to the binder. We sometimes forget that they were also necessary and invaluable in the organization of the division of labor among various collaborators on the script and illumination.

15 *Ora pro nobis beate martir Sebastiane / Ut mereamur pestem epidemie illesi transire... (fol. 30r); Deus qui beatum Sebastianum martyrem tuum in tua fideque dilectione tam ardenter solidasti ut nullis carnalibus blandimentis tyrannorum, nullisque carnificum gladiis sive sagittis aut tormentis a tua potuit cultura revocari, da nobis... in tribulatione auxilium, in omni persecutione solacium, in omni tempore tribulationis et angustie contra pestem epidemie remedium quatinus contra omnes insidias diabolicas viriliter poscimus dimicare... (fols. 30v–31r) Da nobis quesumus domine deus vitiorum nostrorum flammas extinguere qui beato Laurentio martiri tuo tribuisti tormentorum suorum incendia superare... (fols. 32r–32v).*

16 Timmers 1947, p. 365, n°. 760; Idem 1978, p. 179, n°. 481.

17 *La huppe, comme dit Ysidoire en son XIIᵉ chappittre des Ethimologies, est ung oysel que les Grecz appellent ainsi pour ce qu'elle quiert et serche la fiente humaine et se repait de puante viande et est oysel de tres orde nature, estant crestee et heaulmee de creste sur sa teste, tousjours habitant et demourant es sepulcres ou en fiente humaine. Et se, par aventure, aucun estoit oinct du sang de cest oysel, il verroit en son dormant les*

dyables qui le vouldroient suffoquier. ... P. Ruelle, *Le "Dialogue des Créatures". Traduction par Colart Mansion (1482) du "Dialogus creaturarum" (XIVᵉ siècle).* (Brussels 1985) (Académie royale de Belgique. Collection des Anciens Auteurs Belges), pp. 175–76. The *Dialogue* refers to Isidore of Seville, from whom it translates almost literally the passage that ends with *Cuius sanguine quisquis se inunxerit, dormitum pergens daemones suffocantes se videbit. Etymologiae,* ed. W.M. Lindsay (Oxford 1911), Lib. XII, vii, 66. The passage cited from the *Dialogue* appears in the introduction to the fable *de la huppe et du papegay.* Reproduced, with the miniature that accompanies it, after the copy of the *Dialogue des Créatures* that belonged to Louis de Gruuthuse, in: E. König, *Leuchtendes Mittelalter III. Das Goldene Zeitalter der Burgundischen Buchmalerei 1430–1560.* (Rotthalmünster 1991) (Antiquariat Heribert Tenschert, Katalog XXVII) p. 241. See also: R. Marijnissen and P. Ruyffelaere, *Hiëronymus Bosch. Het volledig oeuvre.* (Antwerp 1987) p. 118. Analoglous accounts (in Middle Dutch or in German) are discussed by R. Marijnissen, 'Laatmiddeleeuwse symboliek en de beeldentaal van Hiëronymus Bosch', *Mededelingen van de Koninklijke Academie voor Wetenschappen, Letteren en Schone Kunsten van België. Klasse der Schone Kunsten,* 39 (1977, n° 1), pp. 14–16, 41–42, 51, 53. An analogous passage to that from the *Dialogue* cited above is repeated, after the Dutch version of the *Livre de la Propriété des Choses* of Barthélémy

l'Anglais, *Boeck van den Proprieteyten der Dingen,* printed in Haarlem in 1485. The whoope, like so many other symbols, could be endowed with contradictory significations. These are the qualities of filial love that the Renaissance highlighted, inspired by Antique sources including the *Physiologus*: G. de Tervarent, 'Les animaux symboliques dans les bordures des tapisseries bruxelloises au XVIᵉ siècle', *Académie royale de Belgique. Classe des Beaux–Arts. Mémoires in 8°,* 2ᵐᵉ série, t. 13, fasc. 5 (Brussels 1968) pp. 23–24, fig. 21.

18 The multiform appearance of the devil in the legend of Saint Anthony is a well–known fact, but a number of demons also intervene in the legends of Saint Sebastian and Saint Lawrence. Voragine, 1, pp. 130–131, 139 and 2, pp. 75–76.

19 It is no doubt for this reason that the calligrapher could only finish the text of the prayer that precedes the miniature by adding a fourteenth line of text to fol. 31r, therefore exceeding the thirteen lines per page that are the rule in this manuscript.

20 The Hours of Catherine of Cleves constitutes an excellent example of a luxury manuscript that could only have been realized through a very intense collaboration and cooperation among the artisans responsible for its execution, as Robert G. Calkins has demonstrated: 'Distribution of Labor: The Illuminators of the Hours of Catherine of Cleves and Their Workshop', *Transactions of the American Philosophical Society held at Philadelphia...,* 69, Part 5, 1979.

One of van Lathem's major contributions to book design lay in giving more vividness and charm to marginal decorations, giving them more magnitude, enriching and renewing their repertoire, and freeing them from certain routine formulas. Among the motifs that emerged from his imagination, or reflected his gifts for the observation of nature and daily life, he also adopted and adapted certain motifs from some Northern masters. Always on the lookout, his searches and encounters undoubtedly brought him good luck in discovering the originality and charm of the inventions of colleagues who had worked or were still working in Provence in the circle of René of Anjou. It is to them, it seems, he owes the most productive stimuli that led him to create a border style of his own, which owes its uniqueness and attraction as much to the harmony and rhythm of the arrangement of decorative elements as to the richness of its repertory and color.

It is not only with respect to his borders that van Lathem profited from his contacts with northern colleagues. His miniatures also reveal his attention to and interest in the painters whom his travels allowed him to discover. During a trip to Holland, he must have studied and admired van Ouwater's *Resurrection of Lazarus* in Haarlem, from which he cleverly drew inspiration for his miniature of Jesus Driving the

Moneylenders from the Temple in the prayer book of Philip the Good in Paris. In the architectural setting where the scene takes place, he also integrated elements borrowed from Rogier van der Weyden and his assistants' *Exhumation of Saint Hubert*, a panel that decorated the Saint Hubert Chapel in the Church of Sainte-Gudule in Brussels.[1] This example of the manner in which he profited from his study of particular works sufficiently illustrates the attention and intelligence with which he considered the painting of his contemporaries and predecessors. As the commentaries on some of his miniatures have indicated, Lieven demonstrates several affinities with the work of Dirk Bouts in his interpretations of the type of subjects that he had to treat in this devotional book. No doubt he could still better demonstrate his qualities as a brilliant illustrator in the series of narrative compositions that he devised for the great volumes of chronicles or romances executed for Philip the Good or for Louis de Gruuthuse and Anthony, Grand Bâtard de Bourgogne.

His landscape art certainly has its roots in that of the van Eycks, and more generally in the whole tradition emanating from Jan, as much in the Northern as in the Southern Netherlands. His interior views of architectural structures are also dependent on van Eyck's perspectives. We must

emphasize the sensitivity with which he renders the light and the dreamlike atmosphere that he paints, with its vast spaces that serve as a frame for the innumerable scenes that he has created, their vegetation, their stretches of water or their cityscapes. In Antwerp in particular, his marvelous landscapes presage, and seem to have opened the way to, those that would be painted by artists of the following generation, such as Quentin Metsys and Joachim Patinir.

Plenty of things evidently still escape us concerning van Lathem's activities and the course of his career. One of the intriguing points on which we have had to content ourselves with speculations is the role that could have be played by Jacob Meister, Lieven's father-in-law. We will remember that this *libraire*, a native of Amsterdam, had been established in Antwerp since the middle of the century. His commercial activity must imply that he maintained contacts with the illuminators of northern centers, and this could have led van Lathem to take an interest in them.

Just as painters often participated in the painting trade, Meister, who was a member of the Guild of Saint Luke, could have been a book merchant and artisan at the same time. Whether or not he was an illuminator, he must have been among those whose activities favored the artistic exchanges which, throughout the fifteenth century, were continuously in play from one region to another in the old Burgundian Netherlands.[2]

Van Lathem's establishment in Antwerp and the contacts that would have been fa-vored there by his marriage account for his openness to the possibilities of exchange that presented themselves. The activity of the Hague Master, who seems to have been established and integrated into Spierinc's circle, must have been propitious to such exchanges also developing in Ghent.[3] Certain features of the production of the Master of Mary of Burgundy, and of the circle for which Spierinc seems to have been the axis, probably have their source in the reciprocal gains resulting from these exchanges.

One would like to be able to define Nicolas Spierinc's role in manuscript production with greater precision and certainty. It is perfectly well established that he was an extraordinary calligrapher. Questions remain, however, regarding his activities as an illuminator. The reference to payment for the eight Ordinance manuscripts identifies Spierinc as *enlumineur d'istoires* (ap. 1, doc. 4). This qualification is unusual and ambiguous. The context of many documents that refer to *enlumineurs* prove that this word was generally used as a generic term. When van Lathem was paid for the miniatures and borders of the prayer book (ap. 1, doc. 6), we moreover find him designated solely as *enlumineur*. However, if we take *enluminer* in the strict sense of the word, *enlumineur d'histoires* could relate to the one responsible for providing the '*histoires*', or border miniatures.[4] For the eight Ordinance manuscripts for which the document registers payment, Spierinc had, indeed, had the *histoires* made for him in Antwerp. The unusual term of *enlumineur d'istoires* therefore here

corresponds exactly to the case to which the text relates, and it seems that this time it was intentionally chosen, taking *enlumineur* in its strictest sense. It remains, however, quite doubtful that this specific case authorizes us to conclude that we must apply it to Spierinc's activities as a whole, an interpretation that is also rather restrictive to his qualities as illuminator.[5]

In his capacity as calligrapher, Nicolas Spierinc is the creator of the script and cadels of some of the most brilliant manuscripts produced in Flanders during the seventies and eighties. If, as we can presume, he was surely additionally the master artist and coordinator of these manuscripts' production, it would be rather surprising if he did not also participate in the execution of the illumination for at least some of them. The anagram of his name in the border of the Way to Calvary on fol. 94v of the Vienna Hours of Mary of Burgundy[6] could be taken as confirmation that he participated in the execution of the manuscript's illumination, even, it seems to me, if one believes the anagram must be interpreted as a reference to the person who directed those who divided the work for this manuscript, rather than as the signature of the artist who painted the illumination where the anagram appears.[7]

Spierinc's educational and intellectual formation, his competence as a book artisan, and his rare talent, could contribute to giving him the necessary influence to secure the role of leader of a collective of illuminators, and could have encouraged patrons to ask him to assume it. That he exercised it effectively will not have prevented him from participating personally in the work's execution. As in the duke's prayer book, he will probably have participated in perfecting the program of illumination for other manuscripts also, before executing the calligraphy, and, in some cases, such as that of the Vienna Hours of Mary of Burgundy, he would have then been able to take responsibility for part of the work of illumination. In this case, one would someday like to be able to specify that part with certainty.

One of the remarkable and novel aspects of the Prayer Book of Charles the Bold is its group of borders with tinted backgrounds. While Lieven van Lathem executed them, perhaps with the assistance of a specialized collaborator, Simon Marmion, on his part, painted full pages without decorative borders for the illustration of the duke's breviary, in which the miniature is surrounded by scenes in the margin that complement its subject. Curiously, we therefore see two important masters simultaneously and independently of one another produce, in two books intended for the duke, borders that stand at the beginning of new types of marginal decoration, with multiple variations that were to mark three quarters of a century more of manuscript painting.

Whether they appear as luxurious designs of foliage, flowers, birds, and drolleries, already carrying in them the germs of the marvelous *trompe-lœil* that will blossom and proliferate some years later, or as narrative complements to the miniature's subject, these new borders thus appeared as of the end of the sixties, as much in

Antwerp and Valenciennes as in Ghent and Bruges, and in still other cities in the duke's provinces. They were designated as being particular to a school termed 'Ghent-Bruges', but today one hardly still need mention that these designs and mises-en-page, new to the old Low Countries, quickly became a very widespread phenomenon there, even if they developed in Ghent and Bruges with more splendor and vigor.

We may wonder about the appropriate way to interpret the journey that Nicolas Spierinc and Lieven van Lathem made to The Hague in the month of August 1469. The duke probably wanted the little book of prayers and the collection of Ordinances that he had commissioned from them to be available as soon as possible. He could have wished or commanded that they be handed over to him as soon as the work was completed. Van Lathem's presence was required for the completion of the manuscript's original program, since the prayers that had been envisaged to illustrate the devotional diptychs still had to be illuminated, each with a depiction of the duke in prayer.

The fact that Spierinc and van Lathem both made the trip to The Hague, in connection with the works that had been commissioned from them, seems to confirm the presumption that they were considered in effect as associates. Wanting them to come and hand over the completed work themselves could be a way of recognizing the excellence of their talent. The two artists were doubtless not insensitive to the mark of esteem that could be furnished by the occasion offered them to hand over the prayer book, the execution of which they had shared, as well as the Ordinance collection made by Spierinc, into the hands of the duke for whom they had been intended.

This interpretation, whether or not it corresponds to the way in which the events were experienced and felt by the interested parties, however does not exclude the possibility that the attendance of the two artists could also have been required for other reasons that escape us. As noted above (at the end of section 2.3), the duke could have wished to profit from their presence in speaking to them about some new work or project. Let us recall that, if they had to commit themselves without delay to a new undertaking, this could explain the hasty execution of the devotional diptychs, and the fact that they had to resort to the Hague Master in order to complete the borders.

The precious information that the documents provide regarding the relations of the two artists with their patron may lead us to imagine that similar encounters could have taken place at the time of the decision to add the Hours of the Cross to the little prayer book, or perhaps, with Margaret of York, during the possible adaptations of the Vienna Hours of Mary of Burgundy, in which two of the principal performers were the same as for the duke's prayer book.

Charles the Bold's conception of princely dignity and grandeur led to the requirement that books intended for his personal use be of an absolutely exceptional quality of execution. Three new luxury books intended for his devotions were made for

him during the years that immediately preceded and followed the time he succeeded his father: the breviary commissioned from Marmion, the black book of hours offered by the aldermen of the Franc de Bruges, and the little prayer book commissioned from Spierinc and van Lathem. Everything seems to indicate that it was as a prudent connoisseur that Charles made the choice each time of the illuminators who were given responsibility for their execution. For the black book of hours, offered when incomplete, it was the aldermen of the Franc de Bruges who had chosen de Mazerolles, but perhaps they did not do this without having inquired whether the artist would win the favor of the Count of Charolais. It is in any case quite remarkable that even before having finished the black book of hours, de Mazerolles saw himself promoted to *valet de chambre* and illuminator of the future duke.[8]

All the authors who, since 1841, have been interested in Simon Marmion, have claimed or believed that it was Philip the Good who had commissioned from him in April of 1467 the very luxurious breviary that he executed.[9] However, it was surely Charles, when still Count of Charolais, who commissioned this important breviary. The record of a payment to Marmion in April of 1467 can be found in the account of Barthélemy Trotin, *conseiller et receveur général de toutes les finances de monseigneur le conte (sic) de Charolais, seigneur de Chasteaubelin et de Béthune* for the year 1467.[10] After the death of Philip the Good, this account registers the receipts and expenses of the new duke. The

Receiver General for Philip the Good was Guilbert de Ruple, whose last account covers the period from October 1, 1466, until Philip's death, on June 15, 1467.[11] Charles did not then keep de Ruple in his post. From Philip the Good's death, on June 15, 1467, Trotin in effect took over Guilbert de Ruple's remit as Receiver General for the Duke.[12] Trotin's account for 1467 thus registers Charles's receipts and expenses, when he was still the Count of Charolais, but, after Philip the Good's death, the receipts and expenses of Charles as the new duke and his father's successor are the ones recorded there.[13] The record of the advance paid to Marmion in April of 1467 had been published once before, by Dehaisnes in 1881, under the title of the account reproduced above.[14] In publishing the document again in 1892,[15] he seems not to have remembered that this record appeared in the accounts of Charles of Charolais before the death of Philip the Good. It is thus that the error took hold, leading for a long time to the belief that it was Philip the Good who commissioned this breviary.

At the time that Simon Marmion had received an advance for the breviary's commission and had begun to execute it, Philippe de Mazerolles was at work completing the illumination of the black book of hours; the payment for this work was settled in April of 1468.[16] Several months later, Nicolas Spierinc and Lieven van Lathem were entrusted with creating the little prayer book.[17] Meanwhile, Marmion still carried on with the creation of the breviary. The final payment to Marmion for completing the considerable task that the

realization of the breviary represented was recorded in January of 1470.[18]

In three years' time, the duke was thus provided with three new devotional books of exceptional quality. Very dissimilar in content and function, they differed also in the style and technique of their illumination. Knowing that the books they created were intended for the duke's personal use, the artists who created them would not have failed to try to outdo themselves. Spierinc and van Lathem's idea, no doubt mutual, to create colored borders of a resolutely new conception for the prayer book's decoration could have come out of their care and ambition to make this book a work that, in addition to its rare qualities of execution, would also surprise by its element of the unusual.

The duke had plenty of other breviaries, books of hours, and prayer books at his disposal, beyond the three precious manuscripts just mentioned. In addition to those that he inherited from Philip the Good, we must count those that he had received or acquired before succeeding his father, such as the Psalter that he received in 1441, while still a child;[19] the *heures de Nostre Dame garnyes de plusieurs ystoires et oroisons* that his mother had bought for him in 1443;[20] or the breviary with a cover restored in February of 1467,[21] and which could well be the Parisian Dominican Breviary illuminated by the Master of Jean Rolin, now preserved in Vienna.[22] We are right to think that the Marmion Breviary, the Black Hours, and the prayer book furnished by Spierinc and van Lathem were among those that he most often liked to

keep for himself.[23] It is clear that he would use them for his devotions, but surely he will not have failed to page through them from time to time, solely for the visual pleasure.

There were, however, still more devotional books to which Charles could have been attached, and which, if they survive, have not now been located or identified. This is the case with the two devotional books to which he had had supplementary texts added, some time before his trip to Holland in the summer of 1469. This task was entrusted to a priest living or staying in Bruges, named Jehan Dinghelsche or d'Inghelsche, alias l'Englès.[24]

After having written and having illuminated three quires, which were to be added to the duke's *petites Heures* (ap.1, doc. 2),[25] he was busy writing *pluseurs oroisons et choses salutaires* to enhance the contents of *ung ancien livret* of the duke. D'Inghelsche had the texts added to this manuscript provided with six *ymages* and had *relyer ledit livret et dorer dessus* (ap. 1, doc. 7).[26] Before embarking for Veere on August 10, 1469, the duke already had his complete Little Hours at his disposal, but Jeannin de le Staghe, one of the treasurer's clerks, was entrusted with going to find the other devotional book with d'Inghelsche in Bruges, and bringing in to the duke at The Hague (ap. 1, doc. 3).[27] It is probably this *ancien livret* that Ernoul de Duvel provided with a gold clasp at the same time as the little prayer book created by Spierinc and van Lathem (ap. 1, doc. 8).

The commissions for the breviary from Marmion, for the completion of the black

book of hours from de Mazerolles, and for the prayer book from Spierinc and van Lathem, illustrate at the same time the duke's taste for luxury objects and the importance that he ascribed to his devotions. The religious sentiments that animated him also manifest themselves in the texts that he had added to certain devotional manuscripts in the summer of 1469, and, later, in the commission of the Hours of the Cross as a supplement to the little prayer book. Other echoes of his religious inclinations have moreover been mentioned above.[28] The devotional diptychs in themselves constitute clear testimony of this, like the many gifts of antependia, metalwork, and other ex-votos to sanctuaries at pilgrimage sites, which were recently the subject of a remarkable study.[29]

The importance that the duke attached to his devotions will hardly be surprising, if we take into account his close ties with his mother, Isabella of Portugal, and the religious instruction that she took care to give him from his childhood. In this sphere, Isabella had herself been profoundly influenced by her mother, Philippa of Lancaster.[30]

Endnotes

1 Prayer Book of Philip the Good (Paris, BnF, n. a. fr. 16428, fol. 61): De Schryver 2001, pp. 217–221.

2 These 'trans-cultural interchanges' were the subject of substantial papers by Marrow, Brinkmann, and Smeyers and Cardon, presented at the 'Congress on Manuscript Illumination in the Northern Netherlands' in Utrecht in 1989 and published in *Masters and Miniatures. Proceedings of the Congress on Medieval Manuscript Illumination in the Northern Netherlands (Utrecht, 10–13 December 1989)*, K. van der Horst and J.-C. Klamt eds., Doornspijk 1991.

3 He was not the first illuminator from the North to have been active in Ghent. See chapter 4, note 89.

4 It was Marcel Thomas who, in 1975, made this judicious remark to me during a conversation at the Bibliothèque nationale, for which he is cordially thanked.

5 The fact that he is designated as *escripvain* in January of 1469 (ap. 1, doc. 1) does not permit us to see him only as a calligrapher, as some seem to have been able to believe. Simon Marmion is also cited as an *escripvain*, and in a document that specifies that he is responsible for historiating and illuminating the breviary that he was to execute. See below. Other painters or miniaturists were sometimes designated as engaging in both practices : *Jan Wenckaert, Casyn sone* was admitted in 1466 to the Guild of Saint Luke in Antwerp as *boekschryver en schilder* (writer of books and painter); Rombouts/Van Lerius 1864, p. 17.

6 As I have suggested: De Schryver 1969/1, pp. 95–97.

7 Interpretation suggested by Anne van Buren, 1975, p. 297, who introduced the designation of this team as "the Ghent associates". Contrary to what I had thought in 1969, the execution of the Vienna Hours could be an operation conducted in several stages, including the adaptations or modifications of later work. Spierinc, whose presence was implied there from the beginning, seems to have remained for the rest.

8 A. de Schryver, 'Philippe de Mazerolles : le livre d'heures noir et les manuscrits d'Ordonnance militaires de Charles le Téméraire', *Revue de l'Art*, n° 126 (1999, 4), pp. 50–67, with reference to earlier publications.

9 Le Glay, *Mémoire sur quelques inscriptions historiques du département du Nord* (Lille, 1841), p. 27; Laborde 1–1849, p. 496; Pinchart 1863, pp. 201–206; C. Dehaisnes, *Recherches sur le retable de Saint-Bertin et sur Simon Marmion* (Lille, 1892) and M. Hénault, 'Les Marmion (Jehan, Simon, Mille et Colinet), peintres amiénois du 15ᵉ siècle', *Revue archéologique*, 4ᵉ série (1907), t. IX, pp. 119–140, 282–304, 410–424 and t. X, pp. 108–124. Until the recent studies referring to the breviary, the authoritative authors of these publications had been trusted on this point.

10 ADN, B. 2064, fol. 128v–129r.

11 ADN, B. 2061. P. Cockshaw, 'La comptabilité publique dans les états bourguignons: L'exemple des comptes généraux', *Mélanges offerts à C. Dickstein-Bernard*, P. Bonenfant and P. Cockshaw, eds., p. 67.

12 When the duke modified the accounting organisation by an ordinance of February 8, 1468, and separated the receipts, entrusted to the Receiver General, and the expenditures, entrusted to the Treasurer,

G. de Ruple was named Treasurer. K. Papin, 'Guilbert de Ruple, biografie van een topman uit de Bourgondische financiële administratie', *Handelingen der Maatschappij voor Geschiedenis en Oudheidkunde te Gent*, nieuwe reeks, deel LIII (1999), p. 108.

13 Receipts coming from the domain of the Count of Charolais are registered in the first months of the year. Other references recognisable as related to the Count of Charolais, or concerning payments to people who had long been in his service—such as Jean Hennequart, who is already mentioned as his painter and *valet de chambre* in 1457; Jean le Tourneur, his *sommelier de corps*; Fastre Hollet, who in 1457 was the count's *clerc des offices de l'hôtel*; or even Charles de Visen, the Count of Charolais's *valet de chambre* and *garde des joyaux*, who had married Jaqueline, Jean le Tourneur's daughter, in 1457.

14 *Inventaire sommaire des Archives départementales antérieures à 1790*, tome 4 (Lille, 1881), pp. 224–225.

15 C. Dehaisnes 1892, p. 138.

16 De Schryver 1999, p. 50.

17 The commission probably took place after the duke's marriage on July 3, 1468, and during the month of July at the earliest.

18 AGR, CDC, N° 1925, folz. 474–475. Published by Dehaisnes, Hénault, and others (see note 8). The document provides a very precise reckoning of Marmion's work. In addition to the illuminated folios of the calendar, the breviary comprised 78 quires of eight folios, provided with borders. Ninety-four of these folios were illustrated with miniatures. The total number of initials of different heights goes up to 8564. The research undertaken to find this manuscript again has remained in vain, and leads us to believe that it is lost. Happily, in studying two isolated folios from the Lehman Collection at the Metropolitan Museum of Art, Sandra Hindman surmised, and then demonstrated, that these two folios most likely come from the breviary that Charles commissioned from Marmion: Hindman 1992.

19 ADN, B.1972, fol. 209v; Laborde 1849–52, vol. 1, p. 381; Pinchart 1860–81, pp. 99–100.

20 M. Sommé, *Isabelle de Portugal, duchesse de Bourgogne: Une femme au pouvoir au XVᵉ siècle* (Lille, 1998), p. 57.

21 ADN, B.2064, fol. 81r.

22 Vienna, ÖNB, s.n. 12735. Paris 1993, p. 44. Described in Pächt/Thoss 1974, pp. 157–161, to correct for the date, the notice having not taken into account the break in the arms by a lambel, indicating that it belonged to Charles before he succeeded his father. F. Avril, 'Manuscrits à peinture d'origine française à la Bibliothèque nationale de Vienne', *Bulletin monumental*, 134 (1976), pp. 329–338. D. Thoss, *Französische Gotik und Renaissance in Meisterwerken der Buchmalerei* (exh. cat), Graz, 1978, pp. 147–149.

23 He had in any case brought the breviary and the black book of hours with him during his campaigns in the Lorraine and in Switzerland. The two manuscripts were part of the Swiss spoils: De Schryver 1999, pp. 51–53.

24 We may wonder whether this Jean Dinghelsche could not be the Jan Dinghelsche who owed money on his property located not far from the church of Saint James in Ghent, and close to *Gelukstraat*, where Nicolas Spierinc lived (see Chapter 4). SAG, *Terrier des cens de la ville*, série 152, n° 7, fols. 43r and 44v. In a payment for these quires, the name d'Inghelsche appears in the Gallicised form of *l'Englès*. Translated literally, the name does indeed mean 'the Englishman'. There is however no need to believe that Jehan Dinghelsche was English. The name Dinghelsche or d'Inghelsche was quite widespread in Flanders, and in Ghent and Bruges, among other places. Some examples, among others, are: a Ghyselbrecht Dinghelsche, living in Ghent at the corner of *Kathelinestrate* (Saint Katherine's Street) and *Gelukstraat*, neighbouring houses belonging to Nicolas Spierinc. SAG, série 301, n° 56, *Keure 1481–1482*, fol. 165v, Act of May 10, 1482. A *Jacob Dynghelsche* and his sons Jan and Lucas, who were members of the Guild of Saint Luke at the end of the 15th and beginning of the 16th centuries. An *Abraham Dinghelsche, filius Pieters*, a 16th-century glassblower. V. van der Haeghen, *La Corporation des Peintres et des Sculpteurs de Gand* (Ghent 1906), (Annales de la Société d'Histoire et d'Archéologie de Gand, 6) pp. 6, 8, 17.

25 L'Englès had accepted the task of executing and supplying three quires *par marchié fait avec lui*. The price of 40 s. had therefore been agreed upon at the time of the commission, and also included the illumination that l'Englès had had done in these three quires. The agreed price leads us to assume that task of making the illuminations provided was not very important. It does not refer to the binding, which could indicate that the Little Hours still had to be bound.

26 One would have expected that he had *histoires* made, but the document speaks of *ymages*. The use of this term surely seems to have intended to mark a distinction in contrast to *histoire*, which is usually used to designate miniatures. Perhaps it was intended to allude to isolated miniatures intended to be inserted into the quires, or to be pasted-in to places provided and reserved for the illustration of the text. Such pasted-in miniatures can be found, for example, in the Grandes Heures of Philippe le

Hardi, divided between Brussels, KBR, Ms. 11035-37 and Cambridge, Fitzwilliam Museum, Ms. 3 - 1954. This last part includes the supplements to the text that Philip the Good had added, and which were provided with pasted-in miniatures (*images*?). F. Wormald and Ph. M. Giles, "Description of Fitzwilliam Museum Ms. 3-1954", *Transactions of the Cambridge Bibliographical Society*, vol. IV, 1 (1964), pp. 26–28; P.M. de Winter, *La Bibliothèque de Philippe le Hardi, duc de Bourgogne (1364–1404)* (Paris 1985), pp. 189–194; A. Arnould and J.M. Massing, *Splendours of Flanders*, exh. cat. (Fitzwilliam Museum, 1993), pp. 144–145, n°46.

27 The journey was necessarily undertaken partially by boat : he was also paid for *son battelaige*. Jehennin de le Staghe seems to have been entrusted with missions of responsibility. He was sent once again to Bruges, leaving The Hague on August 24 to go to Gérard Loyet, the duke's goldsmith, *pour avoir de luy deux colliers de l'ordre de la Thoison d'or* (AGR, CDC, n° 1924, fol. 92v). F. de Gruben, *Les Chapitres de la Toison d'Or à l'époque bourguignonne (1430–1477)* (Leuven, 1997), p. 566.

28 See, for example, note 50, and the gifts relating to his devotion to Saint Hubert (under section 6.18).

29 H. van der Velden, *The Donor's Image: Gerard Loyet and the Votive Portraits of Charles the Bold*, (Turnhout, 2000).

30 C. Lemaire and M. Henry, *Isabelle de Portugal, duchesse de Bourgogne. 1397-1471.* exh. cat. (Bibliothèque royale, Brussels, 1991), p. 21; M. Sommé, *Isabelle de Portugal, duchesse de Bourgogne: Une femme au pouvoir au XVᵉ siècle* (Lille, 1998), pp. 54–57.

PLATE XXXVII | 257

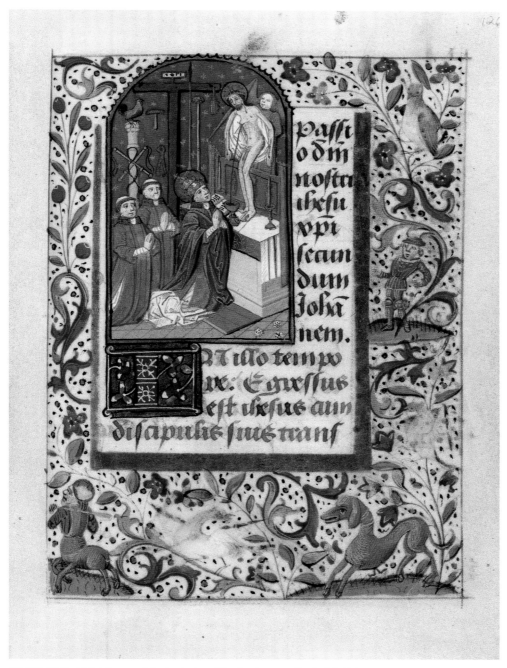

Fol. 126r: Mass of Saint Gregory at the beginning of the Passion according to Saint John.

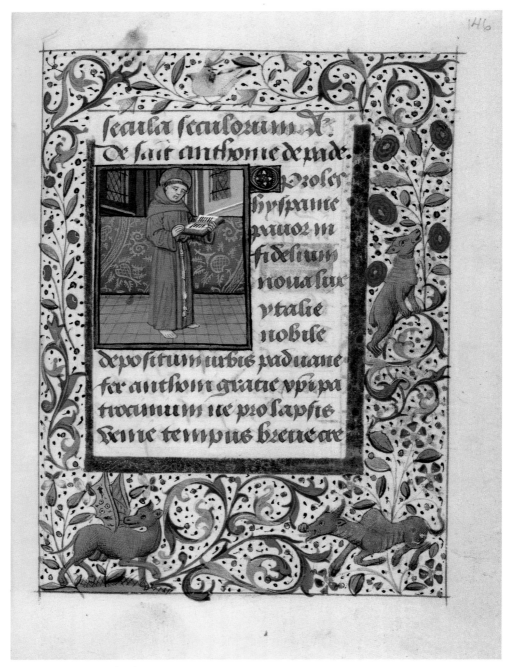

Fol. 146r: Saint Anthony of Padua.

PLATE XXXIX | 259

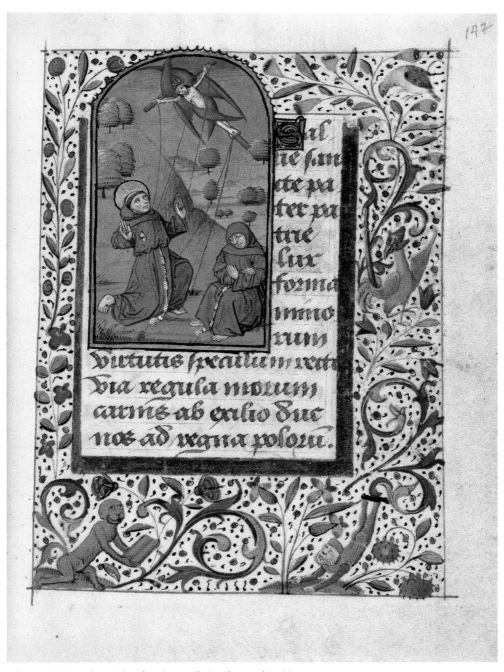

Fol. 147r: Saint Francis receiving the stigmata during the seraphic Vision.

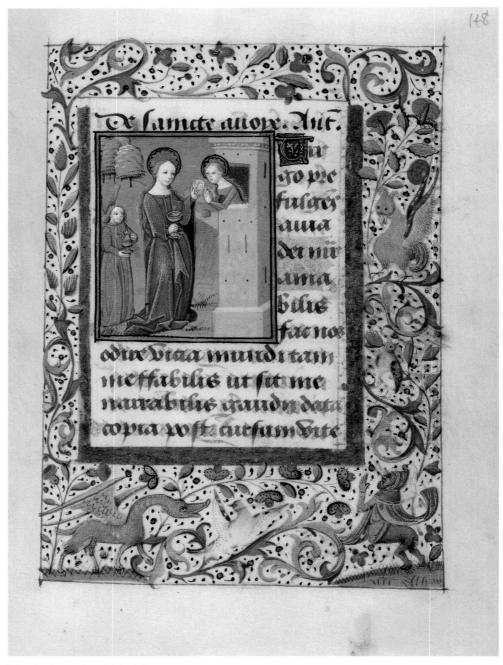

Fol. 148r: Communion of Saint Avia.

PLATE XLI | 261

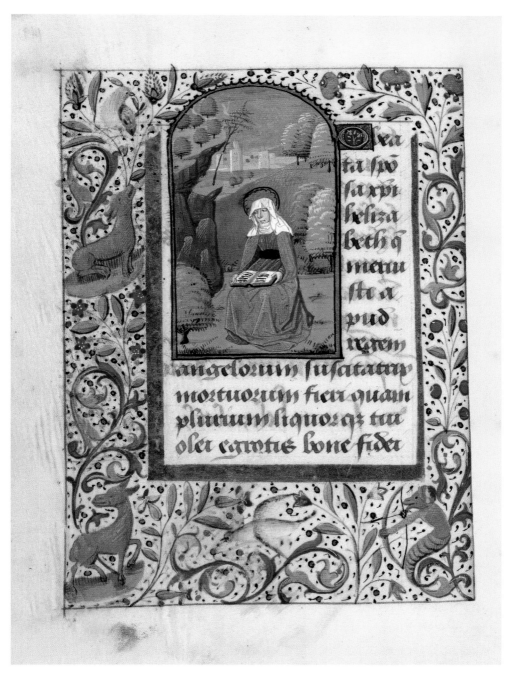

Fol. 149v: Saint Elizabeth.

151

Fol. 151r: Saint Barbara.

PLATE XLIII | **263**

Fol. 152v: Saint Genevieve.

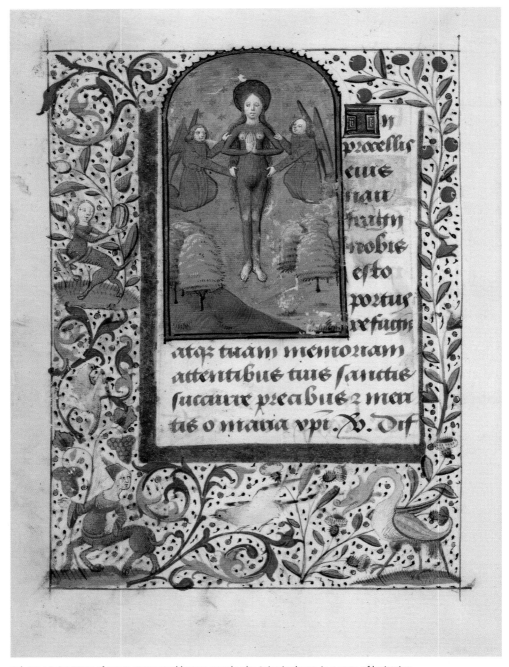

Fol. 153v: Saint Mary of Egypt. Supported by two angels, the Saint is shown in a state of levitation.

EXCERPTS FROM THE ACCOUNTS OF THE TREASURER OF THE DUKE OF BURGUNDY FOR THE YEAR 1469

(BRUSSELS, ARCHIVES GÉNÉRALES DU ROYAUME, CHAMBRE DES COMPTES, N° 1924)[1]

DOCUMENT 1

Fols. 278–279

Nicolas Spierinc is paid for the writing of prayers for Charles the Bold. (January 1469).

A Clay[2] Spierinc, escripvain, la somme de douze livres dix solz dudit pris pour ses painne et sallaire d'avoir escript dudit commandement (Id est: du commandement du duc) aucuns oroisons pour mondit seigneur. Pour ce par sa quictance ladicte somme de 12 lb. 10 s.

DOCUMENT 2

Fol. 305v

Jehan l'Englès, priest, is paid for having written and having had illuminated three quires in the little hours of Charles the Bold. (July 1469)

A Sire Jehan l'Englès, prebstre, la somme de 40 s. dudit pris, pour avoir escript et fait enluminer 3 quaiers es petites heures de mondit seigneur par marchié fait avec lui.

Pour ce, par certifficacion de mesdits seigneurs les maistres d'ostel contenant ledit payement, icelle somme de 40 s.

DOCUMENT 3

Fol. 91

Jehannin de la Staghe, Treasurer's Clerk, is paid for his voyage from Vere in Zeeland to Bruges to Jehan d'Inghelsche, to fetch a devotional book of the duke's in which d'Inghelsche had written certain pious texts, and to bring the manuscript to the duke at The Hague.[3] (August 1469)

A Jehannin de le Staghe, clerc dudit argentier, la somme de 6 lb. dudit pris, pour le dixième jour dudit mois d'aoust, des lieux et commandement que dessus (Id est: 'de Vere et du commandement du duc'), estre alé à Bruges querré ung livre de dévocion de mondit seigneur que sire Jehan d'Inghelsche avoit lors devers lui pour y escripre pluseurs oroisons et choses salutaires. Enquoy ledit Jehennin vacqua, alant et retournant devers mondit seigneur à La Haye en Hollande par huit jours entiers finis tous ensuivans qui au pris de douze solz dicte monnoye que mondit seigneur luy a ordonné et tauxé prenre et avoir de lui pour chacun desdits jours font la somme de 4 lb. 16 s.

Et pour son battelaige 24 s., font ensemble ces deux parties, ladite somme de 6 lb.

Pour ce, par sa quictance, icelle somme de 6 lb.

DOCUMENT 4

Fols. 322r-322v

Nicolas Spierinc is paid for the transcription, illumination, and binding of eight books of the Palace Ordinances. (August 1469)

A Clay Spierinc, enlumineur d'istoires, la somme de 45 lb. dudit pris, pour pluseurs parties d'istoires, vignettes et autres par luy faictes du commandement de mondit seigneur, en huit livretz ou sont escriptes toutes les ordonnances de l'ostel de mondit seigneur, ainsi qui s'ensieut, assavoir:

Premièrement, pour huit histoires faistes esdits huit livrez, assavoir en chacun livret une histoire au pris de 16 s. pièce, font 6 lb. 8 s.

Item, pour seize grandes vignettes faictes esdits huit livretz, asavoir en chacun livret deux à 10 s. pièce, font 8 lb.

Item, pour quatre vings huit petites vignettes faictes esdits livretz, assavoir en chacun livret unze vignettes a douze deniers pièce, font 4 lb. 8 s.

Item, pour vingt-quatre peaulx de vellin employez esdits livretz, asavoir pour chacun livret trois peaulx au pris de deux solz le peau, font 48 s.

Item, pour treize[4] grandes lettres dorée(s?) faictes en chacun desdits huit livretz, en tout 32 s.

Item, pour lier et lister lesdits livretz à 6 s. piece, font 48 s.

Item, pour avoir envoyé querré lesdites histoires de Bruxelles en Anvers 12 s.

Et pour l'escripture et cadelure desdits livretz et cibaurye où il n'a aucune enluminure a 48 s. chacun livret font 19 lb. 4 s.

Reviennent ensemble toutes lesdictes parties a ladite somme de 45 lb. Pour ce par sa quictance ladicte somme de 45 lb.

DOCUMENT 5

Fols. 322v–323r

Nicolas Spierinc is paid for having written and illuminated a book of the government of the duke's hôtel, and for having brought the book from Brussels to The Hague. (August 1469)

A luy, la somme de 34 lb. 14 s. dudit pris, pour pluseurs autres histoires, lettres, vignettes et autres parties par luy faictes en ung livre contenant les ordonnances des chevaliers et escuiers de l'ostel de mondit seigneur pour mettre en garde devers luy, ainsi qui s'ensieut, assavoir:

Premièrement, pour une histoire faicte au commenchement dudit livre, 18 s.

Item, pour neuf vignettes faictes en icellui livre a 6 s. pièce font 54 s.

Item, pour cent et quatre grandes lectres faictes en icellui livre, a 3 d. pièce, font 26 s.

Item, pour soixante seize petites vignettes faictes oudit livre a douze deniers pièce, font 76 s.

Item, pour l'escripture, estoffe, cadellure et autres cybauries faictes oudit livre où il n'a aucune enluminure, pour tout 24 lb.

Et pour avoir porté ledit livre de Bruxelles à La Haye en Hollande, comprins son retour, 40 s.

Reviennent toutes lesdites parties ensemble a la dicte somme de 34 lb. 14 s. Pour ce par sa quictance, icelle somme de 34 lb. 14 s.

Document 6

Fol. 323r

Lieven van Lathem is paid for the illumination of the duke's little prayer book, and for his journey from Antwerp to The Hague for the delivery of the work. (August 1469)

A Liévin de Lattem, aussi enlumineur, la somme de 37 lb. 8 s. dudit pris, pour autres[5] parties d'istoires, vignettes, lettres dorées et autres par luy faicte en ung petit livret de mondit seigneur, contenant pluseurs oroison faiz à sa dévotion, ainsi qu'il s'ensuit, assavoir:

Premièrement, pour vingt cinq histoires et autant de vignettes qu'il a faictes oudit livret au pris de 24 s. pour histoire et vignette font 30 lb.

Item, pour quatre vings huit moindres vignettes nommez bastons au pris de 12 d. pièce font 4 lb. 8 s.

Item, pour deux cens lettres de champaignes pour tout 20 s.

Et pour sa despence et sallaire d'avoir porté ledit livret d'Anvers audit lieu de La Haye en Hollande, comprins son retour, 40 s.

Reviennent ensemble toutes lesdites parties à la dicte somme de 37 lb. 8 s. Pour ce par sa quictance, icelle somme de 37 lb. 8 s.

Document 7

Fol. 323r

Jehan d'Inghelsche is paid for having written several prayers and other pious texts in an old book of the duke's, and for having had six 'images' made there, and for having had the book bound. (August 1469)

A Messire Jehan d'Inghelsche, prebstre, la somme de cent deux solz dusit pris pour son sallaire d'avoir escript en ung ancien livret de mondit seigneur pluseurs oroisons et choses salutaires et y fait faire 6 ymages, en tout 4 lb. 4 s.

Et pour avoir fait relyer ledit livret et dorer dessus 18 s.

Font ensemble ces deux parties ladite somme de 102 s. Pour ce par certification de mesdis seigneurs les maistres d'ostel contenant le payement desdites parties, icelle somme de 102 s.

Document 8

Fol. 323v

Ernoul de Duvel, goldsmith, of The Hague, is paid for having made and delivered the gold clasps for two small devotional books of Charles the Bold. (September 1469)

A Ernoul de Duvel, orfèvre demourant à La Haye en Hollande, la somme de 12 lb. 16 s. dudit pris qui deue luy estoit pour, du commandement de mondit seigneur, avoir fait deux cloans servans à deux ses livretz où sont escript pluseurs oroisons et dévotions et à ce avoir livré l'or, pesant l'un desdiz cloans treize estrelins et demi d'or, et l'autre huit estrelins et demi d'or, qui font ensemble vingt deux estrelins, qui au pris de dix solz six deniers dicte monnoye l'estrelin, font 11 lb. 11 s.

Et pour la fachon desdits deux cloans, assavoir de l'un 15 s. et de l'autre 10 s. font 25 s.

Reviennent ensemble lesdictes deux parties à la dicte somme de 12 lb. 16 s. Pour ce

par sa quittance icelle somme de 12 lb.
16 s.

DOCUMENT 9

Fol. 323v

Payment for having had bound one book
of ordinances and one devotional book of
the duke's.[6] (September 1469)

*Pour avoir fait relyer deux livretz de mon-
dit seigneur, dont en l'un sont escriptes les
ordonnances des estas de son hostel, et en
l'autre pluseurs oroisons à la dévocion de
mondit seigneur, comprins six feulletz de
parchemin qui à ce ont esté delivrez.*

*En tout la somme de 30 s. dudit pris. Pour
ce icy ladite somme de 30 s.*

DOCUMENT 10

Fols. 345v–346r

Charles de Visen, the duke's *sommelier de
corps*, is paid for having had covered with
black velvet a little prayer book of the
duke's. (November 1469)

*A Charles de Visen, sommelier de corps de
mondit seigneur, la somme de 20 s. dudit
pris, pour avoir fait couvrir de velours noir
certain livret où sont escriptes pluseurs oroi-
sons pour mondit seigneur. Pour ce icy ladite
somme de 20 s.*

Endnotes

1 Documents 1, 4, and 5 have been published in
Pinchart 1863, pp. 207–208. I provided a more exact
transcription of them in De Schryver 1969/1, pp.
454 and 456–457, which is repeated here. Unless the
notes indicate otherwise, the other documents that
follow are previously unpublished. The prices men-
tioned are all expressed in *livres* of 40 Flemish groats,
usually used by the ducal *Chambre des Comptes*. For
greater legibility, accents have been added in accor-
dance with modern French usage, and the amounts
that appear in Roman numerals in the account have
here been converted to Arabic numerals.

2 The Ghent documents most often refer to this illu-
minator as *Meester Claeys Spierinc*, also as *Meester
Clais Spierinc*. *Clais* is an abbreviated form of *Niclais*,
Nicolas in French. *Clais* has here been changed to
Clay.

3 This document is excerpted from the *Messageries*
heading, which constitutes a special chapter usually
found at the beginning of the annual account regis-
ters.

4 In Pinchart 1863, p. 207, we find her '3 grandes
lettres'. The original definitely has: **treize** grandes
lettres. De Schryver 1969/1, p. 456.

5 It notes 'pour **autres** parties d'istoires, vignettes,…'
because this payment reference is preceding by those
that register the two payments also made to Spierinc
for histoires, vignettes, etc. Lieven van Lathem (here
in the Gallicised form de Lattem) is called '**aussi** en-
lumineur' because the reference concerning him fol-
lows that ofthe payment to his colleague Spierinc.

6 Published: De Schryver 1969/2, p. 457. This account
article does not mention the person who received
this payment. Such an anomaly is rare in these ac-
counts, expenditures having to be justified by a re-
ceipt. It is no doubt due to an oversight committed
at the time that the expense was registered.

CODICOLOGICAL DESCRIPTION AND ANALYSIS OF THE PRAYER BOOK OF CHARLES THE BOLD

1. MATERIAL COMPOSITION AND MISE-EN-PAGE

The manuscript includes 159 folios of parchment, recently foliated in pencil, preceded and followed by unfoliated double parchment folios that form guard leaf and pastedown. Folios 1 to 25 constitute the Prayer Book of Charles the Bold. The remainder, constituting folios 126 to 159, was added to the manuscript later, and was made in another centre of production. It is the subject of Appendix 4.

The folios are 123–125 mm in height and 91–96 mm in width. The ruled space of 65 × 47 mm comprises 13 lines of text per page. Justification lines and ruling are drawn very faintly. Often they are no longer perceptible, or are barely perceptible. No prickings are preserved. The 125 folios of the duke's manuscript are divided among 17 quires. The large number of signatures still visible aid in determining with certitude the composition of the quires.

Signatures appear at the left of the folios, quite close to the spine of the quire and at the height of the line delimiting the base of the ruled space. They are generally drawn quite faintly and are of the type e, e1, e2, e3, e4, e5; f, f1, f2, f3… etc. One will note the use of Arabic numerals and the fact that the signature of the first folio of the quires is marked only by the letter. On the central bifolio of a quaternion, the letter is therefore accompanied by the number 3. The middle of a quire is moreover marked each time by a small cross drawn on the recto of the quire's central opening and in the same place as the signatures on the preceding folios. There are no traces of signatures from this series in the manuscript's first quire.

Signatures of another type can be seen lower on the folios. The letter is accompanied by a Roman numeral, and the number accompanies the letter from the signature of the quire's first folio. In the latter series, the centre of the quire is likewise marked by a cross on the recto of the quire's central opening, in the same place as the signatures on the previous rectos. The signatures of this series appear in the lower left hand corners of the rectos of the first halves of the quires, except for the first quire, in which the signatures are in the lower right hand corners of the folios. The signatures in this series were probably added during a replacement of the binding. On the central bifolio of the sixteenth quire, the signature *q v* had been noted by mistake at the

bottom of fol. 118r. A cross added above rectifies the error (fol. 117r, which is part of the same bifolio, moreover bears the signature *qiiij*).

The two series of signatures corroborate one another. Both mark the middle of the quires with the same letters, until r. According to custom, the letter i is omitted from the sequence to avoid any confusion with the Roman numeral 'one'.

Nine quires are quaternions of very regular composition. Eight others depart from this norm. Quire J is a ternion. Quires a, b, e, k, l, m, and r all include one or two singletons that combine in various fashions with the bifolia. The list that follows specifies the composition of each quire. The diagrams attached make it possible to visualize this data by locating the placement of the singletons and their stubs in the irregular quires. Moreover, they indicate the placement and the subject of the miniatures, and the place where certain texts begin. In the list that follows, the quire's ordinal number is followed by the letter used as its signature.

SIGNATURE	FOLIO	COMMENTARY
Quire 1: a	fol. 1–8	fols. 1 and 5 are singletons, with miniatures on the versos
Quire 2: b	fol. 9–13	fol. 9 is a blank singleton
Quire 3: c	fol. 14–21	
Quire 4: d	fol. 22–29	
Quire 5: e	fol. 30–39	fols. 30 and 32 are singletons
Quire 6: f	fol. 40–47	
Quire 7: g	fol. 48–55	
Quire 8: h	fol. 56–63	
Quire 9: j	fol. 64–69	
Quire 10: k	fol. 70–77	fols. 70 and 71 are singletons. Fols. 70v and 71r, with miniatures forming a diptych
Quire 11: l	fol. 78–86	Four bifolia preceded by a singleton
Quire 12: m	fol. 87–89	Single bifolium preceded by a singleton. Short quire permits the beginning of Terce to coincide with the beginning of the following quire.
Quire 13: n	fol. 90–97	
Quire 14: o	fol. 98–105	
Quire 15: p	fol. 106–113	
Quire 16: q	fol. 114–121	
Quire 17: r	fol. 122–125	fols. 122 and 123 are singletons.

2. SCRIPT

The script is a very meticulous and quite slender *bâtarde*, with cadels and often important *jeux de plume*. This calligraphy and its graphical extensions are discussed in Chapter 5. The rubrics are written in blue.

No catchwords. Chapter 1, section 1.3, describes the book's contents.

3. DECORATED INITIALS AND LINE FILLERS

Initials are one or two lines in height. They are gold, blue, pink, or red, against a background of one or two of the other colors. Blue or pink initials, and pink, red, or blue backgrounds are often decorated with motifs traced in gold or white. The centre of many initials contains an animal motif: a lion rampant or eagle *éployé* of heraldic inspiration, sometimes also a small dragon or other imaginary animal. The brown gold of the initials or of their gold backgrounds is often decorated by small stamped *pointillé* motifs. On fol. 15v, the initial's red background is decorated with acanthus leaves lightly drawn in gold. It is the only initial of this type in the manuscript. The branches of the initials beneath the miniatures on fols. 18r, 26r, and 45r, extend into acanthus foliage in the border.

In the Hours of the Cross, initials with pink vine-foliage on a gold ground follow each of the miniatures with a border painted on a colored background. The initial below the miniature of Calvary, fol. 106r, is decorated with the Instruments of the Passion and the tomb, lightly sketched in gold lines on a blue background.

The line fillers are baguettes of alternating colors, decorated according to a formula analogous to that of the illuminated initials. Some line fillers of a different technique are the same blue as the rubrics. On fols. 11r, 32v, 54r, 54v, and 59v, they take the form of small elongated dragons, whose tails sometimes end in foliate forms. Their silhouettes stand out against the plain background of the parchment. Others are in the form of baguettes in which the blue alternates with a very brilliant gold.

4. PARTIAL BORDERS

The exterior margin of every text page is decorated with a partial border of the same height as the ruled space. Folios 25v and 70r, which have only six and two lines of text, respectively, were left without borders. However, fol. 13v is provided with a border, even though the page has no text.

These partial borders are decorated with blue and gold acanthus branches, and spiral–shaped foliage, drawn very finely with a pen, with a few leaves and flowers, and small gold discs encircled by black lines and provided with little black antennae. Some birds are often added to the design. These borders are framed and delimited by a single pink line, with the exception of fols. 68v–69r, which have a double line.

On fols. 30r, 30v, 32r, and 32v, the partial border has been replaced by drolleries. They occupy almost the entire height of the exterior margin.

5. FULL BORDERS

All the pages with miniatures are framed by full borders, of which the exterior dimensions are on average 106 mm in height and 76 mm in width. There are 21 with motifs on backgrounds of gold or colors. They alternate with those borders, 18 in number, with designs that stand out against the plain background of the parchment. The list of miniatures that follows also specifies in each case the color of the border's background.

The majority of full borders with plain backgrounds are framed by a pink line. Those of fols. 2r, 26r, and 48r are framed by gold lines. All of the borders with colored and with plain backgrounds on fols. 1v, 82v, 95v, 106r and 119v, are framed by a thin gold baguette inserted between two black lines. On fol. 1v, a pink line is added to the outside of the gold baguette. The borders with colored backgrounds for the diptych of Saint George, fols. 67v–68r, are framed by a double black line without an intermediary gold baguette. The borders with gold or colored backgrounds for fols. 29r, 33r, and 46v are framed by a single black line.

6. MINIATURES

The thirty-nine miniatures all have frames that are curved at the top. The majority of them measure 65 to 70 mm in height and 40 to 45 mm in width. The full-page miniatures on the left sides of the four diptychs, and that of Saint Hubert, are the same width, and a height of about 75 to 80 mm. On the folios that have borders with plain backgrounds, the arch at the top of the frame is jagged. The miniatures' frames are most often made up of three black lines enclosing a thin gold baguette on the exterior, and a white, pink, or blue ruling on the interior. This baguette sometimes extends at the bottom to frame the two or three lines of text below the miniature as well. On a portion of the exterior contour of the miniature's frame, about a millimeter away from it, a second baguette quite often separates the border from the miniature. On fols. 10r, 17r, 22r, 36r, 43r, 49v, and 70v, the miniature is framed by a much larger gold frame, decorated with meandering designs stamped in *pointillé* on the gold leaf. The frame of fol. 22r is also adorned with little blue and pink rosettes. On fol. 70v, however, the frame's band of brown gold is lacking in *pointillé* or other motifs.

In the list that follows, the subject of the miniature alone is indicated. The complementary scenes or motifs in the borders are not indicated here. They are identified and discussed in Chapters 6 and 8. The subjects or figures appearing in the borders of the miniatures of the Hours of the Cross are identified and discussed in Chapter 9.

FOLIO	SUBJECT OF THE MINIATURE	BORDER
1v–2r	Diptych of the Holy Face. Charles the Bold presented by Saint George, fol. 1v. Veronica displays the imprint of the Holy Face, fol. 2r.	Borders with plain background.
5v–6r	Diptych of the Virgin. The Virgin and Child surrounded by three angel musicians, fol. 5v. Charles the Bold kneeling under the protection of Saint George, fol. 6r.	Borders with grey background.
10r	Virgin nursing the child, seated in a garden, surrounded by two angel musicians.	Border imitating brocade with motifs of gold and silver on a black background.
14r	The Holy Trinity represented as the Throne of Wisdom [Fr., 'grâce'].	Border with matt gold background.
15v	Saint Michael fighting the demons.	Border with plain background.
17r	Beheading of Saint John the Baptist. Salomé assists at the scene. In the background, on the left, in an open architectural structure: Herod and Herodias at the table to which Salomé brings the head of John the Baptist.	Border with olive–green background.
18r	Saint John on Patmos.	Border with plain background.
19v	Appearance of the risen Christ to Saint Peter and Saint Paul fallen down on the road to Damascus.	Border with brown background imitating a precious fabric with motifs of gold and silver.
21r	Crucifixion of Saint Andrew.	Border with plain background.
22r	Christ blessing Saint James the Greater on his floating island.	Border with greenish–blue background.
23v	The Last Supper.	Border with plain background.
24v	Stoning of Saint Stephen.	Border with red background imitating a precious fabric with motifs of gold and silver.

Folio	Subject of the miniature	Border
26r	Saint Christopher crosses the river with the Child.	Border with plain background.
29r	Martyrdom of Saint Sebastian.	Grisaille border with matt gold background.
31v	Martyrdom of Saint Lawrence.	Border with plain background.
33r	Temptation of Saint Anthony the Hermit.	Grisaille border with matt gold background.
34v	Saint Martin dividing his cloak.	Border with plain background.
36r	Preaching of Saint Gatianus.	Border with grey monochrome decoration.
38r	Saint Fiacre assailed by a woman.	Border with plain background.
39v	Vision of Saint Hubert.	Border with bronze brown background.
41v	Saint Eutropius healing the maimed.	Border with plain background.
43r	All Saints adoring the Lamb.	Border with olive-green background.
45r	Saint Anne with the Virgin and Child.	Border with plain background.
46v	Christ appearing to Saint Mary Magdalene after the resurrection.	Border with red background imitating a precious fabric with motifs of gold and silver.
48r	Martyrdom of Saint Catherine.	Border with plain background.
49v	Saint Margaret prevails against the dragon.	Grisaille border with matt gold background.
50v	Martyrdom of Saint Apollonia.	Border with plain background.
67v–68r	Diptych. Saint George on horseback fighting the dragon, fol. 67v. Charles the Bold kneeling in a church and presented by an angel, fol. 68r.	The two borders have a bronze brown background.
70v–71r	Diptych. Christ's prayer at Gethsemane, fol. 70v. Arrest of Christ, fol. 71r.	Borders with grey background.

FOLIO	SUBJECT OF THE MINIATURE	BORDER
82v	Jesus brought before Pilate.	Border with plain background.
90r	Flagellation of Christ.	Border with grey-blue background.
95v	Way to Calvary.	Border with plain background.
106r	Calvary.	Border with plain background.
111v	The Deposition.	Border with olive-green background.
119v	The Entombment.	Border with plain background.

7. DIAGRAM OF THE QUIRE STRUCTURE OF THE MANUSCRIPT AND OF THE PLACEMENT OF ITS MINIATURES

Quire 1 / Signature a

5 — fol. 5v : Diptych of the Virgin. The Virgin and Child surrounded by three angel musicians.

6 — fol. 6r : Charles the Bold kneeling under the protection of Saint George.

fol. 2r : Veronica displays the imprint of the Holy Face.

fol. 1v : Diptych of the Holy Face. Charles the Bold presented by Saint George.

a

Quire 2 / Signature b

b

Quire 3 / Signature c

c

Quire 4 / Signature d

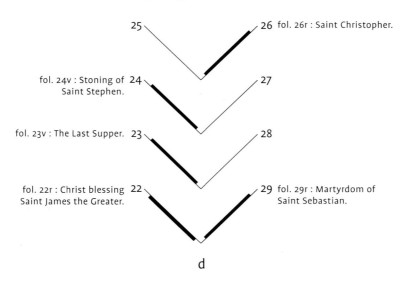

25
26 fol. 26r : Saint Christopher.

fol. 24v : Stoning of 24
Saint Stephen.
27

fol. 23v : The Last Supper. 23
28

fol. 22r : Christ blessing 22
Saint James the Greater.
29 fol. 29r : Martyrdom of
Saint Sebastian.

d

Quire 5 / Signature e

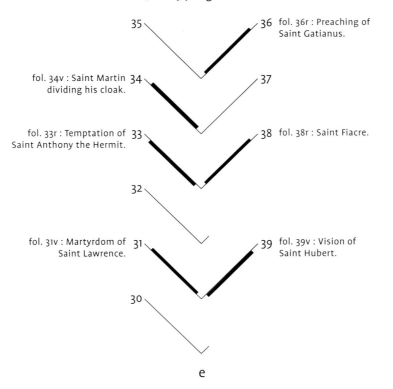

35
36 fol. 36r : Preaching of
Saint Gatianus.

fol. 34v : Saint Martin 34
dividing his cloak.
37

fol. 33r : Temptation of 33
Saint Anthony the Hermit.
38 fol. 38r : Saint Fiacre.

32

fol. 31v : Martyrdom of 31
Saint Lawrence.
39 fol. 39v : Vision of
Saint Hubert.

30

e

Quire 6 / Signature f

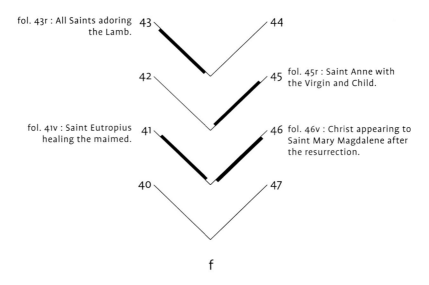

fol. 43r : All Saints adoring the Lamb. — 43

44

42

45 — fol. 45r : Saint Anne with the Virgin and Child.

fol. 41v : Saint Eutropius healing the maimed. — 41

46 — fol. 46v : Christ appearing to Saint Mary Magdalene after the resurrection.

40

47

f

Quire 7 / Signature g

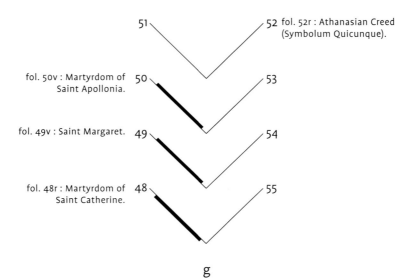

51

52 — fol. 52r : Athanasian Creed (Symbolum Quicunque).

fol. 50v : Martyrdom of Saint Apollonia. — 50

53

fol. 49v : Saint Margaret. — 49

54

fol. 48r : Martyrdom of Saint Catherine. — 48

55

g

Quire 8 / Signature h

fol. 59v–61v : Seven Versicles of Saint Bernard (Illumina oculos meos…)

fol. 58r–59r : Prayer following the Athanasian Creed.

fol. 62r–65v : French prayer (Iuste Iuge Jhesu, Roy des roys, et Seigneur des seigneurs qui tousjours regnes …).

h

Quire 9 / Signature j

fol. 67v : Saint George fighting the dragon.

fol. 68r : Charles the Bold presented by an angel

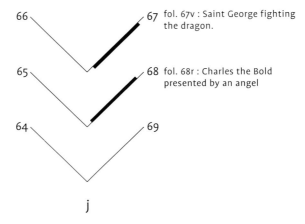

j

Quire 10 / Signature k

fol. 71r : Arrest of Christ. 71

fol. 70v : Christ's prayer at 70
Gethsemane. (Matins)

k

Quire 11 / Signature l

fol. 82v : Jesus brought 82
before Pilate. (Prime)

l

Quire 12 / Signature m

m

Quire 13 / Signature n

fol. 95v : Way to Calvary. (Sext)

fol. 90r : Flagellation of Christ. (Terce)

n

Quire 14 / Signature o

o

Quire 15 / Signature p

p

Quire 16 / Signature q

fol. 119v : The Entombment
(Compline)

q

Quire 17 / Signature r

r

THE SUPPLEMENT ADDED FOR A LATER OWNER OF THE MANUSCRIPT

The final section of the manuscript, fols. 126–159, constitutes an addition for another owner of the manuscript, made much later than the portions that precede it. We recognize this immediately: its parchment is not as fine, and the script and the style of the different elements of its illumination reveal an origin that has nothing in common with that of the first 125 folios that were executed in several phases for Charles the Bold.

This addition adopted the same mise-en-page as that of the original manuscript. It is made up of five quires: two ternions, fols. 126–131 and 132–137; two quaternions, fols. 138–145 and 146–153; one ternion, fols. 154–159.

The *bâtarde* script is less slender than that of the older portions, and has neither cadels nor *jeux de plume*. The rubrics are in red. The decorated initials are one or two lines in height.

These added quires contain the Passion according to Saint John, and seven prayers addressed to Saints Anthony of Padua, Francis of Assisi, Avia, Elizabeth, Barbara, Genevieve, and Mary of Egypt. Then follow a prayer for peace, fol. 155r, and some antiphons and prayers to the Virgin. These texts are all in Latin, but their rubrics are in French, except for that of the Passion according to Saint John.

The miniatures are of more reduced dimensions than the justification, in terms of both width and height. Six miniatures are inscribed in frames with curved shapes that extend in height to the line framing the border. The miniatures on fols. 146r and 148r are of smaller dimensions and are rectangular in shape.

The Passion according to Saint John is illustrated with the Mass of Saint Gregory (fol. 126r). Here one sees Saint Gregory, wearing the tiara, kneeling before the altar on top of which Christ appears, supported under his arms by an angel. Christ wears the Crown of Thorns on his nimbed head. His breast and limbs bear the stigmata of the five wounds, and a stream of blood escapes from his side wound and flows into the chalice on the altar. Two priests are kneeling behind Saint Gregory. The Instruments of the Passion are represented in the background of the miniature.

The seven other miniatures in this addition each illustrate prayers to a particular saint. Saint Anthony of Padua is depicted standing in an interior, fol. 146r. Saint Francis receiving the stigmata during the seraphic Vision is depicted in the foreground

of a rather basic landscape, fol. 147r. Francis is kneeling on the left, while near him on the right his companion sits asleep with arms crossed.

The miniature on fol. 148r illustrates an episode from the legend of Saint Avia. Persecuted and imprisoned, the saint was miraculously fed by an angel who brought her three pieces of bread every week. One day, it was the Virgin who came, and brought her Communion.[1] It is this Communion of Saint Avia that is depicted. The saint is locked in the tower on the right that occupies the entire height of the painting. The Virgin gives Communion to Saint Avia, who appears at the window. An angel on the left, who holds a small ewer, assists at the scene.

Saint Elizabeth is represented sitting in a landscape and holding an open book on her knees, fol. 149v. The two following miniatures, fols. 151r and 152v, depict Saint Barbara and Saint Genevieve standing in interiors. Saint Barbara holds a palm in her left hand. With her right, she points to the tower, her traditional attribute, placed here on the tiles of an interior. Saint Genevieve holds an open book in her left hand, and in her right a candle that a little demon tries to extinguish but an angel has just re-lit.

The last miniature, fol. 153v, depicts Saint Mary of Egypt. Supported by two angels, the saint is shown in a state of levitation above a landscape.

These miniatures were probably painted in Rouen. Their style is very close to that of the Master of the Rouen Echevinage, whose secular works have been studied by Claudia Rabel.[2] The creator of the miniatures at issue here could well be an artisan in the circle of the Echevinage Master. His art can definitely be considered as representative of mid–level production in Rouen during the last two decades of the century.

One can pick out several characteristic elements that are repeatedly found in the work of the Master of the Rouen Echevinage. One will notice that the rather aerial and centered perspective in the tiling of the foreground interiors, in which Anthony of Padua, Barbara, and Genevieve are depicted; the architectural elements, treated rather sharply, and for which only the major lines are indicated; and the cloths of honor stretched in the background, forming screens behind the saints, exempt the artist from having to represent in a coherent manner the architectural details that he shields from our gaze. These are so many elements that we find in an analogous manner in the miniatures of the Echevinage Master.

The frequency, in the interior scenes, of walls covered up to a certain height with cloths of honor of rich brocade, the motifs of which are generally rendered in a linear manner, most often without really succeeding in suggesting the luster and the material of these sumptuous fabrics, is another characteristic found with the Echevinage Master, as with other Rouen masters of the second half of the century.[3]

The Communion of Saint Avia, fol. 148r, was a subject quite frequently depicted in Paris and Rouen, two of the cities where the saint was honored.[4] This miniature presents a striking analogy, not in style but in composition, with that of the same subject in

the so-called Hours of Henri IV, dating to the beginning of the sixteenth century (Fig. 124).[5] The illumination of this last manuscript is attributed to the Master of the Petrarch Triumphs, who then worked in Rouen for the Cardinal d'Amboise.[6] In spite of the differences in quality and style of the two miniatures, everything seems to indicate that they go back to a common source. The two elongated slits piercing the wall toward the bottom of the tower is found in the two miniatures. This is also the case with the small plant resembling a fern that is visible close to their lower edges. However, in contrast to the Triumphs Master, the creator of the book's little miniature has inversed hid model, in such a way that the tower is on the right not on the left, and the Virgin gives Communion with her left hand.

The Master of the Petrarch Triumphs, whose art is on a much higher level than that of the miniatures at issue here, did not neglect any detail in interpreting his model. The bars on the window that he had painted with such care are missing in the little book's miniature. The masonry joints that the Triumphs Master carefully detailed, the three pieces of bread carried by the angel, in accordance with the legend, were doubtless not absent from the prototype to which the two miniatures refer. However, these precise details do not seem to have held the attention of the illuminator of this addition to this book. In choosing to represent a square tower, he departed from what his model suggested. Perhaps he did so to differentiate this miniature from that of Saint Barbara, where the saint in flanked by an imposing round tower.

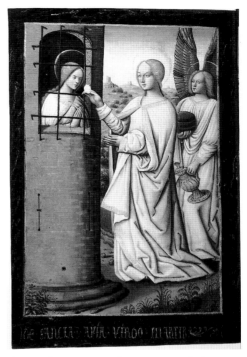

Fig. 124: *The Communion of Saint Avia.* So-called Hours of Henri IV. Paris, BnF, Ms. lat. 1171, fol. 83v.

In the landscape of the miniature of the Stigmatization of Saint Francis, and those of Saint Avia, Elizabeth, and Mary of Egypt, the trees are all treated in a uniform manner. Their trunks are short and straight, the rounded shape of their branches, and the treatment of the foliage, are very close to those of the Master of the Rouen Echevinage, for example in the Allegory of Good Government or the Falcon Hunt from the *Livre des Trois Âges de l'homme* (Figs. 125–126).[7] The quite summary drawing of the hillside slopes, not very suggestive of space or landscape, is also found in the little book's miniatures. The steep rocks, at the left of the miniature of Saint Elizabeth, are

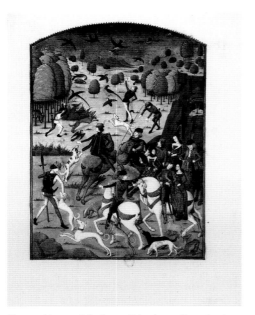

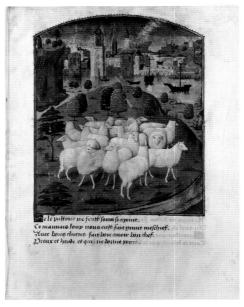

Fig. 125: Master of the Rouen Echevinage, *Heron hunt.* Pierre Choisnet, *Le Livre des trois âges de l'homme*, Paris, BnF, Ms. Smith-Lesouëf 70, fol. 5r.

Fig. 126: Master of the Rouen Echevinage, *Flock of sheep in the countryside.* Pierre Choisnet, *Le Livre des trois âges de l'homme*, Paris, BnF, Ms. Smith-Lesouëf 70, fol. 12r.

quite comparable to those on the left in the Allegory of Good Government.

The miniature of the Mass of Saint Gregory includes the archaism of a starry background, unexpected in an interior scene. We can no doubt see a reminiscence here of the starry skies painted some thirty or forty years earlier, by such artists as the Bedford Master, Master of the Munich Golden Legend, the Talbot Master, and the Master of Jean Rolin, whose productions directly or indirectly influenced the development of manuscript painting in Rouen.

The execution of the lateral partial borders on the text pages, and the full borders that frame the folios with miniatures, could have been entrusted to a specialized *vigneteur* craftsman. The borders have plain back-grounds, and are decorated with a rather traditional design of acanthus *rinceaux*, with some flowers and fruit. The full borders framing the historiated folios furthermore all have some figures and drolleries. The latter are arranged especially at the lower corners of the bottom of the border, and midway up its external vertical branch. As in the Echevinage Master's borders,[8] figures or drolleries are quite often placed on these little lumps of ground, usually covered with some vegetation, that at the time were called *terasses*. The figures, animals, and hybrid beings, usually awkward, are painted rather clumsily. They are often very disproportionate to one another, and testify neither to a very attentive observation of the natural world, nor especially to the nec-

essary talent to represent them in a convincing fashion. Only the birds sometimes seem to have been captured better.

Each folio with a full border is also provided with a decorative baguette separating the text field and that of the border on each side and on the bottom. Below the text and on the side facing the exterior margin, this baguette is of greater width. The pages of text without miniatures are all decorated with a partial border of the same height as the justification.

The style of this addition allows us to presume that it was executed during the 1480s at the earliest. If one takes into account the information set out in Appendix V on Mary of Luxemburg, it is likely that it will only have been made after the second marriage of Mary of Luxemburg, to François de Bourbon, Count de Vendôme, in 1487. As Durrieu had indicated, Saints Francis of Assisi, Anthony of Padua, and Elizabeth were '*très en honneur chez les princes de la Maison de Bourbon-Vendôme, et les quatre saintes Avoie, Barbe, Geneviève et Marie l'Égyptienne, particulièrement vénérées à Paris*'.[9]

Endnotes

1 Réau 1955–59, III-1, pp. 164–165; LCI 1968–76, 7, col. 298; on the subject of the relation between the legend of Saint Avia with the Communion of Saint Denis, see: P. Perdrizet 1933, p. 238.

2 C. Rabel, 'Artiste et clientèle à la fin du Moyen Age: les manuscrits profanes du Maître de l'Echevinage de Rouen' *Revue de l'Art* 84 (1989), pp. 48–60. The sobriquet replaces that of Master of the Geneva Latini, which had previously been given to this master by J. Plummer, after the copy of Brunetto Latini's *Tresor* (Geneva, Bibliothèque publique et universitaire, ms. fr. 160). *The Last Flowering. French Painting in Manuscripts, 1420–1530, from American Collections* exh. cat., with G. Clark (New York, Pierpont Morgan Library 1982) pp. 66–67, n° 87–88.

3 See the illustrations in Rabel 1989; A. Blum and Ph. Lauer, *La Miniature française aux XVe et XVIe siècles* (Paris, Brussels, 1930) Pl. 47. H. Martin and Ph. Lauer, *Les principaux manuscrits à peintures de la Bibliothèque de l'Arsenal à Paris* (Paris 1929), p. 54, pl. 73; C. de Hamel, *A History of Illuminated Manuscripts* (Boston, 1986), p. 184, Figs. 186–189. Analogous cloths of honor are also found in a number of manuscripts made in Bruges. One can surely see here one of the revealing indications of contacts and exchanges that must have existed between book artisans in Rouen and Bruges over the course of the second half of the fifteenth century.

4 *Dictionnaire d'Histoire et de Géographie ecclésiastiques*, vol. 5 (Paris 1931), s.v. 'Avia'; Leroquais, *Heures*, vol. 1, p. LIII; Réau 1955–59, III-1, pp. 164–165; LCI 1968–76, 5, col. 298.

5 Paris, BnF, Ms. lat. 1171, fol. 83v. Leroquais, *Heures*, Pl. CXXI; also reproduced in LCI 1968–76, 5, col. 298.

6 Plummer/Clark 1982, p. 90; Paris 1993, pp. 415–418.

7 Paris, BnF, Ms. Smith-Lesouëf 70, fols. 6 and 12. These two miniatures are reproduced in C. Rabel 1989, p. 54, Fig. 8 and Paris 1993, p. 173.

8 See the borders of folios reproduced by Rabel 1989.

9 Durrieu 1916, p. 124.

THE BINDING

The manuscript has come down to us in an antique binding, covered with purple velvet and adorned with silver appliqué. The corner pieces that decorate the covers are marked with the initials 'SG' in gothic letters, above a frieze of meanders suggesting the edge of a cloud. A circular medallion is applied at the centre of each of the covers, inscribed NON TERRA DISSOLVET UNITA CELIS in classical capitals, and decorated with two interlaced hunting horns. These medallions were originally gilded and partially enameled, as were the binding's clasps, where we also find the two horns. Inasmuch as a few remnants of enamel allow it to be established, the horns appear to have been green; the laces, red; and the background, blue.

Durrieu remarked that the rather medieval orthography 'celis', instead of 'coelis', could even date to the fifteenth century, although at first glance one would more likely situate this binding toward the middle of the sixteenth century. He noted, moreover, that the Roman capitals of the inscription were analogous to those engraved around the '*boullons*', or heads of nails, that decorate the original bindings of the famous Froissart of Antoine, *Grand Bâtard de Bourgogne* (Berlin, SBPK, Depot Breslau, Ms. 1).[1]

In analysis, this binding does not fail to intrigue. The medallions and clasps appear to be more recent than the corner pieces. The latter could date to the fifteenth century. Their style appears irreconcilable with that of the medallions. Radiography has shown that the velvet does not cover wood boards as had previously been thought. Certain material elements lead us to believe that the binding's fabrication, such as it stands today, goes back to the seventeenth century, which further complicates our assessment of this binding.[2]

It is perhaps not out of the question that we are dealing with the re-use of a binding that once covered another book, as Thomas Kren, Curator of Manuscripts at the J. Paul Getty Museum wrote to me (October 24, 2000). If one considers this possibility, the medallions and clasps could have been added at the time when the book was provided with this new casing. Perhaps a solution to the riddles posed by the medallions and clasps or the corner pieces will one day make it possible to supplement what we know about the manuscript's history. On the subject of the initials 'SG' decorating the corner pieces, Durrieu had expressed an idea 'comme un simple amusement de l'esprit' and, he noted, without wanting to conclude more than is advisable.[3] He

believed the S to be crossed-out, and compared it to an analogous set of initials found on coins and medals in the name of Jeanne d'Albret. The latter's husband was the grandson of Mary of Luxembourg. However it seems difficult to take into account an explanation that relates to one of the two initials without shedding light on the meaning of the other.

Endnotes

1 Durrieu 1916, pp. 125–127, especially note 4. One of the Froissart bindings is reproduced in A. Lindner, *Der Breslauer Froissart* (Berlin 1912) p. 21.
2 This is what Nancy Turner, conservator at the J. Paul Getty Museum, concluded after a more exhaustive examination of the binding.
3 Durrieu 1916, p. 126.

HISTORY OF THE MANUSCRIPT

The first specific fact that we have concerning the history of the prayer book after Charles the Bold's death is the lovely calligraphic inscription, *Je suys a Mademoiselle de Marles*, written on the flyleaf at the beginning of the manuscript. As Durrieu demonstrated,[1] the person thus indicated is Marie de Luxembourg, daughter of Pierre II de Luxembourg and granddaughter of Louis de Luxembourg, Count of Saint-Pol, and Constable of France, whom Louis XI had condemned and decapitated for the crime of *lèse-majesté* on December 19th, 1475.[2]

In order to know more about the fate of the duke's prayer book, we must therefore look into the history of Marie de Luxembourg and of the important lineage to which she was heir. To know when she could call herself Mademoiselle de Marle brings us back to specifying the period during which the precious manuscript must have come to her. Information about her ancestry or descendents, and what we know of her biography, could put us on the track of useful indications relating to the manuscript's history.

Louis de Luxembourg, Mary's grandfather, had first served the Duke of Burgundy, but in 1465 entered the service of Louis XI, who made him his constable. In the end,

however, he attracted the resentment of the Duke and the King through his intrigues and duplicity.[3] The two sovereigns got to the point of fearing him, and looked for an occasion to cause his downfall. They secretly made an agreement to get rid of the constable.[4] Not long afterward, the duke had him arrested quite treacherously at Mons, in spite of the safe-conduct that he had accorded him. He ended up ordering that the constable be delivered to the King's emissaries.[5] Sent to Paris, he was imprisoned in the Bastille, and proceedings were started against him in Parliament. The sentence, oriented in advance, was made known to him on December 19, 1475. Declared guilty of the crime of *lèse-majesté*, he was decapitated the same day at the Place de Grève.[6]

His conviction led to the confiscation of his property and that of his sons, who had always been partisans of the duke's in his wars against Louis XI. As it had been agreed during the decision to eliminate the constable, the king thus left the confiscated money and moveable property to the Duke of Ham and Bohain.[7] A number of *seigneuries* reverted back to the king, who disposed of them as he was intending to. The oldest child of the son of Louis de Luxembourg, Jean, Count of Marle and Soissons, who was therefore in the service of Charles the

Bold, was in the duke's retinue at the meeting in Trier in 1473. In the list of lords of high nobility who were dressed in cloth of gold on that occassion, *Monseigneur de Marle* is mentioned third, after Jehan and Philip of Cleves.[8] Jean de Luxembourg died in the Battle of Morat on June 22, 1476. As he left no descendants, his brothers' oldest child, Pierre, Count of Brienne, was his heir.[9] Pierre could therefore from then on pride himself on the titles of Count of Marle and of Soissons, even if the confiscations did not allow him to take full possession of the lands and properties to which these titles related.

After the duke's death in January of 1477, Mary of Burgundy returned to Pierre the property of Louis de Luxembourg that Charles the Bold had appropriated.[10] Pierre attended the Duchess's inauguration in Ghent on February 16, 1477, where he must have met Philip of Cleves and Jacques de Savoie, Count of Romont, who would later marry one of his daughters.[11] The Count of Romont was his brother-in-law, with whom he seems to have maintained a trusting relationship.[12] During the events that unfolded in Ghent shortly after Charles the Bold's death, Pierre de Luxembourg would have played an avenging role from the shadows with regard to the chancellor Hugonet and Guy de Brimeu, Lord of Humbercourt, when the latter were condemned and executed by the people of Ghent.[13]

Pierre de Luxembourg was a respected figure at the court of Mary of Burgundy. At the baptism of Philip the Fair in Bruges on July 28, 1478, the child was carried in an imposing procession from the Prinsenhof to the Church of Saint Donatian. Margaret of York was in the place of honor, in her role as the prince's godmother, accompanied, on her right, by Adolph of Cleves, who was his godfather, and, on her left, by Pierre de Luxembourg, who carried the child. In the funeral procession of Mary of Burgundy, on April 2, 1482, Pierre de Luxembourg was one of the six lords who surrounded Maximilian.[14] The Estates General held an assembly in Ghent from April 28 to May 3, 1482, to deliberate on the situation of the Low Countries after the death of Mary of Burgundy. Pierre de Luxembourg attended as a delegate of the nobility.[15]

Pierre was also the Lord of Edingen, where he often resided. It was in his château in Edingen that he died, on October 25, 1482. His burial took place shortly thereafter. A month later, on November 28 and 29, a grand funeral was celebrated, organized under the direction of Antoine Rolin, Lord of Aymeries, Great Bailiff of Hainaut, and executor of the deceased's will, with the assistance of the King of Arms of Hainaut, and of Lothier, one of the heralds of the House of Burgundy. Olivier de La Marche did not fail to appreciate the meticulous ceremonial of this funeral from a connoisseur's point of view, and described its progress.[16] He had been entrusted with representing there the Archduke Maximilian, for whom he was the chief *maître d'hôtel*. His account details the imposing procession in which the officers and people of the deceased's palace, dressed in black robes, preceded the deceased's closest relatives. Many dignitaries and lords followed, come to pay their last respects to the deceased. On

November 28, this procession went to the Church of Saint Nicolas for the vigils, and on November 29, for a solemn mass sung by the Bishop of Cambrai, Henri de Berghes. These ceremonies attracted an enormous crowd to Edingen, to the degree that twenty-eight people were crushed to death.[17]

Pierre de Luxembourg left two daughters: Marie and Françoise. Marie was then a young and eligible woman. In her position as the eldest, she could certainly have been called Mademoiselle de Marle after the death of her father on October 25, 1482.

All of this took place at the time when the crisis of authority with which the Burgundian Netherlands were confronted after the death of Charles the Bold was further aggravated by the death of the duchess Mary of Burgundy on March 27, 1482.[18] The country was tired of war, and of the heavy price that it entailed. It reproached Maximilian for his excessively autocratic policies and the lack of control in the management of state by representative bodies. Louis XI, who hoped to marry the dauphin to Margaret of Austria, Maximilian's daughter, had made overtures of peace.[19] The assembly of the Estates General wanted to engage in negotiations, and Maximilian consented. Under pressure from Flanders, and Ghent in particular, it was the Estates General who appointed the delegates who would negotiate peace with France. The tensions that still reigned at the time between the Estates General and Maximilian were to some degree forced to accept the treaty established at Arras in December of 1482, after a month of debate.[20] The condi-

tions that this treaty imposed, however, were extremely disadvantageous for the Archduke. He did not resign himself to ratifying it until the end of March in 1483.[21] After the death of Louis XI, Maximilian protested with the young Charles VIII against a treaty established by a delegation that he had not recognized, and his diplomacy attempted in vain to renege on the treaty's stipulations, among other things in the hope of regaining possession of Burgundy.[22]

The Arras treaty of December 23, 1482, included an article of considerable importance for the descendants of Louis de Luxembourg. Among the amnesty clauses accepted by the parties, there was one which expressly stipulated that the property that had been confiscated from Louis de Luxembourg and his two sons was to be restored to Marie and Françoise de Luxembourg, and to their mother, Marguerite de Savoie.[23] Subsequent to the treaty's establishment, the widow and two orphans that Pierre de Luxembourg had left upon his death could thus hope to recover the significant part of their domains that had been confiscated in France.

In the treaty of Arras, Louis XI obtained an important political success. The agreement ceded the Duchy of Burgundy to him, and stipulated that Margaret of Austria would marry the dauphin and would immediately bring as her dowry Artois, Franche-Comté, the Mâconnais, Charolais, and Auxerrois. The jurisdiction of the Parliament of Paris over Flanders was re-established. The population of the Burgundian Netherlands accepted with enthusiasm the

hope of peace that the treaty seemed to of-
fer. As the king had wished, the treaty was
announced and celebrated in France. The
text of the treaty was widely diffused in
print through both France and Burgundy.[24]
Louis XI had ratified the treaty at Plessis-
lez-Tours, where he then remained con-
fined. Already very ill, he felt himself to be
seriously in decline.

In May of 1483, in Hesdin, Margaret of
Austria—then still a young child—was
turned over to Philippe de Crèvecoeur,
Lord of Esquerdes, King's Lieutenant in
Picardy and Artois, and primary negotiator
of the treaty. Margaret was taken to Am-
boise, where the dauphin was waiting for
her. She was three years old, and he was
thirteen. A wedding ceremony took place
in June. The townspeople were invited.
They went to Amboise, then Tours, happy
to celebrate the peace that this precocious
union seemed to seal.[25]

Louis XI, however, had ratified the treaty
without any real intention of discharging
the commitment that it entailed to the con-
stable's family. He had, subsequent to their
confiscation, used the property of Louis de
Luxembourg and his sons as gifts to people
in his favor, and whose assistance and ex-
pertise were valuable to him. How, conse-
quently, could he resolve to relieve them of
the considerable possessions that he had of-
fered them a few years before?

Guy Pot, who served Louis XI as a nego-
tiator on numerous occasions and who was
then Chamberlain, Governor of the County
of Blois, and Bailiff of Vermandois, had re-
ceived the *seigneurie* of Tingry and the
county of Saint-Pol. Since January of 1476,

the king had given Pierre de Rohan, Lord of
Gié and Marshal of France, the county of
Marle, and half of the county of Soissons, to
which in the following February and March
were added other further *seigneuries* from
Jean de Luxembourg's confiscated proper-
ty.[26] This explains why we find Gié and Guy
Pot mentioned in the king's circle as the
Count of Marle and the Count of Saint-Pol,
respectively,[27] while in Flanders or in Hain-
aut, Pierre II de Luxembourg, in his capac-
ity as his brother's heir, likewise called him-
self Count of Marle and Count of Saint-Pol,
and was also referred to as such.[28]

Figures of Guy Pot's or Gié's stature were
hardly ready to let themselves be dispos-
sessed of such notable increases in their
property without defending themselves.
They were, moreover, not the only ones to
hold *seigneuries* originally from the Luxem-
bourg family. The county of Ligny, for ex-
ample, was thus passed into the hands of
George de la Trémoille, Lord of Craon,
King's First Chamberlain, his lieutenant,
and the Governor General of the Duchy of
Burgundy in the wake of Charles the Bold's
death.[29]

The importance of the people who held
property that came from the confiscation of
the Luxembourg patrimony rendered un-
certain their eventual restitution. We will
therefore not be surprised that nothing had
been resolved at the time of Louis XI's death
on August 31, 1483, nor by the death of
Marguerite de Savoie, widow of Pierre de
Luxembourg, at the Hôtel de Ghistelles in
Bruges on March 9, 1484.[30]

Shortly after the death of her father, Ma-
rie de Luxembourg was married; she mar-

ried her uncle, Jacques de Savoie, Count of Romont.[31] Obtaining the papal dispensation for this marriage between close relatives was done through the Lucca merchant Reale Reali, who was established in Bruges.[32] The settlement of this marriage, which is mistakenly often dated too early, did not take place until the beginning of 1483, in Ath.[33] From this moment forward, Marie de Luxembourg would probably no longer be called Mademoiselle de Marle. Her husband, the Count of Romont, was a younger brother of her mother and of Queen Charlotte of Savoy, whom Louis XI had married in 1451 while still the dauphin. He had started out, while still quite young, in 1468 in the service of Charles the Bold. He played an important role in military operations, in his capacity as the duke's Lieutenant-General during the last years of his reign. He then served under Mary of Burgundy.[34]

We have already alluded to the period of difficulties and tensions in the Burgundian Netherlands in the wake of Mary of Burgundy's death on March 27, 1482. The political situation remained troubled, unstable, and confused for years. We shall not recall here either the stages of its evolution or the fortunes of the adherents to various sympathies who opposed one another. Let it suffice to note that the course of events finally led Jacques de Savoie, Count Romont, to support the States of Flanders, and particularly Ghent, in their opposition to Maximilian. He was chosen by Flanders as Lieutenant General of their troops against Maximilian.[35] This brought him closer to Charles VIII, with whom he was ultimately allied against Maximilian.

A long letter from Charles VIII, written at Melun on January 28, 1485, concerns the question of the restoration of the property that had been confiscated from the Luxembourg family.[36] It alludes to the many steps taken by Jacques de Savoie and his wife to recover this property. Ambassadors of the '*Membres*' of Flanders and of the young Duke Philip the Fair, sent to Tours with Charles VIII, had already insisted on getting the king to order or have the necessary steps taken for the matter to be resolved in accordance with what the Treaty of Arras stipulated. This document of January 28, 1485, clearly reveals the complexity of the case, and the difficulties that prevented the actions taken from succeeding. We can feel emerging from this text the embarrassing situation in which Charles VIII found himself with regard to his '*oncle et tante de Romont*' in this matter. It alludes to the authority and esteem that still preserved by those whom the favor of Louis XI had endowed with Luxembourg property. Here we learn that, from the moment he ratified the Treaty of Arras of 1482, Louis XI would have expressed reservations about the clause allowing for the restitution of property to the constable's heirs. Curiously (or cynically?), however, that did not prevent him from authorizing the plaintiffs from going to court '*pour obtenir delivrance desdits biens*'. Charles VIII nevertheless declares that he will remove the reservations made by his late father, and affirms that, in aid of Jacques de Romont and his wife, and in aid of their sister Françoise de Luxembourg, he will quash and revoke all provisions and declarations that obstruct the restitution.

When Jacques de Savoie died in his Château de Ham on January 30, 1487,[37] some of the property had been restored, but Marie de Luxembourg and her sister Françoise were still waiting to recover a considerable amount of property that was to return to them. Marie, who was seven or eight months pregnant when her husband died, brought a little girl into the world whom she called Françoise, like her aunt, and who would later marry Henry, Count of Nassau-Vianden.[38]

The widowhood of Marie de Luxembourg would allow the matter to take a more favorable turn. At the request of Charles VIII, the young widow and rich heiress accepted the hand of François de Bourbon, Count of Vendôme.[39] She therefore obtained from the king and his Council a declaration dated at Ancenis in the month of July, 1487,[40] according to which he renewed his declaration of January 28, 1485, which willed that she and her sister could finally obtain the restitution of the property that was part of the estate of the constable and his wife, Jeanne de Bar, their grandmother. These properties were still held by other hands in France.[41]

Despite the king's renewed declaration, Marie and Françoise de Luxembourg nonetheless had to bring a lawsuit to finally obtain satisfaction. Some of the holders of the confiscated properties defended themselves until the end. Lodging an appeal against the king's letters, they pleaded their case before Parliament. On February 10, 1489, a judgment of Parliament finally concluded the case 'au proufict des demanderesses suivant l'intention du Roy.[42]

We still do not know the details of the way in which the little prayer book of Charles the Bold came into the hands of Marie de Luxembourg, nor about the possible intermediary through whom she could have obtained it. That the manuscript was in her hands as a young girl, about the time of her father's death on October 25, 1482, and before her marriage to Jacques de Savoie less than six months later, would tend to make us believe that she could have inherited the prayer book when her father died, or have received it from him shortly before his death, unless she got it from Jacques de Savoie, who could have offered it to her shortly before he married her.

If we imagine, on the contrary, that the prayer book could have formed part of the spoils that the Swiss took upon Duke Charles's defeat,[43] it is quite difficult to see how the precious jewel could, some few years later, have ended up in the hands of that very young girl, who then still belonged to the circles close to the Court of Burgundy.

In 1479 and 1480, Maximilian, always short of money, was forced to pawn his jewels,[44] have his plate melted down for coin, and to further appeal for help in meeting his military expenditures.[45] Although it is perhaps not absolutely impossible, it seems difficult to imagine that Mary of Burgundy, in such circumstances, could have thought of parting with the little prayer book, or could have allowed the small book with its gold work binding to figure in a lot of precious objects entrusted on deposit to guarantee a loan.[46]

Perhaps she could have offered it or given it up in return for funds, while taking

care to prevent it from falling into indifferent hands, even to enemies, but rather into those of a family or person of high rank whom she held in esteem, just like a Pierre de Luxembourg, Count of Marle, or the Count of Romont, both of whom she had had elected as Knights of the Order of the Golden Fleece on the first of May in 1478.[47] However, it is also possible that the manuscript only changed hands after the death of Mary of Burgundy on March 27, 1482, and that circumstance then lent themselves to the manuscript's transmission into other hands.

The care with which the duke's shield was removed, near his kneeling portrait on fol. 1v of the prayer book (see Chapter 1) appears significant. It seems that in letting the helmet remain, with its fleur-de-lys crest and its roll or *tortil* in the colors of Burgundy, there was a desire to preserve it as an allusion to the work's original owner and patron. The respect with which they carried out the shield's removal would be quite understandable on the part of the Count of Romont, who held high offices in the service of Duke Charles and his daughter. Pierre de Luxembourg, as well, could have chosen to respect the heraldic elements alluding to the dukes' lineage, taking into account the rank that he occupied at the court of Mary of Burgundy, and the esteem with which he seems to have been surrounded there.

The beautiful calligraphy, with a prettily cadeled initial, of the inscription '*Je suys a Mademoiselle de Marles*' on the guard leaf of the little prayer book betrays the hand of a writing professional. None of the manuscripts preserved that belonged to Marie de Luxembourg bear an ex-libris calligraphed with such care. Nor is any marked as belonging to Mademoiselle de Marle. They generally bear the signature *Marie de Luxembourg* in cursive, added beneath the explicit or beneath the last line of text. Léopold Delisle established a list of manuscripts that belonged to Marie de Luxembourg.[48] We will add to this the famous *Livre des Tournois*, in which the signature that Marie of Luxembourg had marked on fol. 109 has been scraped off.[49] In several other manuscripts as well, her signature can still be recognized even though it was likewise scraped off, for example in the *Traité des anciens tournois* of Antoine de La Salle, BnF, Ms. fr. 5867, fol. 39v, and the *Traité des monnaies*, fr. 5913, fol. 49v. In the *Brut d'Engleterre*, Marie de Luxembourg's signature can be found on fol. 113r, beneath that of her grandfather Louis de Luxembourg.[50] C. Thelliez has reproduced Marie de Luxembourg's signature that appears at the end of the text of the 'Évangiles des quenouilles' (Paris, BnF, Ms.fr. 2151).[51]

The inscription in the prayer book, exceptional in its calligraphy and its formulation, doubtless must have been affixed at the request of whoever intended the manuscript for Mademoiselle de Marle. The person who had this inscription calligraphed could well be Jacques de Romont, who could have had it done shortly before he married Marie de Luxembourg. Taking into account the rank that he occupied and the role that he played, Romont could have had occasion to come into possession of the precious small book. The circumstances

mentioned above could have lent themselves to this, perhaps especially after the death of Mary of Burgundy. He could have sought this acquisition with the idea of being able to offer a magnificent gift to his future wife. Another possibility could be that it was Pierre de Luxembourg who managed to obtain the book and who would have offered it to his eldest daughter.

In the context of the events and connections mentioned, these speculations would be perfectly plausible. We must not however lose sight of the fact that, in the current state of the question, these engaging notions remain conjectures.

An 18th-century inscription, dating to after 1715, appears on fol. 1r of the manuscript. Some portions of it have become almost illegible and can be deciphered today only in fluorescence under ultra-violet rays (Wood's light).[52] The transcription follows; underlined words or letters represent uncertain readings. One quite small word remains illegible and is indicated by points.

> Marie Jeanne de <u>Chaussy</u>
> veuve de <u>Antoine</u> de Choquier
> capitaine … des gardes du
> corps de S.A.R. Monsieur
> frère unique du roy Louis 14 et de
> Mgr. le duc d'Orléans régent
> de France

This is probably the same hand that traced the maxim 'Sans Dieu nul bonheur' at the bottom of fol. 184, beneath the border of the miniature of Saint John on Patmos; it could well be a personal device and relate to Marie Jeanne de Chaussy.

So it emerged from the first of these inscriptions that at the time of the Regency of Philip of Orléans, the manuscript was in the hands of Marie Jeanne de Chaussy, widow of Antoine de Choquier, who, after having been captain of Monsieur's bodyguards—that is to say, of Philip of Orléans, brother of Louis XIV—was likewise for Philip II of Orléans, who secured the regency from 1715 to 1723. This lady of Chaussy, or her husband, perhaps obtained the precious little book from the Regent. If this was the case, one could suppose that before this, over the course of two centuries, the descendants of Marie de Luxembourg, who lived until the first of April in 1546, and François de Bourbon, who died on October 30, 1495, passed it down from one generation to the next until Philip of Orléans. We must not, however, exclude the possibility that during these two centuries the manuscript suffered a more capricious fate.

At the bottom of fol. 1r, a quite legible signature was traced in the 19th century in a darker ink: 'H Delaroche'. This is probably the painter Hippolyte (called 'Paul') Delaroche (1797-1856), who married the daughter of Horace Vernet. Count Paul Durrieu, who seems to have acquired this book at the beginning of the 20th century, indicated—without naming him—that the manuscript had in the 19th century passed into the hands of a famous painter.[53] This painter could therefore be Paul Delaroche.

The book passed from Paul Durrieu's hands into those of his son, Count Jean Durrieu, who died without heirs on July 7, 1975. The manuscript was acquired by the J. Paul Getty Museum in 1989.

Endnotes

1 Durrieu, 1916, pp. 123–124.

2 Vaughan 1973, p. 250–252.

3 Louis de Luxembourg was nowhere sovereign prince of his vast possessions. He had to pay homage to the Duke of Burgundy for some of them, and to the King of France for many others. This situation to some degree explains his schemes. Ph. de Commynes, *Mémoires*, ed. J. Calmette, (Paris 1924–1925) vol. 1, p. 244–245; D. Soumillion, 'Le procès de Louis de Luxembourg (1475). L'image d'un grand vassal de Louis XI et de Charles le Téméraire', *Publication du Centre européen d'Études bourguignonnes (XIVe – XVIe s.)* 37, Neuchâtel, 1997, pp. 212–213; C. Thelliez, *Marie de Luxembourg, duchesse douairière de Vendôme, comtesse douairière de St.–Pol… et son temps*, (Louvain, Paris, 1970) (Anciens Pays et Assemblées d'États, LII), p. 10.

4 During the truce negotiations at Bouvines in May of 1474, the King's and the Duke's ambassadors came to an agreement to do away with him. This agreement, however, was annulled almost immediately by common agreement at the King's request. The King had not changed his mind, but he preferred, as a tactical calculation, to postpone the plot's execution. The matter was repeated in similar terms when the Truce of Soleuvre was concluded in September of 1475. De Commynes 1924–25, vol. 1, pp. 243–252; vol. 2, pp. 22–27, 33–39, 83–91; J. Molinet, *Chroniques* (Brussels 1935–1937), ed. Doutrepont and Jodogne, vol. 1, pp. 130–135; N. Vigner *Histoire de la Maison de Luxembourg…* (Paris 1619), re-edited, annotated, and completed by N.G. Pavillon. pp. 630–639, 693; Vaughan 1973, pp. 250–252 and 351–352.

5 He seems to have hesitated to do it, and delayed before his decision. De Commynes 1924–25, vol. 2, pp. 88–90, and the remarks made by Calmette in the notes.

6 De Commynes 1924–25, vol. 2, p. 91; Vaughan, 1973, pp. 250–252; Soumillion 1997, pp. 205–229.

7 De Commynes 1924–25, vol. 1, p. 247; Vigner 1619, p. 693. The duke thus increased the inheritance that had already been confiscated from Louis de Luxembourg in 1465, when the latter had entered the king's service, but did not completely dispossess the constable's sons who remained loyal. Vaughan 1973, p. 251.

8 ADN, B.2098/67326, fol. 1r. Jean de Luxembourg took part in several diplomatic missions in 1473 and 1474: W. Paravicini, *Guy de Brimeu. Der burgundische Staat und seine adlige Führungsschicht unter Karl dem Kühnen* (Bonn 1975), p. 467.

9 Vigner 1619, p. 751; J.-M. Cauchies, 'Pierre de Luxembourg, comte de Saint–Pol…', *Les Chevaliers de l'Ordre de la Toison d'or au XVe siècle* (Frankfurt am Main, 2000) ed. R. de Smedt, pp. 200–201.

10 It is alluded to in a letter of Charles VIII, dated January 28, 1485, in Melun, which will be discussed below. *Ordonnances des rois de France…*, vol. 19 (Paris 1835), pp. 458–461.

11 E. Matthieu, *Histoire de la ville d'Enghien* (Mons, Enghien, 1877) vol. 1, p. 119.

12 Romont intervened to assist Pierre de Luxembourg in an act concerning the leasing of market–duty by Peter II of Luxembourg in the city of Bruges on April 16, 1481. L. Gilliodts-van Severen, *Inventaire des Archives de la ville de Bruges*, vol. 6 (Bruges 1876), pp. 205–210. The rights to the market-duty in Bruges had passed by marriage from the Lords of Ghistelles to the Luxembourg family. A. Duclos, *Bruges, Histoire et souvenirs* (Bruges, 1910), pp. 41, 527 and 529. In about 1400, Jeanne de Luxembourg was the wife of Louis de Ghistelles: Wilhelm Karl Prinz von Isenburg, *Europäische Stammtafeln. Stammtafeln zur Geschichte der europäischen Staaten*, vol. 3, (Marburg 1964), pl. 109.

13 "*À quoy on dit que Pierre de Luxembourg sceult bien prester la main.*" Vigner 1619, pp. 751–752. He hated these two people "*pour avoir esté les principaux persecuteurs du Connestable, …*" (Idem). They were the ones who had on the duke's behalf entered the agreement and the plot of Bouvines in 1474, which was fatal to the constable. Humbercourt had made still more interventions, with the county of Marle, among other things, which seems to have been ill–received by the Luxembourg famly. Paravicini 1975, pp. 261–265, 418 and 480–483. Duke John of Cleves and the Bishop of Liège, Louis de Bourbon, could also have influenced the outcome of Ghent's trial of Hugonet and Humbercourt. Y. Cazaux, *Marie de Bourgogne* (Paris 1967), p. 215; De Commynes 1924–25, vol. 1, pp. 245–246, vol. 2, pp. 198–199.

14 Molinet 1935–37, vol. 1, pp. 273–276 and 370.

15 R. Wellens, *Les États Généraux des Pays–Bas des Origines à la fin du règne de Philippe le Beau (1464–1506)*, (Heule 1974), (Anciens Pays et Assemblées d'États, LXIV) pp. 448–449.

16 Published by H. Stein, 'Nouveaux documents sur Olivier de La Marche et sa famille', *Mémoires de la Classe des Lettres… Académie royale de Belgique*, 2nd series, tome IX, fasc. 1, p. 57.

17 Molinet 1935–37, vol. 1, pp. 406–408; Matthieu 1877, vol. 1, pp. 119–120.

18 For the problems due to the death of Mary of Burgundy see Blockmans 1974; H. Wiesflecker, *Kaiser Maximilian I. Das Reich, Österreich und Europa an der Wende zur Neuzeit*, Munich, Vienna 1971, vol. 1, pp. 160–181.

19 Wellens 1974, pp. 190–194.

20 The text of the treaty is reproduced *in extenso* by Molinet 1935–37, vol. 1, pp. 377–406. E. Picot and H. Stein provide a note that references all the editions of the treaty, as well as the names, defaced in most editions, of the plenipotentiaries equipped with full power to negoatiate the treaty: *Recueil des pièces historiques imprimées sous le règne de Louis XI, reproduites en fac–similé* (Paris 1923) pp. 269–270.

21 Gilliodts-van Severen 1876, vol. 6, pp. 230–232; Wiesflecker 1971, vol. 1, pp. 165–166.

22 Wiesflecker 1971, p. 169; ADN, B. 361; C. Dehaisnes and J.Finot, *Inventaire sommaire des archives départementales… du Nord* (Lille 1899), vol. 1, partie 1, pp. 248–249; Gilliodts-van Severen 1876, vol. 6, p. 251.

23 Molinet 1935–37, vol. 1, pp. 393–394.

24 We know of twelve different printed examples of it, of which nine were published in 1483 in Paris, Lyon, and Ghent. The king had very much wanted news of the treaty to spread rapidly. See: Picot and Stein 1923, pp. 269–299.

25 De Commynes 1924–25, vol. 2, p. 303; Molinet 1935–37, vol. 1, pp. 416–418; L. Hommel, *Marguerite d'York ou la duchesse Junon* (Paris 1959) pp. 145–146; Wiesflecker 1971, p. 166.

26 *Ordonnances des rois de France…*, vol. 18, p. 231.

27 *Ordonnances des rois de France…*, vol. 18, pp. 225, 231 et alia; vol. 19, pp. 104, 131, 134, 337, 350, 360. On April 1, 1483, 'Guy Pot, Comte de Saint–Pol' was named Governor of Touraine. Gié had three sons, and no daughter who could call herself Mademoiselle de Marle. T. de Morembert, 'Gié (Pierre de Rohan, dit le maréchal de)', *Dictionnaire de Biographie française*, tome 15 (Paris 1982), col. 1485–1488.

28 For example: C. Dehaisnes 1881, vol. 4, p. 263; Gilliodts–Van Severen 1876, vol. 6, p. 205.

29 He was the one who had the inventory drawn up from March 6 to March 15, 1477, of the moveable goods and jewels found in the duke's palace in Dijon. The king offered them to him. The Marshal of Gié, not knowing that the king had given them to the Lord of Craon, sought this gift from Louis XI, who could evidently no longer grant it to him. Dijon, Archives départementales de la Côte d'Or, B.302, fol. 1r–59r. Partially published: G. Peignot, *Catalogue d'une partie des livres composant la bibliothèque des ducs de Bourgogne, au XVe siècle*, seconde édition revue … (Dijon 1841), pp. 99–100. After the death of the Lord of Craon in 1481, Louis XI gave the county of Ligny to Louis, bâtard de Bourbon and Admiral of France, despite the opposition of Parliament: de Barante, *Histoire des ducs de Bourgogne*, ed. M. Marchal, (Brussels 1839), vol. 10, p. 135.

30 Marie de Luxembourg's parents were depicted recumbent on the tomb that Mary had built at the Abbey of Cercamp where they were buried. Their epi-

taphs recall their titles and *seigneuries*. Vigner 1619, p. 776, published the two epitaphs, which were also published by Matthieu 1877, vol. 1, p. 121, but according to another source that includes several variants. In the Church of the Carthusians of Hérinnes, where the heart of Pierre de Luxembourg was laid to rest, another inscription can be read in his memory. Idem, p. 120.

31 Memling painted a portrait of Jacques de Savoie dating from before his election to the Order of the Golden Fleece in May of 1478. A contemporary copy is preserved at the Öffentliche Kunstsammlung in Basel. D. De Vos, *Hans Memling* (Antwerp 1994), p. 339. M.J. Friedländer, *Early Netherlandish Painting*, vol. VI, part 1 (Leyden-Brussels, 1971), pl. 127.

32 The financial settlement for this transaction reached the sum of 2580 lb., 13 s., and 10 d. groats, Flanders currency, and the expenditures and remunerations Reali accounted for his intervention as well as for some supplies (silk cloth, among other things), led to a dispute between him and Marie de Luxembourg. The matter was brought before the Great Council of Mechlin. The suit dragged on at least until 1491. AGR, Grand Conseil de Malines, première instance, n° 66 and 154. I owe Lorne Cambell for having put me on the track of these documents, for which I am sincerely grateful.

33 Several authors give 1460 as the date of this marriage: L. Colot, 'Jacques de Savoie, comte de Romont, homme lige de la Maison de Bourgogne', *Publication du Centre européen d'Études Burgondo–médianes* n° 20 (Basel 1980) (Rencontres de Milan, 21–23 septembre 1978), p. 90; B. Bauchau, 'Jacques de Savoie, comte de Romont', *Les Chevaliers de l'Ordre de la Toison d'or au XVe siècle* (Frankfurt am Main 2000) ed. R. de Smedt, pp. 201–202; Paris, 1993, p. 91. The error seems to come from: Von Isenburg 1965, vol. 2, pl. 112. The date of Marie de Luxembourg's death, April 1, 1546, makes it impossible that she could have married in 1460! Her epitaph, from the Collegiate Church of Saint George in Vendôme and now preserved at the Musée de Vendôme, does not mention her date of birth. Thelliez 1970, p. 120. Marie de Luxembourg was not yet born in 1460. Her mother, Marguerite de Savoie, could only have married Pierre II de Luxembourg after the death of her first husband, Jean IV de Montferrat, who died on January 29, 1464: Von Isenburg 1965, vol. 2, pl. 137. At Romont's death, on January 30, 1487, Marie was seven or eight months pregnant: Molinet 1935–37, vol. 1, p. 555, but she would scarcely have been more than eighteen then. Matthieu 1877, vol. 1, p. 126. The documents cited in the preceding note establish that Marie was still a minor at the time she requested the dispensation for her marriage.

34 Vaughan 1973, pp. 243–245, and passim.

35 Wellens 1974, pp. 196–197. The Count of Romont was, however, still distinguished at Maximilian's side, at the head of the Flemish Militia at the Battle of Guinegate on August 7, 1479. Molinet 1935–37, vol. 1, pp. 310–311 and 554–555. De Commynes 1934–25, vol. 2, pp. 274–276; Wiesflecker 1971, pp. 147–149.

36 *Ordonnances des rois de France…*, vol. 19 (Paris 1835), pp. 458–461.

37 And not 1486 as some others have indicated, forgetting to take into account the Paschal Calendar style. His epitaph is published by Thelliez 1970, p. 11. His tomb, where he was depicted kneeling, could still be seen in 1634 in the church of Notre-Dame de Ham. Ham was part of the property confiscated by Charles the Bold in 1475, but restored to Pierre de Luxembourg by Mary of Burgundy in 1477.

38 Molinet 1935–37, vol. 1, p. 555. She died young, and without having had children. Vigner 1619, p. 770.

39 François had been eight years old at the death of his father in 1478. *Ordonnances des rois de France…*, vol. 19, pp. 350–353. He was therefore seventeen or eighteen years old when he married Marie. Five children were born of this union. The eldest, Charles de Bourbon, was the grandfather of King Henri IV. Marie de Luxembourg, granddaughter of the constable executed by order of a king of France, was therefore the great–grandmother of another king of France.

40 *Ordonnances des rois de France…*, vol. 20, pp. 9–14. The document in surely dated at Ancenis (with no indication as to the day of the month), and not from Amiens, as Thelliez says in error: Thelliez 1970, pp. 10–12.

41 *Ordonnances des rois de France…*, vol. 20, pp. 9–14; Vigner 1619, p. 756.

42 Vigner 1619, pp. 756–770, 777.

43 A list of the spoils taken at Grandson mentions a small illuminated book of prayers: '*Item, ein clein gefloriert bettbuch, ist angeschlagen für 60 gulden.*' *Amtliche Sammlung der älteren Eidgenössischen Abschiede*, vol. II (1421–1477), (Lucerne 1863), p. 591. Nothing allows us to confirm that this concerns a prayer book of the duke's, as Deuchler believed: Deuchler 1963, p. 349. His notice for n° 316 relates to a manuscript of testimonies in fact concerning

different manuscripts, as I have pointed out: De Schryver, 1999, p. 65, note 34.

44 J. Barrois, *Bibliothèque protypographique ou Librairies des fils du roi Jean…* (Paris 1830), pp. 333–338; Pinchart 1863, pp. 88–89; Dehaisnes 1881, pp. 257–258, B 2119 and B 2122. L. Hommel, *Marie de Bourgogne ou le Grand Héritage*, (Brussels 1945), p. 323. The '*Membres*' of Flanders reproached Maximilian in 1482 for having squandered these jewels: Blockmans 1974, pp. 324–325.

45 Wiesflecker 1971, pp. 136, 141.

46 As Maximilian later gave away a lot of jewels to guarantee a debt of 10,000 livres contracted with the Duchess of Brittany for the pay of warriors that she put at his service. ADN: B 895; Dehaisnes 1881, p. 78. It is acknowledged that manuscripts were sometimes pawned to guarantee loans.

47 J.-M. Cauchies, 'Pierre de Luxembourg, comte de Saint–Pol, de Conversano et de Brienne, seigneur d'Enghien', *Les Chevaliers de l'Ordre de la Toison d'or au XVe siècle* (Frankfurt am Main, 2000) ed. R. de Smedt, pp. 200–201; B. Bauchau, 'Jacques de Savoie, comte de Romont', in idem, pp. 201–202) (The error of the Comte de Romont's marriage date will be corrected: 1483 and not 1460)

48 L. Delisle, *Le Cabinet des Manuscrits de la Bibliothèque Nationale*, vol. 2 (Paris 1874), pp. 379–380.

49 F. Avril, *Le Livre des Tournois du roi René de la Bibliothèque nationale (ms. Fr. 2695)* (Paris 1986), pp. 9–10 and 81; Paris 1993, p. 236.

50 Louis de Luxembourg also possessed an example in three volumes of the *Histoires romaines*, a Parisian manuscript of the end of the 14th century: The Hague, Koninklijke Bibliotheek, ms. 71 A 16–18. His signature appears in 71 A 18. The manuscript belonged to Philip of Cleves, who had married Françoise de Luxembourg, Marie's sister. *Schatten van de Koninklijke Bibliotheek*, exh. cat. ('s Gravenhage, Rijksmuseum Meermanno-Westreenianum, 1980), pp. 72–73, n° 29).

51 Thelliez 1970, p. 109.

52 Durrieu, 1916, did not mention this inscription. In 1916, one was unaware of the possibilities of reading that fluorescence under ultra-violet rays permitted.

53 Durrieu, 1916, p. 113.

Bibliography

AINSWORTH/MARTENS 1994

M.W. AINSWORTH and M.P.J. MARTENS, *Petrus Christus: Renaissance Master of Bruges,* New York 1994.

ALEXANDER 1970

J.J.G. ALEXANDER, *The Master of Mary of Burgundy: A Book of Hours for Engelbert of Nassau*, New York 1970.

AVRIL 1977

F. AVRIL, 'Pour l'enluminure provençale. Enguerrand Quarton peintre de manuscrits?' in *Revue de l'art* 35, 1977, pp. 9–40.

BERTRAND 1994

P. BERTRAND, 'Eustache', in *Dictionnaire d'histoire et de géographie ecclésiastiques*, Paris 1994, XXV.

BIERMANN 1975

A.W. BIERMANN, 'Die Miniaturenhandschriften des Kardinals Albrecht von Brandenburg (1514–1545)', in *Aachener Kunstblätter* 46, 1975, pp. 15–311.

BLOCKMANS 1974

W. BLOCKMANS, 'Autocratie ou polyarchie? La lutte pour le pouvoir politique en Flandre, d'après les documents inédits, 1482–1492', in *Bulletin de la Commission royale d'histoire* 140, 1974, pp. 257–368

BOON 1961

K.G. BOON, 'Een Utrechtse Schilder uit de 15de eeuw, de Meester van de Boom van Jesse in de Buurkerk', in *Oud Holland* 76, 1961, pp. 51–60.

BOON 1964

K.G. BOON, 'Nieuwe gegevens over de Meester van Katharina van Kleef en zijn Atelier', in *Bulletin van de Koninklijke Nederlandsche Oudheidkundige Bond* 17, 1964, col. 241–254.

BOON 1985

K.G. BOON, 'De Meester van het Amsterdamse kabinet of de Meester van het Hausbuch en zijn verhouding tot de kunst van de Bourgondische Nederlanden', in J.P. FILEDT KOK et al., *'s Levens felheid : de Meester van het Amsterdamse kabinet of de Hausbuch-meester, ca. 1470–1500*, exh. cat., Amsterdam 1985, pp. 11–21.

BOONE et al. 1981

M. BOONE et al., *Immobiliënmarkt, Fiscaliteit en Sociale Ongelijkheid te Gent, 1483–1503*, Anciens Pays et Assemblées d'États, LXXVIII, Courtrai-Heule 1981.

BRÄM 1997

A. BRÄM, *Das Andachtsbuch der Marie de Gavre (Paris, Bibliothèque nationale, Ms. nouv. acq. fr. 16251).*

Buchmalerei in der Diözese Cambrai im letzten Viertel des 13. Jahrhunderts, Wiesbaden 1997.

BRINKMANN 1989

B. BRINKMANN, '"Marginalia" on Dürer: Netherlandish Sources for his Illustrations in the Prayerbook of Emperor Maximilian', in *Middeleeuwse handschriftenkunde in de Nederlanden 1988. Verslag van de Groningse Codicologendagen 28–29 april 1988*, Grave 1989, pp. 183–197.

BRINKMANN 1997

B. BRINKMANN, *Die flämische Buchmalerei am Ende des Burgunderreichs. Der Meister des Dresdener Gebetbuchs und die Miniaturisten seiner Zeit,* Turnhout 1997.

BRUGES 1981

C. LEMAIRE, 'De bibliotheek van Lodewijk van Gruuthuse', in C. LEMAIRE and A. DE SCHRYVER, *Vlaamse Kunst op perkament. Handschriften en miniaturen te Brugge van de 12de tot de 16de eeuw*, exh. cat., Bruges 1981, pp. 207–277.

BRUSSELS 1959

L.M.J. DELAISSÉ, *Le Siècle d'or de la miniature flamande. Le mécénat de Philippe le Bon*, exh. cat., Brussels 1959.

BRUSSELS 1973

Le Cinquième centenaire de l'imprimerie dans les anciens Pays-Bas, exh. cat., Brussels 1973.

BRUSSELS 1991

C. LEMAIRE and M. HENRY, *Isabelle de Portugal, duchesse de Bourgogne. 1397–1471*, exh. cat., Brussels 1991.

BYVANCK 1937

A.W. BYVANCK, *La Miniature dans les Pays-Bas septentrionaux*, Paris 1937.

BYVANCK/HOOGEWERFF 1922–25

A.W. BYVANCK and G. J. HOOGEWERFF, *Noord-Nederlandsche miniaturen in handschriften der 14e, 15e en 16e eeuwen*, The Hague 1922–25, 3 vols.

CALKINS 1978

R.G. CALKINS, 'Parallels Between Incunabula and Manuscripts from the Circle of the Master of Catherine of Clèves', in *Oud Holland* 92, 1978, pp. 137–160.

CAMBRIDGE 1993

J.M. MASSING and A. ARNOULD, *Splendours of Flanders*, exh. cat., Cambridge 1993.

CARTER 1962

D.G. CARTER, 'The Providence Crucifixion: Its Place and Meaning for Dutch Fifteenth-Century Painting', in *Bulletin of Rhode Island School of Design* 48.4, May 1962, pp. 1–40.

CHÂTELET 1980
A. CHÂTELET, *Les Primitifs hollandais. La peinture dans les Pays-Bas du Nord au XVe siècle*, Paris 1980.

CHEVALIER 1892
U. CHEVALIER, *Repertorium hymnologicum. Catalogue des chants, hymnes, proses, séquences, tropes en usage dans l'Église latine depuis les origines jusqu'à nos jours*, Louvain 1892.

COLMAR 1991
Le beau Martin. Gravures et dessins de Martin Schongauer (vers 1450–1491), exh. cat., Colmar 1991.

CORNELIS 1988
E. CORNELIS, 'De Kunstenaar in het laat-middeleeuwse Gent. II. De sociaal-economische positie van de meesters van de Sint-Lucasgilde in de 15de eeuw', in *Handelingen der Maatschappij voor Geschiedenis en Oudheidkunde te Gent* 42 (nieuwe reeks), 1988, pp. 95–138.

DE COMMYNES 1924/25
P. de Commynes, *Mémoires*, ed. J. CALMETTE, Paris 1924/25, 3 vols.

DEHAISNES 1881
C. DEHAISNES, *Inventaire sommaire des archives départementales antérieures à 1790*, Lille 1881, IV.

DEHAISNES 1892
C. DEHAISNES, *Recherches sur le Retable de saint Bertin et sur Simon Marmion*, Lille-Valenciennes 1892.

DELAISSÉ 1949
L.M.J. DELAISSÉ, 'Le livre d'heures de Mary van Vronensteyn, chef-d'œuvre inconnu d'un atelier d'Utrecht, achevé en 1460', in *Scriptorium* 3, 1949, pp. 230–245.

DELAISSÉ 1958
L.M.J. DELAISSÉ, 'Les techniques du livre dans le bréviaire bénédictin de Grammont', in *Scriptorium* 12, 1958, pp. 104–107.

DELAISSÉ 1968
L.M.J. DELAISSÉ, *A Century of Dutch Manuscript Illumination*, Berkeley-Los Angeles 1968.

DE POTTER 1891/92
F. DE POTTER, *Gent, van den oudsten tijd tot heden*, Ghent, 1891/92, VI.

DE RAM 1863
P. DE RAM, 'Anciens statuts de la faculté de médecine de Louvain', in *Compte-rendu des séances de la Commission royale d'histoire ou recueil de ses bulletins*, V (3rd series), Brussels 1863, pp. 395–396.

DE SCHRYVER 1969/1
A. DE SCHRYVER, 'Étude de l'enluminure', in *Gebetbuch Karls des Kühnen vel potius, Stundenbuch der Maria von Burgund. Codex Vindobonensis 1857 der Österreichischen Nationalbibliothek*, Graz 1969, pp. 21–173.

DE SCHRYVER 1969/2
A. DE SCHRYVER, 'Nicolas Spierinc, calligraphe et enlumineur des Ordonnances des États de l'Hôtel de Charles le Téméraire', in *Scriptorium* 23, 1969, pp. 434–459.

DE SCHRYVER 1974
A. DE SCHRYVER, 'Pour une meilleure orientation des recherches à propos du Maître de Girart de Roussillon', in *Rogier van der Weyden en zijn tijd. Internationaal Colloquium, 11–12 Juni 1964*, Brussels 1974, pp. 43–82.

DE SCHRYVER 1979
A. DE SCHRYVER, 'Prix de l'enluminure et codicologie. Le point comme unité de calcul de l'enlumineur dans *Le Songe du viel pellerin* et *Les Faictz et gestes d'Alexandre* (Paris, Bibliothèque nationale de France, fr. 9200–9201 et fr. 22547)', in *Miscellanea codicologica F. Masai dicata MCMLXXIX*, ed. P. COCKSHAW et al., Ghent 1979, II, pp. 469–479.

DE SCHRYVER 1992
A. DE SCHRYVER, 'The Louthe Master and the Marmion Case', in *Margaret of York, Simon Marmion and 'The Visions of Tondal'*, ed. T. KREN, Malibu 1992, pp. 171–180.

DE SCHRYVER 1999
A. DE SCHRYVER, 'Philippe de Mazerolles. Le Livre d'heures noir et les manuscrits d'Ordonnances militaires de Charles le Téméraire', in *Revue de l'art* 126, 1999, pp. 50–67.

DE SCHRYVER 2001
A. DE SCHRYVER, 'Relations et parentés entre l'œuvre de Liévin van Lathem et celle de Dirk Bouts et d'Albert van Ouwater', in *Bouts Studies: Proceedings of the International Colloquium (Leuven, 26–28 November 1998)*, ed. B. CARDON et al., Louvain-Paris-Sterling-Virginia 2001, pp. 209–222.

DE VOS 1994
D. DE VOS, *Hans Memling. Het volledig œuvre*, Antwerp 1994.

DE WINTER 1981
P.M. DE WINTER, 'A Book of Hours of Queen Isabel la Catolica', in *The Bulletin of The Cleveland Museum of Art* 67, 1981, pp. 341–428.

DE WINTER 1985
P.M. DE WINTER, *La Bibliothèque de Philippe le Hardi, duc de Bourgogne (1364–1404)*, Paris 1985.

DHANENS 1965
E. DHANENS, *Het retabel van het Lam Gods in de Sint-Baafskathedraal te Gent* (Inventaris van het Kunstpatrimonium van Oost-Vlaanderen 6), Ghent 1965.

DHANENS 1998
E. DHANENS, *Hugo van der Goes*, Antwerp 1998.

DURRIEU 1902
P. DURRIEU, *Heures de Turin*, Paris 1902.

DURRIEU 1910
P. DURRIEU, 'Les "Préfigures" de la passion dans l'ornementation d'un manuscrit du XVe siècle', in *Revue de l'art chrétien* 60, 1910, pp. 67–69.

DURRIEU 1914

P. DURRIEU, 'Les miniaturistes franco-flamands des XIVe et XVe siècles', in *Annales du XXIIIe Congrès de la Fédération archéologique et historique de Belgique (1913)*, Ghent 1914, III, pp. 217–239.

DURRIEU 1916

P. DURRIEU, 'Livre de prières peint pour Charles le Téméraire par son enlumineur en titre Philippe de Mazerolles. (Le maître de *La Conquête de la Toison d'Or)*', in *Monuments et mémoires publiés par l'Académie des Inscriptions et Belles-Lettres (Fondation Eugène Piot)* 22 (fasc. 1), 1916, pp. 71–130.

E. DUVERGER 1996

E. DUVERGER, 'Une déclaration faite par Lieven van Lathem au sujet de peintres flamands au Portugal en 1490', in *Gentse Bijdragen tot de Kunstgeschiedenis en Oudheidkunde* 31, 1996, pp. 291–295.

J. DUVERGER 1954

J. DUVERGER, 'Kopieën van het "Lam-Gods"-retabel van Hubrecht en Jan van Eyck', in *Bulletin Koninklijke Musea voor Schone Kunsten* 2, Brussels 1954, pp. 50–68.

J. DUVERGER 1969

J. DUVERGER, 'Hofschilder Lieven van Lathem (ca.1430–1493)', in *Jaarboek van het Koninklijk Museum voor Schone Kunsten Antwerpen*, 1969, pp. 97–104.

J. DUVERGER 1982

J. DUVERGER, 'Het statuut van de zestiende-eeuwse hofkunstenaar in de Nederlanden', in *Jaarboek van het Koninklijk Museum voor Schone Kunsten Antwerpen*, 1982, pp. 61–95.

EUW/PLOTZEK 1979–85

A. VON EUW and J. M. PLOTZEK, *Die Handschriften der Sammlung Ludwig*, Cologne 1979–85, 4 vol.

FRIEDLÄNDER 1967–76

M.J. FRIEDLÄNDER, *Early Netherlandish Painting*, New York 1967–76, 14 vols.

GHENT 1975

A. DE SCHRYVER, 'Miniatuurkunst', in *Gent. Duizend jaar kunst en cultuur*, exh. cat., Ghent 1975, pp. 321–396.

GILLIODTS-VAN SEVEREN 1876

L. GILLIODTS-VAN SEVEREN, *Inventaire des archives de la ville de Bruges*, Bruges 1876, VI.

GORISSEN 1973

F. GORISSEN, *Das Stundenbuch der Katharina von Kleve. Analyse und Kommentar*, Berlin 1973.

GRAY 1904

G.J. GRAY, *The Earlier Cambridge Stationers and Bookbinders and the first Cambridge Printers* (Illustrated Monographs issued by the Bibliographical Society 13), Oxford 1904.

HÉNAULT 1907

M. HÉNAULT, 'Les Marmion (Jehan, Simon, Mille et Collinet), peintres amiénois du XVe siècle', in *Revue archéologique* 9 (4th series), 1907, pp. 119–140, 282–304, 410–424; 10 (4th series), 1907, pp. 108–124.

HINDMAN 1992

S. HINDMAN, 'Two Leaves from an Unknown Breviary: The Case for Simon Marmion', in *Margaret of York, Simon Marmion, and The Visions of Tondal*, ed. T. KREN, Malibu 1992, pp. 223–232.

HOOGEWERFF 1937

G.J. HOOGEWERFF, *De Noord-Nederlandsche Schilderkunst*, The Hague 1937, II.

JACOMET 1995

H. JACOMET, 'L'énigmatique odyssée de saint Jacques', in *Archéologia* 318, December 1995, pp. 58–67.

KREN 1983

T. KREN, 'Flemish Manuscript Illumination, 1475–1550', in *Renaissance Painting in Manuscripts: Treasures from the British Library*, New York-London 1983.

KUPFER-TARASULO 1979

M. KUPFER-TARASULO, 'Innovation and Copy in the Stein Quadriptych of Simon Bening', in *Zeitschrift für Kunstgeschichte* 42, 1979, pp. 274–298.

LABORDE 1849–52

L. LABORDE, *Les Ducs de Bourgogne. Étude sur les lettres, les arts et l'industrie pendant le 15e siècle, et plus particulièrement dans les Pays-Bas et le Duché de Bourgogne*, Paris 1849–52, 3 vols.

LEROQUAIS 1927

V. LEROQUAIS, *Les Livres d'heures manuscrits de la Bibliothèque nationale*, Paris 1927, 3 vols.

LEROQUAIS 1932–34

V. LEROQUAIS, *Les Bréviaires manuscrits des bibliothèques publiques de France*, Paris 1932–34, 6 vols.

LIEFTINCK 1969

G.I. LIEFTINCK, *Boekverluchters uit de omgeving van Maria van Bourgondië, c. 1475–c. 1485*, Brussels 1969.

LINDNER 1912

A. LINDNER, *Der Breslauer Froissart*, Berlin 1912.

LOUVAIN 1969

Erasmus en Leuven, exh. cat., Louvain 1969, p. 158.

LOUVAIN 1998

Dirk Bouts (ca.1410–1475). Een Vlaams primitief te Leuven, exh. cat., Louvain 1998.

MADOU 1994

M. MADOU, 'Zittende Jacobus', in *De Jacobsstaf* 22, 1994, pp. 44–54.

MARROW 1968

J. H. MARROW, 'Dutch Manuscript Illumination before the Master of Catherine of Clèves: The Master of the Morgan Infancy Cycle', in *Nederlands Kunsthistorisch Jaarboek* 19, 1968, pp. 51–113.

MARROW 1987

J. H. MARROW, 'Prolegomena to a New Descriptive Catalogue of Dutch Illuminated Manuscripts', in *Miscellanea Neerlandica. Opstellen voor Dr. Jan*

Deschamps ter Gelegenheid van zijn zeventigste Verjaardag, eds E. COCKX-INDESTEGE and F. HENDRICKX, Louvain 1987, I, pp. 295–309.

MARTENS 1992
M.P.J. MARTENS, *Lodewijk van Gruuthuse, mecenas en Europees diplomaat ca. 1427–1492*, Bruges 1992.

MATTHIEU 1877
E. MATTHIEU, *Histoire de la ville d'Enghien*, Mons-Enghien 1877, I.

MEISS 1967
M. MEISS, *French Painting in the Time of Jean de Berry: The Late Fourteenth Century and the Patronage of the Duke*, London 1967.

MEISS 1968
M. MEISS, *French Painting in the Time of Jean de Berry: The Boucicaut Master*, London 1968.

MEISS 1974
M. MEISS, *French Painting in the Time of Jean de Berry: The Limbourgs and Their Contemporaries*, New York 1974.

MOLINET 1935–37
J. Molinet, *Chroniques*, eds G. DOUTREPONT and O. JODOGNE, Brussels 1935–37, 3 vols.

NEW YORK 1982
J. PLUMMER, *The Last Flowering: French Painting in Manuscripts 1420–1530*, exh. cat., New York 1982.

NEW YORK 1989
H.L.M. DEFOER et al., *The Golden Age of Dutch Manuscript Painting*, exh. cat., New York 1989.

OLDHAM 1943
J.B. OLDHAM, *Shrewsbury School Library Bindings: Catalogue raisonné*, Oxford 1943.

Ordonnances
Ordonnances des rois de France, Paris 1828–40, XVIII–XX.

PÄCHT 1973
O. PÄCHT, 'René d'Anjou—Studien I', in *Jahrbuch der Kunsthistorischen Sammlungen in Wien* 69, 1973, pp. 85–126.

PÄCHT/THOSS 1974
O. PÄCHT and D. THOSS, *Die Illuminierten Handschriften und Inkunabeln der Österreichischen Nationalbibliothek. Französische Schule I* (Veröffentlichungen der Kommission für Schrift- und Buchwesen des Mittelalters, Reihe I, Band 1), Vienna 1974, 2 vols.

PÄCHT/JENNI 1975
O. PÄCHT, U. JENNI, *Die Illuminierten Handschriften und Inkunabeln der Österreichischen Nationalbibliothek. Holländische Schule* (Veröffentlichungen der Kommission für Schrift- und Buchwesen des Mittelalters, Reihe I, Band 3), Vienna 1975, 2 vols.

PÄCHT/JENNI/THOSS 1983
O. PÄCHT, U. JENNI and D. THOSS, *Die Illuminierten Handschriften und Inkunabeln der Österreichischen Nationalbibliothek. Flämische Schule I* (Veröffent-

lichungen der Kommission für Schrift- und Buchwesen des Mittelalters, Reihe I, Band 6), Vienna 1983, 2 vols.

PÄCHT/THOSS 1990
O. PÄCHT, D. THOSS, *Die Illuminierten Handschriften und Inkunabeln der Österreichischen Nationalbibliothek. Flämische Schule II* (Veröffentlichungen der Kommission für Schrift- und Buchwesen des Mittelalters, Reihe I, Band 7), Vienna 1990, 2 vols.

PANOFSKY 1953
E. PANOFSKY, *Early Netherlandish Painting: Its Origins and Character*, Cambridge (Mass.) 1953.

PARAVICINI 1975
W. PARAVICINI, *Guy de Brimeu. Der burgundische Staat und seine adlige Führungsschicht unter Karl dem Kühnen*, Bonn 1975.

PARIS 1972
Le Livre, exh. cat., Paris 1972.

PARIS 1991
S. RENOUARD DE BUSSIERRE, *Martin Schongauer. Maître de la gravure rhénane. Vers 1450–1491*, exh. cat., Paris 1991.

PARIS 1993
F. AVRIL and N. REYNAUD, *Les Manuscrits à peintures en France 1440–1520*, exh. cat., Paris 1993.

PERDRIZET 1933
P. PERDRIZET, *Le Calendrier parisien à la fin du Moyen Âge d'après le bréviaire et les livres d'heures* (Publications de la Faculté des lettres de l'Université de Strasbourg 63), Paris 1933

PICOT/STEIN 1923
E. PICOT, H. STEIN, *Recueil des pièces historiques imprimées sous le règne de Louis XI, reproduites en facsimilé*, Paris 1923.

PIEPER 1966
P. PIEPER, 'Das Stundenbuch der Katharina van Lochorst und der Meister der Katharina von Kleve', in *Westfalen* 44, 1966, pp. 97–157.

PINCHART 1860–81
A. PINCHART, *Archives des arts, sciences et lettres. Documents inédits annotés*, Ghent 1860–81, 3 vols.

PINCHART 1863
A. PINCHART, 'Les historiens de la peinture flamande, aux XVᵉ et XVIᵉ siècles', in *Les Anciens peintres flamands. Leur vie et leurs œuvres*, eds J.A. CROWE and G.B. CAVALCASELLE, Brussels 1863, II, pp. 175–334 (dated end of March 1865).

PINCHART 1865
A. PINCHART, 'Miniaturistes, enlumineurs et calligraphes employés par Philippe le Bon et Charles le Téméraire', in *Bulletin des commissions royales d'art et d'archéologie* 4, 1865, pp. 473–510.

PLUMMER 1966
J. PLUMMER, *The Book of Hours of Catherine of Clèves*, London-New York 1966.

PREVENIER/BOONE 1989

W. PREVENIER and M. BOONE, 'De "stadsstaat"-droom, in *Gent. Apologie van een rebelse stad*, ed. J. DECAVELE, Antwerp 1989, pp. 99–103.

RABEL 1989

C. RABEL, 'Artiste et clientèle à la fin du Moyen Âge. Les manuscrits profanes du Maître de l'Échevinage de Rouen', in *Revue de l'art* 84, 1989, pp. 48–60.

RÉAU 1955–59

L. RÉAU, *Iconographie de l'art chrétien*, Paris 1955–59, 3 tomes (6 vols).

REYNAUD 1989

N. REYNAUD, 'Barthélémy d'Eyck avant 1450', in *Revue de l'art* 84, 1989, pp. 22–43.

ROMBOUTS/VAN LERIUS 1864

P. ROMBOUTS and T. VAN LERIUS, *De Liggeren der Antwerpsche St-Lucasgilde*, Antwerp 1864, I.

ROOSEN-RUNGE 1981

H. ROOSEN-RUNGE, *Das spätgotische Musterbuch des Stephan Schriber in der Bayerischen Staatsbibliothek München Cod. Icon. 420*, Wiesbaden 1981, 3 vols.

SMEYERS/CARDON 1991

M. SMEYERS, B. CARDON, 'Utrecht and Bruges—South and North "Boundless" Relations in the 15th Century', in *Masters and Miniatures: Proceedings of the Congress on Medieval Manuscript Illumination in the Northern Netherlands (Utrecht, 10–13 December 1989)*, eds K. VAN DER HORST and J.-C. KLAMT, Doornspijk 1991, pp. 89–116.

SMEYERS/VAN DER STOCK 1996

M. SMEYERS and J. VAN DER STOCK (eds), *Flemish Illuminated Manuscripts 1475–1550*, Ghent 1996.

SMOLAR-MEYNAERT 1991

A. SMOLAR-MEYNAERT, 'Des origines à Charles Quint', in *Le Palais de Bruxelles. Huit siècles d'art et d'histoire*, Brussels 1991, pp. 46–53.

SOMMÉ 1998

M. SOMMÉ, *Isabelle de Portugal, duchesse de Bourgogne. Une femme au pouvoir au XVᵉ siècle*, Lille 1998.

SOUMILLION 1997

D. SOUMILLION, *Le Procès de Louis de Luxembourg (1475). L'image d'un grand vassal de Louis XI et de Charles le Téméraire*, Neuchâtel 1997.

STEPPE 1975

J.K. STEPPE, 'Het paneel van de Triniteit in het Leuvense Stadsmuseum. Nieuwe gegevens over een enigmatisch schilderij', in *Dirk Bouts en zijn tijd*, exh. cat., Louvain 1975, pp. 447–498.

STERLING 1983

C. STERLING, *Enguerrand Quarton. Le peintre de la Pietà d'Avignon*, Paris 1983.

STRUBBE/VOET 1960

E. STRUBBE and L. VOET, *De chronologie van de middeleeuwen en de moderne tijden in de Nederlanden*, Antwerp 1960.

THELLIEZ 1970

C. THELLIEZ, *Marie de Luxembourg, duchesse douairière de Vendôme, comtesse douairière de St.-Pol,… et son temps* (Anciens Pays et Assemblées d'États, LII), Louvain-Paris 1970.

THIEME/BECKER 1907–50

U. THIEME and F. BECKER, *Allgemeines Lexikon der bildenden Künstler von der Antike bis zur Gegenwart*, Leipzig 1907–50, 37 vols.

THOMAS 1976

M. THOMAS, 'Le livre de prières de Philippe le Bon. Premier bilan d'une découverte', in *Les Dossiers de l'archéologie* 16, May–June 1976, pp. 84–95.

TIMMERS 1947

J.J.M. TIMMERS, *Symboliek en iconographie der christelijke kunst*, Roermond-Maaseik 1947.

TIMMERS 1978

J.J.M. TIMMERS, *Christelijke symboliek en iconografie*, Weesp 1978.

VAN BUREN 1975

A. VAN BUREN, 'The Master of Mary of Burgundy and his Colleagues: The State of Research and Questions of Method', in *Zeitschrift für Kunstgeschichte* 38, 1975, pp. 286–309.

VAN DER HAEGHEN 1899

V. VAN DER HAEGHEN, *Mémoire sur des documents faux relatifs aux anciens peintres, sculpteurs et graveurs flamands* (Mémoires couronnés et autres mémoires publiés par l'Académie royale de Belgique 58), Brussels 1899.

VAN DER LINDEN 1936

H. VAN DER LINDEN, *Itinéraires de Charles, duc de Bourgogne, Marguerite d'York et Marie de Bourgogne (1467–1477)*, Brussels 1936.

VAN MANDER 1604/1994

C. VAN MANDER, *Het Schilder-Boek…* Haarlem 1604 (1994 edition).

VAN SCHOUTE 1963

R. VAN SCHOUTE, *La Chapelle royale de Grenade* (Corpus de la peinture des anciens Pays-Bas méridionaux au quinzième siècle 6), Brussels 1963.

VAUGHAN 1970

R. VAUGHAN, *Philip the Good*, London 1970.

VAUGHAN 1973

R. VAUGHAN, *Charles the Bold*, London 1973.

VIELLARD 1938

J. VIELLARD (ed.), *Le Guide du pèlerin de Saint-Jacques de Compostelle*, Mâcon 1938.

VIENNE 1987

D. THOSS, *Flämische Buchmalerei. Handschriftenschätze aus dem Burgunderreich*, exh. cat., Vienna 1987.

VIGNER 1619

N. Vigner, *Histoire de la Maison de Luxembourg…*, ed. N.G. PAVILLON, Paris 1619.

VON ISENBURG 1964

W.K. VON ISENBURG, *Europäische Stammtafeln. Stammtafeln zur Geschichte der europäischen Staaten*, Marburg 1964, 3 vols.

VORAGINE
J. de Voragine, *La Légende dorée*, Paris 1967, 2 vols.
WAUTERS 1891
A. WAUTERS, 'Liévin van Lathem', in *Biographie natio-nale de Belgique* XI, Brussels 1891, col. 421–425.
WEALE 1898
W.H.J. WEALE, *Bookbindings and Rubbings of Bindings in the National Art Library, South Kensington*, London 1898.
WELLENS 1974
R. WELLENS, *Les États généraux des Pays-Bas des origi-nes à la fin du règne de Philippe le Beau (1464–1506)* (Anciens Pays et Assemblées d'États 64), Heule 1974.
WIESFLECKER 1971
H. WIESFLECKER, *Kaiser Maximilian I. Das Reich, Ös-terreich und Europa an der Wende zur Neuzeit*, Munich-Vienna 1971, I.
WINKLER 1925
F. WINKLER, *Die Flämische Buchmalerei des XV. und XVI. Jahrhunderts*, Leipzig 1925.

WORKS THE AUTHOR WAS UNABLE TO TAKE INTO CONSIDERATION:

D. Thoss, *Das Schwarze Gebetbuch. Vollständiges Fak-simile des Codex Nr. 1856 der Österreichischen Na-tionalbibliothek, Wien*, Frankfurt 1982, pp. 20, 115, fig. 10, 83.
E. Wolf, *Bild in der spät mittelalterlichen Buchmalerei. Das Sachsenheim-Gebetbuch im Werk Lievin van Lathems*, Saarebruk 1993, pp. 15–16.
L. Campbell, *The Fifteenth Century: Netherlandish Schools*, London, National Gallery 1998, pp. 298.
P. Bruyère, 'La plus ancienne représentation connue de l'ex-voto offert par Charles le Hardi à la cathédrale de Liège (circa 1584)', in *Bulletin de la Société Royale, le Vieux-Liège* N° 284, vol. XIV, n° 1, January–March 1999, pp. 833–856.
C. Heck (ed.), *L'art flammand et hollandais. Le siècle des primitifs 1380–1520*, Paris 2003, p. 239, fig. 280.

T. Kren, 'Prayer Book of Charles the Bold', in T. Kren and S. McKendrick, *Illuminating the Renaissance: The Triumph of Flemish Manuscript Painting in Eu-rope*, exh. cat. Los Angeles 2003, pp. 128–131, n° 16.
M. Hofmann / I. Nettekoven (eds), *Philippe de Maze-rolles. Ein unbekanntes Stundenbuch aus Brügge*, Ramsen / Rotthalmünster 2004, pp. 53–57, figs 19–20.
E. Morrison / T. Kren (eds), *Flemish Manuscript Paint-ing in Context: Recent Research*, Los Angeles 2006, p. 7 (note 24), 19, 21, 45, 128–129.
C. Périer-d'Ieteren, *Dieric Bouts: The Complete Works*, Brussels 2006, p. 216.
T. Kren, 'Landscape in Flemish Illuminated Manuscripts Before Patinir', in *Patinir: Essays and Critical Cata-logue*, exh. cat. Madrid 2007, pp. 117–133.
C. Yvard, 'Un livre d'heures inédit du XVᵉ siècle à la Chester Beatty Library du Dublin', in *Art de l'enluminure*, 19, 2007, pp. 2–64.

SYMBOLS AND ABBREVIATIONS

ADN	Lille, Archives départementales du Nord
AGR	Brussels, Archives générales du Royaume – Algemeen Rijksarchief
BL	London, British Library
BnF	Paris, Bibliothèque nationale de France
BSB	Munich, Bayerische Staatsbibliothek
CDC	Chambre des comptes
KBR	Brussels, Bibliothèque royale de Belgique / Koninklijke Bibliotheek van België
Keure	Ghent, Jaarregisters van de Keure - Registres des échevins de la Keure
ÖNB	Vienna, Österreichische Nationalbibliothek
PML	New York, The Pierpont Morgan Library
SAA	Antwerp, Stadsarchief van Antwerpen - Archives de la ville d'Anvers
SAG	Ghent, Stadsarchief van Gent - Archives de la ville de Gand
SBPK	Berlin, Staatsbibliothek Berlin, Stiftung Preus-sischer Kulturbesitz
WL	Stuttgart, Württembergische Landesbibliothek